JAPONISME

Japanese Influence on French Art 1854-1910

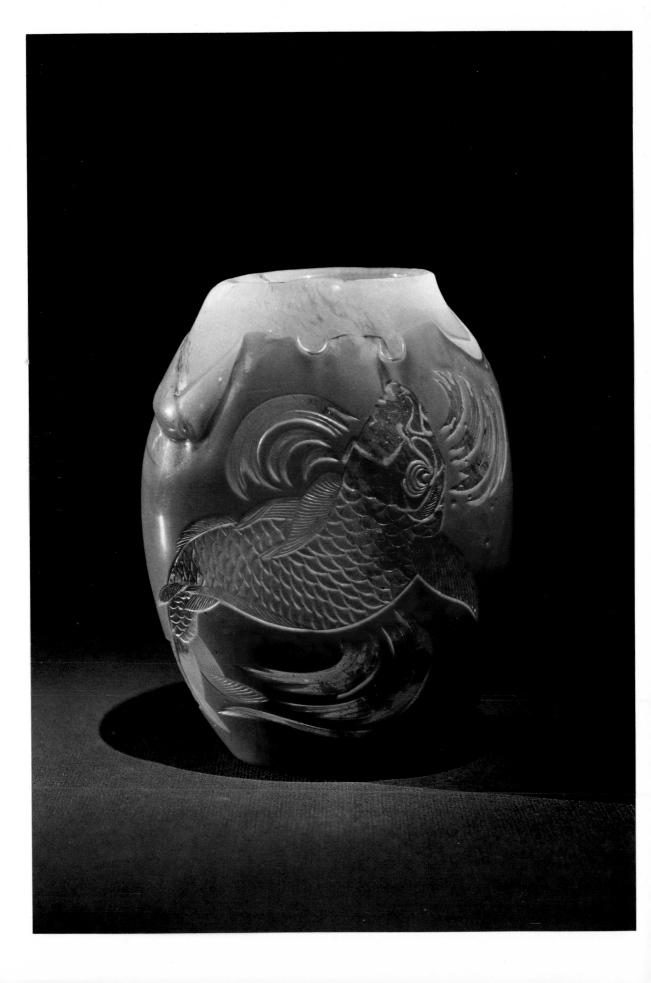

JAPONISME

Japanese Influence on French Art 1854-1910

GABRIEL P. WEISBERG
Curator of Art History and Education, The Cleveland Museum of Art

PHILLIP DENNIS CATE
Director, Rutgers University Art Gallery

GERALD NEEDHAM
Assistant Professor, Douglass College, Rutgers University

MARTIN EIDELBERG
Professor, Department of Art, Rutgers University

WILLIAM R. JOHNSTON
Assistant Director, The Walters Art Gallery

PUBLISHED JOINTLY BY
The Cleveland Museum of Art, The Rutgers University Art Gallery
and The Walters Art Gallery

Exhibition Schedule

The Cleveland Museum of Art: 9 July—31 August, 1975.
The Rutgers University Art Gallery: 4 October—16 November, 1975.
The Walters Art Gallery: 10 December—26 January, 1976.

This exhibition and its accompanying catalog are supported
by grants from the National Endowment for the Arts and
the National Endowment for the Humanities, Washington, D. C.

Frontispiece. **235** Vase by Eugène Rousseau.

Cover. Three Japonisme Ceramics by Albert Dammouse:
205 Cup and Saucer; **206** Vase; and **265** Plaque.

Back Cover. **119** *The Coiffure* by Mary Cassatt.

Distributed by Kent State University Press, Kent, Ohio 44240.

© 1975 by The Cleveland Museum of Art, University Circle, Cleveland, Ohio 44106.
Printed in the United States of America.

Library of Congress Cataloging in Publication Data

Main entry under title:

Japonisme: Japanese influence on French art, 1854–1910.

 Catalog of an exhibition shown at The Cleveland Museum of Art, July 9-Aug. 31, 1975;
The Rutgers University Art Gallery, Oct. 4-Nov. 16, 1975; and The Walters Art Gallery,
Dec. 10, 1975-Jan. 26, 1976.

 Bibliography: p.
 1. Art, French—Exhibitions. 2. Art, Japanese—Exhibitions.
3. Art, Modern—19th century—France. 4. Art, French—Japanese influences.
I. Weisberg, Gabriel P. II. Cleveland Museum of Art. III. Rutgers University,
New Brunswick, N. J., University Art Gallery. IV. Walters Art Gallery, Baltimore.

N6847.J34 709'.44'074013 75-16127

ISBN 0-910386-22-6

Contents

Foreword

Japonisme: Japanese Influence on French Art 1854–1910 marks a milestone in examining relationships periodically existing between the Far East and the West. As the exhibition and accompanying catalog suggest, contacts with the Far East led to fruitful periods of artistic interchange. The creation of *chinoiseries* during the eighteenth century is one such example. While contacts were maturing with China, Portuguese and Dutch traders searching for a faster way to reach the Orient contacted Japan and established trading ties. At first these ties were cordial, but misuse of the arrangements forced Japan to adopt a policy of seclusion. While some goods reached European ports during this bleak period and collections of Japanese objects were formed in Holland, it was not until the nineteenth century that Japan reached out to again establish normal relations with Western nations. Then, under the stimulus of Commodore Matthew C. Perry's trip to Japan, the doors of the country were thrown open to all Western nations. Throughout the 1850's and 1860's, art objects poured into the West, turning attention from the fading tradition of *chinoiseries* toward a fuller appreciation of Japonisme—the study of the culture, history, and art of Japan. Lacquers, fans, bronzes, kakemonos, ceramics, illustrated books, and single *ukiyo*-e prints became prized possessions, frequently fought over by collectors in their quest to obtain all that was new and novel from this exotic country. The result of this constant association with and study of Japanese art objects is recorded in the French prints, paintings, and decorative-art objects assembled for this exhibition.

The harmonious qualities of Japonisme can be understood by placing art objects produced in different media together within their time periods. A basic aim of craftsmen working in the last half of the nineteenth century, prior to the Art Nouveau movement, was to see art works united by removing artificial barriers which had for many centuries traditionally existed in the West between, for example, painting and the decorative arts. Such interrelationships were paramount to the thinking and creativity of many who recognized that the art of Japan was a possible force stimulating such reconsiderations in the West.

Several generations of art historians have concerned themselves with the influence of Japan on Western art; especially its impact on French paint-

ing. With this exhibition, equal—if not more—emphasis is placed upon a broader revisionist outlook, one which seems closer to the truth in its contention that all the arts were influenced by Japan. In some cases, for example, decorative designers were in advance of painters in their use of Japanese motifs and more penetrating in their analysis of Japonisme.

Considerable effort, both in the exhibition and in the catalog, has been spent on reconstructing the historical climate: new sources for Japonisme have been located and documentary photographs have been used to recreate a sense of time and place and to illustrate objects that proved too difficult to borrow. A grant from the National Endowment for the Humanities made this possible, and we are deeply grateful to them for this support. These supporting materials were designed so that complex trends could be made clear and comprehensible. Support from the National Endowment for the Arts allowed the transportation of many significant and aesthetically valuable objects from Europe. The detailed scholarly catalog is also partially funded by the Endowment. We owe both agencies a sincere debt of gratitude for encouraging this exhibition.

Japonisme, as an exhibition, would not have been possible without the concerted efforts of a number of art historians and museum personnel who have worked for several years to bring the show and catalog into clear focus. Phillip Dennis Cate, Director of the Rutgers University Art Gallery, and Dr. Gabriel P. Weisberg, Curator of Art History and Education at The Cleveland Museum of Art, have carefully coordinated the substantial print section of the exhibition; their essays contribute valuable new insights into Japonisme. William R. Johnston, Assistant Director of The Walters Art Gallery, worked on the preparation and cataloging of the decorative arts section of the exhibition. The excellent and exhaustive research of Dr. Martin Eidelberg, Professor in the Art Department at Rutgers University, and his knowledge of European and American collections added immeasurably to the wide range of Japonisme decorative-art examples in the exhibition. The painting section of the show, while small in size, provides essential support to other areas. It was organized by Dr. Gerald Needham, Assistant Professor in the Art Department at Douglass College, Rutgers University. In addition, the efforts of the staff members

of the Cleveland Museum's Department of Art
History and Education in developing the support-
ing components were both creative and untiring.
To these individuals and to the other staff members
of the three co-sponsoring institutions—The Cleve-
land Museum of Art, The Rutgers University Art
Gallery, and The Walters Art Gallery—we owe a
special debt only partially repaid with heartfelt
thanks.

Sherman E. Lee, Director, The Cleveland Museum
of Art
Richard Randall, Director, The Walters Art Gallery,
Baltimore
Phillip Dennis Cate, Director, Rutgers University
Art Gallery

Preface

"Japonisme" was first used as a term in 1872 by the French art critic Philippe Burty (1830–1890) to "designate a new field of study—artistic, historic, and ethnographic. . . ." This new movement had been widely prevalent during the 1860's as Japanese art poured into France, where it was avidly collected by artists, critics, and connoisseurs—Burty himself among them. Appreciation of all things Japanese was stimulated by the Paris Exposition Universelle (1867) which brought many Japanese visitors to the city; it increased during the 1870's as Western artists in printmaking, decorative arts, and painting were affected by the vogue. In fact, since Japonisme was at work simultaneously in several fields, one can sense a harmonization of the visual arts which had not been as apparent in these areas before Western artists had begun their examination of Japanese art. The elucidation of interrelationships that developed at the same historical moment between these avenues of creative expression is as much an aim of this exhibition as is the clarification of how Western artists in France reacted to the art of Japan from 1854 to 1910.

The interest in exploring Japanese influence on French art has intrigued art historians for many years. Initial studies were undertaken by Ernst Scheyer (1943), Clay Lancaster (1952), and Yvonne Thirion (1956 and 1961). These writings were followed by those of John Sandberg on "Whistler's Japonisme" (1964), Gabriel P. Weisberg on "Félix Bracquemond and Japonisme" (1969), and Henri Dorra (in collaboration with Sheila Askin) on "Seurat's Japonisme" (1969). In 1970 a chapter on Japonisme was included in Mark Roskill's book, *Van Gogh, Gauguin, and the Impressionist Circle.* At the time of the 1972 World Olympics a major exhibition was held in Munich examining Near Eastern and Far Eastern influences on nineteenth- and twentieth-century art, and considerable attention was given to the diffusion of Japanese art in the West. The following year, with Japonisme still in the air, a panel discussion on this topic was held at the College Art Association convention in New York. This session was chaired by Gabriel P. Weisberg and included Mark Roskill, Henri Dorra, and Martin Eidelberg; its result was to generate discussions from which the present exhibition emerged. This past year, Colta Ives' *Great Wave: The Influence of Japanese Woodcuts on French Prints,* published in conjunction with an exhibition at The Metropolitan Museum of Art in New York, has given added impetus to the study of this seminal force for nineteenth-century art in France. *Japonisme: Japanese Influence on French Art 1854–1910* is the end product of a long tradition among art historians of examining this problem and represents an attempt on the part of the five catalog essayists to further clarify these long-standing discussions.

A show as complicated as this one would not have been possible without the assistance of numerous individuals both in Europe and in the United States. Support has been given by a number of Oriental-art scholars including: Willem van Gulik, Curator of Japanese Art, Rijksmuseum voor Volkenkunde, Leiden, Holland; Professor William Harkins, Ukiyo-e Society of America; Money Hickman, Assistant Researcher, Asiatic Art Department, Museum of Fine Arts, Boston; Wai-kam Ho, Curator of Chinese Art, The Cleveland Museum of Art; Donald Jenkins, formerly Curator, Department of Oriental Art, The Art Institute of Chicago; Sherman E. Lee, Chief Curator, Department of Oriental Art, and Director, The Cleveland Museum of Art; Amy Poster, Assistant Curator of Oriental Art, The Brooklyn Museum; Valrae Reynolds, Curator of Oriental Art, Newark Museum; Basil Robinson, Curator Emeritus of Oriental Art, The Victoria and Albert Museum, London.

In France, where considerable research work was conducted, kindness and support were generously given by Jean Adhémar, Conservateur en chef, Cabinet des Estampes, Bibliothèque Nationale, Paris; Jean d'Albis, Haviland and Company, Limoges; Laurens d'Albis; Jean Paul Bouillon; Yvonne Brunhammer, Conservateur, Musée des Arts Décoratifs, Paris; Philippe Cazalis; Descendants of Camille Moreau; Sonia Edard; The Franco-American Commission; Antoinette Hallé, Musée National de Céramique, Sèvres; Janine Bailly-Herzberg; Barlach Heuer; Mrs. Robert Hine; Geneviève Allemand Lacambre, Musée du Louvre; Félix Marcilhac; Michel Melot, Conservateur, Cabinet des Estampes, Bibliothèque Nationale, Paris; Alice Stern; Robert Tschoudoujney.

In England assistance was provided by the staff of the Victoria and Albert Museum and Charles H. F. Avery; Elizabeth Aslin, Keeper, Bethnal Green Museum; Mrs. Joan Collins; Hugh Macandrew, Assistant Keeper, Ashmolean Museum.

In the United States special appreciation is due many individuals: Arthur G. Altschul; James D. Burke, Assistant Curator of Prints, Yale University Art Gallery; Herbert Cahoon, Curator of Autograph Manuscripts, Pierpoint Morgan Library; Fred Cain, National Gallery of Art, Washington; Sylvan Cole; William Dane, Art and Music Department, Newark Library; Raphael Esmerian; Roy Fisher; Clive Getty; Lucien Goldschmidt; Barbara Guggenheim; Henry Hawley, Curator of Post-Renaissance Decorative Arts, The Cleveland Museum of Art; George Heard Hamilton, Sterling and Francine Clark Art Institute; Robert Herbert, Yale University; Sinclair Hitchings, Keeper of Prints, Boston Public Library; Penelope Hunter; Ellen Jacobowitz, Assistant Curator of Prints, Philadelphia Museum of Art; John Jesse; Harold Joachim, Curator of Prints, The Art Institute of Chicago; J. Stewart Johnson; Robert Johnson, Assistant Curator of Prints, Baltimore Museum of Art; Ruth Fine Lehrer, Alverthorpe Gallery; Paula Lipsitz; Jean Mailley, Curator of Textiles, Metropolitan Museum of Art; Richard McComb; Kneeland McNulty, Curator of Prints, Philadelphia Museum of Art; Jo Miller, Curator of Prints, The Brooklyn Museum; Mrs. Lillian Nassau; George Olson, Art Department, College of Wooster; Louise S. Richards, Curator of Prints and Drawings, The Cleveland Museum of Art; Dr. and Mrs. R. Roncalli; Minna Rosenblatt; Barbara Ross, Curator of Prints, Princeton Museum; Elizabeth Roth, Prints Division, New York Public Library; Joseph Rothrock, Curator, Collection of Graphic Prints, Princeton University Library; Barbara Shapiro, Print Department, Museum of Fine Arts, Boston; Mr. and Mrs. Herbert Schimmel; Richard Taylor; David Tunick; Roberta Waddell, Prints Division, New York Public Library; Peter Wick, Houghton Library, Harvard University; Ian Woodner.

The preparation of the exhibition and catalog was aided by: Sadie Zainy, Secretary to the Director, Rutgers University Fine Arts Collection; Helen O. Borowitz, The Cleveland Museum of Art; Martin Linsey, Instructor, Department of Art History and Education, The Cleveland Museum of Art, whose photography work permitted a deeper understanding of art objects in the show; the Publications Department, The Cleveland Museum of Art, under the guidance of Dr. Merald E. Wrolstad, and with the assistance of Sally Goodfellow, Sarah Gramentine, and Barbara Weltman, who worked diligently to prepare the catalog; Janet L. Leonard, Secretary to the Curator, Department of Art History and Education, The Cleveland Museum of Art; Sherley Hobbs, photographer, The Walters Art Gallery, and Margaret Cooke, Curatorial Secretary, The Walters Art Gallery, also aided in the research work.

The supporting educational materials—used at all institutions—were prepared by Janet Mack, Assistant Curator, Department of Art History and Education, The Cleveland Museum of Art; and by Gabriel P. Weisberg.

Phillip Dennis Cate
William R. Johnston
Gabriel P. Weisberg

Note:
The references which appear in brackets — for example [121] — indicate catalog numbers.

I. Japonisme: Early Sources and the French Printmaker 1854-1882

Gabriel P. Weisberg

When an art critic commented on the widespread phenomenon of Japonisme during the mid-1870's as a "caprice of bored dilettantes," his remark underscored the propagation of a new tendency of aesthetes to divert themselves with the pursuit of *curiosités* from the Orient.[1] No doubt, some saw the appearance of Japanese prints and other *objets d'art* in France as part of the nineteenth century's continuing romantic dialogue with exotic cultures.[2] Prints which appeared by 1880, including ones by the popular Henry Somm (Figs. 1a,b), did much to cultivate this romantic myth. The mesmerizing qualities of Japan had obviously captured the imagination of lovely French women, as they were in fact affecting thousands in France, who seemed entranced by dreams of exotic people, and by the Japanese albums and fans which were obtainable in Parisian department stores by 1880.[3] This image clearly symbolizes the mass appeal of Japonisme, a quality nurtured by ceramic manufacturers and textile factories, as the craze was somewhat faddish.[4] On the other hand, many artists saw in Japanese art a means of revitalizing their imagery and, even during the 1860's, turned to a serious examination and use of Japanese motifs and concepts. Indeed, one must keep in mind that Japonisme was a complex trend involving popular and artistic aspects apparent from the start of the movement.[5]

Early Illustrated Source Books on Japan

Japonisme, initiated as it was by the opening of Japan to the West in the early 1850's by the American Commodore Matthew C. Perry, encouraged expanded trade in art works.[6] Before long, examples of Japanese art made their appearance in the *curiosité* shops of Paris and London. Anything Japanese excited controversy, as each new shipment of *curiosités* brought the interest of a growing band of Japonistes to fever-pitch excitement. James McNeill Whistler and the French art critic, Zacharie Astruc, even had to be physically restrained from a fight over a particularly choice Japanese fan.[7]

Among the earliest Japonisme enthusiasts were printmakers, including Félix Bracquemond, Jules Jacquemart, James McNeill Whistler, Edouard Manet, James Tissot, Edgar Degas, and the art critic and sometimes etcher, Philippe Burty. All of them were familiar with Japan and its culture, as Burty had in his library, at an early date, volumes which he most likely shared with others and which provided valuable source material about the country.[8] The *Atlas Japanensis* (London, 1670) [1] had engravings of the landscape and people of Japan and also described the earliest contacts Japan experienced with the West.[9] Four other volumes were available to French critics and artists through

Figures 1a [61a] and 1b [61b]. *Japonisme* and *Woman Surrounded by Japonisme Objects.* Etchings. Henry Somm.

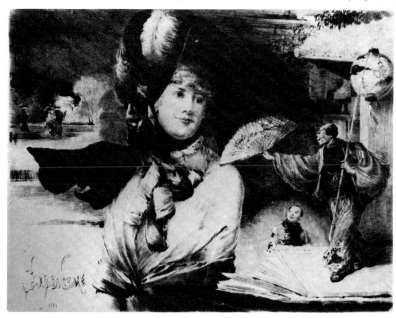

Figure 2a. Engraving from Von Siebold's *Nippon Archiv zur Beschreibung von Japon.*
4-5/16 x 5-29/32 inches (11 x 15 cm.), 1831. L. Nader, del. Leiden, Courtesy Rijksmuseum voor Volkenkunde.

Burty's library: Kaempfer's *The History of Japan* (London, 1727) [2], Charlevoix's *Histoire et Description générale du Japon* (Paris, 1736), Titsingh's *Illustrations of Japan* (London, 1822) [3], and Von Siebold's monumental *Nippon Archiv zur Beschreibung von Japon* published in Leiden, Holland, from 1831 (Figs. 2a,b).[10] Von Siebold's work was also published in France in 1838 under the title *Voyage au Japon* [4]. Kaempfer's work and the compendium by Von Siebold (Dutch edition) were lavishly illustrated with images of fish and animals, creating an early study guide for later French Japonistes. Charlevoix, while not fully illustrated, also discussed the animals of Japan.[11] Importantly, while Von Siebold's works contained lithographs by the artist Keiga, who was Von Siebold's companion in Japan, there are several instances in which lithographs were clearly based on illustrations from Hokusai's *Manga* (Figs. 2a, b).[12] These images bear in miniscule print the inscription for "Hok-sai pinxit," showing that a diffusion of Hokusai's images was possible before the 1850's with the availability of this work in France. Von Siebold brought back to Holland copies of the *Manga* which could have been studied by those individuals aware

of Von Siebold's museum in Leiden, which he opened to the general public in 1837.[13] The existence of other Japanese print collections and books in the "Royal Cabinet of Rarities" in the Hague before 1835 further emphasizes the substantial ethnological exhibitions shown in Holland that dealt with Japan.[14] Which French artists, critics, and collectors travelled to either The Hague or Leiden remains an open question, one that can be partially answered only through the examination of "Guest-Books" which recorded visitors to the Von Siebold collections.[15] By 1883 the Von Siebold collection and the others were certainly known to Louis Gonse, who mentioned them in his book *L'Art Japonais*.[16] This year was also significant for Leiden, as all the collections were merged and ample attention given to the National Museum of Ethnology.[17]

The early availability of Japanese prints in Holland should not be overlooked in the establishment of those print albums and single sheets upon which French artists could have drawn. Since books recording these collections were known to the early French Japonistes, it is possible that more detailed ties will eventually emerge. Thus, the appearance of Japanese prints in France most likely did not come

Figure 2b. Landscape from the Manga, volume 7. Woodcut, 9 x 11-1/2 inches (22.9 x 29.2 cm.).
Katsushika Hokusai. Leiden, Courtesy Rijksmuseum voor Volkenkunde.

as a surprise, for it emerged in the wake of increasing general European interest in Japan. By the early 1860's other travel books were published, some with facsimile illustrations by Hokusai, providing further encouragement for French study.[18] Indeed, by 1862, the English voyager to Japan, Sir Rutherford Alcock, saw to it that Japanese art was brought to London, thus creating an exhibition which French artists could have attended.[19]

The Availability of Japanese Prints in Paris

It is possible that considerable credence can be given to the discovery by Félix Bracquemond of Hokusai's *Manga* in 1856 at the shop of the printer Delâtre; certainly, by 1866–67 he was copying directly from these albums, as well as others, in his prints used for the Rousseau ceramic service.[20] There is little doubt, as other art historians have shown, that by 1867, the time of the Exposition Universelle, Japanese prints were everywhere.[21] However, it seems that most attention has focused upon Hokusai's *Manga*, certainly an important source for French artists, but one which has inhibited an examination of other Japanese albums

and single prints [15, 16, 17] that were circulated and used during the 1860's.[22] The securing and knowledge of Japanese prints during the 1860's and 1870's were supported by many stores where print albums were easily purchased, including tea warehouses, *curiosité* shops, candy stores, and large *magasins*.[23] By examining the writings of Philippe Burty and Zacharie Astruc, among others, which mentioned that Japanese prints were appearing everywhere, important clues to specific shops, including that of Mme. Desoye, emerged.[24] Mme. Desoye was, however, not the owner of the fabled *La Porte Chinoise* — a key store for the dissemination of Japanese goods — as mentioned by the de Goncourts and reiterated by numerous historians.[25] In unravelling this mystery, which is of considerable importance for establishing the priorities of Japanese prints during the 1860's, attention must focus on other shops, even the most ephemeral, and upon the true proprietor of *La Porte Chinoise*. The existence, then, of two shops — *La Porte Chinoise* at 36 Rue Vivienne and the shop of E. Desoye, which opened in 1862 on the Rue de Rivoli — demonstrates an increasing interest in stores selling Japanese objects.[26] Curiously, *La Porte Chinoise* had

Figure 3 [51]. *Alphonse Hirsch*. Etching. Edgar Degas.

a long tradition in Paris, first opening as a *Salon des Thés* in 1826 and participating in selling both Chinese and Japanese objects under a variety of owners, including Pierre Bouillette, who ran the store during the 1860's when it attracted James Mc-Neill Whistler, Edouard Manet, and many others.[27] These shops were confused by observers of the day and later writers, who certainly knew of a third store: Decelle's *à l'Empire Chinois*, which sold Japanese objects in the 1850's.[28] The availability of print albums at many other locations is further documented by over forty Japanese albums owned by the ceramist Camille Moreau, an acquaintance of Bracquemond, which bear stamps from other shops, including Decelle, where they had been purchased.[29] These albums will be discussed later.

La Porte Chinoise, Mme. Desoye's, Decelle's and others were obviously meeting places for lovers of the Far East and collectors of Japanese prints. Manet, the de Goncourts, Jacquemart, Degas, and Burty, all of whom began to form print collections at this time, while recorded as having gone to *La*

Porte Chinoise, most likely knew of the other stores which proliferated following the Exposition Universelle of 1867.[30] By the 1870's print albums were sold at the *Bon marché,* Guerrier and Company (a tea warehouse), and the *Compagnie Coloniale,* which had sold chocolates under the Second Empire. In addition to Japanese prints, the Fairs of 1867 and 1878 brought other objects to an ever-increasing audience. Pieces exhibited in 1867, which had been brought directly from Japan, were sold immediately after the Fair, although some were shown again in 1869 at the *Musée Oriental.*[31] At the Fair of 1878, bronzes and lacquers owned by Burty and S. Bing were also prominently displayed as part of a huge Japanese pavillion.[32]

The Japanese Print Albums of Bracquemond and Moreau

The albums owned by Bracquemond and Moreau reveal common interests: a love of the plants and animals of Japan, an awareness of curvilinear flower motifs, and an attempt to obtain albums by varied *ukiyo-e* artists.[33] It is probable that both artists, with strong decorative tendencies, selected print albums which reinforced their own natural, romantic sensibilities. Moreau (especially since this seems a fair sample of the albums she owned) scoured the shops and stalls in search of albums — no matter how small — which provided new decorative motifs for her ceramics. The albums she selected demonstrate that a wide range of choices was available and that many of the prints were not of choice aesthetic quality. Her prints suggest that artists seized upon any novel album which excited their imagination without pausing to scrutinize its intrinsic quality and without knowing what Japanese printmaker had produced the image. In this process, Bracquemond — with his use of the *Manga* — obviously set a precedent that others followed.

Bracquemond's reliance on the *Manga* is well known [5], and his use of other albums will be revealed later in this essay when the prints for the Rousseau service are examined in detail. Suf'· ₂ it to say that his use of Japanese motifs and his acquaintance with Moreau led her to begin her collection in the 1860's. While not all of her albums were purchased at an early date, and some are signed and dated by her in the 1880's, many of the albums bear the mark of the Adolphe Moreau col-

lection, attesting to their ownership by the family early in her career.[34] Several of the albums bear stamps of the shops where they were purchased.[35]

Among the works owned by Camille Moreau are prints from the "Fish series" by Hiroshige [6], a widely known group of prints also used by Bracquemond. The prints from the Moreau collection are pasted in an album, six to each side, with the album folding out to reveal one print per page. Moreau also owned the second volume from the *Manga* of Hokusai, which she probably purchased after their primary use by Bracquemond.[36] Other albums include numerous examples of fish, birds, shells, turtles, lobsters, plants, and flowers. One album was commented upon by the Japanese scholar Léon de Rosny in 1872, namely the *So-moku-kin-yo-siu (Study of Leaves and Plants)*, printed in Kyoto in 1829.[37] This attracted Moreau, since it contained accurate studies of plants and flowers. Other Japanese albums from the Moreau collection were by Shigemasa [7], Sadahide [8], Hiroshige [9], Kyosai [11], and probably Kuniyoshi [10].[38]

While the albums vary in size and quality, they provide a good model of a typical collection of Japanese prints owned and used by a practicing nineteenth-century artist. Since Moreau, in many ways, learned from Bracquemond, her collection probably mirrored some of his selections, although this remains undocumentable as no accurate listing of Bracquemond's Japanese print albums now seems possible.[39] Moreau's print albums, developed from her natural inclinations, do document many types of Japanese flower and animal albums available in France almost immediately after they appeared in Japan. A good case in point is Kyosai's album *Kyosai Rakuga (Drawn with Pleasure by Kyosai)*, which was printed in Tokyo in 1881 and which was signed and dated by Moreau in 1882 [11].[40]

Thus, many Japanese albums provided a solid base from which printmakers could study motifs for their own use. The Burty collection of prints, built up from the 1860's, was undoubtedly available to many artists and serves, along with the Moreau collection, as a good guide to tastes and acquisition tendencies of the early Japonistes.[41] Nowhere was this love of Japan more visible than in the secret society of the Jing-lar, which had many members among the printmakers and collectors during this opening decade of Japonisme.

The Secret Société du Jing-lar

In keeping with the increasing enthusiasm for things Japanese during the 1860's, some artists and critics banded together to form the Société du Jing-lar. While the substance of their monthly meetings at Solon's house at Sèvres was deliberately kept secret, one can assume that the members discussed Japanese art, dressed in kimonos, and possibly ate meals from the Rousseau service which Bracquemond was working on at the time. [41a] The members of this small club, including Burty, Astruc, Fantin-Latour, Jacquemart, Alphonse Hirsch (Fig. 3), who was later etched by Degas, and M. L. Solon, prepared a membership card which was etched by Bracquemond [19]. The names of the individual members were placed in the center of a smoking volcano, the image obviously inspired by either Hokusai's or Hiroshige's view of Mt. Fujiyama [15]. In the design, two Japanese, preparing a meal, frame this middle section. Apparently, Solon, who was then working at the Sèvres ceramic manufactory (where a strong interest in Japanese art was getting underway), was one of the driving forces behind bringing the various members together at his house. He sent letters of encouragement, including one to Bracquemond, noting that ". . . Jing-lar without Bracquemond would be like Jing-lar without Jing-lar."[42] Solon and other members in the Société were quite sensitive to events in the Parisian art world. When Bracquemond won a medal for printmaking at the Salon of 1867, Solon responded by saying:

> To the Left!
> Jacquemart writes to me — Jing-lar has triumphed and our dear Bracquemond has his medal. The very sincere congratulations I send you extend to the artist whom everyone loves, the committee which was able to appreciate him, and Jing-lar, which is very justifiably proud of the success of one of its members.[43]

Despite their overriding interest in Japanese art, the battle for recognition of printmaking and decorative art was still very much at the back of the minds of almost all the members of the Société.[44]

Solon was amused by the Jing-lar Société, and perhaps this quality is visible in the humorous *diplôme* that Bracquemond etched for the group. In a letter to Bracquemond, Solon wrote:

Figures 4a-d. Colored woodcuts from the series *The Large Fishes (Uo zukushi),* each approximately 10 x 15 inches (25.5 x 38.2 cm.), 1832. Ando Hiroshige. Boston, Museum of Fine Arts, Spaulding Collection.

Figure 4a. *Lobsters and Shrimps.*

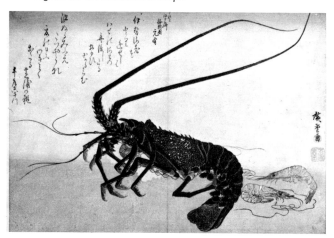

Figure 4b. *Flatheads and Eggplant.*

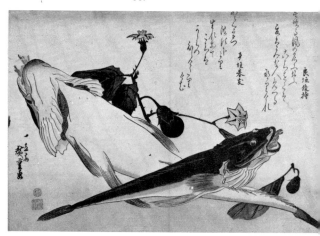

. . . therefore I warn you that I shall treasure it and that I charge it to constitute for future ages, together with the list you returned to me, the precious archives of a society which will be all the more secret in that it will leave perhaps no traces other than these two important pieces and the magnificent diploma that you have engraved.[45]

In addition, possibly at Bracquemond's request, Solon transcribed a short sonnet for the group. This poem captures the humorous atmosphere prevailing at meetings of the society. It also suggests that the group was devoted not only to the pleasures of Japan but to the way in which Japanese art could aid it in its own work. The sonnet reads:

Jing-lar is a liqueur
Fit to skim molten bronzes;
It exalts, in Paris, the heart
And the precious art of eight bronzes.

The Bouddhas, 'neath the giant pines,
In the blooms of the magic lotus,
Adored it — their wide-eyed gazes
To fill with a lethargic dream
Hail! wine of the mysterious ones
Through you our deliriums are illuminated
Master of brushes and of lyres.

You come from glorious Japan
Evoking new usages
To be sung by Sages.[46]

The mixing of food and the appreciation of the Orient firmly established the atmosphere of this

private club devoted to understanding Japanese art. An early example of their use of Japonisme is found in Bracquemond's commission to produce a ceramic service, for sale in Paris, for the firm of E. Rousseau.

Prints by Members of the Société du Jing-lar

The Jing-lar gathering instilled in members a continuing preoccupation with Japan which was translated by each individual into a study of the art objects he possessed. Without doubt, Bracquemond was committed to using Japanese motifs, as his preparatory etchings served as guidelines for the Rousseau service. It is not fair, however, to overlook prints by Jules Jacquemart, some of which were completed earlier than those by Bracquemond, which illustrated Japanese objects. Burty, whose writings supported Japan and whose art collection and library were substantial resources, also did a number of prints which reveal his personal taste for Japanese art. All these prints reveal a surprising number of images demonstrating how members of this group examined Japanese objects by 1874, the date of the first Impressionist exhibition.[47] In studying these images one can better understand the taste for Japonisme.

The etchings by Bracquemond show direct borrowings of Japanese motifs and the intimate connection being established between graphic art and decorative creations. The immediate success of the Rousseau service, which will be discussed else-

Figure 4c. *Carp.*

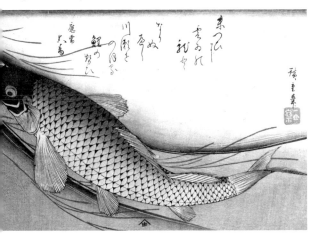

Figure 4d. *Trout.*

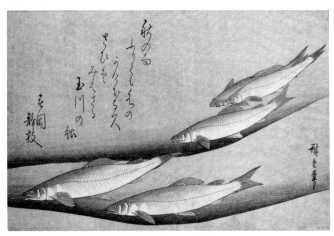

where, and its pioneering efforts in revitalizing ceramic decoration should not be lost in reconstructing the specific *ukiyo-e* albums and prints that Bracquemond used outside Hokusai's *Manga.* As noted earlier, Bracquemond etched a large series of preparatory studies which eventually served as transfer images for the ceramic decorator. This, in turn, led to the rarity of the prints for this service.[48] "The etchings from this series which have been found contain a wide range of animal and plant life including birds, lobsters, roosters, hens, ducks, many types of fish, butterflies and flowers. In each etching, however, the motifs have been arranged without any apparent order: in one print, for example, can be found a pheasant, a tiny group of fish and flowers."[49] In examining the preparatory etchings, one can note the emerging influence of other source books available to Bracquemond, although the random nature of each print is maintained. In fact, the white space around the forms creates an abstract effect as if the images were suspended from their natural habitat. In the prints, Bracquemond essentially relied upon four Japanese sources: Hokusai's *Manga,* which provided the largest share of motifs [5]; Hokusai's *Kwacho Gwafu* [12]; Hiroshige's animal prints (Figs. 4a,b,c,d), especially from his fish series; the *Kwacho Sansui Zushiki (Drawings of Flowers, Birds, and Landscapes)* [13a,b,c,d] by Isai (active 1821–80), an album published in five parts between 1847 and 1865; and the *Kwacho Gaden (Pictures of Flowers and Birds)* [14], published in two volumes circa 1849 and given to Hokusen (active 1820's to 1850's),

a pupil of Hokusai.[50] This last album provided some of the most striking sources for Bracquemond's borrowings.

The etchings functioned as an artist's notebook, or as study pages, since Bracquemond carefully numbered each print in the plate, demonstrating that he had selected the known plant and animal prints available to him in 1866–67. The etchings were also a storehouse where the ceramic decorator could turn for images to be freely placed on the surface of his earthenware plates. The Rousseau service uses almost all the motifs found in the prints, even if a plate was occasionally not colored because a design was too complicated.[51]

Among the preparatory prints is a large pheasant [20], situated with several other birds. When the pheasant was transferred to a large oval platter it created a successful image and a motif that was later borrowed by other ceramic decorators. The preparatory etching shows, however, that Bracquemond copied either from pages in the *Kwacho Gaden* [14a] or from two pages in the *Kwacho Gwafu,* where the same pheasant is found [12]. In both cases, Bracquemond eliminated surrounding foliage to concentrate on the bird. Curiously, an original drawing exists for the large pheasant which gives some indication of a ground line, but exactly when this was completed is not clear.[52] Other borrowings from the *Kwacho Gaden* exist [21], but, curiously, the majority of Bracquemond's selections seem to have come from one of the two albums [14b,c].[53]

The second unexamined source for Bracque-

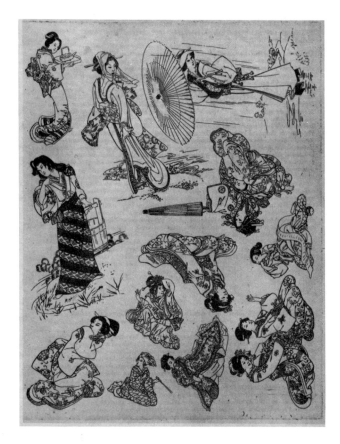

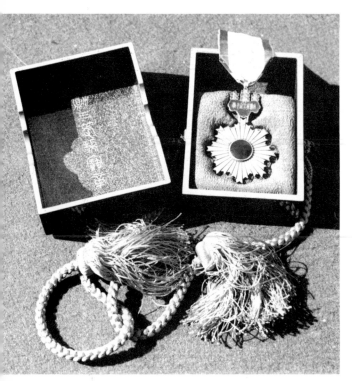

mond was the fish series by Hiroshige.[54] This group
of prints, also owned by Moreau, existed as large
single prints and demonstrates that Bracquemond
selected motifs from areas other than small albums
that he could place in a pocket. The large images
repeated in reverse in several preparatory etchings
emphasize a lobster or a carp in a stream [22, 23,
24]. The random selection of accompanying de-
tails, such as an eggplant or water lilies, also is
found in the same Hiroshige series (Figs. 4a,b,c,d).

Still another Japanese album, albeit smaller than
those discussed, served as a direct source. This was
the *Kwacho Sansui Zushiki* [13c,d], which pro-
vided a number of the smaller motifs found in sev-
eral preliminary etchings [25, 26]. One section of
this album was also in the possession of Moreau,
attesting to its availability to other decorative artists
of the period.

Thus, while the *Manga* [5c] of Hokusai did func-
tion as a basic starting point for Bracquemond [27],
his attention focused on a variety of albums from
which he could select a diverse range of animals
and plants. The fact that Bracquemond was the first
to examine systematically and catalogue such mo-
tifs in his prints increases the value of studying the
Rousseau preparatory etchings to grasp the range
of various Japanese sources available during the
1860's.[55]

The *ukiyo-e* albums not only affected other
artists, but also set the course that Bracquemond
was to follow throughout his career as a decorative
designer.[56] When he worked for Haviland and
Company during the 1870's, he prepared a large
series of prints for the *Service Parisien,* 1875–76
[28–29]. While these works mingle Impressionist
and Japanese sources, direct borrowings from Jap-
anese prints remain. However, the forms are assim-
ilated in the creation of decoration which captures
a sense of changing seasons similar to that in prints
by Hokusai or Hiroshige.[57] Here it was not neces-
sary to copy directly, as images—such as a wind-
swept marsh with bamboo—were now being
created that people could associate with Japan.

Other prints by Bracquemond, created from the
1850's into the 1880's, evoke Japonisme in various
ways. One print, *Treize grâces japonaises* (Fig. 5),
shows how the image of Japanese women, so popu-
lar with painters during the 1860's, entered the
realm of prints. The women seem as randomly
placed as the models for the Rousseau service or

pages from the *Manga*.[57a] Bracquemond's *Les Canards l'ont bien passée,* 1856 [30], with its use of the slanting pattern of rain, suggests that he had studied pages from the *Manga* where similar weather effects were found [5b]. In Bracquemond's *Vanneaux et Sarcelles* [31] one is thrust directly into a marsh where birds flutter in all directions. The close-up examination of these animals and the cutting of the plants and marsh-reeds by the border clearly suggest that Bracquemond was moving away from direct borrowing of Japanese motifs. He was attempting to use Japanese print concepts: a severing of forms by the edge of a composition and the intensified study of details by placement of forms near the foreground plane. Another etching, *Les Hirondelles* [32], while suggesting birds from the *ukiyo-e* prints, places them within a distinctly Impressionist landscape. The clear reference to Bracquemond's Japonisme dedication is the high vantage point, a bird's eye perspective, where one can examine the scene from a cosmic realm. This type of vantage point was common practice in many Japanese landscape prints.

Bracquemond's continued use of and inspiration from Japanese sources helped endear him to other members of the Jing-lar group. Jacquemart was first drawn into the circle of Japonisme when he did a series of etchings of oriental ceramics for his father's *Histoire de la Porcelaine* (1862). Jacquemart, like others of this early group, studied Chinese objects [33] and also illustrated Japanese cups, plates, and bowls [34-35]. Jacquemart's prints, extremely accurate in detail, record objects well known to connoisseurs of the Orient, porcelains which might have helped inspire French decorators in their designs. Another of Jacquemart's prints, *Le Supplicié Muamija-Hasime* [36], continued his accurate realism, especially since it was copied from a contemporary photograph. Produced when it was, at a time of revolution in Japan, this image was given wide attention in France and was published in *L'Illustration nouvelle*.[58] In this image, Jacquemart's interest in Japan was mixed with reporting.

The third member of the Société to do prints illustrating Japanese material was the art critic Philippe Burty. His images, produced circa 1870, are dispersed and hence are difficult to obtain. For the most part, Burty, like his colleagues, illustrated works in his possession, such as small objects [37a]

or wood netsuke [37b]. These prints, not widely disseminated, were given to friends as a sign of his serious dedication to Japonisme. They remain an intimate recording of the tastes of a major collector of Japanese art objects.[59] They also suggest that he looked at the pages from the *Manga* in the arrangement of his forms, since he left considerable negative areas in each print. Burty's collection, like his library, was easily accessible to his friends (Edgar Degas and Edmond de Goncourt, among others), and objects he owned were also etched by his friend Félix Buhot.[60] Because of Burty's support of Japan in France, he received a medal from the Japanese Legation in Paris (Fig. 6).

Essentially the prints by members of the Société du Jing-lar reflected exact copying or an illustration of objects owned. Only occasionally, as in the case of a few prints by Bracquemond, was there the movement toward assimilation of principles that attracted other printmakers like Manet or Whistler.

The Writings of the Jing-lars

Two of three early supporters of Japonisme in the Parisian press were members of this secret group. Both Burty, in his book *Les Emaux cloisonnés anciens et modernes* (1868) and in articles for *Le Rappel* (1869), and Zacharie Astruc, in articles for *L'Etendard* (1867–68), continually supported the value of Japanese art. They called on French artists to examine this art for their own uses.[61] The third art critic who strongly encouraged Japanese art was Ernest Chesneau in articles for *Le Constitutionnel* (1868–69) and in his pamphlet *L'Art Japonais* (1869), the latter among the first writings to analyze Japanese art according to principles of design and color.[62] Chesneau firmly believed that "... the authority of the principle of observation in Japanese art is that it renders with a remarkable aesthetic power and an inimitable perfection of design ..." and hoped this was not lost upon French artists.[63]

When Astruc, the defender and friend of Manet, spoke out on Japanese art appearing at the Exposition Universelle of 1867 and elsewhere, a similar effect must have been experienced among the avant-garde. Indeed, Astruc's article in *L'Etendard* entitled "Le Japon chez nous" gives a complete list (before Chesneau in 1878) of those artists, writers, and collectors affected by Japonisme:

Figure 7. *Arai, Picture of Boats Crossing the Sea Over a Distance of 1.5 ri (kaijô ichi-ri han funawatashi no zu)*, no. 32 from the *Fifty-three Stages Along the Tokaido Highway (Gyôsho Tôkaidô)*. Colored woodcut, 7-7/8 x 12-5/8 inches (20 x 32 cm.), 1841–42. Ando Hiroshige. Leiden, Rijksmuseum voor Volkenkunde.

... the gothic Tissot; ... Champfleury, with his extreme fondness for cats ... ; Solon, the prince of ceramics, ... Bracquemond, who is erecting a porcelaine temple in honor of his oriental masters; Fantin, amazed to find in them the Delacroix of his dreams; Burty, ardent admirer and scholar, indefatigable collector; the Goncourt brothers, downright connoisseurs; Manet, who is carried away by such a personality; ... and myself, the first in Paris (will this glory at least be mine? ...) who wanted to write about the grandeur and the exquisite character of their work.[64]

While Burty was able to coin the name for the movement, Japonisme (1872), Astruc, detecting its influence among his friends, first wrote on the value of Japanese art in 1868.[65] Thus, by 1872, there already existed a body of articles examining the new interest.

The Prints of Manet, Tissot, and Whistler

Although Edouard Manet is not recorded as a member of the Société du Jing-lar, he was sympathetic to Japanese art, as noted by Astruc in 1868, and, as recently demonstrated, he copied motifs from Hokusai's *Manga*.[66] The exact borrowings from the *Manga*, found in Manet's late drawings, underline his familiarity with some *ukiyo-e* albums used first during the 1860's.[67] Manet's *Les Chats*, circa 1869 [40], shows a knowledge of Champfleury's book on cats, as well as an examination of an occasional feline from the second volume of the *Manga* [5d] and from Hiroshige. The cats in Manet's print are not copies, but are inspired by the way in which Hiroshige, in his *Ukiyo Ryusai Gwafu* [40a], caught cats in different poses. A sketch-like arrangement present in Manet's image and emphasized by the varying sizes between his cats easily corresponds to Hiroshige's basic intention — to capture spontaneous poses. Manet's *Le Chat et les fleurs*, 1869 [41], continues the same theme and exhibits other Japanese-inspired qualities. By placing the cat and flower vase close to the picture plane, Manet thrusts his forms immediately at the viewer; similarly, the asymmetrically divided backplane and the cutting of objects by the edge of the print — in this case, by an actual picture frame — show that similar oriental concepts were being used by contemporary artists. At the right of the print, placed on metal supporters, is an orientally inspired ceramic. A large crane flies over a wave-like pattern, suggestive of Japonisme ceramics then being produced by compatriots of Manet.[68]

The best-known of Manet's prints using a cat theme is his lithograph for Champfleury's *Le Rendez-vous des Chats*, 1868–70 [39].[69] A second version of this image appeared as a poster advertising the volume and was also reprinted in newspapers of the day. It uses silhouette images, with no solidity or shading to their form, and is inspired by patterned, flat shapes found in *ukiyo-e* prints. These simple forms, almost like cut-paper shapes, antici-

pate "Le Chat Noir" illustrations of the 1890's.[70]

Other Manet prints are suggestive of Japanese prototypes: *Marine* [38] is reminiscent of similar subjects by Hiroshige, for example, in Figure 7 [16]; and *Line in front of a Butcher Shop,* 1870 [42], with its high vantage point and the schematic rendering of umbrellas which hide the figures beneath them, is similar to pictures of groups holding umbrellas in the *Manga* [5a]. A late illustration for Manet's work on *L'Après-midi d'un faun* [43] has the same type of *bas-de-page* illustration as his late letters, where he again seems to borrow from Hokusai [5e]. This image completes the cycle of Manet's Japonisme, a tendency which led him to attempt to assimilate concepts, as he did in his paintings, rather than to copy directly.

James Tissot, although having strong ties with Victorian London, was active in France during the 1860's exhibiting Japonisme paintings at the Salon (1869).[71] He also developed an early interest in printmaking.[72] Tissot was an avid admirer of Japanese art as recorded by Astruc in 1868.[73] His prints submerge direct borrowings from Japanese prints in the creation of a lush romantic-symbolist atmosphere. The first print by Tissot that suggests Japonisme elements is *Matinée de printemps,* circa 1875 [44], where a single, well-dressed woman is silhouetted against a background plane in a way similar to the situation of women or actors in some *ukiyo-e* prints. Among other prints by Tissot of contemporary subjects [45] the fragmentary appearance of a scene and the placement of forms at odd angles reveal that Tissot could have assimilated these principles from the work of his friends, photography, or Japanese prints.[74] The languorous impression evoked by Tissot's women, for example, in *Soirée d'Été,* 1881 [46], might be due to studying graceful poses of Japanese women as well as to photographic snapshots then coming into vogue. While Tissot's Japonisme is not as specific as that of other printmakers, his study of different Japanese prints—e.g. Haronobu and Utamaro—is apparent.

One of the most difficult printmakers to discuss in terms of the impact of Japan is James McNeill Whistler. His contacts with *La Porte Chinoise* are documentable, especially in his letters to Fantin-Latour, where he talks of the shop after April, 1864.[75] Exactly what he purchased, or what types of Japanese prints he saw, remains to be fully ascertained. Art historians disagree over an exact date

when the impact of Japan can be seen in his paintings, some seeing it early in his career[76] and others documenting this interest with *The Lange Lijzen of the Six Marks,* 1864 [185].[77] His prints were exhibited in Paris in the 1860's. They were noted by Burty in a review for *Gazette des Beaux-Arts,* establishing Whistler's familiarity with the circle of printmakers involved with Japonisme. Whistler's prints from the 1870's, notably *Old Battersea Bridge* [48], *Old Putney Bridge* [49], or *The Little Putney* [50], are related to bridge compositions by Hiroshige in Figure 8 [17]. The motif of the bridge, however, is only the first level of Japanese inspiration, as other *ukiyo-e* elements should be sought. Whistler's Japonisme was "an interlude of crisis" marking many of his paintings during the 1860's; it is similarly found in his prints, works he valued highly enough to propose them for exhibition at the Paris Salons of 1861 and 1864.[78]

Whistler's bridge prints should be seen as part of a series, each separate composition existing in several states as the artist made subtle changes in shading and compositional harmony. By repeating the image of a bridge in varied compositions, Whistler reinforced his observation of "a bridge motif" in Japanese prints. *Old Battersea Bridge* [48] has numerous people walking across, similar to the sketchy figures traversing many Japanese bridges (Fig. 8). Some river traffic — an occasional sailboat — is shown beneath the bridge, recalling the junks floating beneath Japanese piers. However, Whistler saw his motif as a realistic structure with detailed timbers and did little to simplify or flatten the bridge. In this sense, he remained true to native Western realism.

In each river scene Whistler avoids a completely Western style by situating the bridge high in his composition. In two cases [48, 50] he did not use detailed foreground or background shapes, only casting a few shadows beneath the bridge, making it possible to read it, not only three-dimensionally, but as a two-dimensional motif placed high in the composition for essentially decorative purposes. Thus, there seems a built-in ambiguity in these prints, as there is in much of Whistler's painting, which prevents one from seeing the compositions as solely Western or only influenced by Japan.[79] The Japanese qualities are there, especially the broad negative areas which become flattened forms, the emphasis upon asymmetry, and the in-

Figure 8. *Clear Morning after a Snowfall at Nihonbashi Bridge (Nihonbashi yukibare no asa)* from *One Hundred Views of Famous Places of Edo (Edo meishô)*. Colored woodcut, 9-1/16 x 13-25/32 inches (23 x 35 cm.), 1847–48. Ando Hiroshige. Leiden, Rijksmuseum voor Volkenkunde.

Figure 9. *Courtesan Trimming a Lamp* from *Customs of the Passing Years (Hoshi-no-shimo tosei fuzoku)*. Colored woodcut, 15-1/4 x 10-1/2 inches (38.7 x 26.7 cm.), ca. 1815–20. Utagawa Kunisada. The Cleveland Museum of Art, Bequest of Edward L. Whittemore. 30.201

terest in opening up landscape space. This is counterbalanced by Whistler's sketch-like realism, showing he did not copy Japanese motifs directly, but tried, rather, to dissect motifs in several efforts devoted to one pictorial subject. He is, therefore, quite original in analyzing Japonisme motifs according to his own predilections, translating these suggestions into a purely personal idiom.

Two Impressionists React to Japonisme

The works of Edgar Degas and Camille Pissarro move us toward the impact of Japan upon the Impressionists, although both artists had many ties with the Parisian art world of the 1860's. Degas was also actively engaged in collecting Japanese prints. He first began purchasing examples at *La Porte Chinoise* and eventually amassed a cabinet which included works by Sukenobu, Utamaro, and Kiyonaga.[80] Degas hung a print of Kiyonaga's *Bath House* (now in the Boston Museum of Fine Arts) over his bed, attesting to the value he placed on this image.[81] Degas' friendships with Burty and Théodore Duret, another avowed Japoniste, gave him ample opportunity for discussing Japanese art and for see-

ing numerous examples in other collections. Prints at the Bibliothèque Nationale, which Burty noted in 1885 as being rich in Japanese holdings, were augmented in 1899 when Duret gave 1,350 Japanese albums to the Cabinet des Estampes.[82] Degas had probably seen these albums, but the placement in the official library of Paris gave them added esteem. With all these sources available for Degas' examination of Japanese prints, it still remains difficult to assign an exact date when the impact of Japanese art can be detected in his work. Perhaps his painting of *Woman with Chrysanthemums* (Metropolitan Museum, New York), 1865, where the figure is placed asymmetrically, can be seen as the starting point for Degas' Japonisme.[83] Degas' prints, which were not prolifically produced until the 1870's, show 1875 as the approximate date for his use of Japanese devices.

Degas' *Aux Ambassadeurs*, 1875 [52], places two performers on stage with props cutting the scene at the right. The curtain also seems about to descend, further creating an irregular design. This device of placing a partition within a composition was common to Japanese prints, an example being Kunisada's *Courtesan Trimming a Lamp* (Fig. 9), where a

screen severs the foreground plane. Degas' treatment of other cafe-concert subjects [53] revealed his ability to situate compositions obliquely while searching for the essential gestures of his figures. A similar partitioning appears in his *At the Louvre* [54], where Mary Cassatt, strolling through picture galleries, is seen disappearing behind a wall. The uptilting of the floor and the geometrical division of the rear wall suggest other Japanese devices used by Degas. These early efforts, however, only begin to show Degas' debt to *ukiyo-e* prints.

Aside from using compositional devices, Degas was an astute student of Hokusai's *Manga*. Different volumes led him to observe his own world more sharply, capturing the most revealing movement and unusual body placement either in a dance-class or in women at their toilette. Since Degas was a realist who sought the essence of reality behind the superficial facade of daily existence, it was possible for him to appreciate Hokusai's similar quest. Other Japanese printmakers, who were devoted to women, helped reinforce his interest in feminine rituals, especially the printmaker Sukenobu, whose *Cent femmes de différentes classes* (Fig. 10) Degas probably owned.[84] But, it is Degas' debt to Hokusai

which is worth examining further, as Taichiro Kobayashi has written:

> It is clear that Hokusai and Degas are never satisfied with ordinary things or conventional visions. They seek out eagerly the bizarre and the unusual which are concealed in the underside of superficial reality. They scour this reality from every angle ceaselessly in their search for the unusual and the unexpected, because they believe, perhaps, that the essence of reality must be extremely bizarre and extraordinary.[85]

Degas' *Leaving the Bath*, 1882 [55], can be seen as at the beginning of a series and, like the *ukiyo-e* prints, emphasized one aspect of feminine ritual. In lithographs of the 1880's and later that are devoted to this subject, echoes of various Japanese masters are found. Degas most likely was dedicated to the image of women with long, trailing hair, prevalent throughout the Art Nouveau period, after seeing similar motifs in prints by, for example, Kunisada (Fig. 11). The theme of having a servant assist either in combing the hair or at the morning toilette was also found in works by Utamaro [18] and Sukenobu and was revised by Degas [56, 57, 58]. Whatever the specific source Degas used, he had ample

Figure 12. *Pontoon Bridge at Sano, Province of Kozuke* from *Picturesque Views of Famous Bridges in Several Provinces.*
Colored woodcut, 10 x 14-7/8 inches (25.4 x 37.8 cm.), ca. 1820. Katsushika Hokusai.
The Cleveland Museum of Art, Bequest of James Parmelee. 40.1001

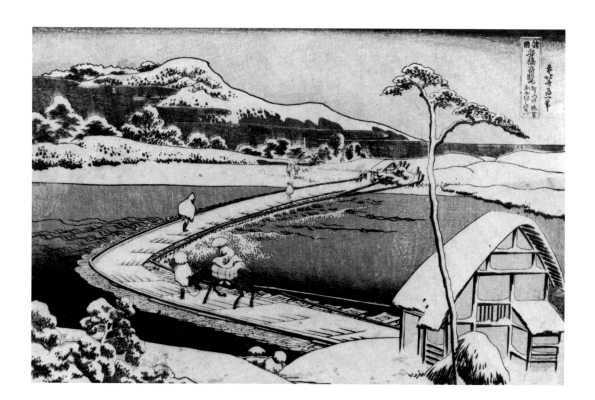

models to draw from. In the process, he moved further than other printmakers in attempting to grasp the essence of Japanese prints. These frequently sought the unusual behind a surface reality, and Degas translated this quality into a personal quest for ritualistic gestures and movements.

Camille Pissarro, a key member of the Impressionists, used Japanese prints in another way. Aware of Japonisme through contacts with Degas and others, Pissarro studied the landscapes of Hiroshige, whose broad vistas and high vantage points, often with Mt. Fujiyama in the distance, affected his own landscapes of the 1870's.[86] *Twilight with Haystacks,* 1879 [59], is an example of this effect whereby a winding road with two figures sweeps far into the distance. The angle of vision is high, a type of bird's-eye perspective, so that one looks down at the haystacks and up at the distant horizon. Pissarro was also interested in different times of the year, a quality inherent in Impressionism, and was probably assisted in depicting the same scene in winter or summer by *ukiyo-e* prints created as a remembrance of a particular region or road in Japan (Fig. 12). While Pissarro's debt to Japanese prints is not as extensive as Degas', he shared with other Impressionists, particularly Monet, a

fondness for oblique angles, broad vistas, high vantage points, and changing climates — a tendency which led him to study Hiroshige.

The Debt of Early Printmakers to Japan

Each of the early printmakers, many of whom lived into the twentieth century, shows a diverse involvement with Japonisme. Few printmakers selected the same type of *ukiyo-e* print to study, and therefore each artist must be studied individually if a proper picture of the Japanese impact and its sources is to be presented. Since these artists remained active throughout the entire period of intensive Japanese influence, their presence, and their own work, continued to affect younger creators. The significance of Japonisme to these first initiates was that it had a self-renewing quality which gave it fresh impetus for each creator and did not lead to sterility. No matter how often, or how many, studied Hokusai's *Manga,* for example, fresh and stimulating insights could always be found. The wide range of potential *ukiyo-e* choices, and the great collections of Japanese art prepared at an early date in France, made study of this new art easier during the period 1854–82.

14

1. This remark is noted by Philippe Burty, "Japonisme III," *La Renaissance littéraire et artistique*, 1872, p. 83. Burty was upset by the comment, since he still believed he had to make people understand the value of Japanese art and culture. The exact source of this disparagement still must be located, although Champfleury, in "La Mode des Japoniaiseries, "*La Vie Parisienne*, 1868–69, had satirically poked fun at the new cult. Burty is credited with first using the term "Japonisme" in a review in 1872 and, hence, providing a movement with an identifiable name. He used Japonisme to mean a study of the history, culture, and art of Japan without drawing any further distinctions from the phenomenon he saw taking place in France. The literature on Japonisme is detailed and should include, for a general introduction, Ernest Chesneau, "Le Japon a Paris," *Gazette des Beaux-Arts, XVIII* (1878), 385–97; Louis Gonse, "L'Art Japonais et son influence sur le gout européen," *Revue des arts décoratifs* (Paris, 1898); Ernst Scheyer, "Far Eastern Art and French Impressionism, "*The Art Quarterly*, no. 6 (1943), pp. 116–43; Leopold Reidemeister, *Der Japonismus in der Malerei und Graphik des 19 Jahrunderts* (Berlin, 1965); Exposition Universelle d'Osaka 1970; *Rencontres Franco-Japonaises* (Catalogue de la collection historique réunie sur les rapports de la France et du Japon du XVIIème au XXème siècle, Paris-Osaka, 1970); and *World Cultures and Modern Art* (catalogue of the encounter of the nineteenth-and twentieth-century European art and music with Asia, Africa, Oceania, Afro- and Indo-America, Exhibition on the occasion of the Games of the XXth Olympiad (Munich, June 16–September 30, 1972). Japonisme continues to attract comment but some current articles often fail to present new material and to misinterpret recent discoveries. For reference, see Charlotte van Rappard-Boon, "Japonism: The First Years, 1856–1876," in *Liber Amicorum, Karel G. Boon* (Amsterdam, 1974), pp. 110–17. The author expresses gratitude for assistance given in the preparation of this article to Jean Adhémar, Conservateur en Chef, Cabinet des Estampes, Paris; Willem van Gulik, Curator of Japanese Art, Rijksmuseum voor Volkenkunde, Leiden, Holland; Money Hickman, Assistant Researcher, Asiatic Art Department, The Boston Museum of Fine Arts; Donald Jenkins, formerly Curator, Department of Oriental Art, The Art Institute of Chicago; Jean d'Albis, Haviland and Company, Limoges; the staff of the Library of the Victoria and Albert Museum, London; the heirs of Camille Moreau and Etienne Moreau-Nélaton, for permission to use material pertaining to their family; and Yvonne M. L. Weisberg for her devoted assistance in this complex project.

2. Philippe Burty saw the development of Japonisme as closely interwined with French romanticism; see his *Les Emaux cloisonnés anciens et modernes* (Paris, 1868). Other early writers on this subject, such as Zacharie Astruc in *L'Etendard* (1867 and 1868), also saw romantic qualities in an appreciation of Japanese art and culture.

3. *Le Bon Marché,* Rue du Bac, and other locations in Paris sold Japanese print albums at extremely low prices in 1880. Several albums owned by Camille Moreau (1840–1897) were purchased at this shop. The availability of Japanese print albums, not always of first-rate aesthetic quality, in large Parisian department stores as well as at *curiosité* shops should be the subject of further detailed examination. Obviously, Somm's print (Fig. la) was humorously commenting on this phenomenon.

4. Some art historians see the decorative and "fantastic" qualities associated with the cult of Japan as possibly less deserving of study than those works using pure Japonisme. This differentiation seems somewhat artificial and certainly not developed with a clear understanding of decorative art (i.e., ceramics, furniture, glass, etc.). See Mark Roskill, *Van Gogh, Gauguin and the Impressionist Circle* (New York, 1970), pp. 57ff. for a comparison of the terms "Japonaiserie" and "Japonisme." While the term Japoniaiserie was used by Champfleury in his article on "La Mode des Japoniaiseries," the author has been unable to trace the evolution of Japonaiserie beyond the references cited by Roskill (p. 254) which link it to the 1870's. Because of this, Japonisme, a far simpler term to grasp and one based on a compassionate understanding of the movement, has been used. It was known to artists and critics in all the arts without any sense of disparagement. For a discussion of early Japonisme in the decorative arts, see Gabriel P. Weisberg, "Japonisme in French Ceramic Decoration. Part I: The Pieces for E. Rousseau, Paris," *The Connoisseur, CLXXXIII* (July 1973), 210–13. Japonisme imagery was found in textiles and wallpaper designs by 1890. For a discussion and reprinting of Champfleury's writings on the Japanese influence, see Champfleury, *Le Réalisme* (Textes choisis et présentés par Geneviève et Jean Lacambre, Paris, 1973), pp. 140–45.

5. The problem of the mass appeal for goods in the Japonisme mode still must be carefully considered. Many artists did merchandise their goods since there was a ready market eager for images that were *au courant*. Other artists seriously analyzed Japanese art and absorbed concepts into their own style. Both aspects of Japonisme are closely intertwined.

6. Trade connections with the Far East were established shortly after 1850 by some French art dealers in Paris such as Decelle at *L'Empire Chinois*, on Rue Vivienne, or, later, Desoye, who supposedly travelled to Japan. Early trips to Japan, which stimulated the acquisition of art objects, were undertaken by Théodore Duret and Henri Cernuschi (1871) and S. Bing (1875). It would be useful to locate records on these "missions," which could have been supported by official channels. Théodore Duret did become an avowed supporter of Japanese art and his collection of *ukiyo-e* prints and albums was given to the Bibliothèque Nationale in 1900. See Théodore Duret, *Livres et albums illustrés du Japon réunis et catalogués* (Paris, 1900). Bing's interest in Japanese art was championed by his merchandising of objects, his publication of *Artistic Japan* (1888–1891), and his own private collection. For further information, see Gabriel P. Weisberg, "Samuel Bing: Patron of Art Nouveau," *The Connoisseur, CLXXII* (October 1969), 119-125; *CLXXII* (December 1969), 294-299; and *CLXXIII* (January 1970), 61-68.

7. Charles R. Spencer, *The Aesthetic Movement, 1869–1890* (London, 1973).

8. The appearance of source books on Japan is discussed in John Sandberg, "The Discovery of Japanese prints in the nineteenth century before 1867," *Gazette des Beaux-Arts* (June, 1968), 295–302. For a listing of the books in Burty's library pertaining to Japan, see *Collection Ph. Burty, Catalogue de peintures et d'estampes japonaises, de kakémonos, de miniatures indo-persanes et de livres relatifs à l'Orient et au Japon* (Paris, March 16–20, 1891).

9. This book is found in the library of the Victoria and Albert Museum, London.

10. These books were widely available and collected in Paris, as they were studied by Léon de Rosny, who taught the Japanese language at the Collège de France. Rosny was a close friend of Burty's and the art critic possessed all his books. See *Collection Ph. Burty* nos. 1114, 1112, 1113, 1122, 1139, and 1109. Von Siebold was a surgeon who worked for the Dutch East India Company in Japan. While there, and through the assistance of a Japanese artist, he made studies of the country and collected

Japanese art which he brought back to Holland. His ethno-
graphic collection, compiled between 1823 and 1829, was
available at an early date to visitors who came to Leiden. The
volumes he began to publish in 1831, while never completed
because of lack of funds, were studied in other countries. For
further information, see *Guide to the National Museum of
Ethnology* (Leiden, 1962), pp. 1–6, 124–25.

11. Charlevoix wrote: "Les productions de la Mer ne fournis-
sent pas moins à la subsistence de nos insulaires que les fruits
de la Terre, si on en excepte le Ris. . . . Les côtes de la Mer
abondent en toutes sortes de Plantes marines, de Poissons,
d'Ecrevisses et de Coquillages, et il n'y en a presque point,
qu'on ne puisse manger. Il y en a même quelques-uns, qui
sont exquis, et qui font honneur sur les meilleures tables."
Charlevoix also commented upon the birds of Japan. See Père
de Charlevoix, *Histoire et Description générale du Japon, VIII*
(Paris, 1736), 86–132.

12. This is mentioned in a letter from Willem van Gulik to Mr.
Jack Hillier, September 20, 1974 (Museum voor Volkenkunde,
Leiden, archives). Van Gulik wrote: "Although most of the lith-
ograph illustrations in his (Von Siebold's) work are based on
the paintings by Keiga, there are several instances where the
lithos are clearly based on illustrations for the Hokusai *Manga*."

13. Discussions with Willem van Gulik, Leiden, August, 1974.
See also *Guide to the National Museum of Ethnology*, p. 2.

14. Other collections also were available in The Hague, in-
cluding those of J. Cock Blomhoff and J. F. Overmeer Fischer.
They contained Japanese prints now housed, as well, in Leiden.

15. These "Guest-Books" are in existence, but the author was
unable to consult them. Mr. Van Gulik is in the process of try-
ing to locate them at the time of the completion of this cata-
logue. They could contain valuable information as to the speci-
fic individuals who visited the Von Siebold collection at an
early date. The Goncourts travelled to the Siebold Museum in
1861 and saw the collection, as noted in their *Journal* for
September 4, 1861.

16. See Louis Gonse, *L'Art Japonais, II* (Paris, 1883), 339. Gonse
mentioned the collections housed in the Leiden Academy
which, between 1857 and 1870, had become an Institute con-
cerned with China and Japan.

17. See *Guide to the National Museum of Ethnology*, pp.1–6.

18. See Jacques de Caso, "1861: Hokusai rue Jacob," *The Bur-
lington Magazine, III* (September 1969), 562–63. See also Mar-
tin Eidelberg's new research on this subject.

19. See Rutherford Alcock, Esq., *Catalogue of Works of Indus-
try and Art, Sent from Japan, International Exhibition* (London,
1862). Paintings, lithochrome prints, textile fabrics, paper sam-
ples, fabrics, silks, porcelain, lacquer work, and bronzes were
among those examples selected and classified by Alcock in his
catalogue for the exposition. Japanese prints could have been
shown, although no specific mention is made of artists. Since
Eugène Rousseau, among the first to support Japanese art in
France, exhibited at this exposition, he could have seen the
Japanese objects.

20. See Gabriel P. Weisberg, "Félix Bracquemond and Japan-
ese Influence in Ceramic Decoration," *The Art Bulletin, LI*
(September 1969), 277–80. The date of 1856, when Bracque-
mond could have found the *Manga*, probably cannot be sub-
stantiated through contemporary nineteenth-century evi-
dence. For further discussions on this problem, see De Caso
and L. Bénédite, "Félix Bracquemond l'Animalier," *Art et
Décoration, XVII* (February 1905), 35–47.

21. De Caso, p. 562. It is possible that some Japanese prints
entered France as packing materials for other objects, although
which examples probably will never be known.

22. The examination of Hokusai as the best known of Japan-
ese printmakers can be traced to Théodore Duret, *L'Art Japo-
nais*, 1882. Other critics, notably Ernest Renan, also extolled
the values of Hokusai. See Ernest Renan, "Hokusai's Manga,"
Artistic Japan, IX (1889), 99ff.

23. The documentation of certain albums as belonging to Félix
Bracquemond and secured at *La Porte Chinoise*, a major curio
shop, can now only be substantiated by the word of a family
relative. These albums, formerly in the collection of Mme.
Henriod Bracquemond, should be relocated so that a detailed
examination of them can continue. For reproduction of some
pages from these albums, see Gabriel P. Weisberg, "Félix Brac-
quemond and Japonisme," *The Art Quarterly, XXXII* (Spring
1969), 56–68.

24. Burty mentions securing albums on the rue de Rivoli. See
Philippe Burty, "Japonisme II," *La Renaissance littéraire et ar-
tistique, V* (1872), 60. This seems to be a reference to the shop
owned by Mme. Desoye. Burty also commented upon shops
selling Japanese objects in his novel *Grave Imprudence* (1882).
See Zacharie Astruc, "Beaux-Arts, L'Empire du Soleil Levant,"
l'Etendard, February 27 and March 23, 1867, for a brief men-
tion of the shops selling Japanese art works. See also Edmond
Duranty, "L'Extrême Orient à l'Exposition Universelle," *Ga-
zette des Beaux-Arts, XVIII* (1878).

25. This constant reiteration of the shop of *La Porte Chinoise*
with the Desoyes is cited in almost all of the literature exam-
ining the Japanese influence during the 1860's. See William
Leonard Schwartz, "The Priority of the Goncourts' Discovery
of Japanese Art," *Publications of the Modern Language Associ-
ation of America, XLII* (1927), 798–806; John Rewald, *The His-
tory of Impressionism* (New York, 1973), pp. 207–8; De Caso,
p. 562, and many others. The first to point out the error of
associating these names with one another was Geneviève Alle-
mand (Lacambre) in "Le Rôle du Japon dans l'évolution de
l'habitation et de son décor en France dans la seconde moitié
du *XIXè* siècle et au début du *XXè* siècle" (unpublished the-
sis, Ecole du Louvre, December 1964).

26. See *Didot-Bottin Annuaire — Almanach du Commerce et
de l'industrie . . .* (Paris, 1862), p. 227, for the notice of Mme.
Desoye, propriétaire, Oudinet 14. Whether this shop sold
curiosités remains to be established. See also *Didot-Bottin*,
1863, pp. 235 and 768, where E. Desoye is listed as selling
curiosités at 220 Rue de Rivoli. For further reference to De-
soye, see *Archives de Paris*, DP4, C959, Rue de Rivoli, no. 220
(Cadastre, 1862). Two other dealers are also cited in the
Didot-Bottin (1863): Bouillette (at *la Porte Chinoise*) and E.
Decelle (at *l'Empire Chinois*).

27. *Didot-Bottin*. Actually, a shop owned by a J. G. Houssaye
existed at 36 rue Vivienne in the 1850's and sold objects from
China and India. See *Didot-Bottin*, 1851, p. 251. Artists of the
period could have mixed the name Houssaye (the former own-
er of *La Porte Chinoise*) with Desoye to arrive at the incorrect
information reiterated by art historians since the nineteenth
century. See also Allemand, p. 81. The starting date for Bouil-
lette's management is probably in 1857. See *Archives de Paris*,
Carton 1224, C1225, DP4, Rue Vivienne no. 36 (Cadastre, 1862).

28. Decelle's shop seems equally as important as the others
since it was in existence for a long time. See *Didot-Bottin*,
1862, p. 210, for the address of Decelle as 55 Rue Vivienne, an
address sometimes given to *La Porte Chinoise*. Decelle's shop
was still in existence in 1876 when it was listed under the new

Bottin heading "Chinoiseries et Japonneries" along with Bouillette (La Porte Chinoise) and many others. The first time this new heading was used was in 1869. See Allemand, p. 86. Apparently Decelle had a shop at 55 Rue Vivienne in 1856, as confirmed by examining records for this address. See Archives de Paris, DP4, C1224, 1856, Rue Vivienne no. 55.

29. These albums are among the most important to come to light, since they are owned by relatives of Camille Moreau and their authenticity cannot be questioned. The albums are essentially animal and bird studies by numerous printmakers, which were secured at many places in Paris. All are signed by Moreau and some are dated, establishing when she first had them in her collection. Importantly, the prints might have entered Paris as packing, but many were obviously sold in curio shops—as these albums prove. The author is preparing an article on them.

30. See Didot-Bottin, 1869, p. 795, for the listing of shops selling "Chinoiserie et Japonnerie" objects. Allemand notes that the number of stores increased following the Fair of 1867 (p. 86).

31. This collection was widely written about by critics in 1869. See Philippe Burty, "Le Musée Oriental à l'Union centrale," Le Rappel, October 25 and November 2, 1869. See also Exposition des Beaux-Arts appliqués à l'industrie, Guide du Visiteur du Musée Oriental (Paris, 1869). A Japanese print exhibition numbering 100 pieces was held in 1867 in Paris, and a catalogue published. Unfortunately, this catalogue cannot be located. Colta Ives, in The Great Wave: The Influence of Japanese Woodcuts on French Prints (New York, 1974), p. 11, cites among the printmakers represented at this exhibition Sadahide and Hiroshige III. They were the leading printmakers of the time but were weaker than Hokusai or Hiroshige. Since Sadahide and other printmakers were collected by Camille Moreau, an interest in late representatives of the ukiyo-e tradition is correctly assumed. Geneviève Allemand has noted that the print exhibition of 1867 was largely arranged ethnographically, revealing Japanese life to Parisians.

32. See Le Japon à l'Exposition Universelle de 1878 (Paris, 1878) for a general listing of objects. See also Philippe Burty, "Exposition Universelle de 1878, Le Japon Ancien et le Japon Moderne," L'Art, XV (1878), 241ff., with illustrations of objects owned by Burty. This exhibition should be more deeply studied for the availability of objects.

33. On the basis of existing albums and those attributed to the possession of Félix Bracquemond by Mme. Henriod Bracquemond, these characteristics were developed.

34. The mark of the Moreau family is found on the majority of the forty-three print albums examined by the author in Paris, Summer 1974. Adolphe Moreau might have obtained these prints even before his wife Camille signed the albums.

35. These marks are varied, but most contain the name and address where the albums were purchased, such as Decelle, 53 Rue Vivienne, or Compagnie Coloniale, 62 Rue du Bac. Occasionally, the price paid for an album, especially those purchased at the Bon Marché, is found on the album cover. The 53 Rue Vivienne address for Decelle was used after 1875.

36. The influence of Bracquemond on other artists is suggested in Gabriel P. Weisberg, "Japonisme in French Ceramic Decoration," The Connoisseur, CLXXIII (July 1973), 210–13; CLXXXIV (October 1973), 125–31. See also Etienne Moreau Nélaton, Camille Moreau (Paris, 1898), for a discussion of Camille Moreau's interest in Bracquemond's 1866–67 service.

37. See Léon de Rosny, "Botanique du Nippon, aperçu de quelques ouvrages japonais relatifs à l'étude des plantes,"

Mémoires de l'Athénée Oriental (Paris, 1871–72), pp.123–32. This album was purchased by Camille Moreau at Decelle, à l'Empire Chinois, 53 Rue Vivienne.

38. These albums were identified with the assistance of Willem van Gulik, Curator of Japanese Art, Museum voor Volkenkunde, Leiden, Summer 1974.

39. Jean Paul Bouillon, the leading French expert on Félix Bracquemond, in discussions with the author, Summer 1974, reiterated the difficulty of obtaining further detailed information on Bracquemond's Japonisme due to the disappearance of many key letters. See Jean Paul Bouillon, "La Correspondance de Félix Bracquemond, une source inédite pour l'histoire de l'art français dans la seconde moitié du XIXè siècle," Gazette des Beaux-Arts, December 1973, pp. 351–86 and specifically no. 3, p. 354. Another early source for Japanese print albums was Raoul Duseigneur, father of the printmaker Georges Duseigneur (1841–1906). His print albums, probably collected between 1840 and 1860, appeared in Lyon where Raoul Duseigneur was in the silk industry. These albums, which the author examined in Paris, Summer 1974, contained several volumes from Hokusai's Manga. The connection between Paris and Lyon awaits further clarification in the dissemination of Japanese albums. See Bibliothèque Nationale, L'Estampe Impressionniste, (catalogue by Michel Melot, Conservateur au Cabinet des Estampes, Paris, 1974), p. 16, and the entire section on Le Japonisme, pp. 4ff.

40. The album is clearly signed and dated on the back page. The identification of this album was supplied by Willem van Gulik, Leiden. The relationship between Kyosai and Manet is suggested by Ives, p. 31, although documentary evidence of Manet's knowledge of albums by this artist is not established.

41. For further information on Burty's collection of Japanese prints, see Collection Ph. Burty. Burty possessed prints by all of the major artists of the ukiyo-e tradition.

41a. Weisberg, "Félix Bracquemond and Japanese Influence in Ceramic Decoration," p. 280. See Papiers Bracquemond, Tome 3, N.A. Fr. no. 14 676, ref. 424–425, n. d., for a discussion of the formation of the Société. This document has been listed by Bouillon as numbers 915–16 in his article on this material.

42. Papiers Bracquemond, Tome 3, N.A. Fr. no. 14 676, ref. 421 n. d., noted by Bouillon as number 912. Ives has named Carolus Duran as a member of the Jing-lar group (p. 21, n. 4). No documentation has been made to substantiate this claim. In French this is: ". . . Jing-lar sans Jing-lar il n'en serais pas d'avantage sans Bracquemond."

43. Papiers Bracquemond, Tome 3, N.A. Fr. no. 14 676, ref. 424. In French this is: A Gauche! Jacquemart m'écrit—Le Jing-lar triomphe et notre cher Bracquemond a sa médaille. Je confonds dans les félicitations bien sincères que je vous adresse et l'artiste que tous aiment, et le jury qui a su l'apprécier et le Jing-lar qui a bien le droit d'être fier au succès d'un de ses membres.

44. For a discussion of the print revival during the 1860's, see Janine Bailly Herzberg, L'Eau-forte de peintre au dix-neuvième siècle: La Société des Aquafortistes (1862–1867) (Paris, 1972). Almost all the members, including Alphonse Hirsch, were involved with prints.

45. Papiers Bracquemond, Tome 3, N.A. Fr. no. 14 676, ref. 424–425, noted by Bouillon as numbers 915–16. In French this is: . . . aussi je vous préviens que je vais la conserver précieusement et que je la charge de constituer, pour les siècles à venir, avec la liste que m'avez renvoyée les précieuses archives d'une société qui sera d'autant plus secrète qu'elle ne laissera

peut-être pas d'autres traces que ces deux pièces significatives et le magnifique diplôme que vous avez gravé.

46. *Ibid.* Chesneau discusses the sonnet in "Le Japon à Paris," *Gazette des Beaux-Arts,* 1878, p. 388, but attributes it to Astruc. Apparently Chesneau cited a play, *L'Ile de la Demoiselle,* which Astruc had written but which was never performed in a theatre. It is unusual to find Solon sending the complete sonnet to Bracquemond in a letter if he had no hand in preparing it. In French this is:

Le Jinglar est une liqueur
Faite pour écumer aux bronzes;
Elle exalte, à Paris, le coeur
Et l'art précieux de huit bonzes.

Les Bouddhas, sous les pins géants,
Dans les fleurs du lotus magique,
L'adoraient — leurs regards béants
Remplir d'un songe léthargique
Salut! vin des mystérieux
Par toi s'éclairent nos délires
Maître des pinceaux et des lyres.

Tu viens du Japon glorieux
Evoquant de nouveaux usages
Pour être chansé par des Sages.

47. Bracquemond, Burty, and Astruc were involved with the first Impressionist exhibition. Bracquemond hung prints and one drawing; Burty wrote articles for *La République française* and *The Academy* (England) which staunchly supported the new movement. Astruc, often overlooked as a contributor, exhibited water colors, including one of *Poupées japonaises.* See *L'Exposition de 1874 chez Nadar* (retrospective documentaire, catalogue by Hélène Adhémar and Sylvie Gache, Paris, 1974), for further information on this exhibition.

48. See Weisberg, "Félix Bracquemond and Japanese Influence in Ceramic Decoration," pp. 277–80. Several marks have come to light for the ceramic service suggesting that is was reissued several times after 1866–67.

49. *Ibid.*

50. Information on Hokusen was supplied by Donald Jenkins, former Curator of Oriental Art, The Art Institute of Chicago, in discussions with the author, Spring, 1974. The Art Institute of Chicago possesses both albums of the *Kwacho Gaden.* See Kenji Toda, *The Ryerson Collection of Japanese and Chinese Illustrated Books* (The Art Institute of Chicago, 1931), p. 281, for further information on the albums.

51. The author owns a plate from the service—an oval platter —which is uncolored, perhaps due to a complicated design taken from the *Manga.* It reveals the black outlining quite well.

52. These drawings were purchased by Laurens d'Albis from an art dealer in Paris. According to Jean Bouillon the drawings seem to have been completed after the service was fired; they could, however, be early studies for the etchings. For a reproduction of one of the drawings, see Gabriel P. Weisberg, "Aspects of Japonisme," *The Bulletin of The Cleveland Museum of Art, LXII* (April 1975).

53. The reliance on one volume over the other might be due to the unusual designs in the first volume. It is not possible that Bracquemond knew only one of the two volumes, as motifs for the Rousseau service are occasionally found in the second volume of the *Kwacho Gaden.* This album was not unknown to other Japonistes—Burty owned both volumes. See *Collection Ph. Burty,* p. 142, where the album was attributed to Hokusai.

54. These prints are well known and were available as single prints. The Boston Museum of Fine Arts possesses a large number from this series. See also Chuji Ikegamis, "Le Japonisme de Félix Bracquemond en 1866," *The Kenkyu* (Kobe University, 1969), pp. 30-62, for reference to Hiroshige.

55. By the 1870's books appeared in France which had reproduced motifs of animals and plants from the *ukiyo-e* albums. See Thomas W. Cutler, *A Grammar of Japanese Ornament and Design* (London, 1879).

56. Bracquemond is being studied as a decorative designer by Jean Paul Bouillon.

57. Weisberg, "Félix Bracquemond and Japanese Influence in Ceramic Decoration," p. 280.

57a. This print was reproduced for the first time in Bibliothèque Nationale, *L'Estampe Impressionniste,* p. 4, cat. no. 6. It was not described by Henri Béraldi, and hence attribution and date are open for further consideration. The images in this print were used in ceramics for Haviland and Company.

58. This print was reproduced December 1, 1868, with the title "Le Supplicié muamija-Hasime, assassin d'Européens devant le temple de Kamoukara (Japan)," May, 1867.

59. See *Collection Ph. Burty* for a further listing of objects. Burty gave his etchings to close friends such as Edmond de Goncourt.

60. Buhot etched this series of prints between 1875 and 1883. A well-known print from this series is a *Bronze crapaud,* an inkwell which Buhot completed in 1883. For further information, see Henri Béraldi, *Les Graveurs du dix-neuvième siècle,* IX, 27, nos. 11–20.

61. Astruc's articles are not well known and deserve further study, including his "Le Japon chez nous," *L'Etendard,* May 26, 1868.

62. For Chesneau's articles, see "Beaux-Arts, L'Art Japonais," *Le Constitutionnel,* January 14 and 22 and February 11, 1868. In these reviews Chesneau marvelled at the inventiveness of Japanese design, the striking effects in their work, and their excellent qualities of drawing as found in "Oksai" (*sic*).

63. Ernest Chesneau, "Beaux-Arts, L'Art Japonais," January 14, 1868. In French this is: ". . . l'autorité du principe d'observation dans l'art japonais, c'est qu'il rend avec une puissance esthétique remarquable, avec une perfection de dessin sans rivale"

64. Zacharie Astruc, "Le Japon chez nous," *L'Etendard,* May 26, 1868, p. 2. In French this is: . . . le gothique Tissot; . . . Champfleury, que sa passion pour les chats . . . Solon, le prince de la céramique, . . . — Bracquemond, qui élève un temple en faience à ses maîtres orientaux; — Fantin, étonné de retrouver en eux le Delacroix de ses rêves; Burty, admirateur passioné et savant, collectionneur infatigable; les de Goncourt, profond connaisseurs; — Manet, qu'une telle personalité transporte; . . . — et moi — même qui le premier à Paris (cette gloire me sera -t-elle au moins réservée? . . .) ai voulu écrire la grandeur et l'exquisité de leur production.

65. See Philippe Burty, "Japonisme I," *La Renaissance littéraire et artistique,* no. 4 (1872), pp. 25–26.

66. See Ann Coffin Hanson, review of *The Drawings of Edouard Manet* by Alain de Leiris, *Art Bulletin, LIII* (December 1971), 542–47.

67. *Ibid.* One has only to study Bracquemond's prints and ceramic designs to document this.

68. The ceramics of Laurent Bouvier, discussed elsewhere in this catalogue, were first produced in 1867–68. Bouvier was a

close friend of Fantin-Latour, Manet, and others using Japon-isme motifs in their work. An early example of a Bouvier ceramic employing Japonisme decoration is found in the collection of the Bethnal Green Museum, London.

69. The print appeared in *La Chronique illustrée*, Sunday, October 25, 1868. The volume by Champfleury also had designs in the margins taken from *ukiyo-e* albums.

70. This material is currently being assembled by Karen Smith as an M.A. thesis in art history for Case Western Reserve University. She has shown that members of the Chat-noir circle relied heavily on silhouette images.

71. The painting exhibited at the Salon of 1869, *Femmes regardant des objets japonais*, is now in a private collection in Ohio. Tissot did other Japonisme subjects which were commented upon by Henri Zerner, David S. Brooke, and Michael Wentworth in *James Jacques Joseph Tissot (1838–1902)* (retrospective exhibition catalogue, Rhode Island School of Design, 1968).

72. See J. J. Tissot, *Eaux–fortes, manière noire, pointe-sèches* (Paris, 1886). Tissot started etching in the 1860's.

73. Astruc, "Le Japon chez nous," p. 2.

74. See *James Jacques Joseph Tissot (1836–1902)* (retrospective exhibition catalogue, Rhode Island School of Design, 1968), for a brief discussion of some of these aspects.

75. See John Sandberg, "Japonisme and Whistler," *Burlington Magazine*, CVI (November 1964), 500, 503, note. 1.

76. Léonce Bénédite, "Whistler," *Gazette des Beaux-Arts, III* (June 1905), 142–58.

77. See Sandberg, "Japonisme and Whistler," p. 503.

78. Letter of James McNeill Whistler to Count Niewerkerke, February 3, 1864, asking for a delay in sending paintings and etchings to the Salon. See Archives du Louvre, X Salon 1864. See also letter of E. Delannoy, writing for Whistler, to Monsieur le Directeur Général des Musées Impériaux, April 13, 1861, asking to send his etchings later to the Salon (Archives du Louvre, X Salon 1861). While the Japanese effects appear in Whistler's prints from a later date, the fact that he was exposed to other French printmakers during the 1860's as well as to the interest in all things Japanese should not be discounted in formulating his Japonisme tendencies. His paintings throughout the 1860's manage to display strong Japanese qualities which he later used in his prints.

79. See Sandberg, "Japonisme and Whistler," who cites similar relationships with Whistler's paintings. For further reference, see Siegfried Wichmann, "Some Observations on the 'Bridge' as a motif in Far-Eastern and European painting during the nineteenth century" in *World Cultures and Modern Art*, pp. 104–6.

80. In 1918 the contents of Degas' studio were sold at auction at the Hôtel Drouot. The author has relied upon this sale catalogue to reconstruct, only partially, the prints in Degas' possession. The catalogue was incomplete in listing the Japanese prints and under one number (331) placed fourteen separate albums without providing clear documentation as to their content. Degas had prints by Kiyonaga, Sukenobu, Utamaro (two triptychs), Hiroshige (42 landscapes, the majority by this artist), Shunsho, Yeizan, Yeisho, Toyokuni, and Hokusai, among others. For further information, see *Catalogue des Estampes Anciennes et Modernes . . . Collection Edgar Degas*, 6 et 7 Novembre, 1918 (Paris, 1918). See also P. A. Lemoisne, *Degas et son oeuvre, I* (Paris, 1946), 176–80. Colta Ives, in *The Great Wave*, has incorrectly copied the prints available in the Degas

sale. She completely omitted any reference to Sukenobu as substantiated by the sale catalogue and Lemoisne.

81. Barbara A. Shapiro, *Edgar Degas: The Reluctant Impressionist* (Boston, 1974). Shapiro notes the Kiyonaga print is now in the Boston Museum collection. P. A. Lemoisne first noted Degas' placement of this print over his bed.

82. For further information on this collection, see Théodore Duret, *Livres et albums illustrés du Japon réunis et catalogués* (Paris, 1900). Degas could have seen Japanese prints in the collection of Alexis and Henri Rouart. Burty also had prints in his collection by Sukenobu, Kunisada, and Utamaro. See *Collection Ph. Burty*, pp. 49–50, 60–64, 75ff.

83. See Taichiro Kobayashi, "Hokusai et Degas sur la peinture Franco-Japonaise en France et au Japon," reprinted from *International Symposium on History of Eastern and Western Cultural Contacts*, compiled by the Japanese National Commission for UNESCO, November 1959, pp. 69–75. Information kindly supplied by Jean Adhémar.

84. The reference to Sikenobu *(sic)* is tentative, but in the sales catalogue the date of 1723 is given along with the reference to to two albums. See *Catalogue des Estampes Anciennes et Modernes* (Paris, 1918), no. 325. Burty had albums by Sukenobu in his collection.

85. Kobayashi, p. 73. The statement in French reads: On voit, Hokusai et Degas ne se contentent jamais de choses ordinaires ni de visions habituelles. Ils poursuivent acharnés le bizarre et l'étrange qui se cachent au revers de la réalité superficielle. Ils la fouillent en tous les sens sans cesse en quête de l'insolite et de l'inattendu, parce qu'ils croient, peut–être, que l'essence de la réalité doive être extrêment bizarre et extraordinaire.

86. This point has been examined by Barbara A. Shapiro in *Camille Pissarro: The Impressionist Printmaker* (Boston, 1973).

Catalog

Early Source Books on Japan: 1670–1854

Arnoldus Montanus.

1 *Atlas Japanensis, Being Remarkable Addresses by Way of Embassy from the East India Company of the United Provinces to the Emperor of Japan.*
Published London, 1670.
14-1/2 x 11 inches (36.8 x 27.9 cm.).
Detroit Public Library.

This represents the first book on Japan created under the auspices of the Dutch East India Company. Philippe Burty probably had the French edition published in Amsterdam in 1680. The volume includes essays on the land, plants, cities, temples, laws, and customs of Japan. Engravings are included which provide views of the costumes of the natives and views of different cities.

Engelbertus Kaempfer.

2 *Natural, civil, and ecclesiastic history of the Japanese Empire . . . (Histoire naturelle, civile et ecclésiastique de l'Empire du Japon . . .).*
Published by P. Gosse and J. Neaulme, The Hague, 1729.
15-3/4 x 9-1/2 inches (40 x 24.2 cm.).
Cleveland Public Library.

Engelbertus Kaempfer (1651-1716) was a physician to the Dutch Embassy in Japan and was attached to the Emperor's court. He apparently served in this capacity from May 1690 until November 1692 when he left Japan to continue his studies at the University of Leiden. While in Japan, Kaempfer took extensive notes on the character of the countryside, investigated the government, and studied the history of the country. His book, first published in 1727, was available in a French edition in 1729. This volume, with large engravings accompanying Kaempfer's text, was avidly read in France. Almost all of the Japonistes owned a copy, since it provided a picturesque travel guide to an "exotic" country.

Isaac Titsingh.

3 *Illustrations of Japan: consisting of private memoirs and anecdotes of the reigning dynasty of the Djogouns, or Sovereigns of Japan; a description of the feasts and ceremonies observed throughout the year at their court; and of the ceremonies customary at marriages and funerals: to which are subjoined, observations on the legal suicide of the Japanese; remarks on their poetry; an explanation of their mode of reckoning time, particulars respecting the dosia powder, the preface of a work on Confoutzee on filial piety, etc.*
Published by R. Ackermann, 101 Strand, London, 1822.
11-7/8 x 9-3/4 inches (30.2 x 24.8 cm.).
Bloomington, Indiana University, The Lilly Library.

Titsingh served as chief agent for the Dutch East India Company at Nagasaki and compiled his work from first-hand experiences. The volume provides information on the Dutch factory at Nagasaki and contains fragments of Japanese poetry. Titsingh's work was not as well known as that by Kaempfer.

Philip Franz von Siebold.

4 *Voyage to Japan, completed during the years 1823 to 1830 to the Japanese Empire (Voyage au Japon, exécuté pendant les années 1823 à 1830 de l'Empire Japonais).*
First published Leiden, 1831; French edition, 1838.
9-1/4 x 6 x 2-3/4 inches (23.5 x 15.2 x 7 cm.).
Washington, D. C., Office of Naval Records and Literature.

Von Siebold (1796–1866) was a surgeon with the Dutch East India Company. While in Japan from 1823 to 1829, he amassed collections and information for this monumental undertaking on the culture, land, and art of Japan. His main objective was to do a basic book on Japan, as he believed the earlier publications had only touched the surafce. Most of the illustrations in the original edition *(Nippon Archiv zur Beschreibung von Japon)* are based upon paintings by a Japanese artist named Keiga; some images are copies from Hokusai. Von Siebold also mentioned Hokusai several times and acknowledged his fame in Japan. Images from Von Siebold's publications were reprinted in popular periodicals, including *Le Magasin pittoresque*, further increasing awareness of Japan. The influence of his work cannot be underestimated, especially since his volume was translated into French (1838) under the title *Voyage au Japon.*

Japanese Illustrated Books Collected in France: 1854–1882

Katsushika Hokusai, 1760–1849.

5 Pages from the *Manga*.
Woodcut, 1814–1878, 15 volumes.
9 x 6-1/4 inches (22.9 x 15.9 cm.).
Volume 1 owned by Camille Moreau
 and signed by the French artist on the
 last page.
Newark Public Library.

The *Manga* was an important source of
images for artists throughout the nine-
teenth century in France. The studies of
animals, flowers, landscape vistas, and
people, observed by Hokusai with great
freedom, drew the attention of critics,
collectors, and artists from the moment
they were first seen in Paris during the
late 1850's. The *Manga* can be seen as a
primary source book for motifs and com-
positions. Apparently, volume 1, studied
by Bracquemond, Manet, and Camille
Moreau, could have been the album cir-
culated by Bracquemond among his
friends during the 1850's. Other volumes
followed.

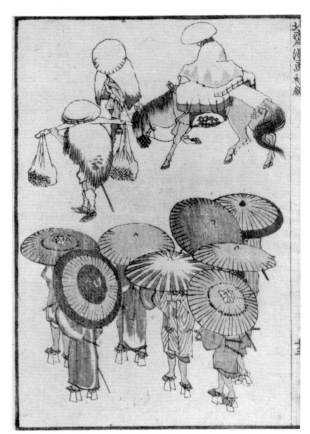

5a *Samurai in the Rain*, from the *Manga*, volume 1.

5d *Page of Animals*, from the *Manga*, volume 2.

5e *Page of Flowers and Plants*, from the *Manga*, volume 1.

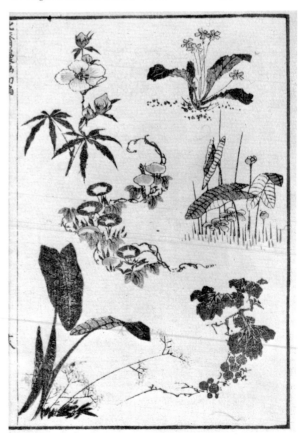

5b *Plant and Rain Pattern,* from the *Manga,* volume 4.

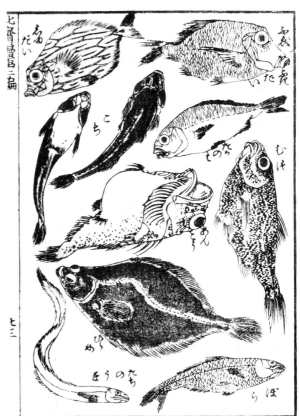

5c *Page of Fish,* from the *Manga,* volume 2.

5f *Page of Flowers,* from the *Manga,* volume 2.

5g *Page of Figures,* from the *Manga,* volume 2.

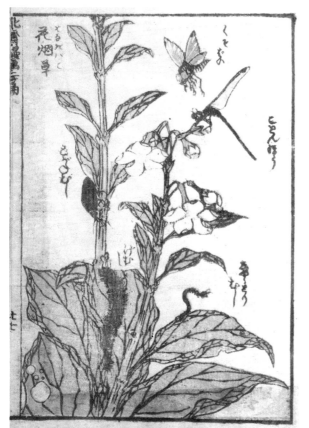

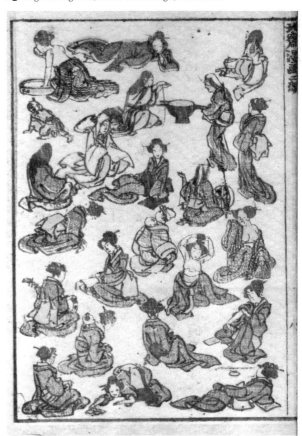

Ando Hiroshige, 1797–1858.

6 Page from "Fish Series" album.
Colored woodcut, ca. 1832.
9-3/4 x 7-1/4 inches (24.8 x 18.4 cm.).
Signed "Clle Moreau"; Adolphe Moreau
collection emblem on cover.
Descendants of Camille Moreau.

These prints also appeared independ-
ently and are considered among Hirosh-
ige's most important images of fish. The
album owned by Camille Moreau seems
a unique example of the popular diffu-
sion in Japan and in France of Hiroshige's
highly acclaimed works from the 1830's.

Kitao Kosuisai (Kitao Shigemasa),
 1739–1820

7 *Page from the Picture Book of the
 Capital of the Dragon (Ehon Tatsu
 No Miyako).*
Colored woodcut, undated.
8-1/2 x 6 inches (21.6 x 15.2 cm.).
Signed "Camille Moreau" on back page;
 Adolphe Moreau collection emblem
 on cover.
Descendants of Camille Moreau.

This album contains fish that were used
as motifs in ceramics by Laurent Bouvier
(1840–1901). The Bouvier pieces are in
the collection of the Moreau-Nélaton
heirs, attesting to a close relationship
between Camille Moreau and Bouvier.

Sadahide, 1820–1867.

8 Pages from the *Album of drawings
 after nature (Bansho Shashin Zufu).*
Colored woodcut print, 1864,
 2 volumes.
7-1/8 x 4-3/4 inches (18.4 x 12.1 cm.).
Signed "Clle. Moreau" on back page;
 with Moreau collection emblem.
Descendants of Camille Moreau.

Théodore Duret collected this album,
now in the Cabinet des Estampes, Biblio-
thèque Nationale. The album represents
a late addition to the Moreau collection
and exemplifies how works, even those
printed in Japan during the 1860's, were
quickly seized upon by European artists.

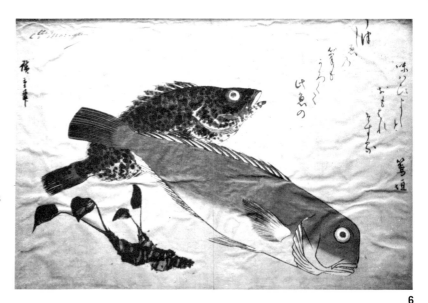

6

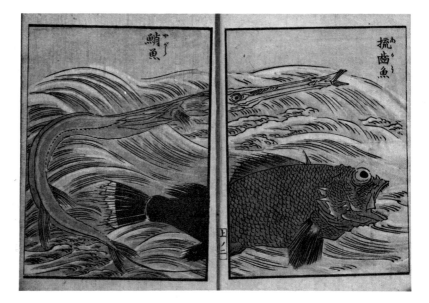

8a

Ando Hiroshige and followers.

9 Pages from *Shoshoku Gatsu,*
 2 volumes.
Colored woodcut, 1863.
7-1/8 x 4-5/8 inches (18.4 x 11.7 cm.).
Circular stamp on inside cover with
 "Fantaisies Chine et Japon, de la Cie
 Coloniale, chocolat bonbons, 62 Rue
 du Bac, Paris, Thés": signature of Mme.
 Nélaton on last page.
Descendants of Camille Moreau.

This album provides documentation on
the wide availability of prints at all types
of Parisian locations. Perhaps some al-
bums were given away when one pur-
chased "bonbons" — a possibility sug-
gested by the mark from the inside
cover [9b].

9a

9b

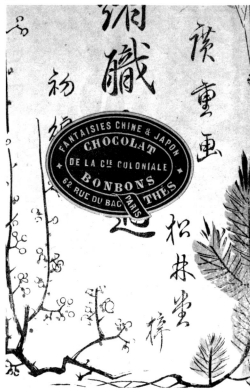

8b

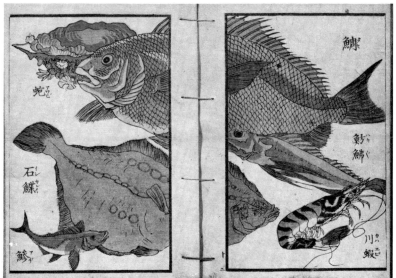

Possibly a late pupil of Utagawa Kuniyoshi, 1797–1861.

10 Pages from the *Pictures of Fish Species (Gyorui Gafu),* 1 volume.
Colored woodcut, second half of nineteenth century.
7 x 4-1/2 inches (17.8 x 11.4 cm.).
With the emblem of the Adolphe Moreau collection.
Descendants of Camille Moreau.

This album, exceptionally small, is poorly printed, suggesting cheap impressions. The images are faint echoes of Hiroshige's well-known fish series used by Bracquemond.

Kawanabe Kyosai, 1828–1889.

11 Page from *Drawn with Pleasure by Kyosai (Kyosai Rakuga),* 2 volumes.
Colored woodcut, 1881.
8-3/4 x 5-7/8 inches (22.2 x 14.9 cm.).
Signed on back page "Camille Moreau '82"; emblem of the Adolphe Moreau collection.
Descendants of Camille Moreau.

A late work, this album was printed in 1881, which establishes how quickly current albums were shipped to France. Since Camille Moreau dated her copy in 1882, she clearly lost no time in purchasing it for her own collection.

11

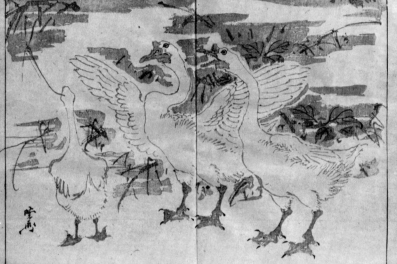

10

10

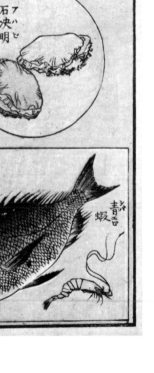

12

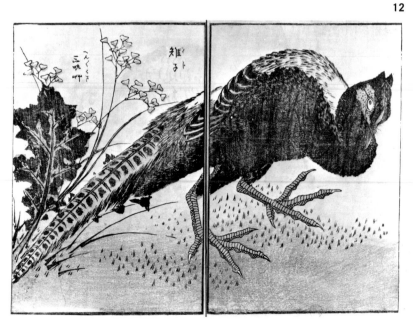

School of Hokusai.

12 Pages from the *Picture Book of Flowers and Birds (Kwacho Gwafu)*.

Colored woodcut, ca. 1812.
8-19/32 x 5-7/8 inches (21.8 x 14.9 cm.).
Ryerson, 271.
Paris, Bibliothèque Nationale, Cabinet des Estampes.

Images from this album were directly copied by Bracquemond for his Rousseau service, 1866-67. The album was also owned by Théodore Duret and is in the collection of the Cabinet des Estampes, Bibliothèque Nationale. Several examples of the *Kwacho Gwafu* are in existence, with images provided by the students of Hokusai. These albums were also known to the French Japonistes, especially Philippe Burty, who had a copy of this work in his collection.

Katsushika Isai, active 1821–1880.

13 Pages from the *Minute Drawings of Flowers (Kwacho Sansui Zushiki)*.

Woodcut, 1847-65 (5 volumes, occasionally bound together).
4-12/16 x 6-7/8 inches (12 x 17.5 cm.).
Ryerson, p. 184
Art Institute of Chicago, Gift of Martin A. Ryerson, 1923 (vol. 1); all other volumes owned by The Museum of Fine Arts, Boston.

These exceptionally small images, frequently four or five per page, were copied by Bracquemond in his search for motifs for the Rousseau service, 1866-67. The first volume for this illustrated book (published in 1847-52 and reissued after 1870) was owned by Camille Moreau. The fourth and fifth volumes (1864, 1865), however, were the ones most heavily used by Bracquemond, who

probably thought the work was by Hokusai. A copy of the book (Boston, Museum of Fine Arts, Asiatic Art Department) contains all five sections bound as one unit and printed on transparent paper. It is probable that Bracquemond knew the book in this format and not in separate units like the volume owned by Camille Moreau.

Isai was a student of Hokusai and was active from 1821 until 1880. Another album, the *Isai Gashiki* (Boston, Museum of Fine Arts, Asiatic Art Department), must have been sold at "à l'Empire Chinois, 53 Rue Vivienne, Decelle" since it contains the shop stamp on the inside cover.

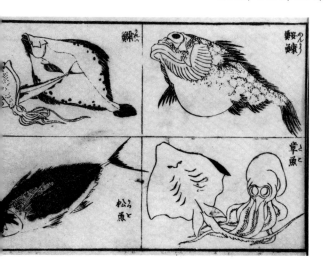

13a Page from the *Kwacho Sansui Zushiki*, volume 1.

13b Page from the *Kwacho Sansui Zushiki*, volume 1.

13c Page from the *Kwacho Sansui Zushiki*, volume 4.

13d Page from the *Kwacho Sansui Zushiki*, volume 5.

Katsushika Taito II (Hokusen), ca. 1820–1850's.

14 Pages from the *Pictures of Flowers and Birds (Kwacho Gaden),* 2 volumes.

Woodcuts, 1848–49.

8-21/32 x 5-23/32 inches (22 x 14.5 cm.); volume 1, 8-9/16 x 5-15/16 inches (21.7 x 15 cm.); volume 2, 8-11/16 x 6 inches (22.1 x 15.2 cm.).

Ryerson, p. 281.

Art Institute of Chicago, Gift of Martin A. Ryerson, 1916.

This album is in the collection of the Cabinet des Estampes, Bibliothèque Nationale, Paris, where it was originally given by Théodore Duret. The album was also owned by Philippe Burty and was sold in 1891 as part of his collection.

14a *Large Pheasant* from the *Kwacho Gaden.*

Single Japanese Prints Collected by French Japonistes

Katsushika Hokusai.

15 Plate 36 from the *Thirty-Six Views of Mt. Fujiyama.*

Woodcut, ca. 1820's.

9-13/16 x 14-9/16 inches (24.9 x 36.9 cm.).

Paris, Bibliothèque Nationale, Cabinet des Estampes, A. Curtis Collection, 1943.

The subject, a large image of Mt. Fujiyama, was immediately seized upon by French printmakers as a recognizable symbol of Japan. It was used on the Jinglar Society's membership card [19].

14b *Small Birds* from the *Kwacho Gaden.*

14c *Roosters* from the *Kwacho Gaden.*

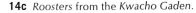
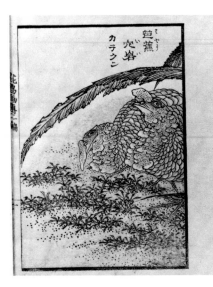

Ando Hiroshige.

16 Plate 32 from the *Fifty-Three Views of the Tokaido.*

Colored woodcut, 1833–34.

9-1/32 x 13-7/8 inches (22.9 x 35.2 cm.).

Paris, Bibliothèque Nationale, Cabinet des Estampes.

The wide expanse of water at the right could have influenced Edouard Manet to choose an off-center position for his boats in *Marine* [38].

17

Ando Hiroshige.

17 Plate 39 from the *Fifty-Three Views of the Tokaido.*
Colored woodcut, ca. 1833–34.
8-31/32 x 14-1/32 inches
(22.8 x 35.6 cm.).
Paris, Bibliothèque Nationale, Cabinet des Estampes.

Kitagawa Utamaro, 1753–1806.

18 *Yamauba, with the Small Kintoki on Her Back, Combing Her Hair.*
Colored woodcut, undated.
9-1/16 x 13-7/8 inches (23.0 x 35.2 cm.).
Paris, Bibliothèque Nationale, Cabinet des Estampes, Gift of Raymond Koech-lin (Reserve).

This print combines the theme of a woman at her toilette combing her hair (which attracted Edgar Degas) with the subject of a mother and child, used by such printmakers as Mary Cassatt.

15

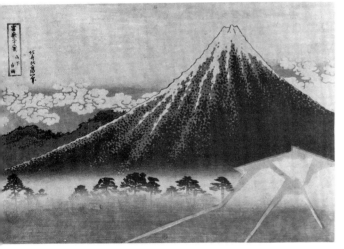

18

16

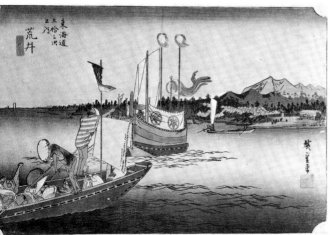

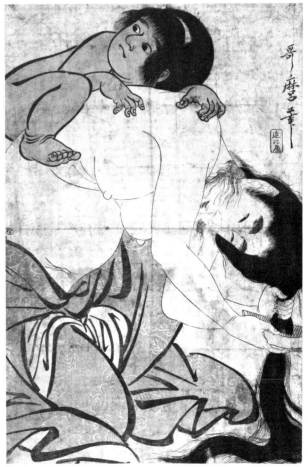

French Printmakers and Japonisme: 1854–1882

Félix Bracquemond, 1833–1914

Bracquemond was a companion of many leading painters, decorative designers, and printmakers during the latter part of the century. Because of these relationships it was possible for him to spread Japonisme through discussions and by showing artists his Japanese albums, which he occasionally carried with him. Bracquemond is credited by many with having discovered Hokusai's *Manga* (1856) at the shop of his printer Délâtre, a tale that may be true.

Bracquemond was a perfectionist in printmaking and the decorative arts, and was recognized as a leading technician from whom many could learn. By the end of his life he had created over 900 prints, many original; others such as the Rousseau service were preparatory etchings copied after famous prints or paintings. He was awarded several prizes, the most notable being a Medal of Honor at the Salon of 1884 and a Grand Prize at the Exposition Universelle of 1900. He is a most important figure for the dissemination of Japonisme and for the study of specific Japanese print albums available during the 1860's — prints which he copied in his own works.

M. L. Solon, 1835–1913, and Félix Bracquemond.

19 *Philippe Burty's Membership Card for the Jing-lar Society.*
Colored etching, ca. 1867.
6-1/8 x 9 inches (15.5 x 22.9 cm.), on paper size 8-1/4 x 11-3/8 inches (21 x 28.9 cm.).
Béraldi 523.
New York Public Library, Prints Division, S. P. Avery Collection.

This print was issued in ten copies, possibly corresponding to the number of members in the Société. The name of the individual member appeared in the smoke above the volcano. Curiously, this print was suggested by numerous visions of Mt. Fujiyama as found in prints by Hokusai or Hiroshige. At either side of the location where the members signed their names are found origami birds. The study of cut-paper shapes certainly captured the imagination of the earliest Japanese enthusiasts, since these forms provided a humorous quality in the appreciation of Japanese art and society. Origami animals had a long tradition in the Orient and would also have attracted Japonistes for this reason.

Membership in this group contained two names which have proven elusive to identify: Prudence and J. Nérat. It is possible that "Prudence" was the wife of one of the members, supporting the contention that this was a convivial gathering often engaging in dinner parties.

19

Félix Bracquemond.

20 *Preparatory Etching of Large Pheasant for Rousseau Service.*
Etching, 1866–67.
9-1/2 x 13-3/4 inches, or 24.1 x 34.9 cm. (plate).
Béraldi 547.
The College of Wooster, John Taylor Arms Collection, Gift of Ward M. and Miriam C. Canaday.

Etchings were used in the preparation of the individual ceramics in the Rousseau table service [20–27]. A print was cut into appropriate segments and fired with the ceramic blank, leaving an outline that provided the form of a motif which was later hand painted. Each etching is numbered as part of the series and contains animals, fish, or flowers taken from pages in Japanese illustrated books.

In this print Bracquemond used Hokusen's *Kwacho Gaden,* circa 1849, and Hokusai's *Kwacho Gwafu* for his pheasant and fighting roosters; the bird at the upper left has not been identified as to a specific album. This same process was

used in all the other etchings, although
the number of illustrated books con-
sulted for each print varied.

When Edmond de Goncourt saw the
motifs on the completed table service he
judged the pieces harshly, for he felt the
designs were "calques d'albums japon-
ais." De Goncourt's evaluation of the
ceramics is borne out by examining the
origins of the etchings.

Félix Bracquemond.

21 *Preparatory Etching of Birds and
Flowers for Rousseau Service.*

Etching, 1866–67.
9-1/2 x 13-3/4 inches (23.5 x 34.5 cm.).
Béraldi 540.
The College of Wooster, John Taylor
Arms Collection, Gift of Ward M. and
Miriam C. Canaday.

Bracquemond relied on pages from the
Kwacho Gaden for his major motifs [14b,
c], although the duck, with wings out-
stretched, seems European and may not
be derived from a Japanese source. The
two roosters also appear in Hokusai's
Manga (vol. 3).

Félix Bracquemond.

22 *Preparatory Etching of Lobster for the
Rousseau Service.*

Etching, 1866–67.
9-1/2 x 13-3/4 inches, or 24.1 x 34.9 cm.
(plate).
Béraldi 550.
The College of Wooster, John Taylor
Arms Collection, Gift of Ward M. and
Miriam C. Canaday.

Bracquemond has combined motifs from
two separate prints by Hiroshige (Figs.
4a, b). The *Great Fish Series* could repre-
sent Bracquemond's first use of inde-
pendent Japanese prints, although the
images were available in an album
owned by Camille Moreau.

20

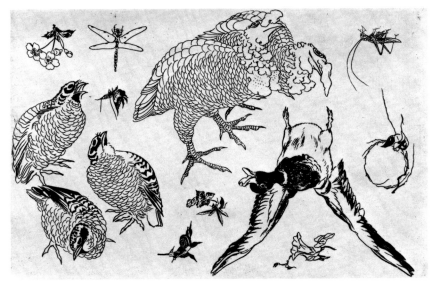

21

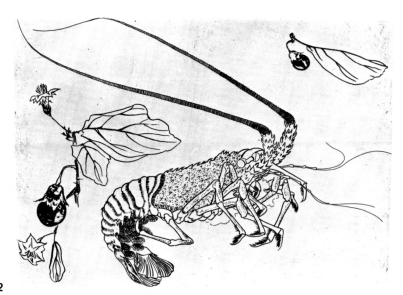

22

31

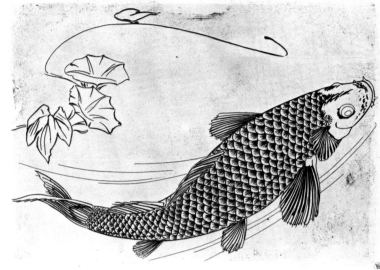

23

Félix Bracquemond.

23 *Preparatory Etching of a Single Carp in Stream for Rousseau Service.*

Etching, 1866–67.

9-1/2 x 13-3/4 inches, or 24.2 x 34.9 cm. (plate).

Béraldi 548.

The College of Wooster, John Taylor Arms Collection, Gift of Ward M. and Miriam C. Canaday.

Bracquemond used the flower streamer, found in another print by Hiroshige, to create a whiplash line.

Félix Bracquemond.

24 *Preparatory Etching of Fish for Rousseau Service.*

Etching, 1866–67.

10-1/2 x 16-3/4 inches, or 26.7 x 42.5 cm. (plate).

Béraldi 532.

The College of Wooster, John Taylor Arms Collection, Gift of Ward M. and Miriam C. Canaday.

Félix Bracquemond.

25 *Preparatory Etching of Birds and Flowers for Rousseau Service.*

Etching, 1866–67.

10-1/4 x 16-1/2 inches, or 26 x 41.9 cm. (plate).

The College of Wooster, John Taylor Arms Collection, Gift of Ward M. and Miriam C. Canaday.

Several birds, including the rooster at the left, are taken from the *Manga.* The *Kwacho Sansui Zushiki* (vol. 4, 1864) provided the motif of the mother hen and her chicks in the center of this print [13c].

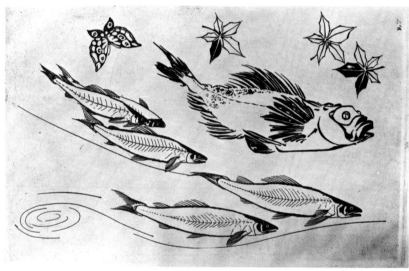

24

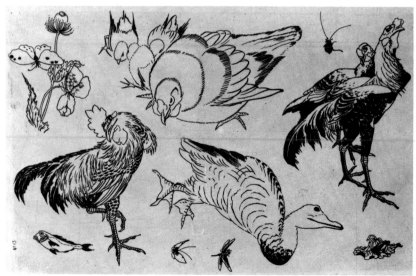

25

Félix Bracquemond.

26 *Preparatory Etching of Birds and Fish for Rousseau Service.*

Etching, 1866–67.

11-1 /4 x 17 inches or 28.6 x 43.2 cm. (plate).

Béraldi 541.

The College of Wooster, John Taylor Arms Collection, Gift of Ward M. and Miriam C. Canaday.

Bracquemond used three, if not more, separate Japanese print sources for the motifs in this etching. The fish at the lower left is taken from Hiroshige's *Ukiyo Ryusai Gwafu* (Boston Museum of Fine Arts, Asiatic Art Department); the two fish in the bottom center come from a page in the *Kwacho Sansui Zushiki* (vol. 5, 1865) [13d]; and the rooster and chick at the lower right are taken from Hokusai's *Manga*. The late date of the motif from the *Kwacho Sansui Zushiki* emphasizes how quickly a new Japanese print album was siezed upon and used in France.

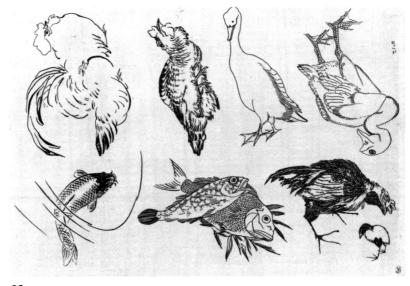

26

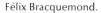

Félix Bracquemond.

27 *Preparatory Etching of Fish for Rousseau Service.*

Etching, 1866–67.

9-1/2 x 13-3/4 inches or 24.1 x 34.9 cm. (plate).

Béraldi 553.

The College of Wooster, John Taylor Arms Collection, Gift of Ward M. and Miriam C. Canaday.

Some of the fish in this etching are found in a page from the *Manga* [5c]; others are copied from the *Kwacho Sansui Zushiki* (vol. 4, 1864).

27

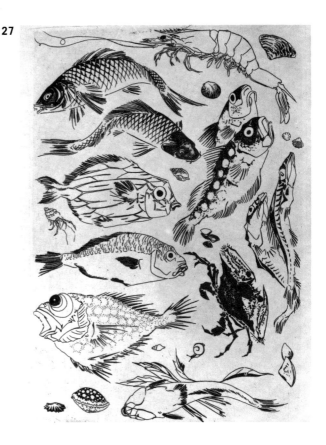

33

28

Félix Bracquemond.

28 *Preparatory Etching for Le Service Parisien: L'Orage.*

Etching, 1875–76.
9-1/2 x 9-7/8 inches (24.1 x 25 cm.).
Béraldi 569.
The Cleveland Museum of Art, Dudley P. Allen Fund. 22.419

This service, for which etchings first functioned as models, was completed by 1876 and sent to the Philadelphia Centennial Exhibition in the United States. An example of the ceramic service is now found in the Musée Adrien Dubouché, Limoges. The interest in changing seasons, the pattern of slanting rain, or the bending of plants in the wind is captured in this print. The *Manga* could have suggested the use of these effects [5b].

As is noted elsewhere (p. 160), there seem to be two variants of this service, with the etchings being related to the first efforts. Charles Haviland, in a letter to Bracquemond (Haviland archives, Limoges) noted the artist's early drawings and asked him to improve the line through etching.

Félix Bracquemond.

29 *Preparatory Etching for Le Service Parisien: Le Brouillard.*

Etching, 1875–76.
9-1/2 x 9-7/8 inches (24.1 x 25 cm.).
Béraldi 562.
The Cleveland Museum of Art, Dudley P. Allen Fund. 22.412

The etchings for this service reflect a delicateness, combined with a Japoniste's concern for changing-season effects. This must have made the completed service, produced by Haviland and Company, Limoges, sought after by those eager to have the newest mode. The border of the plate is marked in the etching, although there were various borders in the completed service.

29

Félix Bracquemond.

30 *The Ducks Have Crossed (Les Canards l'ont bien passée).*

Etching, ca. 1856.

6-1/8 x 10-1/4 inches (15.5 x 26 cm.).

Béraldi 154.

New York Public Library, Prints Division.

Possibly dated in 1856, this print could provide evidence that Bracquemond knew the *Manga* in that year. The slanting pattern of the rain closely resembles a similar effect in the *Manga*. An interest in weather conditions, such as the pattern of rain, was used continuously by other artists throughout the century.

Félix Bracquemond.

31 *Pewits and Teal (Vanneaux et Sarcelles).*

Etching and drypoint, 1862.

7-3/4 x 10-1/2 inches (19.7 x 26.7 cm.).

Béraldi 175.

Boston Public Library, Print Department, Albert H. Wiggin Collection.

The birds are realistically rendered and the Japonisme in this work is restricted to the use of a close vantage point. In fact, one gets the impression of photographic aspects being employed, especially in the bird at the right.

Félix Bracquemond.

32 Swallows *(Les Hirondelles.)*

Etching, undated.

13-1/4 x 11-1/4 inches or 33.6 x 28.6 cm. (plate).

Béraldi 225.

The College of Wooster, John Taylor Arms Collection, Gift of Ward M. and Miriam C. Canaday.

The high vantage point and the swift movement of the *hirondelles* suggest Japonisme observed with a penchant for acute realism. The swiftly moving bird in the direct center of this print is taken from Hiroshige's *Ukiyo Ryusai Gwafu.*

30

31

32

Jules Jacquemart, 1837–1880.

As the son of Albert Jacquemart, a noted collector of porcelains and ceramics, Jules Jacquemart frequently did etchings as illustrations for his father's books. In 1862 Albert Jacquemart published his *Histoire de la porcelaine* with numerous etchings that recorded Oriental pieces then in Paris, including examples from China and Japan. Because of Jacquemart's meticulous ability to capture these objects accurately, one can comprehend the wide range of Far Eastern objects then known.

Jules Jacquemart was a member of the Jing-lar Société and probably collected Japanese art objects in his own right. After the Franco-Prussian War, during which time he was terribly disturbed, he turned to water colors, which were exhibited in 1879 and 1880.

Jules Jacquemart.

33 *Plate 15. Exceptional Manufacture (Fabrications exceptionnelles) from Histoire de la porcelaine, 1862.*

Etching, ca. 1860–62.
9 x 6-5/8 inches, or 22.9 x 16.8 cm. (plate).
Gonse 46.
The College of Wooster, John Taylor Arms Collection, Gift of Ward M. and Miriam C. Canaday.

This print and the two that follow are taken from one of the earliest volumes to reproduce Oriental art objects in France. Albert Jacquemart was an avid collector of decorative art examples which his son Jules etched for this book. The *History of Porcelain,* appearing in 1862, marks an early date for an attempt to record works then known to Oriental connoisseurs. Jules Jacquemart was frequently involved in recording small objects in prints, not only for his father but for official institutions such as the Louvre. It might be interesting to explore ties between Frédéric Villot, an administrator at the Louvre during the 1860's, and the Jacquemart family. It is possible, since Villot was an active supporter of Japanese art, that relationships with many of the members of the Jing-lar Society were encouraged by this association.

Albert Jacquemart was also a collector of Oriental bronzes, some of which were etched by Jules and by Félix Bracquemond. This demonstrates further involvement with Oriental art objects.

Jules Jacquemart.

34 *Plate 7. Famille Rose Japonaise from Histoire de la porcelaine, 1862.*

Etching, ca. 1860–62.
9-5/8 x 6-3/4 inches (24.5 x 17.2 cm.).
Gonse 38.
Boston, Museum of Fine Arts, Duplicate Print Fund and Gift of George Peabody Gardner.

Jules Jacquemart.

35 *Plate 8. Famille Rose Japonaise from Histoire de la porcelaine, 1862.*

Etching, 1860–62.
9-3/4 x 6-7/8 inches (24.8 x 17.5 cm.).
Gonse 39.
Boston, Museum of Fine Arts, Duplicate Print Fund and Gift of George Peabody Gardner.

33

34

Jules Jacquemart.

36 *The Executed Muamija-Hasime, Assassin of Europeans, in Front of the Kamakura Temple, Japan, May, 1867 (Le Supplicié Muamija-Hasime, assassin d'Européens devant le Temple de Kamoukara, Japon, Mai, 1867.*

Etching, 1867–68.
5-1/8 x 7-1/4 inches (13 x 18.4 cm.).
Gonse 313.
Boston Public Library, Print Department, Gift of Joseph C. Gray.

This print appeared in *L'Illustration Nouvelle* on December 1, 1868. Undoubtedly the image comes from a photograph of an actual event which had occurred in Japan. Jacquemart's meticulous approach faithfully recorded the scene, thus making contemporary news from Japan (which was undergoing an intense period of civil war) available to Parisians interested in that country's current problems.

Photographs of Japan, its people, and cities had been taken during the 1860's by Felice Beato and others. Occasionally these images were directly copied as lithographs or engravings which were reproduced in books documenting Japan (see Aimé Humbert, *Le Japon illustré*, 1870).

36

35

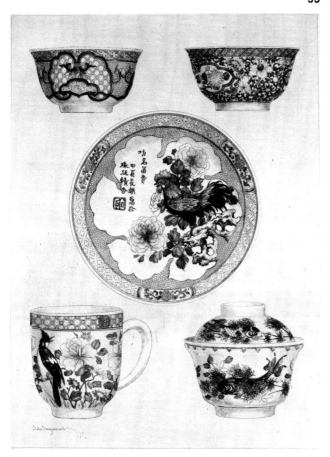

Philippe Burty, 1830–1890

Actively involved in the pursuit of Japanese objects from the early 1860's, Burty quickly became a chief spokesman for Japonisme. His articles in *La Renaissance littéraire et artistique* (1872) not only gave the new movement its name but also demonstrated how widespread was the interest in Japanese art, culture, and history.

Burty began collecting Japanese objects, prints, lacquers, bronzes, and ivories prior to the fair of 1867. His collection was enormous and was visited by artists and connoisseurs. It was the first collection of Japanese objects to be sold in Paris (1891).

Since Burty was a close friend of all the printmakers and painters involved in avant-garde changes during the 1860's and 1870's, it was possible for him to spread his enthusiasm for Japanese art. Moreover, his reviews in *Le Rappel, La République Française,* and *L'Art* continuously reinforced the interest in Japan.

Burty was also a printmaker, and while most of his works cannot be located, those that can show how he copied many of his own Japanese objects. These prints were given to his friends, among them Edmond de Goncourt, and began a tradition of recording objects which was later continued by Félix Buhot [96 a–i]. Burty's impressions suggest a random placement of forms similar to that in the work of Manet [40] or Félix Bracquemond [20–27]. His constant support of Japan led to his receiving a medal from the Japanese Legation in Paris (1884) entitled ''The Order of the Empire of the Rising Sun'' (Fig. 6).

37a

Philippe Burty.

37a *Japanese Objects from the Collection of Philippe Burty.*
Etching, ca. 1873.
7 x 5-1/8 inches (17.8 x 13 cm.).
Béraldi 9.
Inscription: "A mon ami Saint-Marcel Valvins, 1873."
Boston, Museum of Fine Arts, Gift of S. P. Avery.

This print demonstrates how Burty studied Japanese objects he owned while furthering his own personal involvement in printmaking. The objects depicted include a sculpture of a rat (noted by Béraldi), a mask, and a smaller figurine seated on a snail. The majority of Burty's prints have long since disappeared from public and private collections. These prints were often given to friends as mementos of pleasant sessions spent examining Japanese objects from Burty's collection. For a detailed but by no means complete listing of the prints done by Burty, see Béraldi (IV, p. 39).

Philippe Burty.

37b *Japanese Object from the Collection of Philippe Burty.*
Etching, undated.
3-1/16 x 4-5/8 inches (7.8 x 11.7 cm.).
Béraldi 10.
France, Private Collection.

This small figurine suggests a Japanese *netsuke* in the form of a monkey. The collecting of *netsuke* was practiced by many of the Japonistes including Burty, whose collection was quite extensive. Perhaps he purchased some of these objects from either the shop of Sichel or Bing, stores where Burty owed a great deal of money. Because of his passionate collecting of Japanese objects and prints, Burty was forced to sell his nineteenth-century French print collection in London in 1876 and 1878. The money from these sales permitted him to continue his acquisition of Japanese objects and to pay some of his debts to Sichel and Bing. Burty's collection continued to increase up until his death in 1890, when it became the first contemporary collection of Japanese objects to be sold in Paris.

Edouard Manet, 1832–1883.

As the best known painter of his time, Manet was interested in the new impulses affecting art during the 1860's: Spanish painting from earlier periods, photography, and the fad for Japanese art. His compositions, which frequently touched off furious controversy, suggest his occasional attempt to use these new influences, especially in such a painting as *The Fifer*, 1866 (Louvre, Paris), where the patterned quality found in *ukiyo-e* prints is in evidence.

Manet was friendly with all the major figures in the budding Japonisme movement and assuredly learned much about printmaking from Félix Bracquemond. His paintings were also supported by Philippe Burty, with whom Manet developed another close relationship.

While many of Manet's prints repeat themes he had painted, occasional examples suggest that he was examining Japanese print albums in order to recast his design in a new light. Even his painting of *The Gare St. Lazare,* with its partitioned back plane, could suggest a knowledge of devices found in Japanese prints which Manet attempted to incorporate into his contemporary subjects. His full use of Japanese motifs and absorption of compositional devices from *ukiyo-e* prints awaits complete clarification.

Edouard Manet.

38 *Marine.*
Etching and aquatint, ca. 1864–65.
5-1/2 x 7-15/16 inches (14 x 20.2 cm.) (plate).
Harris 40, Guérin 35.
The Philadelphia Museum of Art.

While this image is clearly related to scenes witnessed in the harbor of Boulogne (1864), part of the realization of such an image could be due to Japanese prints of similar subjects. The bird's-eye vantage point and the zig-zagging arrangements of the boats (and their sails) could also have been suggested by somewhat similar placements in *ukiyo-e* prints by Hiroshige, for example, in Figure 7 [see also 16].

38

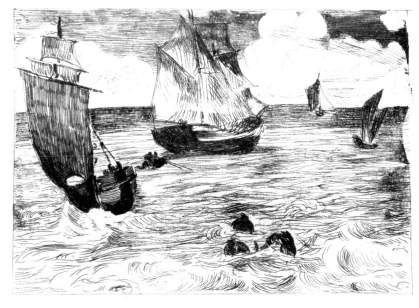

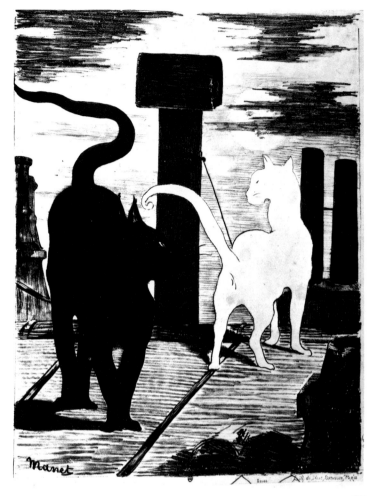

39

Edouard Manet.

39 *The Cats' Rendezvous (Le Rendez-vous des chats).*

Lithograph, ca. 1868–70.
17-1/8 x 13 inches (43.5 x 33 cm.).
Harris 58; Guérin 74.
Paris, Bibliothèque Nationale, Cabinet des Estampes.

While no specific Japanese woodcut can be found as an exact prototype for this image, the influence of Japan is present in the flattened images, recalling cut-out paper forms, and in the curving arabesques created by the movement of the cat's tail. Colta Ives *(The Great Wave, 1974)* has compared this image with a fan print by Kuniyoshi, although complete documentation on how Manet knew this print is needed.

Edouard Manet.

40 *Cats (Les Chats).*

Etching, ca. 1869 (although it is undated).
6-7/8 x 8-9/16 inches (17.6 x 21.8 cm.).
Harris 64, Guérin 52.
The Art Institute of Chicago, Anonymous Gift.

This is one of the most important of Manet's prints, since the extreme economy of composition and line strongly suggests a debt to the art of Japan. Indeed, as has been suggested, the isolated

40 **40a**

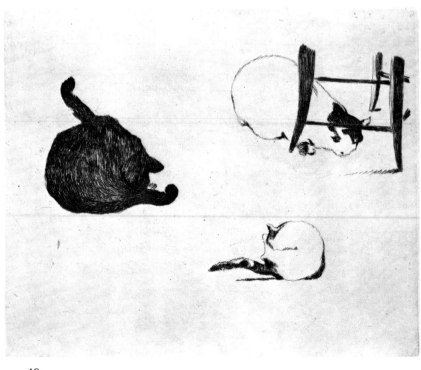

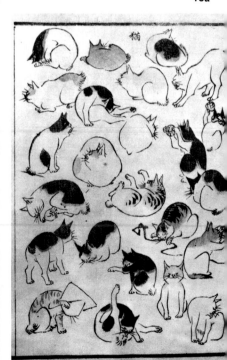

motifs of the cats are related to the image of a cat found in Hokusai's *Manga* (vol. 2) [5d], which Manet was undoubtedly studying at the time of his work for Champfleury's volume of cats. Each cat in Manet's etching seems to float in space and also to be integrated with the abstract design of the overall page. While Manet's print is undated, it suggests a relationship with Bracquemond's arrangement of motifs in etchings for the Rousseau service, especially in the random placement of forms, the suggestion of an examination of Hokusai and other printmakers, and the relationship established with negative spaces in the print. Curiously, a similar placement of Japanese objects is found in Philippe Burty's etchings [37a]. Completely overlooked in studying etchings from this period is the fact that Bracquemond, in 1864, did an etching of cats supposedly after Hokusai. This print is recorded in the catalogue of the Burty etching sale (London, 1876), although it has never been found.

Examination of a second print album reveals that Manet could have studied Hiroshige's *Ukiyo Ryusai Gwafu* (Boston Museum of Fine Arts, Asiatic Art Department; [40a]), where an entire page, in the manner of Hokusai's *Manga*, is devoted to cats. This album was known to Félix Bracquemond, since he copied motifs from it in the preparation of the Rous-

seau service [26]. The cats were also used as illustrations for Champfleury's book, where they were incorrectly identified as works of Hokusai. Champfleury wrote in his text that "la plupart des vignettes japonaises reproduites dans ce volume sont tirées des cahiers de croquis d'un artiste merveilleux . . . ce peintre, appelé Fo-Kou-Soy est plus populaire en France sous le nom de Hok'sai . . ." (the majority of the Japanese vignettes in this volume come from volumes of sketches by a marvelous artist . . . this painter called Fo-Kou-Soy who is most popular in France under the name Hok'sai). The faulty identification of a Japanese printmaker is not suprising during the 1860's, since an accurate study of Japanese art was still a long way from being accomplished. Prints by Hiroshige were frequently confused with those by Hokusai.

Edouard Manet.

41 *Cat and Flowers (Le Chat et les fleurs).*

Etching and aquatint, 1869.
8 x 6 inches (20.3 x 15.2 cm.) (plate); 6-1/2 x 5 inches (16.5 x 12.7 cm.) (composition).
Harris 65, Guérin 53, first state.
The Philadelphia Museum of Art.

It has been noted that the vase of flowers is similar to a vase depicted by Haronobu in a woodcut (cited in Harris, p. 180). This print appeared in Champfleury's *Les Chats.*

Edouard Manet.

42 *Line in Front of a Butcher Shop (Queue devant la boucherie).*

Etching, ca. 1870 (Strolin 1905).
9-5/16 x 6-1/4 inches (16.9 x 14.6 cm.).
Harris 70, Guérin 58.
The Cleveland Museum of Art, Gift of Ralph King. 22.198
Colta Ives (*The Great Wave*, 1974) has pointed out the similarity between this print and a page from Hokusai's *Manga* (vol. 1). She noted, "Manet adapted Hokusai's Samurai in the rain . . . to form the semi-abstract mass of overlapping bodies and umbrellas. . . ." Indeed, the *Manga* image seems reversed by Manet, although the French artist has realistically shaded his forms. The interest in flattened space and large negative areas also suggests the *Manga* relationship.

41

42

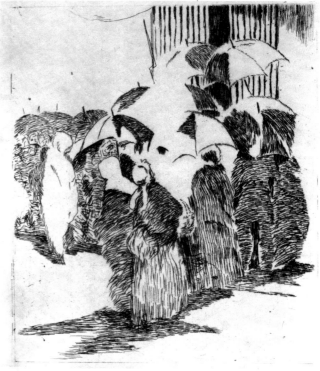

Edouard Manet.

43 *Illustration for the Afternoon of a Faun (Illustration for l'Après-Midi d'un Faune).*

Wood engraving, ca. 1875–76.

14-1/4 x 10-1/8 inches, or 36.2 x 25.7 cm. (sheet).

Harris 84, Guérin 93.

The Baltimore Museum of Art, George A. Lucas Collection on indefinite loan from the Maryland Institute.

Manet seems to have been examining the *Manga* again in 1876 in illustrations for this publication by Mallarmé. The foliage at the bottom of the page comes from the Hokusai work [5e], although Manet used the motif as a vignette (noted by Anne Coffin Hanson, *The Art Bulletin*, 1969). The binding of the first edition, in the Oriental style, complemented the imagery inside.

James Jacques Joseph Tissot, 1836–1902

Tissot started etching in Paris during the 1860's, at the moment of renewed interest in printmaking caused by the Société des Aquafortistes. The number of prints he did at this time remains small. He apparently lost interest in printmaking and did not work again until the mid-1870's, when in England, under the influence of Whistler and Seymour-Haden, his output was renewed. From 1875 to 1886 Tissot did over eighty prints.

Tissot's interest in Japanese art also matured during the 1860's, and as was the case with other artists, he made the rounds of the Parisian *curiosité* shops, most notably *La Porte Chinoise*. Undoubtedly an easily influenced type, Tissot bought Japanese costumes, and the sale of his studio after his death (Hôtel Drouot, July 9–10, 1903) disclosed a collection of Oriental porcelains and robes. Since Degas painted Tissot's portrait under a Japanese scene (Metropolitan Museum of Art) it is visually recorded that he was in the midst of the Japonisme mania. Tissot's own paintings, such as *Jeune femmes regardant des objets japonais,* shown at the Paris Salon of 1869 (private collection, Cincinnati), further demonstrate his exotic taste for Japanese art works, although he did not always absorb the stylistic concepts inherent in these objects. His prints during the 1870's, while using certain devices observed from a study of Japanese prints, also show that he used photographic sources, as did other printmakers, in an effort to keep his work contemporary.

43

44

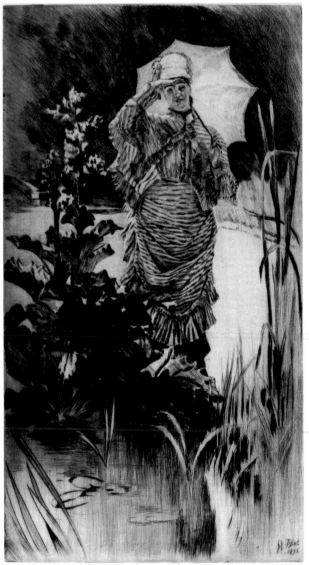

James Jacques Joseph Tissot.

44 *Spring Morning (Matinée de Printemps).*
Etching and drypoint, 1875.
19-15/16 x 11 inches (50.7 x 28 cm.).
Béraldi 7.
Yale University Art Gallery.

As Michael Wentworth has noted (in his Tissot catalog, 1968), Japanese influence is "manifest." The influence of Japan has gone further than just the use of Oriental props (fans, prints, kimonos), as Tissot has silhouetted his figure against a rich black background suggestive of Japanese prints of actors. The reeds in the foreground loom up as large motifs and almost dwarf the figure behind them. Such motifs were occasionally found in Japanese prints of flowers, including images from the *Manga* [5f].

45

James Jacques Joseph Tissot.

45 *On the Grass (Sur l'herbe).*
Etching and drypoint, 1880.
7-3/4 x 10-23/32 inches (19.6 x 27.2 cm.).
Béraldi 41.
Yale University Art Gallery, Gift of Mrs. Howard M. Morse.

This is a composite print, probably drawn from photographic sources and Tissot's own sorrow over the sickness of Kathleen Newton. The image, with an off-center arrangement of the major figures and the lush, decorative treatment of the background, also suggests Japonisme. The reclining figure, conveying an impression of langour, while frequently used by the Impressionists, was also found in Hokusai's *Manga*. Perhaps the increased use of such a pose after the mid-1860's stems from a closer absorption of these poses from the *Manga* [5g].

46

James Jacques Joseph Tissot.

46 *Summer Evening (Soirée d'Été).*
Etching and drypoint, 1881.
10-3/4 x 12-11/16 inches (27.3 x 32.2 cm.).
Béraldi 47.
Yale University Art Gallery, Gift of G. Allen Smith for the G. Allen Smith Collection.

This print suggests that Tissot was drawing upon two sources for his imagery: early Impressionist compositions and the graceful langour frequently found in Japanese prints of women. Since the figure has been placed close to the frontal plane, one senses that Tissot was assimilating Japanese print devices.

James Abbott McNeill Whistler,
1834–1903.

Whistler occupies an important place in the development of Japonisme in painting and printmaking during the 1850's and 1860's. From the moment of his arrival in Europe, fresh from the United States, he was associated with the newer tendencies in the art world on both sides of the English channel. As he moved back and forth between England and France during the 1860's, he must have taken with him news of the interest in Japanese art as well as albums which he could have secured on either side of the channel.

His paintings, including *Purple and Rose: The Lange Lijzen of the Six Marks* [185], show women surrounded by exotic accoutrements. During his formative stage, he is recorded as having visited *La Porte Chinoise* and examined Oriental objects being collected by the Pre-Raphaelites in London. It is possible that Whistler helped spread information about the London (1862) exhibition of Japanese art to his compatriots in France. Clearly he was on close terms during the middle sixties with many printmakers, such as Bracquemond and Manet, who were studying *ukiyo-e* print albums. His own prints were studied, exhibited in the Salons, and commented on by Burty.

Whistler's paintings, such as *Variations in Flesh Color and Green: The Balcony* (Freer Gallery, Washington), begun in 1864, and *Brown and Silver: Old Battersea* (Addison Gallery of American Art), exhibited at the Royal Academy in 1865, show how Japan was affecting his style. The subject of Old Battersea Bridge, which Whistler would depict in prints during the 1870's, demonstrates how motifs from the prints of Hiroshige were being assimilated.

Many of Whistler's prints are not dated, and although he began as a printmaker in the late 1850's—at the moment when there was renewed interest in this medium in France—many of the motifs related to Japonisme have their origin in his interests of the 1860's.

James Abbott McNeill Whistler.

47 *Early Morning, Battersea.*

Etching, middle 1870's (?).
4-13/32 x 5-29/32 inches (11.2 x 15 cm.).
Kennedy 75, only state.

The Art Institute of Chicago, The Bryan Lathrop Collection.

The zig-zagging arrangement of the boats in the middle ground and the irregular balance to the work suggest an absorption of Japanese print motifs from Hiroshige. In Hiroshige's landscape prints or in views from the *Manga* the diagonal placement of a boat, posed against an empty space, is frequently found.

James Abbott McNeill Whistler.

48 *Old Battersea Bridge.*

Etching, ca. 1878.
4-1/16 x 7-11/16 inches (10.3 x 19.5 cm.).
Kennedy 177, *III*.

Boston Public Library, Print Department.

The motif of a bridge, seen in the upper section of prints by Hiroshige, recurs continuously in Whistler's work. Like his Japanese counterpart, Whistler placed figures in motion on the bridge while also giving a glimpse of river traffic beneath. The butterfly cachet placed off-center at the right is not angled in space but recalls the flat plane of the print,

47

48

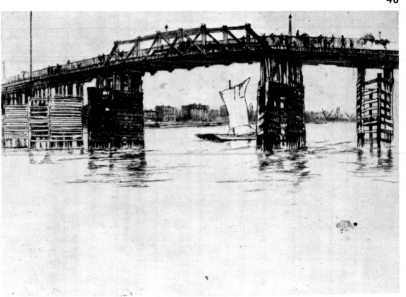

much in the manner of Japanese print seals in works by Hiroshige and others. Undoubtedly the large use of negative space at the bottom and the silhouetting of the bridge against the white of the paper were suggested by Japanese devices. Like the Japanese, Whistler suggests that what is not represented (in this case, further aspects of the bridge) must be imagined, as the detail is related to the whole. The delicate treatment of the bridge also suggests that Whistler was thinking in terms of Impressionism, especially with his handling of light effects.

James Abbott McNeill Whistler.

49a *Old Putney Bridge.*

Etching.

7-15/16 x 11-11/16 inches (20.1 x 29.7 cm.).

Kennedy 178, *I.*

Boston Public Library, Print Department.

Whistler saw the different states of a composition as part of a larger series. This concept could be related to the use of the same continuous image in Japanese prints. The slight changes accent the light which filters across the stationary object, as in views of Mt. Fujiyama in prints by Hokusai and Hiroshige.

James Abbott McNeill Whistler.

49b *Old Putney Bridge.*

Etching.

7-15/16 x 11-11/16 inches (20.1 x 29.7 cm.).

Kennedy 178, *III.*

Rutgers University, Fine Arts Collection.

James Abbott McNeill Whistler.

50 *The Little Putney, No. 1.*

Etching.

5-3/16 x 8-3/16 inches (13.1 x 20.7 cm.).

Kennedy 179, *I.*

The Boston Public Library, Print Department.

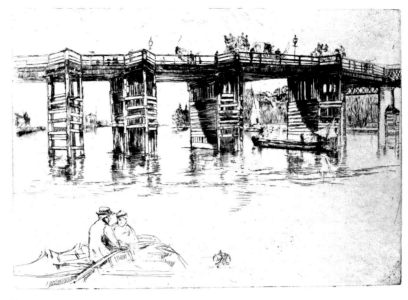

49a

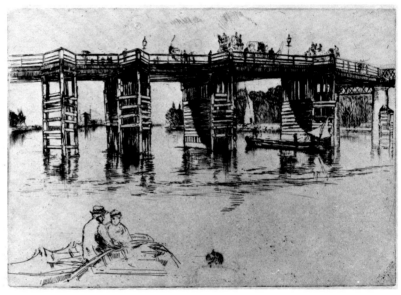

49b

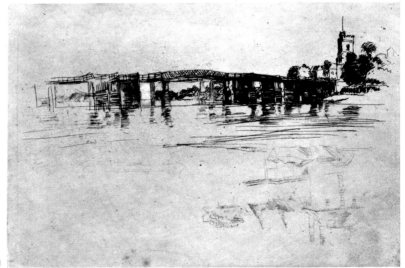

50

Edgar Degas, 1834–1917

Regarded as one of the most versatile of nineteenth-century painters, Degas became a leading supporter of the Impressionist cause. His paintings, first seen at the Salons of the 1860's, combined academic discipline with a study of Japanese prints and photography. Degas' seemingly casual placement of forms in irregular arrangements could have been due to his appreciation and collection of Japanese prints, which he first saw during the 1860's when he went with Burty, Zola, Manet, and Tissot to *La Porte Chinoise*.

Degas also collected his own Japanese prints: landscapes by Hiroshige, albums by Sukenobu, prints by Utamaro and Kiyonaga; and he certainly knew Hokusai's *Manga*. While he did not own all the prints himself, he had ample opportunity to study other examples in the collections of friends like Burty, or Alexis and Henri Rouart. The work of Japanese printmakers undoubtedly led Degas to a deeper study of the female form, especially scenes of women at their toilette, which he did innumerable times. These suggest a series of Japanese print images where the same subjects were frequently employed. His prints demonstrate how deeply affected were the Impressionists by the art of Japan.

Edgar Degas.

51 *Alphonse Hirsch* (See Fig. 3).
Etching, ca. 1870's.
4-15/32 x 2-13/32 inches (11.3 x 6.1 cm.).
Delteil 19, *II*.
Washington, National Gallery of Art, Rosenwald Collection.

Alphonse Hirsch (1843–1884), an artist in his own right, was a member of the Jinglar Société. His collection of Japanese art objects, while not as extensive as Burty's, was available to his friends, including Degas. Part of his collection was shown in 1883 at the major Japanese art exhibition of that year.

Edgar Degas.

52 *At the Ambassadors (Aux Ambassadeurs).*
Etching, aquatint, and drypoint, ca. 1875–77.
18-3/4 x 12-3/8 inches, or 47.6 x 31.4 cm. (sheet); 10-9/16 x 11-9/16 inches, or 26.8 x 29.3 cm. (plate).
Delteil 27, *III/III*.
Sterling and Francine Clark Art Institute.

This is among the earliest of Degas' prints to display any Japanese devices. Seeing the performers from the rear reinforces the casually organized backstage view, seen from a bird's-eye vantage point. The vertical forms at the right suggest stage props which sever the composition.

51

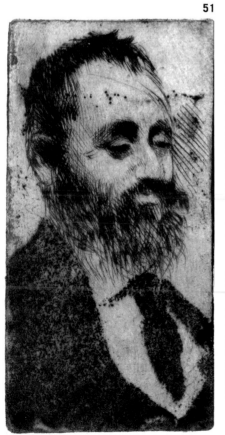

52

Edgar Degas.

53 *Singer in a Cafe-Concert (Chanteuse d'un Café-Concert).*

Lithograph, ca. 1875.

13-7/8 x 7-9/16 inches (35.2 x 19.2 cm.).

Delteil 53, I/II.

The Art Institute of Chicago, The Charles Deering Collection.

Edgar Degas.

54 *At the Louvre: The Painter Mary Cassatt (Au Louvre, la peinture, Mary Cassatt).*

Etching, aquatint, and drypoint, 1879–80.

11-13/16 x 4-7/8 inches (29.3 x 12.4 cm.).

Delteil 29.

The Cleveland Museum or Art, Charles W. Harkness Endowment Fund. 29.876

This, the most carefully composed of Degas' early prints, achieves a decidedly "Japanese" effect. The momentary view of Mary Cassatt stopping briefly before paintings in the Louvre is fused with a decorative quality enhanced by the pattern on the marbleized pillar at the left and the design of the parquet floor. The Japanese print characteristics include the bird's-eye perspective, the uptilting of the background plane, the geometric partitioning of the rear wall (a casual effect which severs the figures in the interior), and an off-center balance. Most important, the extremely narrow format, as Colta Ives has observed (*The Great Wave*, 1974), seems to be derived from *hashira-e* prints which were designed to be displayed on the pillars of houses, and in which oblique angles were frequently employed in compositions by Haronobu. Degas' interest in Japanese effects, such as the silhouetting of forms or the off-center arrangements, was first noted by Philippe Burty in a review of Degas' painting of *Madame Camus* (*Le Rappel*, 1870). These qualities were reiterated by other critics, for example, Huysmans, who saw that Degas' figures were severed by internal forms as in *ukiyo-e* prints.

54

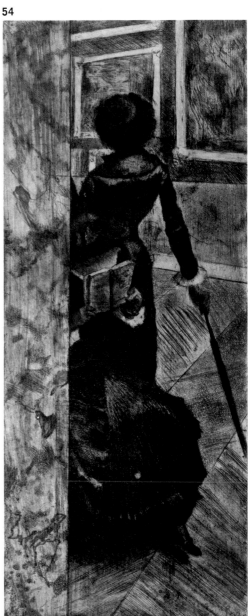

53

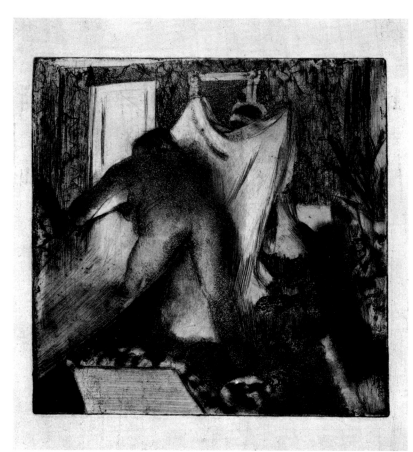

55

Edgar Degas.

55 *Leaving the Bath (La Sortie de Bain).*

Etching, aquatint, and drypoint, ca. 1882.

9-1/8 x 6-15/16 inches, or 23.2 x 17.1 cm.
(sheet); 5 x 5 inches, or 12.7 x 12.7 cm.
(plate).

Delteil 39, *X/XVIII.*

Sterling and Francine Clark Art Institute.

Into this composition, among the first of
Degas' images devoted to the subject of
a bather, the artist introduces the servant
as well. The interest in decorative details
reinforced by the rich pattern of the
wallpaper and carpets emphasizes the
love of decoration inherent in the kimo-
nos and wall hangings frequently found
in Japanese prints. Later versions of the
bather eliminate strong emphasis on
decorative detail.

Edgar Degas.

56 *Nude Woman Standing at Her Toilet,*
Turned to the Right (Femme nue de-
bout à sa toilette, tournée à droite).

Lithograph, ca. 1885–90.

11-15/16 x 8-9/16 inches, or 30.3 x 21.7
cm. (sheet); 7-1/2 x 5-3/4 inches, or
19 x 14.6 cm. (plate).

Delteil 60, undescribed state between
second and fourth states.

Sterling and Francine Clark Art Institute.

Prints of this subject category, which be-
gan in the early 1880's and continued in-
to the 1890's, are part of a series in which
only slight modifications in position and
pose are found. The later prints from this
series do examine, however, a nude
bather in closer detail, and from the
waist upward, perhaps suggesting the
increasing influence of Utamaro's similar
figures on Degas [18].

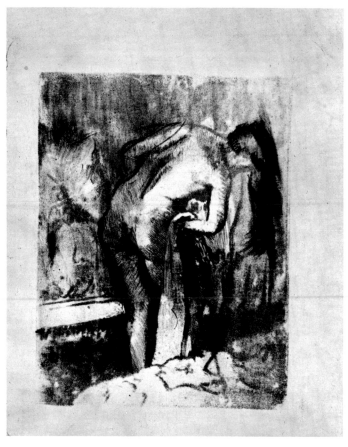

56

Edgar Degas.

57 *Leaving the Bath (La Sortie de bain).*
Lithograph, ca. 1890.
8-5/8 x 9-11/16 inches (21.9 x 24.6 cm.).
Delteil 63.
The Cleveland Museum of Art, Gift of
 Captain Charles G. King, III. 70.825

As one of a series of eight lithographs
which concentrated on a single monu-
mental bather, sometimes accompanied
by a servant, these prints suggest Japan-
ese prototypes. Women washing them-
selves, observed from the back, are
found in Hokusai's *Manga* and in prints
by Kiyonaga, including Degas' own ver-
sion of the *Bath House.* Often Degas'
bather had her hair flowing in long
tresses similar in style to those of women
observed by Kunisada or Utamaro. The
presence of a servant, who often held
toilet articles or a waiting gown or
combed her mistress' hair, is found in
prints by Sukenobu, Utamaro, and Koryu-
yusai. The subjects reinforced Degas' in-
terest in examining the ritualistic aspects
of a woman at her toilette.

Edgar Degas.

58 *Leaving the Bath (La Sortie de bain).*
Lithograph, ca. 1885–90.
12 x 12-5/8 inches (30.4 x 32.4 cm.).
Delteil 64, fourth state.
The Cleveland Museum of Art, Gift of
 Mr. and Mrs. Richard B. King for the
 Fiftieth Anniversary of The Print Club
 of Cleveland. 70.285

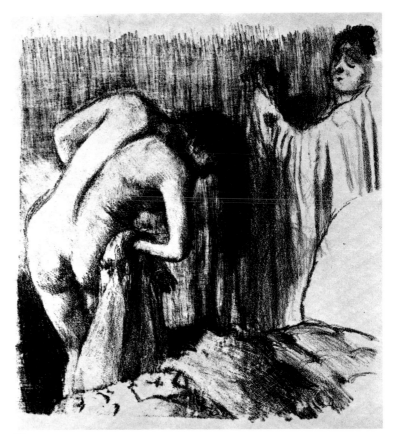

57

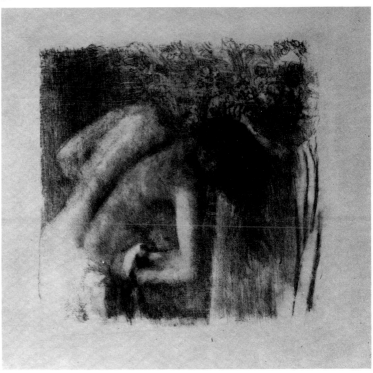

58

Camille Pissarro, 1830–1903.

In the early 1880's Pissarro, long established as one of the leading Impressionists, became increasingly interested in printmaking. His earliest prints show the influence of Camille Corot and Jean-François Millet. It was not until 1879, under the tutelage of Degas and Manet, that his etchings and lithographs became more personal in style.

The vast majority of Pissarro's prints employed the same themes as his paintings and water colors. Frequently, he tried to capture atmospheric effects, qualities of rain, and the changing seasons. The impact of the art of Japan is difficult to establish in his prints, although the gradual interest in capturing climatic effects, the pattern of rain slanting toward the ground, or a sweeping landscape vista observed from a high vantage point could be due to an examination of prints by Hiroshige and others. Since Pissarro was on close terms with other Impressionist printmakers affected by Japanese art, these concepts could have been transmitted to him. However, his Japonisme does not seem as intense as that of many of the other printmakers of the period.

Camille Pissarro.

59 *Twilight with Haystacks (Crépuscule avec Meules).*

Etching, aquatint, and drypoint, 1879.
4-11/16 x 6-5/16 (11.8 x 16 cm.).
Delteil 23, *III/III.*
The Boston Public Library, Print Department.

This transitional print shows Pissarro's use of Japanese print concepts. The sweeping vista, the road in the middle of the composition which disappears at the horizon, the solitary travellers on the road, and the bird's-eye perspective all suggest his examination of prints by Hiroshige. Since the print is dated 1879 it could also mark the influence of Degas and Manet in attempting to bring Pissarro toward a deeper assimilation of Japanese art.

Camille Pissarro.

60 *Setting Sun (Soleil Couchant).*
Aquatint and drypoint, ca. 1879.
4-1/16 x 7-3/32 inches (10.3 x 18 cm.).
Delteil 11, *I/IV.*
The Art Institute of Chicago, Gift of Frank B. Hubachek.

The frieze-like arrangement of the trees and the flattened appearance of the landscape could be due to a deeper study of flattened shapes from the *ukiyo-e* prints. However, the work also displays more of the Impressionistic sketch-like quality which Pissarro was using in a personal fashion by 1879.

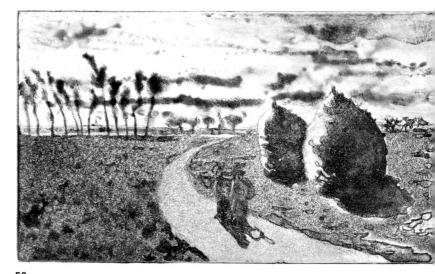

59

60

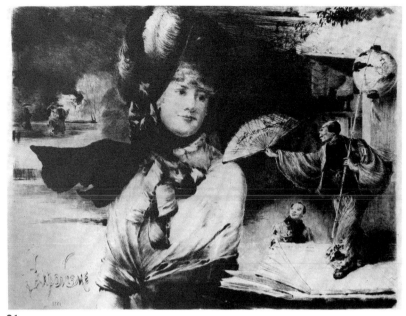

61a

Henry Somm, 1844–1907.

François Clément Sommier, called Somm, was an important printmaker during the latter part of the nineteenth century and a close friend of many of the leading Japonistes. He met Philippe Burty early in his career (at the School for Oriental Language, ca. 1867); both men shared a fascination for Japanese objects. Somm's true personality can be seen in his designs for menus, address cards, and other illustrations which were frequently done in the Japanese style. He did illustrations for the periodical *L'Art* which document Japonisme.

Somm was also a member of the "Chat Noir" circle and his Japonisme-style prints were found in their 1885–86 album and in their journal of prints.

Henry Somm.

61a *Japonisme* (See Fig. 1a).
Etching, 1881.
9-1/2 x 12-1/2 inches (24 x 31.8 cm.).
Béraldi 35.
Paris, Bibliothèque Nationale, Cabinet des Estampes.

This is one of the most intriguing of the prints dedicated to Japonisme, since it visualizes the romantic aura that surrounded Japan in the early 1880's. The small Japanese figures posed on top of print albums and holding a fan and lantern illustrate the accessories which were collected by fashionable Parisians in their quest for exotic objects from the Far East. The dreamy expression on the young woman's face shows how the romantic myth of the mysterious and curious Orient was perpetuated by artists, like Somm, in visual form.

Henry Somm.

61b *Woman in Framed Area Surrounded by Japonisme Objects* (See Fig. 1b).
Etching, undated.
11-5/16 x 8-11/32 inches
 (28.7 x 21.2 cm.).
Béraldi, possibly 37.
Paris, Bibliothèque Nationale, Cabinet des Estampes.

Here a fashionably dressed woman, situated within a framed vignette, is surrounded by objects suggestive of Japonisme. The symbolism of the print is enhanced by the Oriental accessories—fan, album, marsh setting—perpetuating the romantic lushness France frequently associated with the Far East. The small Japanese figure obviously is the source of impressions associated with Japan and intriguing to Parisian women.

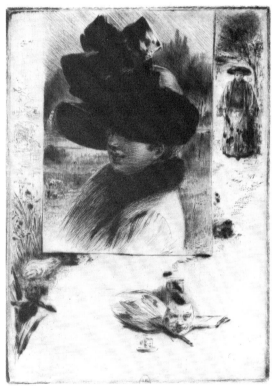

61b

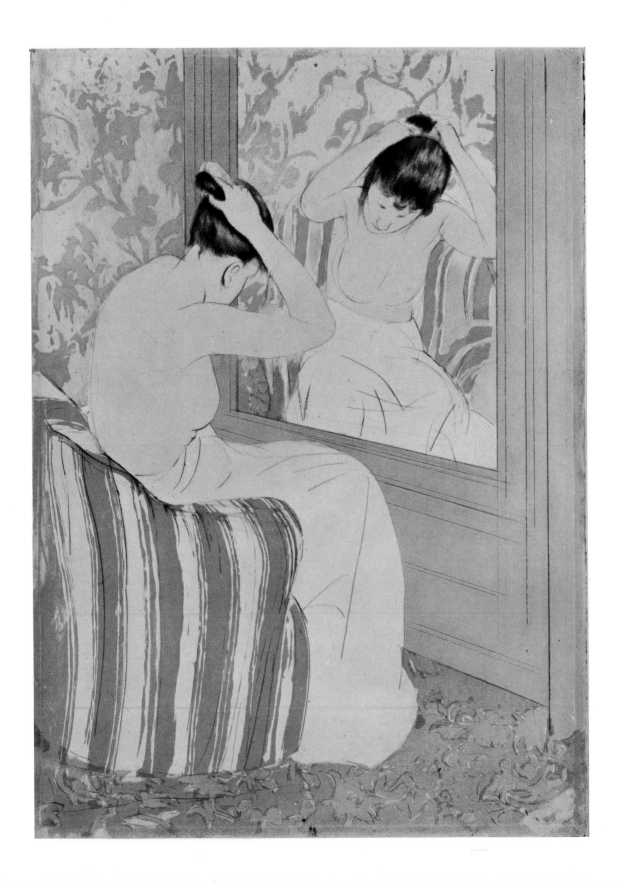

II. Japanese Influence on French Prints 1883-1910

Phillip Dennis Cate

The Growth of Japonisme by 1883

On April 10, 1883, the first major retrospective exhibition of Japanese art in the Western world opened in Paris at the Gallery of Georges Petit, on the Rue de Sèze. It was comprised of paintings, ink drawings, bronzes, lacquers, woodblock illustrated albums, and prints dating from the ninth century through 1868 (the year of the Meiji restoration). The exhibition was organized by Louis Gonse, Director of the *Gazette des Beaux-Arts;* the art objects were borrowed from the rich private collections of such longtime Japanophiles as Gonse, Philippe Burty, Samuel Bing, Théodore Duret, and Alphonse Hirsch. There had been, of course, other large exhibitions of Japanese art in Paris before 1883 — the Paris Universal Expositions of 1867 and 1878; both included displays of Japanese art and industry, but neither had the scale nor the scope of the exhibit at the Georges Petit Gallery. A few months later Gonse followed his exhibition with the publication of a two-volume history, *L'Art Japonais* [178].[1] He hoped, with these two complementary projects, to offer the first fully detailed account of Japanese art — and certainly, in the words of Paul Mantz, the 1883 exhibition was "a source of astonishment and a lesson for all serious Parisians."[2]

Since 1868, articles by Astruc, Chesneau, Burty, and Duranty had served as general introductions to the history of Japanese art, but it was not until the year 1882–83 that the writings of Duret and Gonse initiated a much-needed period of intellectual evaluation and scholarly documentation of the recently accumulated knowledge on the art of Japan.[3] In the area of woodblock prints, for example, Hokusai was still, in the early 1880's, the Japanese artist most highly esteemed by French critics. "He is therefore of the past; he is also of the future, for his talent is of the most eloquent modernity."[4] But the merits of other Japanese printmakers were beginning to be considered as well. Gonse states in *L'Art Japonais* that "Hiroshige is, after Hokusai, the most original and most fecund painter of the nineteenth century; he is also the greatest painter of landscapes";[5] and he notes that by 1830–40 Keisai, Hiroshige, Kunisada, and Kuniyoshi were the most important figures in "l'art populaire" of Japan.[6] Later in his study Gonse praises the work of Shunsho, Toyokuni, and many of their lesser nineteenth-century followers. He also includes a brief, but special, reference to

Utamaro. There are, to be sure, many fundamental gaps in Gonse's and his contemporaries' coverage of Japanese print history. Gonse, for instance, makes only a very general reference to pre-eighteenth-century printmakers and ignores entirely such major eighteenth-century figures as Harunobu, Sharaku, and Kiyonaga. However, these omissions of Japanese printmakers in the literature on Japanese art do not necessarily preclude the availability of their prints in France. Moreover, by the early 1890's such literary discrepancies would be corrected by the efforts, in particular, of Samuel Bing and Edmond de Goncourt, and the major figures in Japanese print history would be placed in proper perspective.[7] Nevertheless, by 1883, the major themes and styles of *ukiyo-e* prints were known and appreciated in France.

It is important to recognize that there was in the second half of the century a close interconnection between artists, critics, and collectors interested in Japanese art. Each had something to offer the other: the objects themselves, the knowledge to write about them, or the ability to reproduce them. Henri-Charles Guérard (1846–1897) collaborated with Gonse in the production of *L'Art Japonais* by illustrating it with eleven full-page etchings and over two hundred drawings of many Japanese objects and prints from various private Parisian collections.[8] By the 1880's Guérard had, in fact, replaced Jules Jacquemart as the predominant etcher-illustrator of art objects. Guérard, however, was also a "modernist, impressionist, devotee of Manet, landscape-painter, seascape-painter, Japonist, whimsical, alchemist. . . ."[9] Beyond the illustrations for *L'Art Japonais* his Japonisme, as realized by his Franco-Japanese caricatures of the mid-1880's for menus [87], calendars [89], invitations, and fans [88], reflects the spirit of comic-fantasy found in Hokusai's *Manga* [67f]. At times he also reveals a knowledge of Japanese compositional devices [93].

It was also in 1883 that Félix Buhot (1847–1898), an etcher known for his rich atmospheric depictions of London and Paris [99], published *Japonisme-Dix Eaux-Fortes* [96a-i], a series of ten etchings depicting a selection of Japanese objects from Burty's private collection. All but one of the etchings [96g] were executed in 1875, four were reproduced in an 1878 article by Duranty, and all of the actual objects were included in the 1883 retro-

spective exhibition.[10] The publication of the Japonisme series was a concerted effort on the part of Buhot to relate his work to the other Japan-oriented activities of the year.

The Japonisme of Félix Buhot

The term Japonisme made its literary debut in 1872 as the title of six articles by Burty.[11] Burty implied that Japonisme was the process of understanding Japanese art, culture, and life solely through visual contact with the art of Japan. Later, in an 1887 article on Buhot written in English for *Harper's New Monthly Magazine*, Burty defined Japonisme succinctly in a reference to Buhot's series of ten etchings:

> I placed at his disposal some of the choicest specimens from my collections of Japanese objects, which might guide him in the difficult rendering of forms, colors, or substances, and he etched some ten of them in a manner of which he may still be proud . . . Japonism — a new word coined to designate a new field of study, artistic, historic and ethnographic — has never had a more intelligent or exact interpreter.[12]

At the time of its appearance, Buhot's Japonisme series was often compared with the reproductive work of Jacquemart. However, when one considers the series in the context of Burty's statement, one realizes that its creation had a purpose for Buhot which went beyond mere imitation — the purpose of understanding and experimenting with Japanese aesthetics.

The term Japonisme was used by Buhot in the title of a work produced as early at 1875, the year he began etching the Burty collection. The work, a painted fan entitled *Japonisme, aquarelle,* was the first by Buhot to be accepted at the Salon, and it was "characterized by a spiritual inspiration that had been created by the vogue, still in its beginnings of paintings, sculptures and silks from the far East."[13] That year Buhot also entered two prints, *Japonaises* [97]; the preceding year he had etched *Cavalier Japonais,* after a work in the Bing collection, and in 1876 he created several business cards with Japanese themes for two Oriental-import shops, Sichel and Labric [98]. This involvement with Japanese art so early in his etching career was to have a significant impact on his future aesthetic concerns.

A letter to Octave Uzanne dated April 4, 1883, reveals Buhot's growing enthusiasm for and knowledge of Japanese aesthetics. After referring to a visit to an Oriental-import shop on the Rue de la Victoire, Buhot exclaims, "J'ai vu là des *délicieux* Japons."[14] The letter also describes in detail the still-to-be-published Japonisme series, and surrounding this description is a quick landscape sketch very much in the style of a Hokusai brush drawing (Fig. 13). Throughout the design are exotic touches of silver and gold pigment, creating an effect and richness similar to that found in Japanese surimono prints.

Gonse observed that "surimonos are the most marvelous prints that one can imagine; delicate goffering, shades of gold, silver, bronze and pewter generally heighten their vividness" [83].[15] In 1883 Gonse had known of 250 such prints in private Parisian collections. These delicate woodcuts, enlivened with subtle textures and reflective qualities by the application of fine metallic pigments, must have had a great appeal to Buhot. He was constantly experimenting with various papers and inks, as well as with aquatint, roulette, and drypoint techniques, in order to bring to his prints a variety of pure textures often unrelated to the objects depicted.

It was in the Japonisme series that Buhot's interest in paper, textures, inks, and qualities of the Japanese surimono first met. On an artist's proof of the series *Ex libris,* Buhot refers to his plans for the ten etchings: "I searched for various plays of nuances for each plate and for this edition on Japan paper, especially. The title will be printed in sanguine and the *Ex Libris* in violet."[16] In other proofs he experimented with a wide range of Oriental color combinations, metallic pigments, and papers.[17] The effects of these experiments upon Buhot's later work are subtle and intermittent.

In 1884 Buhot used gold pigment for the first time, without direct reference to Japanese subject matter, in a print of the *Petit enterrement* [100]. It is a small, delicate etching printed in blue, depicting little figures with umbrellas in a funeral procession scurrying down the rain-drenched Boulevard de Clichy.[18] Gold has been applied to the sky, adding a wonderfully luminescent quality and suggesting the brilliance of the sun as it breaks through the clouds and produces a rainbow. As if to herald this brilliance, Buhot has painted on the

The Renaissance of Printmaking

By the end of the 1880's various collections and events in Paris offered artists a greater knowledge of and access to Japanese prints. Samuel Bing's Oriental-import shop at 22 Rue de Provence became the place for Van Gogh, Bernard, Anquetin, and others to gather and acquaint themselves with Oriental woodcuts. It was, in fact, from the Bing collection that Vincent and Theo Van Gogh organized their 1887 exhibition of Japanese prints at the Café Tambourin, situated in the heart of the artists' quarters of Montmartre. In 1888 Bing put on an even more extensive display of Japanese prints in his shop, and in May of that year he published the first issue of his journal *Artistic Japan* [179–180], which for these years presented fully illustrated articles in color and in black and white on all aspects of Japanese art.[20] The 1889 Universal Exposition in Paris presented a major display of the art of Japan and was followed in 1890 by a comprehensive exhibition at the Ecole Nationale des Beaux-Arts of 725 Japanese prints representing a visual history of *ukiyo-e* prints from the early seventeenth century through 1860.[21]

All of these activities could hardly have been overlooked by printmakers of the time. Indeed, by 1889 the aesthetics of the Japanese print began to play a dominant role in the printmaking renaissance occurring in Paris. Already Japanese prints had stylistically influenced French painting, and they would continue to reinforce and guide the avant-garde, led now by Gauguin and his *Nabis* followers, in their efforts to achieve a flattened pictorial space and a concentration on surface pattern. Now the Japanese print had also become the fundamental influence on woodcut printing and the initial influence on the color printmaking movement.

André Mellerio, the chief editor of the Parisian art journal *l'Estampe et l'Affiche,* was one of the most vocal and enlightened supporters of the renaissance of printmaking. Others who shared his interest included Roger Marx, the critic; André Marty, the publisher of *L'Estampe Originale;* Ambroise Vollard, Director of the Galerie Vollard and publisher of albums of original prints; and the Natanson brothers, Alexandre and Thadée, founders of the art and literary review *Revue Blanche.* These were the men who first recognized and then promoted and sustained the creative printmaking

margins a simple pattern of birds in flight.[19] Later, in 1887, in *Baptême Japonais* [102] and in *Le Château des hiboux* [101], delicate floral and bird patterns are stenciled within areas of aquatint in a manner suggesting that found in an eighteenth-century album of stenciled and colored woodblock illustrations by Sekkosai [64].

Although the *Petit enterrement* does not depict a Japanese subject, it does reveal a more than superficial association with the content of nineteenth-century *ukiyo-e* prints. The motif of scurrying figures subject to the vagaries of the weather and under a pattern of umbrellas is typical of that found in prints from Hokusai's *Manga* [67e] and Hiroshige's *Fifty-three Stations on the Tokaido* and *One Hundred Views of Edo* [76]. In spite of its topic, much of the charm and delight of the *Petit enterrement* as well as that of Buhot's other cityscapes is derived from a characteristic basic to many nineteenth-century Japanese prints — the lively and spirited depiction of man and his natural environs.

efforts, primarily in color lithography, of the young avant-garde. In 1898 Mellerio wrote:

> It seems in particular that the original colored lithograph, since it had not existed previously in the conditions in which we recently saw it flower, is the special production of art in our era. . . . Two influences appeared to have determined again the movement toward color. On the one hand, the school called Impressionism. . . . Add to that Japanese art. . . . There, in a very definitive form with varied and seductive aspects in its curious printings triumphed the color print.[22]

The Woodcut and the Beginning of the Color Printmaking Movement: Lepère, Rivière, Cassatt and Vallotton

Although the processes of color engraving, color etching, and color lithography had been known at least since the first quarter of the nineteenth century and were often used for commercial reproductive purposes, there was in France no sustained or pervasive period of artistic activity in color printmaking before the end of the century. Original black-and-white lithography and etching both had their periods of glory in the early and mid-nineteenth century, respectively — indeed, these movements were reflected in works produced by the major artists of the time, including Delacroix, Géricault, Millet, Daubigny, Manet, and Degas. While there was certainly a great renewal of interest on the part of artists in black-and-white lithography in the late eighties and the nineties, it is particularly significant that this same period witnessed not merely the renewal, but rather the birth, of a movement of original color printmaking in France.[23] Of course, one cannot ignore the polychrome lithograph of *Punchinello* produced by Manet in 1874 nor the vast number of color lithographic posters produced by Chéret in the seventies and eighties. However, these are isolated cases that failed to stimulate to any great extent further activity in the color print medium.[24] It was not until 1889, twenty years after Chéret's first poster, that other French artists began to create color prints and a movement was born. This movement, which was to gain momentum in the 1890's, was promoted, not by the posters of Chéret, but by the seductive charm of the color-woodcut prints of Japan.

Auguste Lepère (1849–1918) and Henri Rivière (1864–1951) produced their first color prints in 1889. These were in the medium of woodcut rather than lithography. In the 1870's Lepère was a reproductive wood engraver for the journal *Le Monde Illustré*. By 1880 he was producing original wood engravings for the journal and had become quite popular for his free and personal interpretations of Paris. Nevertheless, wood engraving implemented by the use of the burin is, even as practiced by Lepère, a linear technique used to create a halftone effect to indicate form and perspective. In contrast, the Japanese woodcut is a planar technique with strong emphasis on contour but no modelling. By 1889 Lepère had come to the conclusion that the art of wood engraving as generally practiced in nineteenth-century France was stylistically too imitative of metal engraving and etching, and that in order to reveal the essential character of wood he would have to replace the burin with the pen knife and cut out the wood instead of engraving it, thus creating a design in relief. *Marchandes au panier* (L.-B. 187), a depiction of women under a doorway selling produce, is Lepère's first woodcut and his first print in color. The subject and composition are Western, but the simplification of technique, the elimination of halftone, and the broad bold lines, cut by a pen knife, are inspired by the Orient.[25]

Various color woodcuts were to follow, each using the essential line block to describe the design but becoming more complicated in the printing procedure with the use of four to eight additional blocks to juxtaposition and superpose color. Another important element introduced by Lepère was the use of water-base pigments enabling him to approximate the subtle wash effects of Japanese color prints. His designs, meanwhile, continued to become more simplified and more akin to Japanese compositions.

Of Lepère's prints from this period, *La Convalescente: Madame Lepère* [103] is probably the most striking and most evocative of Japanese woodcuts.[26] In it are apparent many characteristics of Hiroshige's prints, particularly those from his series *Eight Views of Biwa* (Fig. 14) and *One Hundred Views of Famous Places in Edo* [78]. The subtle areas of pink and blue wash in the sky, the high horizon which pulls the background forward with a pattern of merging planes defined by the sea and sandbars, and the rhythmic zigzag arrangement of

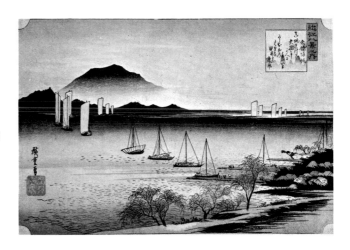

Figure 14. *Fishing Boats Returning to Yabase*
from *Eight Views of Biwa*. Colored woodcut, oban, 9-1/8 x
14 inches (23.2 x 35.5 cm.). Ando Hiroshige.
The Brooklyn Museum, Frank L. Babbott Fund.

men and sailboats silhouetted against the sea and sky are strongly reminiscent of the work of Hiroshige. A particularly obvious parallel occurs in the dramatic placement of Madame Lepère against the frontal plane. There is no middle ground; instead there is a conflation of space between the figure and the distant seascape. It is exactly this kind of dynamic composition which highlights Hiroshige's series of *One Hundred Views*.

The Japanese print also affected Lepère's later work in various media. The manner in which he creates a pronounced diagonal composition continuing out of the picture plane [104], or a vertical print with foreshortened figures cut by the side margins [106], or a rain-drenched landscape with a high horizon [105], or a still life of shrimp [108], has obvious parallels in Japanese prints.

Rivière's first color print was a seven-block woodcut of 1889 entitled *Chantier de la tour Eiffel*.[27] It was one of eventually three woodcuts made for what in 1902 became the series of color lithographs entitled *Les Trente-six vues de la tour Eiffel*.[28] The drawings for this series were executed between 1888 and 1892. The series depicts the various stages of construction and completion of the Eiffel Tower, erected in 1889 as the symbol of modern technology for the Paris Universal Exposition. As Rivière watched the tower gradually rise above the Paris horizon, it became for him comparable in grandeur to Hokusai's Mount Fuji. In fact, the title, the theme, and much of the style and format were inspired by Hokusai's *Thirty-six Views of Mount Fuji*. However, Hiroshige's systems for depicting landscapes also influenced Rivière (cf. Figs. 15, 16), and it is the style of Hiroshige, not Hokusai, which inspired in *Les Trente-six vues de la tour Eiffel* such bold compositions as *Dans la tour* [cf. 78 and Fig. 17].

Middle: Figure 15. *The Tower Under Construction, View from the Trocadero (La Tour en construction, vue du Trocadero)* from the series *Thirty-six Views From the Eiffel Tower (les Trente-six vues de la tour Eiffel)*. Color lithograph, 6-11/16 x 8-3/8 inches (17 x 27 cm.), 1888–1902. Benjamin Jean Pierre Henri Rivière. New York Public Library, Prints Division.

Bottom: Figure 16. *The Gion Temple in Snow* from *Famous Places of Kyoto*. Color woodcut, 8-11/16 x 13-15/16 inches (22 x 35.4 cm.), 1830, published after 1835. Ando Hiroshige. Philadelphia Museum of Art, Gift of Mrs. Anne Archbold.

Catalog 78. *Moon Pine at Ueno* from *One Hundred Views of Edo*. Ando Hiroshige.

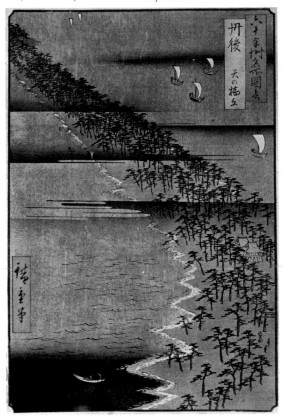

Figure 18. *Ama-no-hashidate* from *Sixty-odd Famous Places of Japan*. Colored woodcut, 1854. Ando Hiroshige. Tokyo, Courtesy of Susumu Uchiyama.

For some reason the series was not continued in wood. However, from 1890 through 1892 Rivière produced another essentially Japanese-inspired series of six woodcuts, *La Mer: études des vagues*, and from 1890 through 1894 he made a much larger set for forty woodcut prints of landscapes of Brittany [109].[29] In 1893 Louis Morin observed that "Rivière prints in colors from blocks. He has been greatly struck by the distinction of the Japanese prints from blocks and has studied their systems and invented others until he can now render French scenes and landscapes as Okousai, Troschigne, and Outamaro [*sic*] might have rendered, a century or two ago, the scenes and landscapes of Japan."[30] For all his woodcuts, Rivière adopted the Japanese method of using pear-tree wood in place of box-wood, and he cut the design on the grain of the plank and not, as with wood engraving, on the end grain. Like Lepère, Rivière also experimented with water-base pigments and printed on rice papers and other absorbent papers. However, unlike the Japanese, who divided the labors of the print among the designer, the cutter, and the printer, Lepère and Rivière designed, cut, and printed their woodcuts themselves.

What is significant in the woodcuts produced by Lepère and Rivière during the late eighties and early nineties is the discovery of a system of color printmaking essentially foreign to the West. In 1891 Mary Cassatt attempted to duplicate this system in her well-known series of ten color-etchings. The previous year she had been impressed by the exhibition of Japanese prints at the Ecole Nationale. She visited the show many times and purchased some of the color prints to hang in her home.[31] This contact had an immediate effect on the composition of several of the later works in her 1889–91 series of twelve drypoints. These reveal a more intimate involvement with Japanese themes [114] and spatial devices, such as reverse perspective systems and an overall emphasis on two-dimensional design [115]. It is Cassatt's color prints [116-119], however, that represent the supreme achievement deriving from her contact with Japanese prints. In a letter to Frank Weitenkampf, Curator of Prints at the New York Public Library, she describes the procedure used in the creation of these remarkable color-etchings:

I drew the outlines in drypoint and laid on a ground where color was to be applied, then colored 'a la poupée.' I was entirely ignorant of the method when I began and as all the plates were colored by me, I varied sometimes the manner of applying the color. The set of ten plates was done with the intention of attempting an imitation of Japanese methods.[32]

Using as many as three plates, this system allowed her to approximate in texture and in simplicity Japanese color woodcuts. Her composition, color schemes, and juxtaposition of varied color patterns, as well as her themes — of mother and child and of the toilette — reflect especially the influence of the eighteenth-century Japanese masters Harunobu and Utamaro.[33]

Another printmaker who must surely have known of the woodcuts of Lepère and Rivière was Félix Vallotton, who produced his first woodcuts in 1891 by using the Japanese system of cutting along the grain of pear wood.[34] However, Vallotton was not attracted by the color of Japanese prints but rather by their stark contrasts of values and by their asymmetry — mechanisms that created forceful compositions with an emphasis on the frontal plane. His production of woodcuts, all in black and white, began in 1892 with a series of six mountain landscapes containing specific Japanese themes and compositional devices as well as the rectangular cartouche motif enclosing his titles. *Glacier du Rhône* [120], with its strong contrasts of black and white and its rhythmic parallel curvilinear cuts, has a Japanese counterpart in Hokusai's woodcut sketch of rock formations [67b]. By 1894, in *La Manifestation* [122], Vallotton would carry to its extreme the Japanese motif of figures scurrying into the distant landscape. The print is abstracted to a simple pattern of black patches of figures against a white background. The large white void in the foreground, exaggerating the composition's asymmetry, intensifies the forceful rush of struggling demonstrators who merge as a black mass streaming up and off the picture plane in the manner of Hiroshige's composition in *Ama-no-hashidate* from *Sixty-odd Famous Places of Japan* (Fig. 18).

As in the case of Japanese prints, large areas of empty space countered by figures in silhouette are important elements in Vallotton's compositions. In *L'Argent* [124], produced in 1898, the man in profile is partially cut off by and emerging from a black

void which covers three-fourths of the print. The dramatic relationship of figure to space is an exaggerated application of compositional principles found in pillar prints [62] and actor prints of Japan (Fig. 19).[35] In each type of print, woodcut, lithograph, or zincograph [121], Vallotton integrates qualities of the Japanese woodblock with his own concerns for simplification and adherence to the frontal plane.

The renewed integrity in France of the woodcut, stimulated by the contact of French artists with Japanese prints, reached its apex in 1896 with the publication of *L'Image*, a review of art and literature founded by *La Corporation Française des Graveurs sur Bois*.[36] For its one year of existence, *L'Image*, under the artistic direction of Tony Beltrand, Auguste Lepère, and Léon Ruffe, was illustrated and decorated solely in the media of wood engraving and woodcut by such artists as Lepère, Vallotton [123], De Feure, and Auriol.

The Influence of Japanese Color Prints on Lithography

By 1889 lithography, which had begun its official come-back in 1884 with the organization of the *Société des Artistes Lithographes Français*, also began to fall under the spell of the Japanese color print. Gauguin's 1889 series of eleven zincographs depicting scenes of Brittany, Arles, and Martinique

was exhibited at the *Galerie Volpini*, a cafe at the Universal Exposition. Many of these prints reveal Gauguin's reliance — also characteristic of his paintings at this time — on Japanese motifs and compositions.[37] The series is printed on yellow paper, a not uncommon practice for the Japanese, and is dominated by aspatial compositions. This latter characteristic is especially obvious in *Baigneuses Bretonnes* [126] and *Misères Humaines* [127] where, in the manner of prints by Harunobu, Koryusai, and Choki (Fig. 20), Gauguin brings the background, middleground, and foreground onto the same plane by the use of an extremely high horizon, further emphasizing the frontal plane by his bold foreshortening of figures and landscape elements. Other particularly Japanese elements, such as curvilinear design, whiplash waves, and the actor-portrait concept, are integrated into these two works. Gauguin's dramatic interpretation of Edgar Allen Poe's *Descent into the Maelstrom* [128] relies on the Japanese fan design as a compositional means of compressing the energy of disaster, while on the other hand *Les Cigales et les fourmis* [125] is based on the kind of serene composition and theme found in *Visitors to Enoshima* (Fig. 21), a triptych by Kiyonaga. Both Kiyonaga and Gauguin use a frieze-like formula placing figures on a beach, in relief, against a gentle seascape. The inter-relationship of figures in both prints is similar,

Figure 21. *Visitors to Enoshima.* Triptych, woodcut, 13-3/4 x 9-1/2 inches (34.9 x 24.1 cm.); 13-7/8 x 10-1/4 inches (35.8 x 26 cm.); 13-3/4 x 10 inches (34.9 x 25.4 cm.). Torri Kiyonaga. Boston, Museum of Fine Arts, Nellie P. Carter Collection.

and the vertical intrusions of poles and trees, respectively, emphasizes the frontal plane and generates a smooth, calm rhythm moving on a slight diagonal across the print. Gauguin found in the Japanese print not only all the various moods of nature he wished to express but also a means, corresponding with his aesthetic ideals, to express them.[38]

The avant-garde theater *Théatre Libre,* founded in 1887 by André Antoine, began in 1888 to have its programs illustrated and soon became a vehicle for original color lithography.[39] The following season Paul Signac, Henri Rivière, and George Auriol produced the theater's first full-color lithographs.[40] Signac's design is a pointillist color scheme, but the other two relate to Japanese works. Rivière's program [111] is a direct take-off on the format of Japanese woodcut albums like the *Manga* by Hokusai [67e], while Auriol's floral design [130] is similar to various illustrations of Japanese designs found in Bing's *Artistic Japan* (Fig. 22). It may even be that Auriol used this journal as a constant reference for Japanese designs, as Van Gogh may have done in 1888 and as Vallotton surely did in 1897 [123].[41] In other works by Auriol, such as the border illustrations in Louis Morin's *French Illustrators of 1893* (Fig. 23), the actual format of the pages and the Japanese-like motifs relate strongly to those found in various issues of Bing's journal [179].

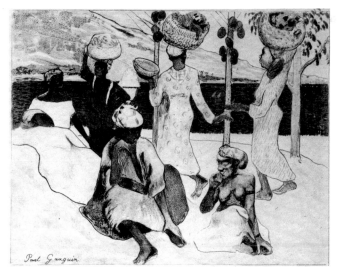

Catalog 125. *The Grasshoppers and the Ants (Les Cigales et les fourmis).* Paul Gauguin.

61

Catalog 130. *Floral Design* from *Théâtre Libre Program,* *1889–90*. Georges Auriol.

L'Estampe Originale

From March of 1893 through early 1895 André Marty, Director of the *Journal des artistes,* published *L'Estampe Originale,* a quarterly album of original etchings, woodcuts, and lithographs.[42] The publication is remarkable for the consistently high quality of its prints by new as well as established artists and also for Marty's almost clairvoyant selection of young artists who within a few years would become leading artists of France. Representing the work of seventy-four artists, *L'Estampe Originale* establishes a significant correlation between Japanese prints and innovative printmaking in France.[43] Out of a total of ninety-five prints, thirty-six are in color, and twenty-two of these reveal Japanese influence. Included among the latter are works by Rivière, Lepère [106], Auriol, Vuillard, Bonnard, Lautrec, Ranson [137], Roussel [138], Denis, Jossot, Rachou, Houdard, and Grasset [134] Obvious examples of Japonisme are Jossot's comic interpretation of Hokusai's *Great Wave off Kanagawa* [136; 68] and Rivière's variant on the wave motifs of Hiroshige and Hokusai [112]. In other cases Utamaro's influence dominates: for example,

Far left: Figure 22. *Drawing of Flowers* from *Artistic Japan* (August 1889), page 33. Anonymous, Japanese.

Left: Figure 23. Page 7 of Louis Morin's *French Illustrators* (New York: Charles Scribner's Sons, 1893). Georges Auriol. New York Public Library, Prints Division.

in Bonnard's *Scène de famille* [152], Ranson's *Tigre dans les jungles* [137], Houdard's *Grenouilles* [135], and Rachou's *Panneau décoratif* [141].[44] Besides influencing color prints, Japanese woodcuts were also the basis for Auriol's woodcut preface design [131], the gypsographs of Pierre Roche [139], and the embossed prints of Alexandre Charpentier [140].

Lautrec's cover for the first year of *L'Estampe Originale* [164] serves as a symbol of both the renewed activity in printmaking and the Japanese influence on that art. It depicts Jane Avril examining a proof from the press of "Le père Cotelle," master printer for the shop of Ancourt. The subtle olive, beige, pink, and yellow color harmonies are reminiscent of the work of Kiyonaga (Fig. 21). The calligraphic drawing, Jane Avril's bleached face in three-quarter view, her volumeless body lost within the spread of her cloak [82], and the diagonal and two-dimensional emphasis of the uptilted printing press are lessons well learned from the Japanese.

Japonistes of the 1890's:
Denis, Bonnard, Vuillard, and Lautrec

There is no question but that a sophisticated visual knowledge of all aspects of Japanese prints was available to the artists of the 1890's. It was the work of Denis, Bonnard, Vuillard, and Lautrec which dominated in quality and quantity innovative printmaking during the last decade of the nineteenth century in France, and the Japanese woodcut directly inspired the initial prints of these four artists and had a sustained and essential influence on their graphic art.

Coming out of the *Nabi* milieu, with its stress on decorative qualities of line and color, Denis, Bonnard, and Vuillard already had a predilection for the Japanese woodcut. As early as 1889 Denis had used the medium of woodcut with broad cuts and stark contrasts for the preliminary illustrations of Paul Verlaine's *Sagesse* [146]. Decorative arabesques and sinuous contours dominate his work of the early nineties. They are especially evident in his illustrations of André Gide's *Voyage d'Urien* [148] where, for instance, figures with Japanese features and carrying Japanese umbrellas merge with the elaborate patterns of whiplash flags in the foreground. Compositionally, Denis' prints of the late

eighties and the nineties are almost exclusively concerned with the close confinement of figures and descriptive elements against the frontal plane. There is virtually no attempt at a traditionally Western perspective scheme; background elements such as trees and sailboats become mere decorative patterns [149]. Often, truncated figures or objects emerge from the bottom border and are silhouetted against a high horizon in the manner of prints by Utamaro, Kiyonaga, and Choki [150].

Because of his kinship with Japanese stylist qualities Bonnard was dubbed by his fellow *Nabis* "Le Nabi très Japonard."[45] His graphic work of the nineties reveals a wide range of Japanese characteristics encompassing the bold figure groupings of Utamaro [152], the lively woodcut sketches of Hokusai, and the urban perspective views of Hiroshige. Bonnard also uses the technique of wash lithography introduced by Alexandre Lunois [133] to young fellow artists in the workshop of the printer Clot.[46] By using a liquid tusche, the quality of Japanese water-base inks could be duplicated in lithography. Bonnard uses a liquid lithographic ink in *Scène de famille* [152] and by this technique, combined with his limited tonal range of subtle greens, pinks, and browns and his flat overlapping figures, he creates the equivalent of an Utamaro [65].

Generally in the 1890's the white of the paper became a positive compositional element in French prints; this characteristic is apparent in the work of Vallotton and Lautrec. In *Au Cirque, la haute-école* [153] Bonnard allows the white of the paper to set off the smooth, rhythmic arrangement of the various stances of horse and rider very much in the manner of Hokusai's study of the same subject in the *Manga* [67d]. This active intrusion of the paper in the composition of Bonnard's prints along with his spirited, almost caricature rendition of people and animals creates the kind of warmth and liveliness inherent in Japanese prints. This quality is best evidenced in the album of twelve lithographs, *Quelques aspects de la vie de Paris.* Here, reflecting Hiroshige's conception of *One Hundred Famous Places in Edo*, Bonnard depicts the daily activities of the city from various vantage points and subject to various forces of nature. From bird's-eye views [156], uptilted vistas, and foreshortened perspective schemes [158], the bustle of Paris comes to life. Dogs and people, in silhouette, scurry through

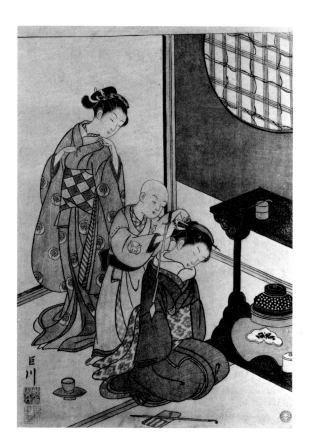

Figure 24. *Evening Rain at the Daisu.* Colored woodcut,
11-1/4 x 8 inches (28.6 x 20.3 cm.), 1765.
Suzuki Harunobu. Metropolitan Museum of Art,
Frederick Charles Hewitt Bequest Income, 1912.

the street, hawkers sell their wares [155], and
coachmen transport their passengers [157]; Paris is
the Edo of the West and Bonnard its Hiroshige.

Vuillard, too, in his 1899 album *Paysages et in-
térieurs,* took his cue from the Japanese predilec-
tion for suites of prints dealing with views of Japan
and with the mores and customs of *ukiyo-e* life.
His spatially complicated, floral wall-papered in-
teriors [161] evoke the charm achieved by Har-
unobu in his series *Eight Views of Indoor Life* (Fig.
24). Stylistically, as Colta Ives has indicated, Vuil-
lard is much indebted to Hokusai and Hiroshige for
various compositions and motifs found in the
Paysages series.[47] And, as was the case with others
of the period, his reliance on Japanese prints was
not a brief flirtation but rather a sustained relation-
ship throughout the decade of the 1890's. Japanese
influence is apparent in Vuillard's very first print,
the *Sower* [159], an 1890 color-lithograph for the
Théatre Libre. The format is that of a geometrically
segmented Japanese woodcut [86]. The calli-
graphic arabesque of the lettering ''Théatre Libre''
is echoed by the bold contours of the sower, tree,

and worms. The ''sower'' of course, has anteced-
ents in the work of Millet and Van Gogh, but the
surface pattern, the spatial ambiguity, and the geo-
metric organization of the composition are derived
from Japan. By the end of the decade, Vuillard's
strongly delineated contours and arabesques
would disappear; the influence of Japanese wood-
cuts would become less obvious. However, in *Sur
le pont de l'Europe* [160] the spatial ambiguity and
the confinement of overlapping figures against the
picture plane subtly reveal the artist's continued
reliance — as late as 1899 — on Japanese sensi-
bilities.

Henri de Toulouse-Lautrec's fascination for Jap-
anese art began in 1882 when he was introduced to
''some splendid Japanese bibelots'' by the Amer-
ican painter, Harry Humphrey Moore, a fellow
student at the studio of Léon Bonnat.[48] This fascina-
tion grew during the eighties as Lautrec visited the
1883 Japanese retrospective exhibition at the
Georges Petit Gallery, mingled with such artists of
Montmarte as Van Gogh and Bernard, and joined
his friend, Henri Rachou, as a collector of Japanese
Kakemonos, statuettes, and prints.[49] It came to a
climax in the early nineties when he began spend-
ing entire days at the print shop of Goupils study-
ing the work of Hokusai, Utamaro, Kiyonaga, and
Harunobu and learning to read and reproduce their
signatures.[50]

In his first graphic work, the lithographic poster
La Goulue au Moulin Rouge [162], Lautrec revo-
lutionized the art of poster-making by borrowing
compositional systems from the Japanese woodcut
to negate illusionistic space and unite the pattern
of pictorial elements with that of the lettering; the
globes of light, ''la Goulue,'' and the audience in
top hats are forced onto the frontal plane by the
uptilted perspective lines and by the use of pure,
flat areas of color outlined in black in a manner
similar to that used in the lettering. The calligraphic
depiction of the dancer, Valentin, is comparable in
form and content to the portraits of Sharaku [63].
The Japanese portraits of Kabuki actors are boldly
silhouetted in profile against a neutral background;
in the eighteenth century, with the work of Shar-
aku, these portraits also began to emphasize the
individual personality of the actor. Lautrec based
his poster of Bruant [167] on this very straight-
forward and elegant format of the Japanese.

In other works Lautrec's penchant for the subtle

yellows and olive-greens and the elegant females of Kiyonaga is revealed.[51] This is especially evident in *Le Divan Japonais* [163]. Here the long, sleek body of Jane Avril and the figure of Dujardin lie as curvilinear patterns on the same plane as the sinuously and monochromatically delineated grey orchestra, yellow stage, and decapitated body of Yvette Gilbert.

A popular printing technique in the nineties, especially with Lautrec and Henri Ibels, was *crachis*: a method of applying a fine spray of ink onto a lithographic stone with a toothbrush. Jules Chéret also used *crachis* in his posters, but Lautrec's work, unlike Chéret's, takes on not only an atmospheric quality but also a textural one, and relates more closely to the Japanese system of *fuki-botan*. Three eighteenth-century woodcut albums by Sekkosai, recently purchased by the Philadelphia Museum from the Henri Vever Collection, combine the techniques of woodblock printing, stencil and hand-coloring, and *fuki-botan* — a blowing or atomizing process of ink application [64].[52] Lautrec used *crachis* in his black-and-white lithograph of *Miss Loie Fuller* [168]. He also hand-colored the print and, in the manner of the Japanese in their surimono prints, applied a gold metallic pigment. His dramatic depiction of Loie Fuller in performance has much the same suggestion of movement, manipulation of drapery, linear rhythm, and flair as the figures in theater posters by Kiyonobu, which — possibly not so coincidentally — were also hand-colored, as was the practice in early Japanese prints. In reality Loie Fuller performed under multicolor electric spotlights wearing an expansive and enveloping gown, the movement of which she directed with sticks and hoops underneath. Lautrec, with the aid of the Japanese aesthetics, caught the essence of her performance. Likewise, with a facile calligraphy, economy of line, and positive integration of the paper with the composition — reminiscent of the ink drawings and sketches of Hokusai — he was able to express the grace and movement of Jane Avril [165] and May Milton [169]. From his first print through his last [170], Lautrec — possibly more than any other artist — assimilated and exploited the stylistic elements and the textural concerns of the Japanese print.

Decline of Japonisme

Despite André Mellerio's optimism of 1898,[53] even by 1897 signs of a decline in French graphic arts were beginning to appear. The original color print rapidly succumbed to commercialism. *L'Estampe Moderne,* a monthly publication of print portfolios, produced (beginning in May, 1897) twenty-four issues containing four color-lithographs each. The publication was an attempt to duplicate, at least in theory, *L'Estampe Originale.* Actually, however, the quality of the prints — even the paper on which they were printed — was generally much inferior to that found in Marty's albums. The avant-garde of the nineties, except for Mucha, were not represented in the albums; as a result, the prints, with a few special exceptions [171–174], were devoid of inventiveness as well as of Japonisme.

By 1900 the renaissance of lithography and the color-printmaking movement had run their course. Vollard produced his last great portfolio of original prints in 1899.[54] Denis' prints after 1900 lost their verve as well as their Japonisme. Bonnard and Vuillard stopped making prints almost entirely until well into the second decade of the twentieth century, and, with the death of Lautrec in 1901, a decade of extreme activity in printmaking had come to a close. Nevertheless, the Japanese print was for half a century a major catalyst to artistic inventiveness in France. Japonisme left to the twentieth century a legacy of graphic art rich in color and in textures, and with a fundamental concern for adherence to the frontal plane.

1. Louis Gonse, *L'Art Japonais,* 2 vols. (Paris, 1883). Wakai and Tadamasa Hayashi, two Japanese art collectors, advised Gonse on Japanese art and history in the publication of *L'Art Japonais.* Wakai lived in Paris, while Hayashi was a frequent visitor from Tokyo and had helped organize the exhibition at the Georges Petit Gallery. Later, in 1889, he amassed a collection of over 400 Japanese surimono prints which are now in the possession of The Metropolitan Museum of Art. His home in Tokyo contained a series of murals painted by Henri Rivière in 1904-5. The color illustrations for *L'Art Japonais* were reproduced by a color photoengraving process newly invented by Charles Gillot who was also a major collector of Japanese prints; see Collection Charles Gillot, *Estampes Japonaises et Livres Illustrés* (sale catalogue, l'Hôtel Drouot, April, 1904).

2. It was ''l'étonnement et la leçon de tous les Parisiens sérieux.'' Paul Mantz, ''Exposition rétrospective de l'art japonais,'' *Gazette des Beaux-Arts*, XXVII (May 1883), 400.

3. Théodore Duret, ''L'Art Japonais,'' *Gazette des Beaux-Arts*, XXVI (August 1882), 113-33.

4. ''Il est donc d'hier; il est aussi de demain car son talent est de la plus éloquente modernité.'' Mantz, p. 410.

5. ''Hiroshighe est, après Hokusai, le peintre de moeurs le plus original et le plus fécond du XIXe siècle; il est aussi le plus grand paysagiste.'' Gonse, II, p. 294.

6. Gonse, II, p. 293.

7. In his discussion on *ukiyo-e* painting, Gonse mentions the work of such pre-nineteenth-century artists as Moronobu, Kiyonobu, Sukenobu, Toyoharu, Toyokuni, Shunsho, Shunman, Shunsei, and Utamaro. Although he had a more detailed knowledge of Japanese painting than of prints, it was still, in 1883, far from complete. Samuel Bing's catalogue for the 1890 exhibition of Japanese prints at the Ecole Nationale des Beaux-Arts significantly updates French knowledge of Japanese print history, while Edmond de Goncourt's monographs on Utamaro and Hokusai concentrate on major Japanese printmakers. See Bing, *Exposition de la gravure japonaise à l'Ecole Nationale des Beaux-Arts* (Paris, 1890); Edmond de Goncourt, *Outamaro, le peintre des maisons vertes* (Paris, 1891); and *Hokousai* (Paris, 1896). Bing (1838-1905) was the leading dealer in Oriental art in Paris during the seventies and eighties. Japanese objects from his collection were included in the 1878 Universal Exposition, and in 1883 he wrote the section on ceramics for Gonse's *L'Art Japonais*.

8. The major collections represented by illustrations in *L'Art Japonais* are those of Gonse, Burty, Bing, and Duret, as well as those of Henri Cernuschi, Wakai and Tadamasa Hayashi, and E. L. Montefiore.

9. ''Moderniste, impressionniste, manetiste, paysagiste, mariniste, japoniste, fantaisiste, alchimiste . . .'' Henri Béraldi, *Les graveurs du XIXe siècle*, II (Paris, 1888), 263.

10. Duranty, ''L'Extrême orient,'' *Gazette des Beaux-Arts*, XVIII (December 1878), 1011-48.

11. Philippe Burty, ''Japonisme II,'' *La Renaissance littéraire et artistique*, I (June 15, 1872), 59.

12. Philippe Burty, ''Félix Buhot, Painter and Etcher,'' *Harper's New Monthly Magazine*, LXXVI (February 1888) 333–34.

13. ''d'une inspiration spirituelle suscitée par la mode, encore à son début, des peintures, sculptures et soieries d'Extrême-Orient.'' André Fontaine'', *Félix Buhot, sa vie et son oeuvre*,'' (unpublished manuscript, Bibliothèque Nationale, Cabinet des Estampes, 1929), p. 91. Fontaine also states that Buhot worked as a fan painter in 1874–75, but was unsuccessful because of his predilection for macabre scenes instead of the popular flower designs.

14. This letter to Uzanne, a close friend of Buhot who was editor of the literary review, *Le Livre*, is contained in a scrapbook entitled *Félix Buhot—Notes et Estampes, 1888*, compiled by Octave Uzanne and now located in the collection of The Boston Public Library's Department of Prints. The scrapbook also contains various states on different papers of the Japonisme series.

15. ''Les sourimonos sont les plus merveilleuses estampes que l'on puisse imaginer: des gaufrures délicates, des tons d'or, d'argent, de bronze et d'étain en rehaussent généralement l'éclat.'' Gonse, II, p. 349.

16. Octave Uzanne, ''Félix Buhot dessinateur et aquafortiste,'' extract from *Le Livre* (Paris, 1888), p. 18.

17. The Uzanne scrapbook from the Print Department of The Boston Public Library contains two exotic proofs of the title page. One is printed in an elegant gold ink on black; the other is printed in black on a white-coated Oriental paper with silver mica fan designs. The New York Public Library's Avery Collection contains the entire series printed on a highly reflective gold-speckled Chinese paper with red floral designs.

18. Technically, a Japanese parallel is the *aizuri* or blue print which is a unique variant on the *ukiyo-e* print produced almost exclusively around 1860 by a few artists including Eisen, Kunisada, Kuniyoshi, and Hiroshige. See Edward F. Strange, *The Colour-Prints of Hiroshige* (London, 1925), p. 6.

19. *Le Convoi funèbre* (Bourcard 159) of 1887 has gold added to its margins; this time, however, floral and bird patterns are part of the etched plate and not later applications to individual prints.

20. Samuel Bing, ed., *Artistic Japan*, I-VI (May 1888–April 1891). The journal was published separately in French, English, and German.

21. Samuel Bing, *Exposition de la gravure japonaise*. Some of the private collections represented in the exhibition were those of Bing, Henri Vever, Charles Gillot, Georges Clemenceau, E. L. Montefiore, and Tadamasa Hayashi. Such major artists as Harunobu, Kiyonaga, and Sharaku, omitted by Gonse in his 1883 study, were included in Bing's exhibition.

22. ''Il semble notamment que la lithographie originale en couleurs n'ayant point existé autrefois dans les conditions ou récemment nous l'avons vue éclore, ne soit la production d'art spéciale de notre époque. . . . Deux influences semblant avoir déterminé encore le mouvement vers la couleur. D'une part l'école dite impressionniste. . . . Joignez-y l'art Japonais. . . . Là, sous une forme très définitive avec des aspects variés et séducteurs en ses curieux tirages, triomphait l'estampe en couleurs.'' André Mellerio, *La Lithographie en couleurs* (Paris, 1898), pp. 2–3.

23. For the etching revival in mid-century, see Gabriel P. Weisberg, *The Etching Renaissance in France: 1850–1880* (exhibition catalogue for the Utah Museum of Fine Arts, University of Utah, 1971); and Janine Bailly-Herzberg, *L'Eau-forte de peintre au dix-neuvième siècle*, 2 vols. (Paris, 1972).

24. Gustave von Groschwitz, ''The Significance of XIX Century Color Lithography,'' *Gazette des Beaux-Arts*, XLIV (November 1954), 243-66.

25. Gabriel Mourey, ''A French Wood Engraver: Auguste Lepère,'' *Studio*, XII (1898), 143–55.

26. Lotz-Brissonneau, who compiled the catalogue raisonné of Lepère's prints, places its date of execution at 1892. However, *La Convalescente*, owned by The Boston Museum of Fine Arts, has the year 1889 inscribed by Lepère in the margin. This leaves some doubt as to the precise date of execution.

27. Georges Toudouze, *Henri Rivière* (Paris, 1907).

28. Henri Rivière, *Les Trente-six vues de la tour Eiffel*, series of thirty-six lithographs in color, with an introduction by Arsène Alexandre, printed by Eugène Verneau (Paris, 1888–1902).

29. In these last two series as many as ten to twelve blocks were used in the production of each print, and each was printed in an edition of twenty.

30. Louis Morin, *French Illustrators* (New York, 1893), p. 36.

31. For Japanese prints owned by Cassatt, see Colta Ives, *The Great Wave: The Influence of Japanese Prints on French Nineteenth-Century Printmakers* (New York, 1974), p. 46.

32. Adelyn Breeskin, *The Graphic Work of Mary Cassatt* (New York, 1948), p. 50.

33. Ives rightly attributes much of the influence on Cassatt's ten color etchings, especially her themes, to prints by Utamaro: see Ives, pp. 45–53. However, the influence of Harunobu on Cassatt must also be considered, particularly his use of floral pattern wall-paper, tilted and extreme diagonal perspective systems, and the coiffure theme (Fig. 24).

34. Charles Saunier, *A. Lepère 1849–1918* (Paris, 1931), p. 84.

35. I am grateful to Jeffrey Wechsler for his observations on the relationship of *L'Argent* to Japanese prints, presented in a paper for a graduate and undergraduate seminar on Japonisme offered by the Art History Department, Rutgers College, Spring 1974.

36. *L'Image*, H. Floury, twelve issues, December 1896–November 1897.

37. For Japanese influence on Gauguin's paintings, see Yvonne Thirion, "L'Influence de l'estampe japonaise dans l'oeuvre de Gauguin," *Gazette des Beaux-Arts*, XLVII (January–April 1956), 95–114.

38. For other examples of Japanese influence on the series of Brittany zincographs, see Ives, pp. 97–102.

39. For a discussion on the illustrated program and literary and artistic activities of the *Théatre Libre* (1887–96) and the *Théatre de l'Oeuvre* (1893–99), see *The Avant-Garde in Theatre and Art: French Playbills of the 1890's*, with an essay by Daryl R. Rubenstein (catalogue for an exhibition circulated by the Smithsonian Institution Traveling Exhibition Service). The artists who produced color lithographic programs for these theaters included Signac, Rivière, Auriol, Vuillard, Lautrec, Ibels, Sérusier, Osbert, and Charpentier.

40. Rivière and Auriol were both on the editorial staff of the journal *Le Chat Noir* (1882–1895). They lived in Montmartre within a short distance of *Le Chat Noir* where Rivière in the late eighties performed his shadow theater. In 1893 Morin observed that Auriol lived in the Rue des Abbesses; a blue Japanese flag adorned his balcony, and his studio was decorated with fragile Japanese objects and reproductions of Flemish masters and Botticelli. Rivière lived just around the corner on the Boulevard de Clichy, directly across from Buhot. See Morin, pp. 33–36.

41. Roskill suggests that Van Gogh's *Arlésienne* of 1888 was influenced by the reproduction of an actor print by Kaigetsudo in the June 1888 issue of *Artistic Japan*. See Mark Roskill, *Van Gogh, Gauguin and the Impressionist Circle* (Greenwich, 1970), p. 83. Likewise Alphonse Mucha is said to have carried with him an issue of *Artistic Japan* as an "inseparable textbook." See Jiri Mucha, *Alphonse Mucha*, trans. by Geraldine Thomsen (Prague, 1966), p. 48.

42. See Timothy Allan Riggs, "L'Estampe originale: A Late Nineteenth-Century Publication of Original Prints" (unpublished Master's thesis, Yale University, 1966), and Donald H. Karshan and Donna M. Stein, *L'Estampe original: A Catalogue Raisoné* (New York, 1970).

43. No such correlation is possible in the relatively conservative albums of *Les Peintres-lithographes* published by Léonce Bénédite in 1892–94.

44. The popularization of Utamaro was enhanced by De Goncourt's 1891 monograph on the artist and by the 1893 exhibition of Utamaro and Hiroshige prints at the Durand-Ruel Gallery. Utamaro's *Tiger* (Fig. 29) and its almost one-to-one relationship to Ranson's *Tigre dans les jungles* [137] was revealed to me in a paper prepared by Ms. Penelope Jones for a graduate and undergraduate seminar on Japonisme offered by the Art History Department, Rutgers College, 1974. I am also grateful to Ms. Natalie Borisorets, Rutgers graduate student in art history, for her discovery of a reproduction of a drawing by Morikuni (engraved in the *E-hon sha-ho bukuro*, 1720) of the same tiger, but without the bamboo background, in William Anderson, *The Pictorial Arts of Japan* (London, 1886), p. 225. Whether Ranson took his tiger from the reproduced drawing or from Utamaro's woodcut is debatable. However, the Anderson book is decisive evidence that by 1886 such designs were available in the West.

45. Charles Chassé, *The Nabis and Their Period*, trans. by Michael Bullock (New York, 1969), p. 67.

46. Claude Roger-Marx, *L'Oeuvre gravé de Vuillard* (Monte-Carlo, 1948), p. 14.

47. Ives, pp. 72–78.

48. Lautrec describes this first encounter with Japanese art in a letter to his father dated April 17, 1882; see Lucien Goldschmidt and Herbert Schimmel, eds., *Unpublished correspondence of Henri de Toulouse-Lautrec* (London, 1969), p. 64.

49. Goldschmidt and Schimmel, ill. nos. 33–37.

50. The monogram in European art is not unique to the nineteenth century. Durer's monogram, for instance, is an obvious earlier example. However, beginning with Whistler's butterfly signature, the monogram in Western art—and especially in France—takes on a decidedly Japanese quality and in most cases becomes an integral part of the compositional emphasis on the picture plane. This is evident in Lautrec's encircled monogram reminiscent of Japanese sword guards and in Auriol's designs for such fellow artists as Rivière and Houdard. Other Japanese-inspired monograms or vertical initials in or out of rectangular cartouches are those by Félix Buhot, Maurice Denis, Félix Vallotton, Henri Rachou, Eugène Grasset, and Théophile Alexandre Steinlen.

51. "Dans ses recherches, il suivit les leçons des estampes du premier état des Torii et d'Haronobou, si fines dans leurs harmonies de jaune et de vert, et de gris gaufre; de celles des Kyonoga, des Outamaro, des Yei-Shi, plus chatoyantes et compliquées." Maurice Joyant, *Henri de Toulouse-Lautrec 1864–1901, dessins-estampes-affiches* (Paris, 1927) p. 100. This is translated as: "In his research, he followed the lessons of the prints of the first state of the Torri and of Haronobu, so delicate in their harmonies of yellow and green and goffered grey; also those of the Kiyonagas, the Utamaros, the Yei-Shis, more iridescent and involved."

52. *Collection Henri Vever* (sale catalogue, Part I, London, Sotheby and Co., March 26, 1974). Japanese prints from the Vever Collection were included in the 1890 exhibition at the Ecole Nationale des Beaux-Arts.

53. See Mellerio's statement in note 22 above.

54. Beginning with Bonnard's album *Quelques aspects de la vie de Paris*, Vollard published (from 1895 through 1899) eight major albums of original prints. His group albums, *L'Album des Peintres-Graveurs*, 1896 and 1897, contain altogether fifty-four original prints by over thirty artists. His one-man albums reproduce works by Redon, Vuillard, Fantin-LaTour, and Maurice Denis. See Una E. Johnson, *Ambroise Vollard Editeur* (New York, 1944).

109 *The Launay Bay* by Henri Rivière.

Catalog

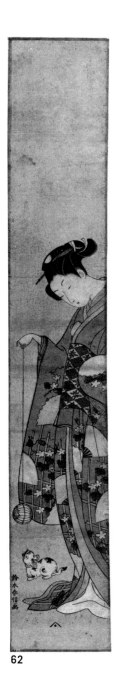

62

63

64

Japanese Print Types Available in France 1883–1910

Suzuki Harunobu, 1725–1770.

62 *Girl with Cat.*
Colored woodcut, 1768–69.
26-3/4 x 4-1/2 inches (68 x 11.4 cm.).
The Newark Museum.

Toshusai Sharaku, 18th century.

63 *Otani Oniji III as Edohei.*
Colored woodcut, 1795.
14-9/16 x 9-1/8 inches (37 x 23.2 cm.).
Philadelphia Museum of Art,
 The S. S. White, III, and
 Vera White Collection.

Kitao Sekkosai, 18th century.

64 *Saishiki Gasen,* volume 1.
Colored woodcut, 1767, stencil and
 drawing.
10-5/8 x 6-7/8 inches (27 x 17.5 cm.).
Philadelphia Museum of Art.

Kitagawa Utamaro, 1753–1806.

65 *An Array of Passionate Lovers.*
Colored woodcut, 18th century.
14-7/8 x 9-7/8 inches (37.8 x 25.1 cm.).
Philadelphia Museum of Art,
 The S. S. White, III, and
 Vera White Collection.

Kitagawa Utamaro.

66 *Love That Seldom Finds Fruition*
 from *Chosen Poems.*
Colored woodcut, ca. 1790.
12-3/4 x 9-5/16 inches (32.4 x 23.6 cm.).
Philadelphia Museum of Art,
 The S. S. White, III, and
 Vera White Collection.

65

66

Katsushika Hokusai, 1760–1849.

67a and 67b *Manga,* volume 2.
Woodcut, 1815.
9 x 11-1/2 inches (22.8 x 29.2 cm.)
Newark Public Library,
 Art and Music Department.

Katsushika Hokusai.

67c *Manga,* volume 5.
Woodcut, 1817.
9 x 5-3/4 inches (22.8 x 14.6 cm.).
Newark Public Library,
 Art and Music Department.

67a

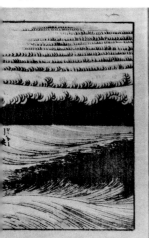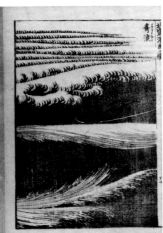

67c

67b

67f 67d

67g 67e

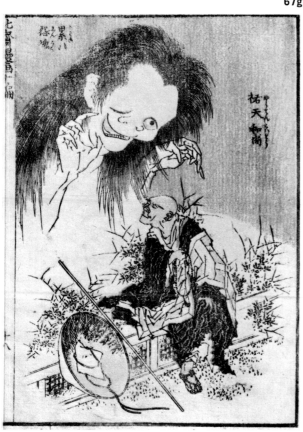

Katsushika Hokusai.

67d *Manga,* volume 6.
Woodcut, 1817.
9 x 11-1/2 inches (22.8 x 29.2 cm.)
Newark Public Library,
 Art and Music Department.

Katsushika Hokusai.

67e *Manga,* volume 7.
Woodcut, 1817.
9 x 11-1/2 inches (22.8 x 29.2 cm.)
Newark Public Library,
 Art and Music Department.

Katsushika Hokusai.

67f *Manga,* volume 8.
Woodcut, 1817.
9 x 5-3/4 inches (22.8 x 14.6 cm.).
Newark Public Library,
 Art and Music Department.

Katsushika Hokusai.

67g *Manga,* volume 10.
Woodcut, 1819.
9 x 5-3/4 inches (22.8 x 14.6 cm.).
Newark Public Library,
 Art and Music Department.

Katsushika Hokusai.

68 *The Great Wave Off Kanagawa*
 from *Thirty-Six Views of Mt. Fuji.*
Colored woodcut, 1823–31.
10 x 14-3/4 inches (25.4 x 37.5 cm.).
Brooks Memorial Art Gallery, Gift of
 Brooks Art Gallery League, Inc.

Katsushika Hokusai.

69 *Hodagaya on the Tokaido*
 from *Thirty-Six Views of Mt. Fuji.*
Colored woodcut, 1823–29.
10-1/8 x 14-3/4 inches (25.7 x 37.5 cm.).
Philadelphia Museum of Art,
 Gift of Mrs. Anne Archbold.

68

69

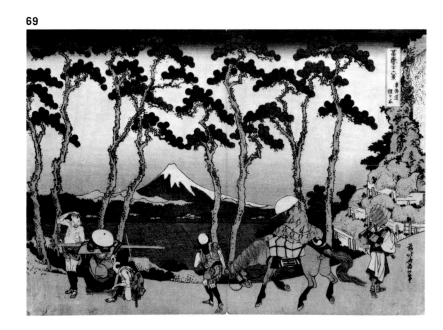

Katsushika Hokusai.

70 *One Hundred Views of Mt. Fuji,*
3 albums.
Woodcut, 1834 (this is the 1875 edition).
8-7/8 x 6-1/8 inches (22.5 x 15.6 cm.).
Philadelphia Museum of Art.
Not Illustrated.

Ando Hiroshige, 1797–1858.

71 *Moonlight at Ryogoku* from
Famous Places in the Eastern Capital.
Colored woodcut, 1832.
The Brooklyn Museum.

Ando Hiroshige.

72 *Lobster and Shrimp.*
Colored woodcut.
10 x 14-1/2 inches (25.4 x 36.8 cm.).
The Newark Museum.
[See Fig 4a]

Ando Hiroshige.

73 *Five Pines Along the Konaki River*
from *One Hundred Views of Famous
Places in Edo.*
Colored woodcut, 1856.
13-3/8 x 8-3/4 inches (34 x 22.2 cm.).
Philadelphia Museum of Art,
Gift of Mrs. Anne Archbold.

Ando Hiroshige.

74 *Asakusa Kinuzan* from
*One Hundred Views of Famous
Places in Edo.*
Colored woodcut, 1856.
12-5/16 x 8-3/4 inches (31.3 x 22.2 cm.).
Philadelphia Museum of Art, Gift of
Mr. and Mrs. Lessing J. Rosenwald.

Ando Hiroshige.

75 *Winter Street Scene, Shiba District*
from *One Hundred Views of Famous
Places in Edo.*
Colored woodcut, 1857.
13-1/4 x 8-5/8 inches (33.6 x 21.9 cm.).
Philadelphia Museum of Art,
Gift of Mrs. John D. Rockefeller.

Ando Hiroshige.

76 *Sudden Shower at Ohashi*
from *One Hundred Views
of Famous Places in Edo.*
Colored woodcut, 1857.
13-1/2 x 8-5/8 inches (34.3 x 21.9 cm.).
Philadelphia Museum of Art,
The S. S. White, III,
and Vera White Collection.

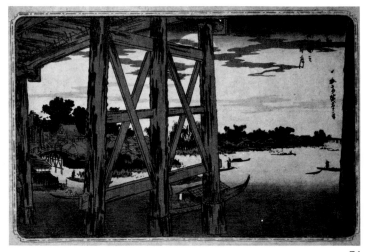

71

73

74

75

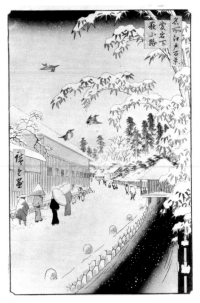

Ando Hiroshige.

77 *Festival at Tori-no Machi at Asakura*
 from *One Hundred Views*
 of Famous Places in Edo.
Colored woodcut, 1857.
14-3/8 x 9-1/4 inches (36.5 x 23.5 cm.).
The Brooklyn Museum.

Ando Hiroshige.

78 *Moon Pine at Ueno*
 from *One Hundred Views*
 of Famous Places in Edo.
Colored woodcut, 1858.
14-3/4 x 10 inches (37.5 x 25.4 cm.).
The Newark Museum.

Ando Hiroshige.

79 *Fireworks, Ryogoku* from
 One Hundred Views
 of Famous Places in Edo.
Colored woodcut, 1858.
14-3/8 x 9-3/8 inches (36.5 x 23.8 cm.).
The Brooklyn Museum.

76

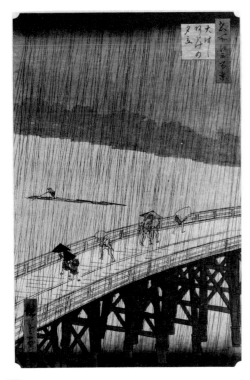

77

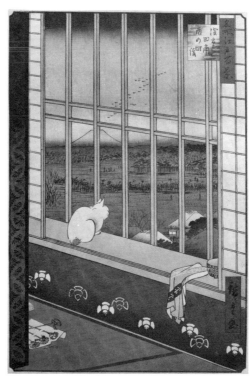

78

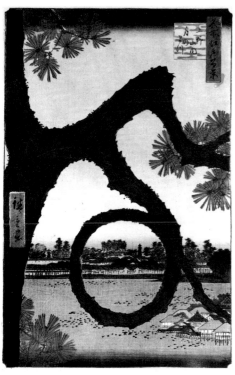

79

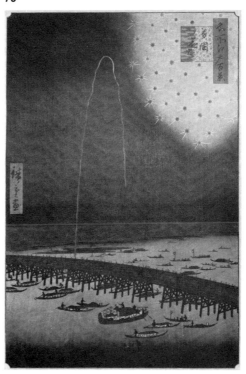

Katsukawa Shunyei, 1762–1819.

80 *Design for a Fan: Group of Actors.*
Colored woodcut.
9 x 10-1/4 inches (22.9 x 26 cm.).
The Newark Museum.

Katsushika Taito, 1804–1848.

81 *The Golden Carp.*
Colored woodblock, 1848.
14-15/16 x 10-3/8 inches (38 x 26.3 cm.).
The Brooklyn Museum.

Ichiyusai Kuniyoshi, 1797–1861.

82 *Actor, Iwai Hanshiro.*
Colored woodcut, 1836.
15 x 10-1/2 inches (38.1 x 26.7 cm.).
Mr. and Mrs. Philip Harding Cate.

Ichiyusai Kuniyoshi.

83 *Fuzoku Onna Suikoden*
(Series of Women's Customs).
Colored woodcut, 19th century.
8-3/8 x 7-3/8 inches (21.3 x 18.8 cm.).
Philadelphia Museum of Art,
The S. S. White, III, and
Vera White Collection.

Utagawa Kuniyasu, 1800–1836.

84 *Actor, Bando Mitsugoro.*
Colored woodcut, 19th century.
15 x 10-1/2 inches (38.1 x 26.7 cm.).
Mr. and Mrs. Philip Harding Cate.

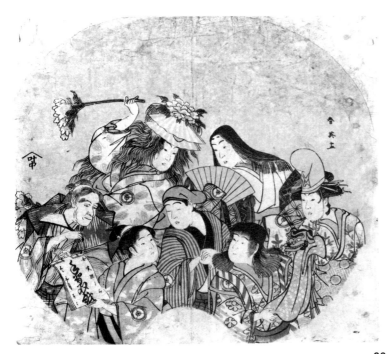

80

81

82

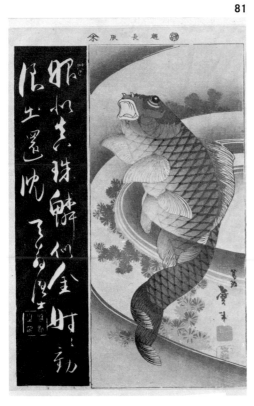

Ichiosai Kunichika.

85 *Actor Portrait.*
Colored woodcut, 19th century.
14-1/8 x 9-1/2 inches (35.9 x 24.1 cm.).
Philadelphia Museum of Art,
 Gift of Richard Baker.

Anonymous, Japanese.

86 *Reunion Portrait of a*
 Tea Society Member.
Colored woodcut, 19th century.
8-3/4 x 6 inches (22.2 x 15.2 cm.).
Rutgers University Fine Arts Collection.

83

84

85

86

87

French Printmakers and Japonisme 1883–1910

Henri-Charles Guérard, 1856–1897.

Born in Paris, Guérard began etching in the early 1870's, and in 1879 married Eva Gonzales, pupil and model of Manet. Much of Guérard's work in the medium of etching, especially his landscapes and portraits, reveals the influence of the Impressionists and the graphic work of Manet. Guérard was a close friend of Félix Buhot as well as of Philippe Burty and Louis Gonse. In 1883 he collaborated with Gonse in *L'Art Japonais* by illustrating over 200 Japanese objects. Along with Félix Bracquemond he helped to organize in 1891 the Society of French Painter-Engravers. Primarily an etcher, he experimented with lithography to a limited extent in the early nineties, as did Buhot. His Franco-Japanese comic etchings of the eighties are humorous examples of the assimilation of Japanese motifs and aesthetics by French artists.

Henri-Charles Guérard.

87 *Franco-Japanese Menus.*
Etchings, mid-1880's.
16-1/2 x 21-1/2 inches (42 x 31.8 cm.).
Béraldi 61–104.
New York Public Library, Prints Division.
(Shown only at Cleveland and Rutgers)
Besides using Japanese motifs such as Japanese figures, fans, and lanterns, these menus are strongly derivative of the a-spatial and asymmetrical compositions found, for instance, in Hokusai's *Manga* [67f].

89

Henri-Charles Guérard.

88 *Fan With Mice.*
Etching, ca. 1880.
6-7/8 x 13-1/2 inches (16.3 x 34.2 cm.).
Béraldi 243.
Paris, Bibliothèque Nationale,
 Cabinet des Estampes.
Not illustrated

Henri-Charles Guérard.

89 *Calendar, 1884.*
Etching, 1883.
8-27/32 x 12-15/16 inches
 (22.4 x 32.8 cm.).
Béraldi 35.
Paris, Bibliothèque Nationale,
 Cabinet des Estampes.
Here Guérard indulges in his Franco-Japanese fantasies.

Henri-Charles Guérard.

90 *Nine Japanese Masks.*
Etchings.
Measurements not known.
Paris, Bibliothèque Nationale,
 Cabinet des Estampes.

Henri-Charles Guérard.

91 *Japanese Lilliputians.*
Etching.
6-5/8 x 9-31/32 inches (16.8 x 25.3 cm.).
Paris, Bibliothèque Nationale,
 Cabinet des Estampes.

Henri-Charles Guérard.

92 *Arrow Shoot in Bloom.*
Etching.
13-11/16 x 7-23/32 inches
 (34.8 x 19.6 cm.).
Paris, Bibliothèque Nationale,
 Cabinet des Estampes.

The arrow shoot is a common plant in
Japan and is depicted quite regularly in
Hokusai's *Manga* [see 5f].

90

92

91

93

Henri-Charles Guérard.

93 Insert title page for
*Printmakers of the 19th Century
(Les Graveurs de XIXᵉ siècle)*
by Henri Béraldi.
Etching, 1889.
6-15/16 x 4-13/16 inches
(17.6 x 12.2 cm.).
Reproduced, Béraldi Vol. VII between
pp. 262/263.
Paris, Bibliothèque Nationale,
Cabinet des Estampes.

In addition to his Japanese fantasy,
Guérard also includes Japanese com-
positional elements: the diagonal strand
of lanterns running across and off the
print, and the figures in the foreground
tightly fitted against the frontal plane.
Guérard reveals his knowledge not only
of Japanese motifs but also of basic
Japanese compositional concerns.

Henri-Charles Guérard.

94 *Grotesque Head (Tête grotesque)*
and *"Philippe Burty wearing a
Japanese mask."*
Lithograph, ca. 1890.
14-31/32 x 11-1/16 inches
(38.0 x 28.1 cm.).
Paris, Bibliothèque Nationale,
Cabinet des Estampes and
Collection J. Bailly-Herzberg.
Not illustrated

Odilon Redon, 1840–1916.

95 *The Chimera Gazed At All Things
With Fear (La Nuit: la chimera
regarda avec effroi toutes choses).*
Lithograph, 1886.
9-3/4 x 7-1/4 inches (24.8 x 18.5 cm.).
Werner 40.
Philadelphia Museum of Art,
Temple and Seeler Funds.

For the grotesque image of the lurking
"Chimera" Redon referred to Hokusai's
Manga, where the metaphysical concerns
of Redon found their Japanese parallel.

Félix Buhot.

Born in Valognes, Normandy, Buhot went
to Paris in 1865 and studied under Lecoq
de Boisbaudran, Isador Pils, and Jules
Noel. By 1872 he was working for a fan-
maker named Duvelleroy and at the
same time producing water colors of land
and seascapes. Buhot's first etchings ap-
peared in the early 1870's; his biogra-
pher, André Fontaine, suggests that they
were begun in 1874, the year Buhot
studied etching under Adolphe Lalauze.
It was also at this time that he became
acquainted with Philippe Burty, the critic
and collector of Japanese art, as well as
with fellow printmakers and Japonistes
Henry Somm and Henri Guérard. His
association with Burty resulted in *Japon-
isme Dix Eaux-Fortes,* a series of etchings
of Japanese objects from Burty's
collection.

Félix Buhot.

96a Title page and *Ex Libris* for the series
Japonisme Dix Eaux-Fortes.
Etching and aquatint, 1883.
11-1/2 x 8 inches; 5-1/2 x 6-1/2 inches
(29 x 20.5 cm.; 14 x 16.5 cm.).
Bourcard 11, 10.
Rutgers University Fine Arts Collection.

The title page is a combination of various
Japanese motifs and objects found in
Burty's collection. The objects depicted
in the other prints from the *Japonisme*
series also came from Burty.

95

Félix Buhot.

96b *Wood Mask (Masque bois sculpté),*
no. 1 from the series
Japonisme Dix Eaux-Fortes.
Etching, 1875, published in 1883.
7-1/2 x 6 inches (19 x 15.2 cm.).
Bourcard 12.
Rutgers University Fine Arts Collection.

Félix Buhot.

96c *Ivory Pharmacy (Pharmacie ivoire),*
no. 2 from the series
Japonisme Dix Eaux-Fortes.
Etching, 1875, published 1883.
7-3/8 x 5-3/4 inches (18.7 x 14.5 cm.).
Bourcard 13.
Rutgers University Fine Arts Collection.

Félix Buhot.

96d *Bronze Genie (Génie bronze),*
no. 3 from the series
Japonisme Dix Eaux-Fortes.
Etching, 1875, published 1883.
7-3/8 x 5-3/4 inches (18.7 x 14.6 cm.).
Bourcard 14.
Rutgers University Fine Arts Collection.

96b

96a

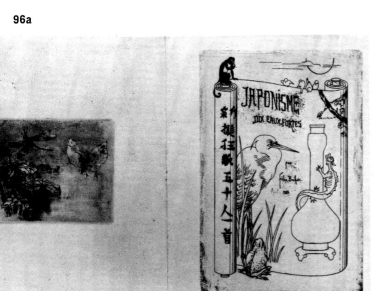

96c

96d

Félix Buhot.

96e *Porcelain Teabox*
(*Boîte à thé porcelaine*),
no. 4 from the series
Japonisme Dix Eaux-Fortes.

Etching, 1875, published in 1883.
8-1/4 x 7-1/8 inches (21 x 18 cm.).
Bourcard 15.
Rutgers University Fine Arts Collection.

Félix Buhot.

96f *Tin Lacquered Vase*
(*Vase étain laqué*),
no. 5 from the series
Japonisme Dix Eaux-Fortes.

Etching, 1875, published in 1883.
8-1/4 x 5-7/8 inches (20.6 x 15 cm.).
Bourcard 16.
Rutgers University Fine Arts Collection.

Félix Buhot.

96g *Bronze Frog Inkwell*
(*Crapaud-encrier-bronze*),
no. 7 from the series
Japonisme Dix Eaux-Fortes.

Etching and aquatint, 1883.
8-1/4 x 6 inches (21 x 15.3 cm.).
Bourcard 18.
Rutgers University Fine Arts Collection.

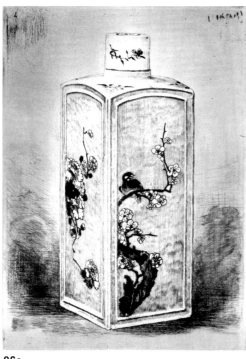

96e

96f

96g

96h

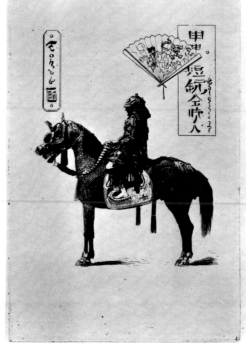

Buhot's own romantic, atmospheric style dominates his depiction of this object from Burty's collection. The bronze frog is depicted in two positions, right side up and upside down, and in perspective, as if it were two real frogs emerging out of the shadows of a moody, moonlit landscape. Its Oriental identity is all but lost.

Félix Buhot.

96h *Cavalier*, from the series *Japonisme Dix Eaux-Fortes.*
Etching, 1875, published in 1883.
9-1/4 x 6-1/4 inches (23.5 x 16 cm.).
Bourcard 17.
Rutgers University Fine Arts Collection.

Buhot creates the effect of a Japanese print by superimposing a fan design and rectangular cartouches containing Japanese characters, both real and of his own invention. (I am indebted to my father, Phillip H. Cate, for his translation and evaluation of the Japanese script in Buhot's prints.)

Félix Buhot.

96i *The Boat of Dai Koku (La Barque de Dai-Koku),* from the series *Japonisme Dix Eaux-Fortes.*
Etching, 1875, published in 1883.
10-1/8 x 13-1/2 inches (25.7 x 34.3 cm.).
Bourcard 19.
Rutgers University Fine Arts Collection.

Félix Buhot.

97 *The Flying Fish (Le Poisson volant).*
Etching, ca. 1875.
5-3/8 x 9-1/4 inches (13.6 x 23.5 cm.).
Bourcard 52.
New York Public Library, Prints Division.
(Shown only at Cleveland and Rutgers)

In this work, Buhot overemphasizes the cartouche motif. The print is in fact an invention by him in which a mixture of motifs typical of the actor prints of Kunisada and other nineteenth-century *ukiyo-e* artists are brought together [83]. Even the characters in the large cartouche bear no relation to the subject depicted; they are poorly copied after those found in *La Barque de Dai-Koku* [96i].

Félix Buhot.

98 *Address of Sichel (Adresse de Sichel).*
Etching, mid-1870's.
3 x 4-13/16 inches (7.6 x 12.2 cm.).
Bourcard 82.
Boston Public Library, Print Department.

Sichel ran an Oriental import shop in Paris.

96i

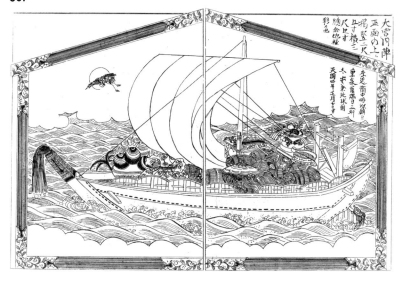

97

98

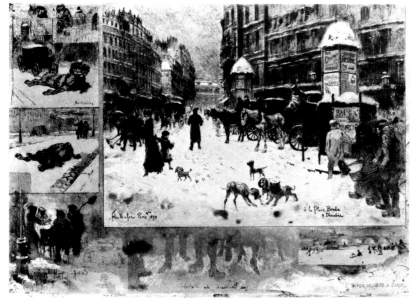

99

Félix Buhot.

99 *Place Breda in Winter*
(L'Hiver à la Place Breda).
Etching with aquatint, 1879.
9-3/8 x 13-1/2 inches (23.8 x 34.3 cm.).
Bourcard 128.
Rutgers University Fine Arts Collection.

Buhot's concern for the Japanese car-touche motif and its effect on overall composition may have been stimulated by the *remarques,* a pictorial element present in much of his own work. The *remarques* or "Remarques sympho-niques," as he called the cursive pictorial notations found on the margins of his etchings, were to a limited extent a part of his earliest works. During the mid-seventies these *remarques* often became formalized and were placed within rec-tangular boxes, in most cases still in the margins. For Buhot the system of the *remarques* was, like the cartouche for the Japanese, a means of elaborating upon a subject without becoming overly nar-rative [86]. If Japanese prints were not directly responsible for the formalized development of Buhot's *remarques,* they most certainly served as strong reinforce-ment for a tendency latent in his art.

100

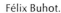

Félix Buhot.

100 *The Tiny Burial*
(Le Petit enterrement).
Etching with gold pigment applied to
the sky and with water color applied
to the upper margin, 1884.
3-3/8 x 4-1/2 inches (8.5 x 11.4 cm.).
Bourcard 154, ii
New York Public Library, Prints Division.
[See 67e, 83]

(Shown only at Cleveland and Rutgers)

Félix Buhot.

101 *The Castle of Owls*
(*Le Château des hiboux*)
with the *Ex Libris of Léon Leroy.*

Etching with aquatint, 1887.
4-1/2 x 7-1/8 inches (11.4 x 18 cm.).
Bourcard 51 and 168.
Boston Public Library, Print Department.

Buhot brings together two prints, creating a dynamic compositional arrangement frequently found in *ukiyo-e* prints —the use of bold geometrical shapes dominating the composition and functioning as windows focusing in upon separate but nevertheless related scenes [86].

101

Félix Buhot.

102 *Japanese Baptism*
(*Baptême Japonais*).

Etching with aquatint, 1887.
8-3/4 x 5-1/4 inches (22.2 x 13.3 cm.).
Bourcard 167.
Boston Public Library, Print Department.

This print containing obvious Japanese elements such as figures in Japanese dress, Japanese lanterns, ink brushes, and ceramics was created in celebration of the birth of Buhot's son, Jean. It is interesting to note that years later Jean produced a book on Chinese and Japanese art, possibly a further indication of his father's ingrained interest in Japanese art.

102

104

Auguste-Louis Lepère, 1849–1918.

Lepère was born in Paris where his father, a sculptor, was his first teacher. He began his career as a wood engraver in 1875, reproducing the work of artists such as Daniel Vierge and Edmond Morin in *Magasin Pittoresque, Le Monde Illustré,* and *L'illustration.* Also in 1875 Bracquemond introduced Lepère to the medium of etching, and by the early 1880's he was producing his own original etchings and wood engravings. Various series of his wood engravings including *Voyage autour des fortifications,* 1886, and *A L'Exposition Universelle,* 1889, appeared in *Revue Illustrée.* By 1889 he began to work in the medium of woodcut, which altered his style from a complicated halftone effect to a simplified system of broad planes. In 1896 he helped to organize *L'Image,* a monthly journal which for one year explored the various uses of reproductive and original wood engraving and woodcut.

103

10

Auguste-Louis Lepère.

103 *The Convalescent: Madame Lepère
(La Convalescente: Mme. Lepère).*
Colored woodcut, 1889–92.
16 x 11-3/4 inches (40.6 x 29.8 cm.).
Lotz-Brissoneau 240.
Boston Public Library, Print Department.
(See Figs. 20, 14)

Auguste-Louis Lepère.

104 *Departure for Greenwich
(Départ pour Greenwich).*
Etching with aquatint, ca. 1890.
4-3/4 x 6-3/4 inches (12 x 17.1 cm.).
Lotz-Brissoneau 30.
Maryland Institute College of Art,
 The George A. Lucas Collection,
 on indefinite loan to the
 Baltimore Museum of Art.
The diagonal emphasis of the composition, confining figures close to the frontal plane, and the system of having architectural elements such as the railing run off the picture plane are derived from Japanese sources [67c].

Auguste-Louis Lepère.

105 *My Studio, at Jouy-le-Moutier
(Mon atelier, à Jouy-le-Moutier).*
Etching, 1893.
9-7/8 x 8-7/16 inches (25.1 x 21.4 cm.).
Lotz-Brissoneau 73.
Boston Public Library, Print Department.
This kind of bird-eye's perspective view of a rain-drenched landscape is often found in the prints of Hokusai [67e] and Hiroshige [76].

Auguste-Louis Lepère.

106 *Washerwomen (Blanchisseuses).*
Color softground etching with aquatint,
 1893.
15-1/2 x 9 inches (39.4 x 22.9 cm.).
Lotz-Brissoneau 91, ii.
Rutgers University Fine Arts Collection.
The vertical format and the cut of the figure in the foreground relate to Japanese pillar prints [62]. The red border is another element derived from the Japanese woodcut.

Auguste-Louis Lepère.

107 *The Rolling Waves, September Tide
(Les lames déferlent,
 Marée de Septembre).*
Colored woodcut, 1901.
11 x 15-1/2 inches (28 x 39.4 cm.).
Lotz-Brissoneau 274.
Boston Public Library, Print Department.

The wave motif became popular in France under the influence of Hokusai and Hiroshige; here Lepère has relied on Hokusai's *Manga* for inspiration [67a].

106

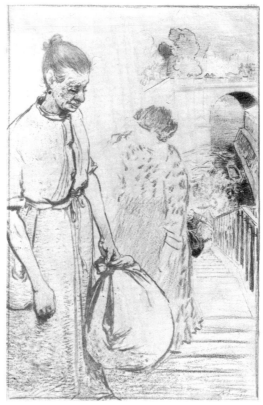

107

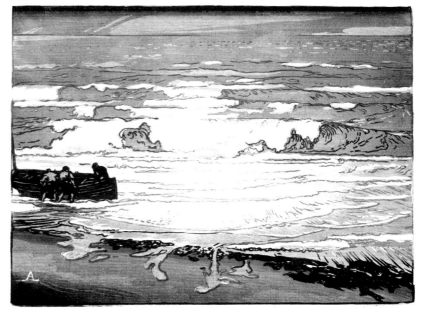

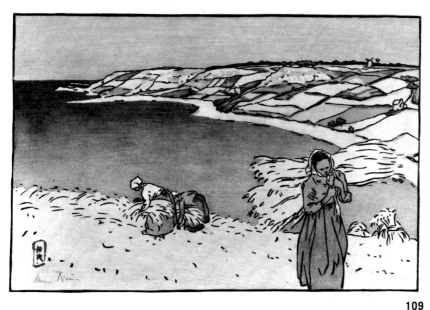

Auguste-Louis Lepère.

108 *The Two Shrimp*
(Les Deux crevettes),
two impressions.
Wood engraving, 1903.
1-1/2 x 5-1/8 inches (3.8 x 13 cm.).
Lotz-Brissoneau 293.
Boston Public Library, Print Department.
[See 72]

Benjamin Jean Pierre Henri Rivière,
1864–1951

Born in Paris, Rivière by the mid-1880's
was associated with the cafe-concert *Le
Chat Noir* and its journal, also called *Le
Chat Noir.* He eventually became secre-
tary to the editor-in-chief of the latter
and co-director of *L'Album Chat Noir,*
1885–86. The *Chat Noir* cafe was found-
ed by Rodolphe Salis in 1881. First lo-
cated on the Boulevard Rochechouart,
it moved in 1884 to the rue Victor Masse.
In the mid-eighties it was the gathering
place for young poets and artists such as
Lautrec, Steinlen, and Auriol. Rivière in-
troduced his shadow theater, *ombres
chinoises,* at the *Chat Noir* in 1887. Out
of enameled glass he created designs of
subtle color combinations which were
projected by a light source onto a screen.
In 1889 he produced his first of many
color woodcut prints and lithographs
and became one of the founders of the
color printmaking movement in France.

109

108

110

Benjamin Jean Pierre Henri Rivière.

109 *The Launay Bay (La Baie de Launay),*
from the series
Landscapes of Brittany
(Paysages bretons).
Colored woodcut, 1891.
8-3/4 x 13-3/4 inches (22.2 x 34.9 cm.).
Rutgers University Fine Arts Collection.

Using the media of colored woodcut
with water-base pigments, Rivière re-
flects in this example a subject and man-
ner typical of Japanese woodcuts. The
quick, speckled notations of shadows in
the grass, the figure in the foreground,
the land-sea-land pattern, and the high
horizon are formulas in Japanese depic-
tions of landscape.

Attributed to
Benjamin Jean Pierre Henri Rivière.

110 *Winter (L'Hiver).*
Colored woodcut, ca. 1890.
8-3/4 x 6-1/4 inches (22.2 x 15.9 cm.).
Rutgers University Fine Arts Collection.

The asymmetrical spread of bamboo
across the picture plane and the very sub-
tle greys of winter are typical Japanese
compositional and motif elements (**Fig.**
16).

Benjamin Jean Pierre Henri Rivière.

111 *Paris Winter,*
from Théatre Libre Program,
1889–90.
Color lithograph, 1889.
8-1/2 x 12-1/4 inches (21.5 x 31.1 cm.).
Rutgers University Fine Arts Collection.

Often in Japanese woodcut albums, for
functional reasons, two woodcuts pro-
ducing one continuous scene are placed
on facing pages. Each is physically iso-
lated by the printed borders and sepa-
rated by the album seam [67e]. This
format is duplicated in Rivière's litho-
graph, although the functional necessity
for doing so is lacking. Other areas of
Japanese influence—especially that of
Hokusai—appear in the diagonal com-
position, the calligraphic drawing, and
the muted tints of greys, pinks, and
greens.

Benjamin Jean Pierre Henri Rivière.

112 *The Wave (La Vague).*
Color lithograph, 1893.
11-1/2 x 18 inches (29.2 x 45.7 cm.).
Karshan and Stein 69.
The Brooklyn Museum,
Charles Stewart Smith Memorial Fund.
38.371

The wave motif is often found in the
work of Hokusai and Hiroshige [68].
Rivière freezes the action and spray of
sea water and, in the manner of the
Japanese, creates a decorative pattern
across the picture plane.

111

112

Benjamin Jean Pierre Henri Rivière.

113 *Douarnevez, View of the Path of the Great River (Douarnevez, vue de la route du grand rio).*

Color lithograph, ca. 1900, after an 1892 water color.
9-1/8 x 24 inches (23.2 x 61 cm.).
Rutgers University Fine Arts Collection.

The high horizon of the land emerging immediately from the foreground and the sequence of trees across the land-scape veiling a distant seascape are compositional formulas found in the work of Hokusai [69, 67e].

113

Mary Cassatt, American, 1845–1926.

114 *The Bonnet.*

Drypoint, 1891.
7-1/4 x 5-7/16 inches (18.4 x 13.8 cm.).
Breeskin 137.
Rutgers University Fine Arts Collection.

Such themes as a woman looking into a hand mirror or a woman combing her hair were basic to the prints of Utamaro, which Cassatt is known to have admired and collected beginning in 1890 (Fig. 25).

114

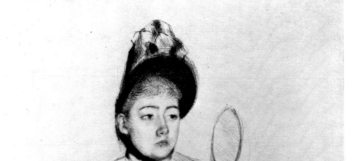

Figure 25. *Gazing at the Mirror.*
Colored woodcut, 15-1/2 x 10-5/8 inches (39.4 x 27 cm.), 1794. Kitagawa Utamaro. The Brooklyn Museum.

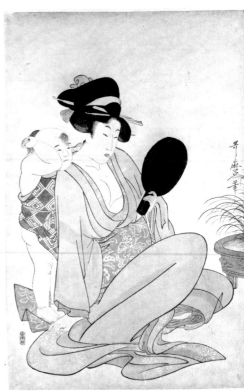

Mary Cassatt.

115 *Nursing.*

Drypoint, 1891.

9-5/8 x 7 inches (24.5 x 17.8 cm.).

Breeskin 135.

Rutgers University Fine Arts Collection.

The up-tilted aspatial arrangement of the table in the foreground is an early example in Cassatt of spatial devices borrowed from the Japanese.

Mary Cassatt.

116 *The Bath.*

Color print with drypoint,
 soft-ground and aquatint, 1891.

12-5/16 x 9-13/16 inches (31.2 x 25 cm.).

Breeskin 243, xi.

The Cleveland Museum of Art,
 Bequest of Charles T. Brooks. 41.70

The silhouetted mother, ambiguous perspective, and basic theme of the "Bath" are derived from Utamaro (Fig. 26).

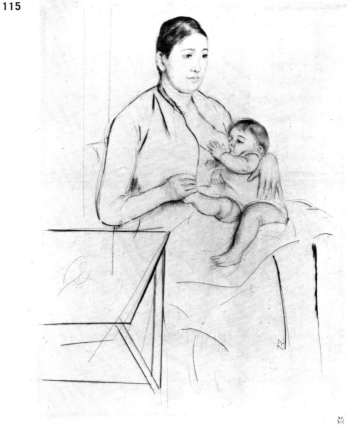

Figure 26. *A Mother Bathing Her Son.* Colored woodcut, 14-7/8 x 10-1/8 inches (37.8 x 25.7 cm.). Kitagawa Utamaro. Kansas City, Nelson-Atkins Gallery, Nelson Fund.

116

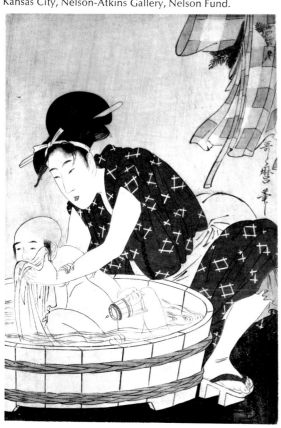

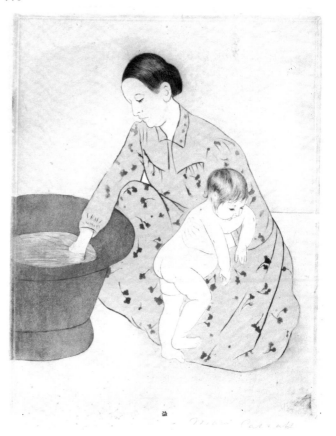

91

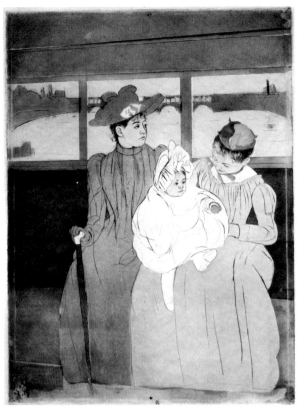

117

Mary Cassatt.

117 *In the Omnibus.*

Color print with drypoint,
 soft-ground and aquatint, 1891.
14-5/16 x 10-1/2 inches (36.3 x 26.7 cm.).
Breeskin 145, iv.
The Cleveland Museum of Art,
 Bequest of Charles T. Brooks. 41.71

In the manner of the Japanese [77, 84],
Cassatt emphasizes the two-dimensional
picture plane by placing her figure close
to the foreground in a confined and am-
biguous space with vertical and slightly
diagonal linear elements and with a high
horizon compressing perspective rather
than defining it.

Mary Cassatt.

118 *The Fitting.*

Color print with drypoint,
 soft-ground and aquatint, 1891.
14-3/4 x 10-1/8 inches (37.5 x 25.7 cm.).
Breeskin 147, v.
The Cleveland Museum of Art,
 Bequest of Charles T. Brooks. 41.72

118

119

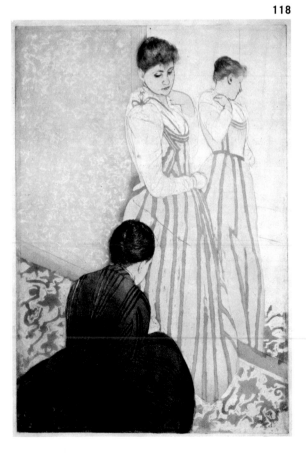

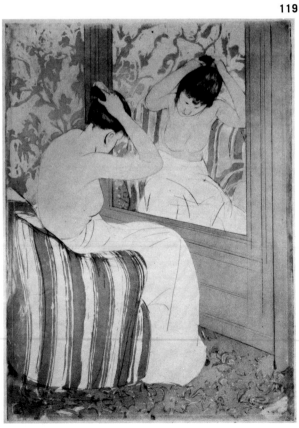

Cassatt looked to Harunobu and Utamaro for her depictions of ladies in their boudoir. Here the extreme aspatiality created by the up-tilted diagonal perspective system and the juxtaposition of the pattern of wallpaper, rug, and gowns are related to the work of Harunobu (Fig. 24).

Mary Cassatt.

119 *The Coiffure.*
Color print with drypoint,
 soft-ground and aquatint, 1891.
14-3/8 x 10-1/2 inches (36.5 x 26.7 cm.).
Breeskin 152, iv.
The Cleveland Museum of Art,
 Bequest of Charles T. Brooks. 41.79
[See 118]

Félix Edouard Vallotton, Swiss,
 1865–1925.

120 *The Rhône Glacier
 (Glacier du Rhône).*
Woodcut, 1892.
5-5/8 x 10 inches (14.1 x 25.4 cm.).
Vallotton and Goerg 89.
New York, Associated American Artists
[See 67b]

Félix Edouard Vallotton.

121 *The Shower (L'Averse).*
Zincograph, 1894.
9 x 12-3/8 inches (22.9 x 31.5 cm.).
Vallotton and Goerg 51.
Rutgers University Fine Arts Collection,
 Gift of Edward T. McClellan
 in memory of William Sloane.

A typical theme in the work of Hokusai and Hiroshige is that of figures scurrying in the rain, which creates a slanted pattern of stripes across the picture plane [67e]. Vallotton also incorporates the Japanese system of using a high horizon and silhouetting figures against the ground. The umbrella cut off by the border of the composition and the rectangular boxes for title and monogram further emphasize the frontal plane in a manner consistent with Japanese woodcuts.

Félix Edouard Vallotton.

122 *The Demonstration
 (La Manifestation).*
Woodcut, 1893.
8 x 12-9/16 inches (20.3 x 31.9 cm.).
Vallotton and Goerg 110.
The Baltimore Museum of Art,
 Gift of Miss Blanche Adler.
(See Fig. 18)

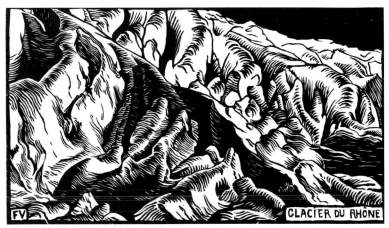

120

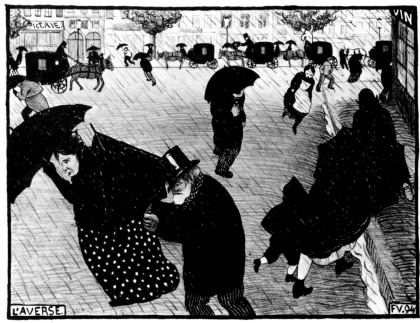

121

122

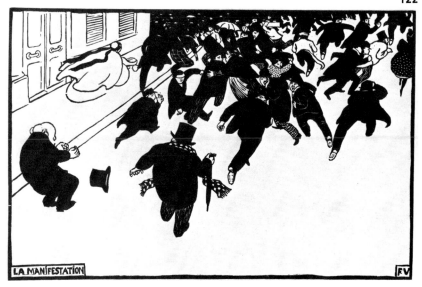

123

Félix Edouard Vallotton.

123 *The Summer (L'Été)* and
The Winter (L'Hiver),
designs framing two poems
by Matthias Morhardt in *L'Image,*
no. 9 (August 1897), pp. 276–77.
Woodcuts.
8-7/8 x 7-1/8 inches (22.5 x 18.1 cm.).
Rutgers University Art Library.

The format for these two designs relates
directly to one found in the February,
1891, issue of *Artistic Japan* [180].

Félix Edouard Vallotton.

124 *Money (L'Argent)* from the series
Intimacies (Intimités).
Woodcut, 1898.
7 x 8-3/4 inches (17.8 x 22.2 cm.).
Vallotton and Goerg 192.
New York, The Museum of Modern Art,
Gift of Abby Aldrich Rockefeller.
[See 62 and Fig. 19]

124

Paul Gauguin, 1848–1903.

125 *The Grasshoppers and the Ants
(Les Cigales et les fourmis).*
Zincograph, 1889.
7-7/8 x 10-5/16 inches (20 x 26.2 cm.).
Guérin 10.
The Cleveland Museum of Art,
Dudley P. Allen Fund. 54.64
(See Fig. 21)

Paul Gauguin.

126 *Bathers of Brittany
(Baigneuses bretonnes).*
Zincograph, 1889.
9-1/4 x 7-7/8 inches (23.5 x 20 cm.).
Guérin 3.
The Cleveland Museum of Art,
Dudley P. Allen Fund. 54.57
[See Fig. 20]

125

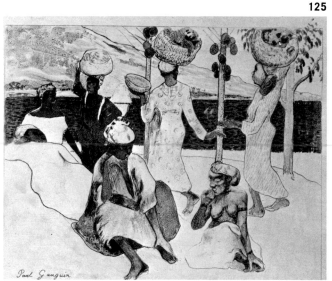

Paul Gauguin.

127 *Human Miseries (Misères humaines).*
Zincograph.
7-1/2 x 9-3/16 inches (19 x 23.3 cm.).
Guérin 5, ii.
Washington, D. C.,
National Gallery of Art,
Rosenwald Collection.
(Cleveland and Rutgers only)

The mask-like features, the grimaces,
and the overlapping arrangement of the
two figures against the frontal plane is
reminiscent of Japanese actor portraits
[65, 63].

94

Paul Gauguin.

128 *Dramas of the Sea*
 (Les Drames de la mer).
Zincograph, 1889.
12 x 17-7/16 inches (30.5 x 44.3 cm.).
Guérin 8, ii.
Washington, National Gallery of Art,
 Rosenwald Collection.
(See Fig. 27)
(Cleveland and Rutgers only)

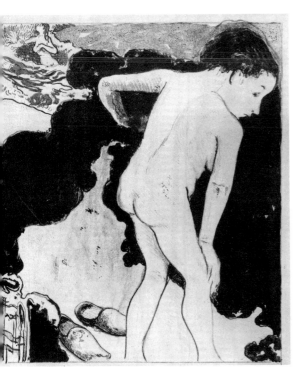

127

128

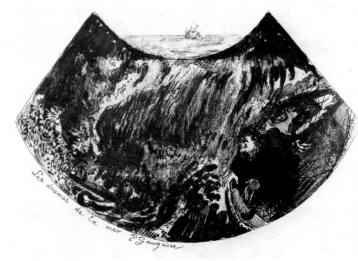

Figure 27. *The Poet Saigyo and Mt. Fuji.*
Colored woodcut, 4-7/8 x 11-1/8 inches (12.4 x 28.3 cm.).
Yashima Gakutei. Metropolitan Museum of Art,
The H.O. Havemeyer Collection,
Bequest of Mrs. H.O. Havemeyer, 1929.

Figure 28.
Theatre Poster:
Kichijuro Tsutsui
Dances the Spear Dance
at the Nakamura Theatre.
Hand-colored print
with gold,
21-7/16 x 11-13/16 inches
(54.5 x 30 cm.), 1704.
Torii Kiyonobu I.
Zurich,
The Rietberg Museum,
Willy Boller Collection.

Emile Bernard, 1868–1941.

129 *In the Woods (Au Bois).*
Hand-colored lithograph, 1890.
7-11/16 x 9-1/16 inches (19.5 x 23 cm.).
Paris, Bibliothèque Nationale,
 Cabinet des Estampes.
Not illustrated

Before the system of multiple color
blocks was invented, early Japanese
woodcuts were hand colored (Fig. 28).
Bernard may have borrowed this pro-
cedure from the Japanese as he and his
fellow *Nabis* borrowed their concern for
aspatial compositions and decorative
patterns.

Georges Auriol, 1863–1938.

Auriol was born in Beauvais, where, in
the mid-eighties, he became friends with
the group of artists including Rivière,
Somm, Steinlen, Willette, and Lautrec
who were associated with the cafe-
concert *Chat Noir* and its journal. By the
nineties he was on the editorial staff of
Chat Noir and lived in Montmartre on
the rue des Abbesses just off the Boule-
vard Clichy. During the nineties he cre-
ated lithographic programs, covers, and
illustrations in flat, pure colors and in a
Japanese decorative manner for the
Théâtre Libre, Le Chat Noir, l'Estampe
and *l'Affiche,* and *La Revue Encyclopédi-*
que. In the year 1901–2 he published
two volumes of his designs à *la Japonaise*
for seals, stamps, and monograms for the
use of various artists, collectors, pub-
lishers, and printers. He also created a
decorative calligraphic type used, for in-
stance, in printing the introduction of
Rivière's *Les Trente-six vues de la tour*
Eiffel. In 1899 Arsene Alexandre referred
to Auriol as "Un Japonais de Paris."

130

Georges Auriol.

130 *Floral Design* from
 Théâtre Libre program, 1889–90.
Color lithograph, 1889.
9-1/2 x 12-1/2 inches (24.1 x 31.7 cm.).
Rutgers University Fine Arts Collection.

131

Georges Auriol.

131 *Floral Design,*
preface for *L'Estampe Originale.*
Woodcut, 1894.
2-5/8 x 8-1/4 inches (6.7 x 21 cm.).
Karshan and Stein 3.
Rutgers University Fine Arts Collection.

There are examples in Hokusai's *Manga* of flower and leaves spread in silhouette against a flat, grey sky and moon. Here Auriol's circular monogram replaces Hokusai's moon.

Georges Auriol.

132 *The First Book of Seals, Stamps, and Monograms,* page 3 of *Le Premier livre des cachets, marques, et monogrammes,* Paris, Librairie Centrale des Beaux-Arts.
Book, 1901.
7-1/4 x 5-1/2 inches (18.4 x 14 cm.).
Rutgers University Fine Arts Collection,
Gift of Mr. and Mrs. Herbert Schimmel.

Auriol modeled his distinctive monograms and seals after the cartouches and seals found on Japanese prints.

132

Alexandre Lunois, 1863–1916.

133 *The Toilette (La Toilette).*
Color lithograph, 1892.
8-7/8 x 6-11/16 inches (22.5 x 16.1 cm.).
Paris, Bibliothèque Nationale,
Cabinet des Estampes.
Not illustrated

Lunois introduced the use of liquid lithographic inks to fellow printmakers of the nineties; this allowed duplication in lithography of the effect of water-base inks found in Japanese woodcut prints. Here, Lunois reveals his own predilection for Japanese motifs, patterns, and aspatial compositions.

Eugène Samuel Grasset, Swiss-French, 1841–1917.

134 *Vitriol-Thrower (Vitrioleuse)* from *L'Estampe Originale.*
Hand-stenciled color lithograph, 1894.
15-9/16 x 10-13/16 inches
(39.5 x 27.5 cm.).
Karshan and Stein 30.
The Brooklyn Museum,
Charles Stewart Smith Memorial Fund, 38.387.

The bold, aggressive actor portraits of Sharaku [63], as well as the whiplash arabesques found in Japanese prints (Fig. 28), had a decisive influence on Grasset.

134

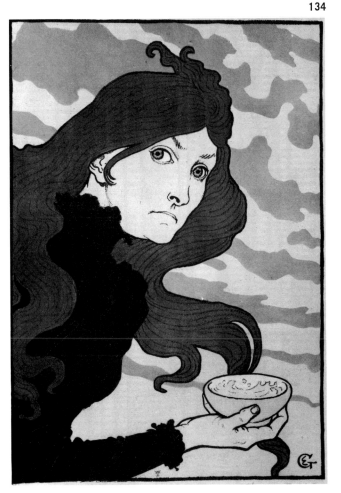

135

Charles-Louis Houdard.

135 *Frogs (Grenouilles)*
 from *L'Estampe Originale.*
Color aquatint, 1894.
10-5/16 x 15-9/16 inches
 (26.2 x 39.5 cm.).
Karshan and Stein 36.
The Brooklyn Museum,
 Charles Stewart Smith Memorial Fund,
 38.406.

The themes of frogs, insects, irises, and lily pads appear over and over again in Japanese prints of the late eighteenth and the nineteenth centuries. Houdard imitates precisely the Japanese system of spreading boldly delineated plants across the picture plane. He also borrows his bright, luminescent colors from the depictions of plants and insects in Japanese surimono prints.

Henri-Gustave Jossot, b. 1866.

136 *The Wave (La Vague)*
 from *L'Estampe Originale.*
Color lithograph, 1894.
20-11/16 x 13-13/16 inches
 (52.5 x 35.1 cm.).
Karshan and Stein 39.
Rutgers University Fine Arts Collection.

136

137

This is a comic interpretation of Hokusai's *Great Wave Off Kanagawa* [68], carrying to its extreme the whiplash arabesque and the truncation of figures by the composition's edge.

Paul Elie Ranson, 1862–1909.

137 *Tiger in the Jungle*
 (Tigre dans la jungle)
 from *L'Estampe Originale*.
Color lithograph, 1893.
14-1/2 x 11-1/4 inches (36.8 x 28.6 cm.).
Karshan and Stein 62.
The Cleveland Museum of Art,
 Gift of The Print Club of Cleveland.
 56.280
[See Fig. 29]

Ker-Xavier Roussel, 1867–1944.

138 *In the Snow (Dans la neige)*
 from *L'Estampe Originale*.
Color lithograph, 1893.
12-15/16 x 7-11/16 inches
 (32.9 x 19.5 cm.).
Karshan and Stein 76.
The Baltimore Museum of Art,
 The Blanche Adler Fund.

Roussel assimilates characteristics of Japanese actor prints with their figures in profile, tightly placed against the picture plane [65]. The elongated figures silhouetted against the horizon suggest Kiyonaga (Fig. 21).

Pierre Roche, 1855–1922.

139 *Algae (Algues marines)*
 from *L'Estampe Originale*.
Color gypsograph, 1893.
6-3/4 x 4-1/4 inches (17.2 x 10.8 cm.).
Karshan and Stein 70.
The Brooklyn Museum,
 Charles Stewart Smith Memorial Fund,
 38.368.

The gypsograph is a process by which paper is pressed over molds of plaster, creating a delicate and varied embossed texture. The embossed prints of Japan inspired the textural concerns of French printmaking in the 1880's and 1890's. The asymmetrical composition and positive intrusions of the paper into the composition are other characteristics absorbed from Roche's contact with Japanese prints.

138

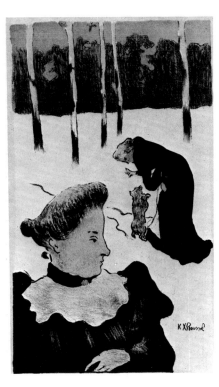

139

Figure 29.
*Picture of
a Tiger*.
Colored woodcut,
14-3/16 x
9-7/16 inches
(36 x 24 cm.),
18th century.
Kitagawa Utamaro.
Zurich,
The Rietberg
Museum,
Willy Boller
Collection.

Alexandre Charpentier, 1856–1909.

140 *Female Nude* from
Théâtre Libre program, 1889–90.
Embossed lithograph, 1889.
9-1/2 x 7-1/4 inches (24.1 x 18.4 cm.).
Rutgers University Fine Arts Collection.
[See annotation, 139]

Henri Rachou, b. 1856.

141 *Decorative Panel*
(Panneau décoratif).
Color lithograph, 1893.
19-1/16 x 11-11/16 inches
(48.4 x 29.7 cm.).
Karshan and Stein 59.
The Brooklyn Museum,
Charles Stewart Smith Memorial Fund,
38.349.

For this print Rachou studied the work of
Utamaro where the trellis and hanging
plant motif, the tilted tub, the limited
color range, and the simple aspatial back-
grounds may all be found. Rachou and
Lautrec were close friends and often
collected Japanese prints together.

Henri-Gabriel Ibels, 1867–1936.

142 *Second Program*
for *Le Théâtre Libre, 1892–93*.
Color lithograph, 1892.
9-1/2 x 12-1/2 inches (24.2 x 31.7 cm.).
Rutgers University Fine Arts Collection.

Ibels was a close friend of Lautrec. His
prints, especially in their use of *crachis*
and color in their reliance on Japanese
composition, are similar to those of Lau-
trec. Here the Japanese system of a high
horizon and a diagonal orientation flat-
tens the pictorial space; the fresh yel-
lows, pinks, and blues of the seascape
suggest Hiroshige (Fig. 14).

Henri-Gabriel Ibels.

143 *Fourth Program*
for *Le Théâtre Libre, 1892–93*.
Color lithograph, 1893.
9-1/2 x 12-1/2 inches (24.1 x 31.7 cm.).
Rutgers University Fine Arts Collection.

The calligraphic descriptions of the fig-
ures and objects, as well as the fore-
shortened and truncated figures and ob-
jects in the foreground, reflect the spirit
of Japanese aesthetics.

Edvard Munch, Norwegian, 1863–1944.

144 *The Shriek.*
Lithograph, 1895.
14 x 10 inches (35.5 x 25.4 cm.).
Washington, National Gallery of Art,
Rosenwald Collection.
(Shown only at Cleveland and Rutgers)

Beginning in 1895, Munch lived in Paris
for a year and a half. There he began
producing lithographs and woodcuts at
the workshop of Clot and fell under the
spell of the Japanese print. *The Shriek*,
although a lithograph, imitates the bold
style of woodcuts. The figure in the fore-
ground and the merging of sinuous linear
patterns and land and sea planes reflect
an appreciation of Japanese stylistics.

Camille Pissarro, 1830–1903.

145 *Peasant Women.*
Lithograph, 1896.
6-5/8 x 5-3/8 inches (16.8 x 13.6 cm.).
Delteil 166.
Boston, Museum of Fine Arts,
Horatio G. Curtis Funds.

The high horizon with figures silhouetted
against the land and the sinuous tree in
the foreground framing the figures are
typical motifs of Japanese prints [83 and
Fig. 20].

140

141

142

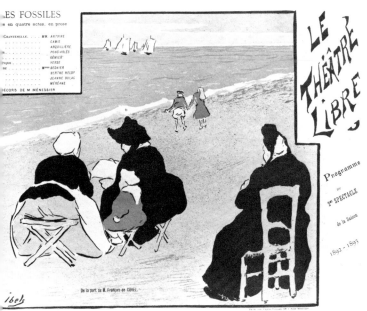

144

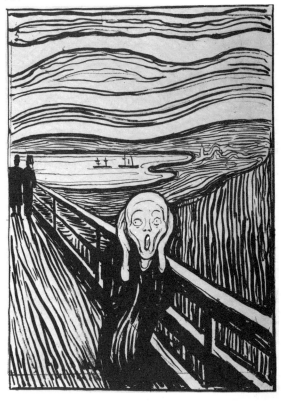

143

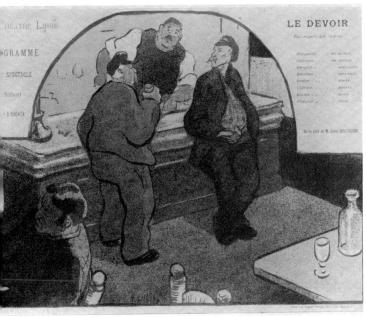

145

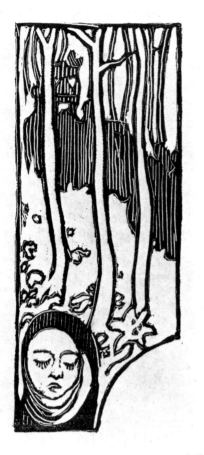

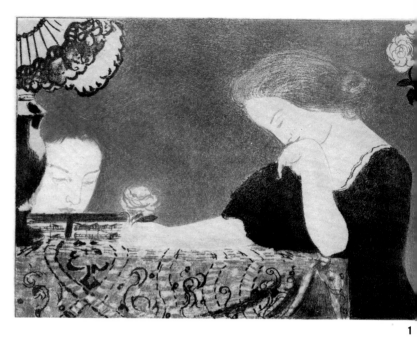

1

146

148

149

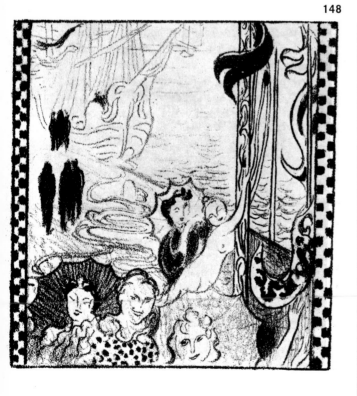

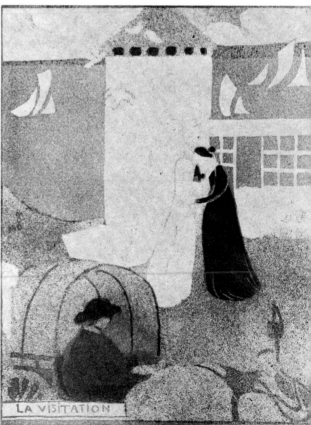

LA VISITATION

Maurice Denis, 1870–1943.

146 Illustration for page 16 of *Sagesse* by Paul Verlaine.

Woodcut, 1889.

4 x 1-3/4 inches (10.2 x 4.5 cm.).

Cailler 13.

Rutgers University Fine Arts Collection.

In this print Denis has exaggerated the Japanese emphasis on the picture plane by means of decorative patterns and truncated figures (Fig. 20).

Maurice Denis.

147 *Our Souls in Slow Gestures (Nos âmes, en des gestes lents)* from the series *Love (Amour)*.

Color lithograph, 1892–99.

11-1/8 x 15-3/4 inches (28.2 x 40 cm.).

Cailler 116.

New York, The Museum of Modern Art, Gift of Leo Auerbach.

The truncation of objects by the print border, the features of the figures, and their silhouette against a neutral background are pictorial elements often found in the work of Utamaro (Fig. 26).

Maurice Denis.

148 Illustration for page 5 of *The Voyage of Urien (Le Voyage d'Urien)* by André Gide, Paris, Librairie de L'Art indépendant, 1893.

Color lithograph, 1893.

8 x 7-1/4 inches (20.3 x 18.4 cm.).

Cailler 39.

Harvard College Library, Department of Printing and Graphic Arts.

The Japanese features of the figures, the umbrella, and the extreme arabesque illustrate this work's relationship to woodcuts of Japan.

Maurice Denis.

149 *The Visit (La Visitation).*

Color lithograph, 1894.

6-3/8 x 5-1/16 inches (16.2 x 12.8 cm.).

Callier 79.

The Baltimore Museum of Art, Museum Purchase.

[See Fig. 21]

Maurice Denis.

150 *Motherhood Before the Sea (Maternité devant la mer).*

Color lithograph, 1900.

13-1/2 x 10 inches (34.3 x 25.4 cm.).

Cailler 120.

Rutgers University Fine Arts Collection.

[See Fig. 20]

Pierre Bonnard, 1867–1946.

151 *The Dogs (Les Chiens)* from issue no. 5 of *L'Escarmouche.*

Lithograph, 1893.

11 x 10-5/8 inches (28 x 27 cm.).

Mr. and Mrs. Herbert Schimmel.

A characteristic of many Japanese woodcuts is the speckled marks on the ground indicating shadows, grass, pebbles, etc. Bonnard uses a similar system of abstraction, creating an unstructured, ambiguous space moving up and down the print in a manner often found in Hokusai's *Manga* [67f].

150

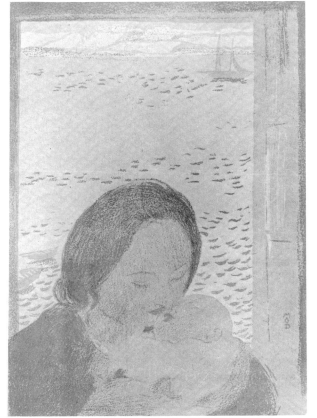

151

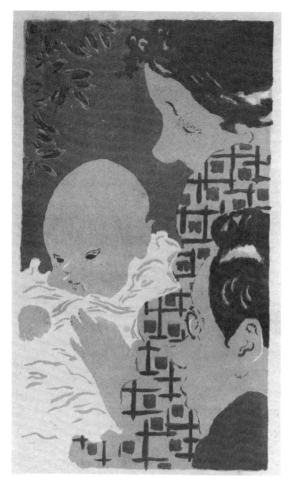

152

153

154

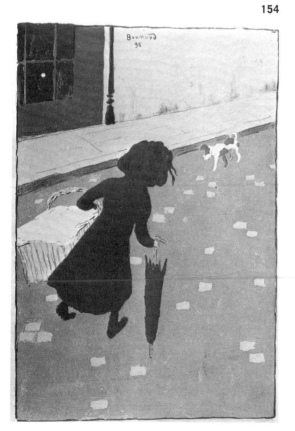

155

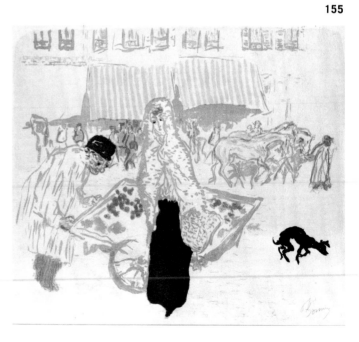

Figure 30. *Evening Scene in Saruwakacho* from *One Hundred Views o Famous Places in Edo.* Colored woodcut, oban, 13-1/4 x 5-5/8 inche (33.6 x 14.3 cm.), 1856. Ando Hiroshige. The Brooklyn Museum

Pierre Bonnard.

152 *Family Scene (Scène de famille).*
Color lithograph, 1893.
12-1/4 x 7 inches (31.1 x 17.8 cm.).
Roger-Marx 4.
The Baltimore Museum of Art,
 Museum Purchase.
[See 65]

Pierre Bonnard.

153 *At the Circus*
 (Au cirque, la haute-école)
 from *Small Familiar Scenes*
 (Petites scènes familières).
Lithograph, 1893.
5-1/2 x 13-1/2 inches (14 x 34.3 cm.).
Roger-Marx 23.
Boston, Museum of Fine Arts,
 Lee M. Friedman Fund.
[See 67d]

Pierre Bonnard.

154 *The Little Washergirl*
 (La Petite blanchisseuse).
Color lithograph, 1896.
11-5/8 x 7-7/8 inches (29.5 x 20 cm.).
Roger-Marx 42.
New York, The Museum of Modern Art,
 Gift of Victor S. Rissenfeld.

The system of flat silhouette, the diagonally rising ground plane, and the bird's-eye perspective focusing on the street and side buildings may be found in the work of Kuniyoshi and in Hiroshige's *Fifty-Three Stages of the Tokaido.*

Pierre Bonnard.

155 *Hawker of Four Seasons*
 (Marchand de quatre saisons)
 from the album
 Some Aspects of Paris Life
 (Quelques aspects de la vie de Paris).
Color lithograph, 1895.
11-9/16 x 13-5/8 inches (29.4 x 34.6 cm.).
Roger-Marx 63.
Boston, Museum of Fine Arts,
 Bequest of W. G. Russell Allen.

Like Hiroshige in his series *One Hundred Views of Famous Places in Edo,* Bonnard depicts the daily life of Paris. He captures the freshness of Japanese prints by his use of warm yellows, beiges, and tans.

Pierre Bonnard.

156 *Corner of the Street,*
 View from Above
 (Coin de rue, vue en haut)
 from the album
 Some Aspects of Paris Life
 (Quelques aspects de la vie de Paris).
Color lithograph, 1895.
14-1/2 x 8-1/2 inches (36.8 x 21.6 cm.).
Roger-Marx 68.
Philadelphia Museum of Art,
 McIlhenny Fund.
[See 74 and Fig. 30]

156

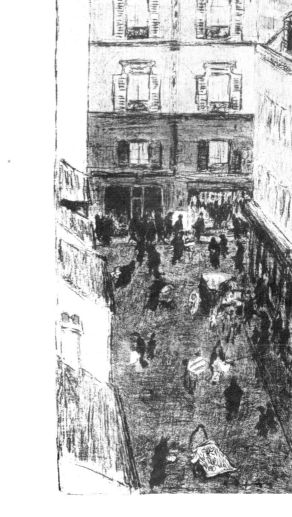

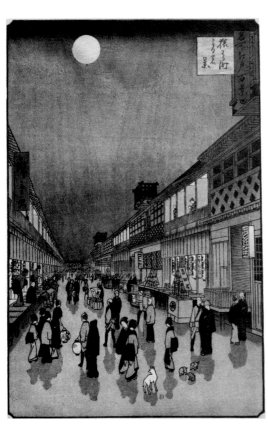

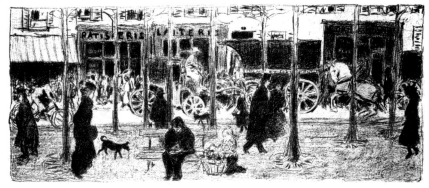

Pierre Bonnard.

157 *Boulevard,* from the album
*Some Aspects of Paris Life
(Quelques aspects de la vie de Paris).*

Color lithograph, 1895.
6-3/4 x 16-15/16 inches (17.2 x 43 cm.).
Roger-Marx 61.
The Cleveland Museum of Art,
 Mr. and Mrs. Lewis B. Williams
 Collection. 41.464

The frieze-like arrangement of the composition tightly confining the figures within a limited space is similar in effect to compositions of Kiyonaga (Fig. 21).

157

158

159

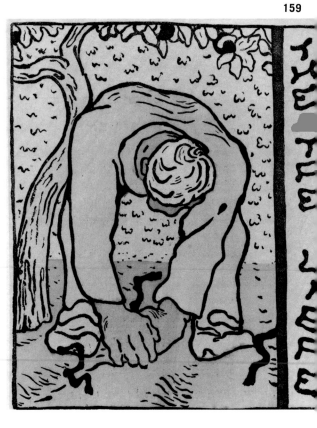

Pierre Bonnard.

158 *House in the Court*
 (Maison dans la cour)
 from the album
 Some Aspects of Paris Life
 (Quelques aspects de la vie de Paris).

Color lithograph, 1895.
13-3/4 x 10-1/4 inches (34.9 x 26 cm.).
Roger-Marx 59.
Philadelphia Museum of Art,
 McIlhenny Fund.

This bold, foreshortened composition
of a view through a window is similar to
those by Hiroshige [74, 77].

Edouard Vuillard, 1868–1910.

159 *The Sower, Théâtre Libre* program,
 1890–91.

Color lithograph, 1890.
8-1/2 x 7-1/2 inches (21.6 x 19 cm.).
Rutgers University Fine Arts Collection.
[See 83]

Edouard Vuillard.

160 *On the Bridge, Europe*
 (Sur le pont de L'Europe)
 from the album
 Landscapes and Interiors
 (Paysages et intérieurs).

Color lithograph, 1899.
12-1/8 x 13-3/4 inches (30.8 x 34.9 cm
Roger-Marx 40, ii.
Philadelphia Museum of Art,
 McIlhenny Fund.
[See 84 and Fig. 20]

Edouard Vuillard.

161 *Interior with Pink Wallpaper III*
 (Intérieur aux tentures roses III)
 from the album
 Landscapes and Interiors
 (Paysages et intérieurs).

Color lithograph, 1899.
13-3/8 x 10-5/8 inches (34 x 27 cm.).
Roger-Marx 38.
Boston, Museum of Fine Arts.

Vuillard found in Harunobu's series
Eight Views of Indoor Life warm interiors
depicted with complicated perspective
systems and the juxtaposition of con-
trasting patterns of wallpaper, furnish-
ings, and dress. The facade of wall and
door, diagonally inclined, is derived from
a similar system found in a work by
Hiroshige [77].

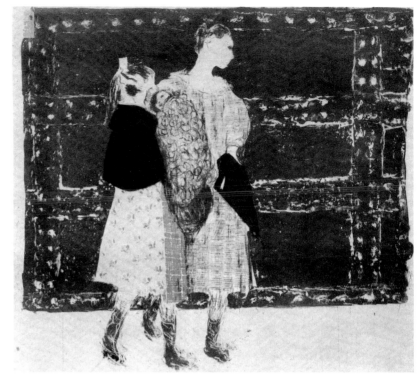

160

161

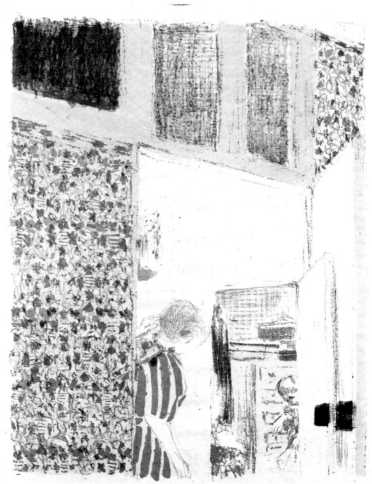

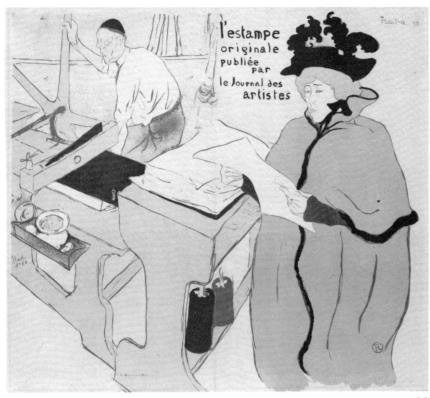

164

Henri de Toulouse-Lautrec, 1864–1901.

162 *"La Goulue" at the Moulin Rouge (La Goulue au Moulin Rouge).*

Lithographic poster, 1891.
67-3/4 x 48 inches (172 x 121.9 cm.).
Delteil 339.
Mr. and Mrs. Herbert Schimmel.

Lautrec revolutionized the art of poster-making by using systems found in the compositions of Japanese woodcuts to negate illusionistic space and to unite pictorial elements with the lettering. An up-tilted perspective, flat colors, the truncation of the globes of yellow light by the edge of the composition, and a decorative calligraphy contribute to the merging of pictorial elements and lettering on the frontal plane.

162

163

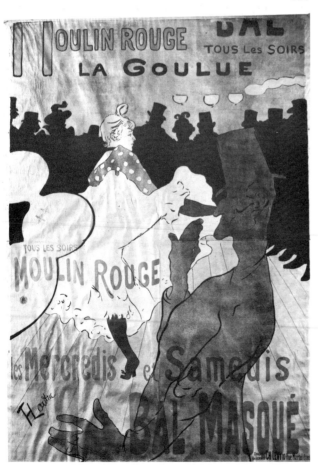

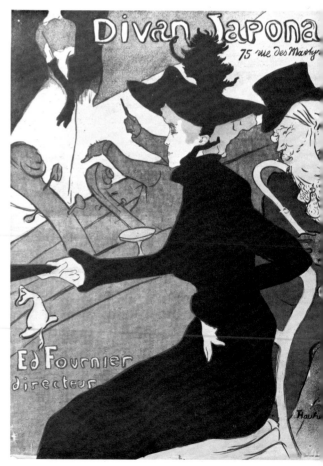

Henri de Toulouse-Lautrec.

163 *Le Divan Japonais.*
Lithographic poster, 1892.
30-1/2 x 24 inches (77.5 x 61 cm.).
Delteil 341.
Rutgers University Fine Arts Collection,
 Class of 1958
 Fifteenth Anniversary Gift.

Borrowing from Japanese examples,
Lautrec avoids illusionistic space by his
lack of modeling and by the use of diag-
onal elements going across and off rath-
er than back and into the composition
[84, 76].

Henri de Toulouse-Lautrec.

164 Cover for *L'Estampe Originale.*
Color lithograph, 1893.
11-5/8 x 25-3/4 inches (29.5 x 65.4 cm.).
Delteil 17.
Princeton University Library,
 Graphic Arts Collection.

Henri de Toulouse-Lautrec.

165 *Jane Avril*
 from the *Café Concert series.*
Lithograph, 1893.
10-7/16 x 8-3/8 inches (27 x 21.3 cm.).
Delteil 18.
Mr. and Mrs. Herbert Schimmel.

Influenced by the manner of Japanese
ink drawings, Lautrec very simply but
decisively suggests the grace and move-
ment of Jane Avril with quick calligraphic
notations.

Henri de Toulouse-Lautrec.

166 *Jane Avril at the Jardin de Paris*
 (Jane Avril au Jardin de Paris).
Lithographic poster, 1893.
51-3/16 x 37 inches (130 x 94 cm.).
Delteil 345, i.
Mr. and Mrs. Herbert Schimmel.

Lautrec foreshortens the staff of the base
violin and uses it to frame the perform-
ance of Jane Avril. A similar type of bold
foreshortening and framing is found in
Hiroshige's *One Hundred Views of
Famous Places in Edo* [78].

165

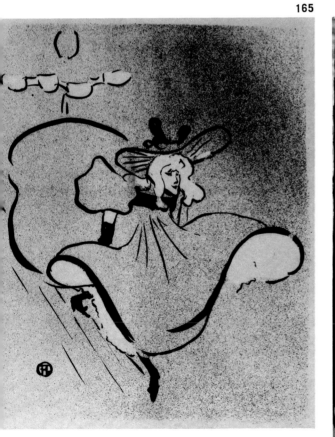

166

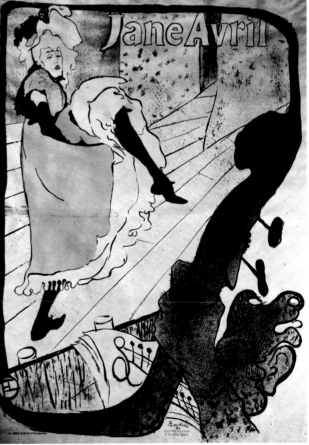

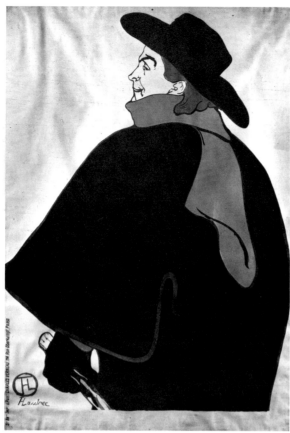

167

Henri de Toulouse-Lautrec.

167 *Bruant in His Night Club*
(Bruant dans son cabaret).
Lithographic poster, 1893.
50 x 36-7/16 inches (127 x 92.5 cm.).
Delteil 348, i.
Mr. and Mrs. Herbert Schimmel.
[See 63]

Henri de Toulouse-Lautrec.

168 *Miss Loie Fuller.*
Hand-colored lithograph, 1894.
16-15/16 x 10-5/8 inches (43 x 27 cm.).
Delteil 39.
David Tunick, Inc.
[See 64 and Fig. 28, p. 96]

Henri de Toulouse-Lautrec.

169 *May Milton.*
Lithographic poster, 1895.
31 x 23-1/2 inches (78.7 x 59.7 cm.).
Delteil 356.
Princeton University, The Art Museum.
Lautrec borrows from the Japanese the system of merging flat, pure colors on the frontal plane and an economical use of calligraphy with the white of the paper [82].

168

169

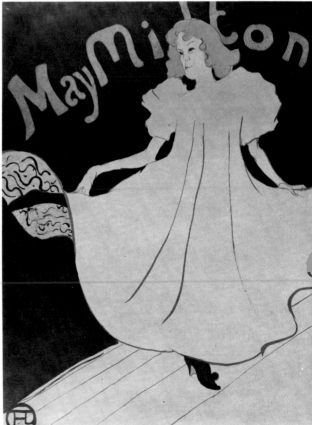

Henri de Toulouse-Lautrec.

170 *The Horse (Le Cheval),*
illustration for
(Histoires naturelles)
by Jules Renard.
Lithograph, 1900.
9-1/16 x 7-1/16 inches (23 x 18 cm.).
Delteil 319.
Library of Congress,
 Rosenwald Collection.
(Shown only at Cleveland and Rutgers)

One of Lautrec's last works, *Le Cheval*—
like sketches in Hokusai's *Manga*—gains
its impact and character from the simple
caricature deliniation of objects placed
aspatially across the white of the paper.

Henri Detouche, 1854–1913.

171 *Among the Thorns
(Dans les ronces)*
from *L'Estampe Moderne.*
Color lithograph, 1898.
13-3/4 x 9-5/8 inches (34.9 x 24.5 cm.).
Rutgers University Fine Arts Collection.

This lithograph and the three that follow
[172, 173, 174] are variants on the Japan-
ese actor portrait. Detouche creates an
aggressive rendition of the typical Japan-
ese prototype with the additional Orien-
tal element of a plant spread across a
picture plane (Fig. 19).

Henri Meunier, Belgian, 1873–1922.

172 *The Hour of Silence
(L'Heure du silence)*
from *L'Estampe moderne.*
Color lithograph, 1897.
16-1/8 x 12-1/8 inches (41 x 30.8 cm.).
Mr. and Mrs. Herbert Schimmel.

Unlike De Feure in *Le Retour* [173],
Meunier retains the quiet elegance and
simplicity found in Utamaro's actor por-
trait from the series *Chosen Poems* [66].

170

171 172

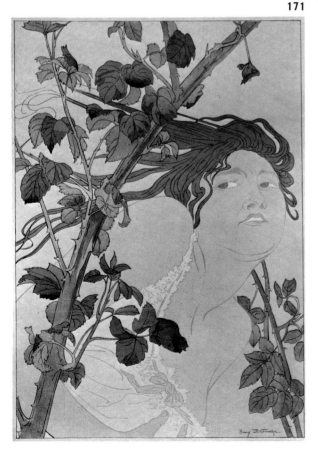

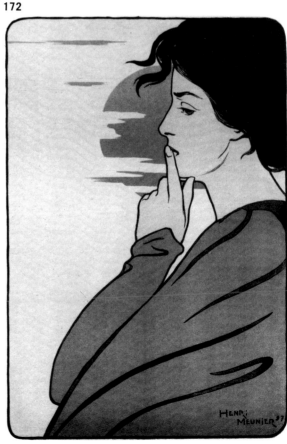

111

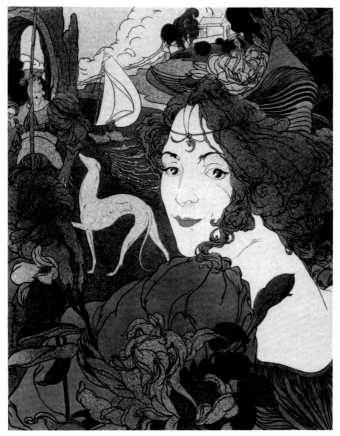

Georges de Feure, 1868–1943.

173 *The Return (Le Retour)*
from the album
L'Estampe Moderne.

Color lithograph, 1897.
13 x 10 inches (33 x 25.4 cm.).
New York, Bogart Gallery.

De Feure combines an elaborately decorative Japanese actor portrait motif [66] with the Japanese high horizon and an exaggerated Japanese arabesque.

Henri Jacques Evenepoel, Belgian,
1872–1899.

174 *At the Square (Au Square)*
from *L'Estampe Moderne.*

Color lithograph, 1897.
13 x 9 inches (33 x 22.9 cm.).
Rutgers University Fine Arts Collection.

Assimilating the style of the Japanese actor print and other prints of Utamaro, Evenepoel silhouettes his figures against a neutral aspatial backdrop and truncates them with his margins.

173

174

175

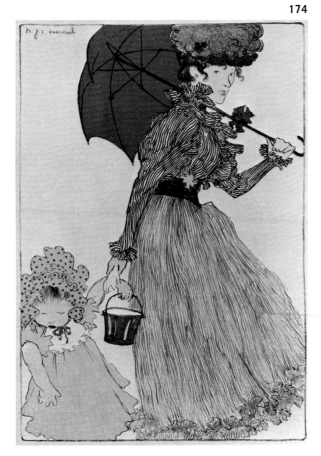

Yoni Beaugourdon.

175 *Lampshade Design,
Rolling Waves and Sunset.*
Color lithograph, ca. 1900.
25-1/2 x 36 inches (64.8 x 91.4 cm.).
Rutgers University Fine Arts Collection.

This design for a lampshade coinciden-
tally mimics the Japanese fan shape (Fig.
27) and for its decorative pattern of
waves relies strongly on Japanese de-
pictions such as Hokusai's *Great Wave*.
The decorative pattern of sea and setting
sun also derive from the Japanese (Fig.
20).

Théophile Alexandre Steinlen, Swiss,
1859–1923.

176 *Seated Cat (Chat assis).*
Color stencil.
4 x 11-1/2 inches (10.2 x 29.2 cm.).
Boston Public Library, Print Department.

The cat's pose in this previously un-
recorded print is not unlike that in Hiro-
shige's *Festival at Tori-No Machi* [77].
However, Steinlen's *Cat* relates more
convincingly to Utamaro's *Tiger* (Fig. 29).
The stenciled, flat patterns of fragmented
stripes and claws and the simple silhou-
ette of the cat derive from formulas simi-
lar to those used in the *Tiger*.

176

Théophile Alexandre Steinlen.

177 *Summer—Cat on a Balustrade
(L'Eté—Chat sur une balustrade).*
Color lithograph, 1909.
18-1/2 x 23-1/8 inches (47 x 58.7 cm.).
Crauzat 191.
Rutgers University Fine Arts Collection,
 Class of 1958 Anniversary Gift.

Steinlen places the diagonal balustrade
and cat flush against the picture plane
and confines space even further by using
a backdrop of a decorative floral pattern.
Spatially the work suggests various Japan-
ese actor prints [84, 85], but it is also
related—in its bold foreshortening of
the balustrade—to works in Hiroshige's
*One Hundred Views of Famous Places in
Edo* [77].

177

113

179

Louis Gonse.

178 *L'Art Japonais,* I.
Published by Quantin, Paris, 1883.
Rutgers University Art Library.
Not Illustrated.

Louis Gonse.

179 Title page for "Korin" from
Artistic Japan, no. 23, p. 133.
March, 1890.
Cleveland,
Dr. and Mrs. Gabriel P. Weisberg.

A. Lasenby Liberty.

180 Title page for
"The Industrial Arts in Japan"
("Les arts industriels au Japon")
from *Artistic Japan,* no. 34, p. 113.
February, 1891.
Cleveland,
Dr. and Mrs. Gabriel P. Weisberg.

III. Japanese Influence on French Painting 1854-1910
Gerald Needham

The Japanese Influence on French Painting

The enthusiasm among painters for Japanese art in the last forty years of the nineteenth century was intense and long-lasting. The admiration of the *Nabis* in the 1890's equaled that of Whistler and his friends in the 1860's. However, the interest of artists in the early twentieth century turned decisively to primitive art, and Japanese art has since become the preserve of specialists and connoisseurs.[1] As a result, though everyone interested in nineteenth-century French painting knows of the Japanese influence, we have lost sight of its full extent. Generally, historians of French painting have not been experts on Oriental art, and they have quoted the same few examples of Japonisme over and over again.[2] It is symptomatic that among the huge number of books devoted to aspects of nineteenth-century art there is not one on the Japanese influence on painting.

A notable exception to this state of affairs was the 1972 exhibition in Munich (World Cultures and Modern Art), which was pioneering in the amount of material that it assembled in the Japanese section. The present exhibition supplements the one in Munich by showing the first as well as the second stage of Japonisme in painting. (We speak of two stages because French painting falls into two different phases divided by the crisis in Impressionism, each of which is affected by different aspects of Japanese art.)

Because it is impossible to assemble all the significant paintings within an exhibition that also includes prints and decorative arts, a cross-section of French paintings illustrating a diversity of influences has been selected. Certain outstanding painters like Bonnard, Cassatt, and Toulouse-Lautrec are omitted because their work is well represented in the print section of the exhibition. To supplement the actual paintings, a number of reproductions are concisely displayed as part of the exhibition in order to demonstrate the ubiquity of Japanese elements in the work of almost every important artist of the period (Cézanne is the only exception). Within this supplement there is a detailed illustration of the impact on Claude Monet to show that every period of his career was intimately bound up with Japanese art. As Monet laid so much stress on his faithfulness to the motif and is usually seen as the purest Impressionist, it is hoped that this will demonstrate both the pervasiveness of the influence and the fact that it occurs where often today we do not suspect it.

A number of reasons accounted for the appeal of Japanese art to writers and artists. Nineteenth-century imperialism included a genuine interest in other peoples and parts of the globe, as is evident from the hero worship of explorers, and from the contents of the World Fairs. The opening up of Japan revealed an almost unknown and decidedly exotic civilization which was both quaint and refined. In addition it seemed to be permeated with artistic values in all aspects of life. This made it doubly attractive to French intellectuals revolted by the more depressing aspects of the new industrial society (one remembers their opposition to the Eiffel Tower), and by that society's failure to appreciate its best artists. Even more important, by the middle of the century the principles of Greco-Roman art which underlay European art had lost most of their vitality, as was widely recognized in spite of the lip service still paid them. Japanese art was introduced to the West at just the right moment to offer the alternative of a varied and sophisticated artistic tradition. A European artist could find in the fans, screens, kimonos, and bric-a-brac a highly refined and delicate inspiration (as Whistler did), or, if he preferred, he could find in the flat colors, emphatic outlines, and frequent grotesqueries of the prints a primitive, refreshing spirit and style. Thus Gauguin could eagerly collect Japanese prints, though Japanese civilization with its elaborate social rituals and over-refinements, was a perfect embodiment of the culture that Gauguin was trying to reject. It was these manifold aspects of Japonisme that gave it such a long life among creative artists.

The First Phase of Japonisme

Open-Air Impressionists in the 1860's and 1870's
The Impressionists were fortunate enough to discover Japanese art while they were still students, and even the older Manet and Degas had not yet formulated their styles. They were thus able to incorporate Japanese ideas as their artistic concepts formed. Older artists who admired the Japanese did not find it easy to introduce Oriental elements into a style that was already formed. The work of

Alfred Stevens, discussed below, reflects this situation.

The first phase of Japonisme is the least appreciated, and its extent is usually underestimated. Books on nineteenth-century art take note of Manet and Degas in this connection but make little reference to the open-air painters. In fact, some writers on Impressionism state that the references to Japanese art and its influence on the open-air painters are exaggerated. Ernst Scheyer expressed this view succinctly: "More and more we come to understand that the two-dimensional flatness of the Japanese print and Impressionism as practiced by Monet, Pissarro, and Sisley are mutually exclusive."[3] This assumption appears reasonable, but it is incorrect. A study of the writings by the Impressionists' friends and a closer examination of Japanese art will reveal a different case.

One of our first questions must be what Japanese art the painters saw. Whistler's pictures from the early sixties like *Purple and Rose: The Lange Lijzen of the Six Marks,* 1864 [185], indicate the diversity of objects that had already been imported into Europe. We find not only the familiar prints but also fans, albums, paintings, screens, and kimonos, not to mention Chinese porcelains. Whistler drew on many of these both for subjects and for style, but the Impressionists, who were less decorative, borrowed mainly from the prints. It is extremely difficult to discover written accounts of what prints were available; most of our evidence must be deduced from the French paintings and prints themselves. Our conclusions follow the dictates of common sense. It was largely nineteenth-century — more or less contemporary — prints that were imported, and we find traces chiefly of Hiroshige, Hokusai, and the "decadents" like Kuniyoshi and Kunisada. Until recently the low estimation of the latter as artists has obscured their importance as an influence, but in fact in the early stages of Japonisme everything was accepted with equal interest. Not surprisingly, the influence of eighteenth-century masters like Harunobu, Kiyonaga, and Utamaro is less evident, though from the Paris World Fair of 1867 on, a great variety of works do seem to have been known.

It must also be stressed that in a number of early paintings like Manet's portraits of Astruc and Zola we see more albums or illustrated books than single prints. This would seem natural, given the greater ease of packing and transporting the books which were bound and usually smaller than the single sheets. Hokusai's fifteen-volume *Manga,* one of the earliest known Japanese works, is an example.

Once Japanese art had become fashionable all types of art were, of course, imported. As a result the important Japanese works in the sixties were not necessarily those that we know best today. For instance, Hokusai's *One Hundred Views of Fuji,* which is a book, was even more influential than the famous *Thirty-Six Views of Fuji.* On the other hand, Hiroshige's single prints of the *One Hundred Views of Famous Places in Edo* had more influence than the *Fifty-Three Stages of the Tokaido* because they were published in the late 1850's, after the opening of Japan, and were extremely accessible to French artists throughout the period of Japonisme. Needless to say, when a Japanese work is cited in this essay or included in the exhibition it does not always mean that an artist must have seen a copy of this particular print. The Japanese artists endlessly copied each other and themselves, and any specific compositional or stylistic element can be found in a number of different works.

An important reason for the assimilation of Oriental ideas by French artists is that many of the Japanese elements they encountered corresponded with effects they had noticed and admired in their own environment. For example, cut-off compositions and silhouetting occurred in photography; the black outlines adopted by the Pont-Aven artists appeared in the medieval art they admired in the churches of Brittany; and certain daring compositions had been created by French caricaturists of the mid-century. This does not mean that we can dispense with the Japanese influence; it simply means that the mutual influence was necessary. Certain effects in photographs (a non-art medium) struck artists, and when similar elements were found in Japanese works it became apparent that these effects could also be achieved in art. In complementary fashion, the photograph corroborated that what might appear outlandish in a print was, in fact, "true"— a key word to the Impressionists with their respect for visual data. The importance of this mutual influence is also illustrated by the case of Gauguin and Bernard at Pont-Aven; without the Japanese example they would have found the black outline of medieval illumination or stained glass too traditional to use.

Among the open-air Impressionists Claude Monet was the leader in absorbing lessons from Japan. This fact has not been recognized, as Monet has always been regarded as the purest Impressionist. The Japanese influence has been seen in only a few Monet works of the sixties and seventies, those which did not have an atmospheric, perspective effect. As W. C. Seitz has written, Monet "followed Whistler and Manet in incorporating the flat, decorative qualities of Japanese prints into his art."[4] This cliché about the "flatness" of Japanese prints is ubiquitous and has prevented us from seeing how varied were the qualities of Japanese art that so fascinated the Impressionists. (Monet's extensive personal collection of prints and fans demonstrates his personal enthusiasm for Japanese art.)

As a matter of fact, the Japanese artists who particularly interested Monet and the open-air Impressionists were the landscapists whose prints were not "flat." The great artists of the late eighteenth and early nineteenth century — Kiyonaga, Hokusai, and Hiroshige — were part of a new realism in the arts, and their popularity was in part caused by the vogue for travel books and novels like Ikku Jippensha's *Hizakurige* of 1802. These printmakers partially rejected the Japanese pictorial tradition and eagerly studied the Western landscape prints (chiefly Dutch) that trickled into Japan through Nagasaki. Not only were European perspective concepts adopted but Hokusai even signed some of his landscapes in horizontal Western fashion to indicate his sources. At the beginning of Monet's development it was these semi-Europeanized pictures that he was able to learn from; he found the more purely Japanese works alien to his search for a faithful rendering of visual experience.

Japanese artists began to copy European perspective in the middle of the eighteenth century. At first these pictures, known as *uki-e* (not to be confused with *ukiyo-e*), were curiosities or were used for architectural scenes where the lines of the buildings provided a natural linear perspective scheme. An emphatic, exaggerated one-point perspective scheme was used in these latter works, presumably because it could be more easily constructed and because the dramatic result suited Japanese taste.

This type of perspective, as mastered by Hiroshige, proved to be a decisive influence in Monet's development during 1866–67, and through him it affected all the other Impressionists. We illustrate a comparison between Monet's *Road Near Honfleur in the Snow*, probably January, 1867, and Hiroshige's *Asakusa Kinryuzan Temple*, 1856 [181a and 74]. The reason Monet borrowed a perspective scheme from Japan which had come from Europe in the first place is that the Japanese exaggeration of perspective foreshortening contributed to the particular kind of painting Monet was trying to evolve. Monet wanted to paint a scene that not only was visually convincing in its freshness and immediacy but also included the atmosphere — what he referred to as the *enveloppe* of air. The traditional Japanese picture precluded this latter element, while the one-point perspective style in Western landscapes created a steady recession with a time element that eliminated immediacy. The dramatization of the perspective in the Honfleur snow pictures rapidly funnels the spectator's eye to the back of the scene, where the lack of any object to fix on forces his attention quickly over the remainder of the canvas. The picture is thus received in a single glance (as an *impression*) without sacrificing the actual depth of the landscape or its atmospheric qualities.

This concept was so successful that it became a standard for Impressionist composition; it was used especially frequently by Pissarro and Sisley in their views down roads.[5] Monet himself used it most often in his views of the Seine where the towpath and the river combine as one perspective unit. This assimilation of the Japanese style was undoubtedly encouraged by some of Jongkind's compositions of the mid-sixties which moved in this direction. Additionally, the foreshortening effect resembles that found in photographs and prints. To emphasize this important compositional type we reproduce another Monet, *Rue de la Bavolle, Honfleur* (Fig. 31), probably Fall 1866, and Hiroshige's *Evening Scene in Saruwakacho* (Fig. 30; see p. 105), circa 1857.[6] The X-shape superimposed on the composition by the buildings creates a surface tension as well as depth.

The most widespread influence of the Japanese on the Impressionists was the freshness and brightness of their color. So different was the Japanese use of color from that of the open-air painters that it might seem an unlikely source of influence. Yet the earliest writers on Impressionism and the Jap-

Figure 31.
Rue de la Bavolle, Honfleur.
Oil on canvas, 22 x 24 inches
(56 x 61 cm.), 1866–67.
Claude Monet.
Boston, The Museum of Fine Arts.

anese — Armand Silvestre and Théodore Duret — both singled out Japanese color as a major influence of these painters, who were well known to them as friends. Though the Impressionist brushstroke and optical realism created an effect very different from the arbitrary Japanese color, the connection was clearly expressed by Duret:

> Well it may seem strange to say it, but it is none the less true, that before the arrival among us of the Japanese picture books, there was no one in France who dared to seat himself on the banks of a river and to put side by side on his canvas, a roof frankly red, a white-washed wall, a green poplar, a yellow road, and blue water.[7]

The freshness of Japanese color thus inspired French painters to seek color boldly in their observation of the motif. This is particularly true of Monet, most of whose works in the sixties were not particularly bright, since he was seeking a harmony of light. In 1871 he bought a number of Japanese prints in Holland (earlier he was too poor to acquire them personally), and his color immediately became brighter. *Blue House at Zaandam,* 1871–72 (private collection), is an obvious example.[8] The Renoir painting *Still Life with Bouquet,* 1871 [182], shows how the color of a Japanese fan can set the tone for a whole painting. It also illustrates the importance of fans and prints in studios and homes of French artists, for Monet was not the only painter to come under this influence. In 1873 Silvestre wrote in the preface to the volume of etchings of paintings belonging to the Durand-Ruel Gallery:

What seems to have hastened the success of these newcomers, Monet, Pissarro and Sisley, is that their pictures are painted in a singularly joyful range of color. A blond light inundates them, and everything in them is gaiety, sparkle, springtime fete, evenings of gold or apple trees in flower — again an inspiration from Japan.[9]

Silvestre's comment suggests another aspect of the Impressionist-Japanese relationship — subject matter. Just as the Impressionists painted scenes of recreation in Paris and the surrounding resorts (the cafes, dance halls, race courses, theaters, boulevards, and bridges, and the promenading and boating at Argenteuil, Bougival, Chatou, or at the seashore), so the *ukiyo-e* prints depicted the pleasures of Edo (the theaters, street scenes, and wrestlers, the cafe life of the brothels,[10] and the many excursionist scenes of surrounding beauty spots). This correlation must have encouraged the assimilation of Japanese qualities and shows why the Impressionists were much less influenced by Japanese paintings and screens.

Pissarro, the most rural of the Impressionists in this period, reveals still another aspect of the influence of Japanese prints in the weather effects of mist, fog, and snow that occur in his canvases. Eventually he was to write to his son Lucien after seeing a show of Japanese prints at the Durand-Ruel Gallery:

> Damn it all, if this show doesn't justify us! There are grey sunsets that are the most striking instances of impressionism. . . . Hiroshige is a mar-

vellous impressionist. Monet, Rodin, and I are enthusiastic about the show.''[11]

The support of Durand-Ruel in the early 1870's after the Franco-Prussian War enabled the Impressionists to buy prints, and their influence on the artists was further strengthened. In addition to the pervasive interest in color, numerous Japanese-inspired motifs can be found in Monet, for example, in his pictures with bridges filling the upper part of the painting, or with a screen of branches obscuring the motif (a technique also favored by Pissarro), in pictures of snow actually falling, and in individual compositions like his painting of men unloading coal from barges.

The famous *La Japonaise,* 1876 (Boston Museum of Fine Arts), Monet's painting of his wife wrapped in a spectacular Japanese-appliqued cloth with fans on the wall behind her, is the one fashionable and obvious picture that he painted in this period. Renoir, Monet's friend, was sensitive to Japanese color but his compositions are less innovative than Monet's; where we see traces of Japonisme they may have come from the works of his friends rather than directly from the Japanese. An admiration for Japanese art is seen most clearly in the use Renoir made of fans, screens, and silks in his portraits, particularly those of Monet's wife.

Pissarro, like Degas, was challenged by the fan shape, and this is especially interesting in his case. He usually had little time for delicate or feminine art, but again the fascination of Japan was irresistible. In the *Girl in a Field with Turkeys* (Fig. 32),

however, the handling of the peasant subject and panoramic landscape almost refutes the Japanese examples. The composition, with a close-up subject on one side and a vista on the other, is derived more from painting than from prints and is equally as much Chinese as Japanese; it may possibly be one of the rare instances at this time of a Chinese inspiration.

Caillebotte was not a major painter but deserves far more recognition than he has received. It is thus very satisfying to have one of his paintings in the exhibition. Caillebotte was a friend and neighbor of Monet's at Argenteuil, and they probably decided together to paint their views at the Gare St. Lazare. Caillebotte's greatest talent was for composition, and several of his canvases use Japanese ideas.[12] The *Pont de l'Europe,* 1876 [183], is the bridge over the railroad tracks at the station. This sketch and the final paintings are remarkable for the prominent place given to the girders of the bridge, which dwarf the passers-by — scarcely an artistic composition at the time it was painted, but in Japanese art the crisscross supports of a bridge were a common theme (they inspired Rivière to execute his *Thirty-Six Views of the Eiffel Tower*). We include a Hiroshige [71] as an example, but Kiyonaga's triptych of people standing in a boat in front of a bridge trestle, *Pleasure Boats Beneath the Azuma Bridge,* could be considered even closer to the Caillebotte.

Figure 33. *The Fifer*. Oil on canvas, 63 x 38-1/4 inches (160 x 97.2 cm.), 1866. Edouard Manet. Paris, The Louvre.

Manet's admiration for Velasquez' single, full-length figures set in an undefined space led him to appreciate the immediacy of the Japanese figures silhouetted against the white of the paper with no ground line. *The Fifer* (Fig. 33) is the most striking example of this style in which the Japanese influence has almost entirely replaced the Spanish. Manet even uses the braid on the boy's trousers to form a black outline like those in the prints. Manet's faces, which disturbed people because of their lack of detailed definition, also came from the prints. Berthe Morisot wrote, "Only Manet and the Japanese are capable of indicating a mouth, eyes, a nose in a single stroke, but so concisely that the rest of the face takes on modeling."[13]

Throughout the 1860's Manet sought to make his figures break out of the confining perspective and semi-gloom beyond the picture frame that made the carefully painted pictures of his time lack the touch of life. In Japanese art, with its fresh color, lack of half tones, and simplification of background, he found an art which paralleled his own search and went beyond the Spanish seventeenth-century masters.

Many of Manet's subjects corresponded with those in the prints. The exquisite aspect of the geishas powdering in the mirror or showing off their kimonos and coiffures must have inspired Manet, the great painter of the *parisienne* and her gloves, hats, parasols, and petticoats. The French courtesan *Nana*, 1877, stands half-dressed in front of a mirror powdering herself, while her gentleman caller is cut in half by the edge of the painting in an amusing Japanese reference which reminds us that the traditional Western subject of the woman and mirror could be revivified by the Yoshiwara theme of courtesan and client.

Manet and Degas

Manet and Degas borrowed different elements from Japanese art than did their open-air friends, and it has always been easier to recognize their debt. Manet's use of flat, unmodulated color and surface compositions in works like *Olympia*, 1863, and *The Fifer*, 1866 (a technique which led contemporaries to describe both paintings as "playing cards"), has long been recognized as being derived in part from Japanese art. His portraits of *Zacharie Astruc*, 1864, and *Emile Zola*, 1868, included Japanese albums, prints, and a screen, reflecting his own enthusiasms as well as those of his friends.

The art of Degas was a particularly conspicuous example of Japonisme because it was the non-Western qualities of Japanese art that attracted him: asymmetrical compositions, figures thrust dramatically into the foreground or pushed up to the top of the picture, interior scenes with bird's-eye viewpoints and steeply sloping floors, figures sliced by the edge of the picture, or touches of the grotesque. When we compare these devices with the ideas that Degas jotted down in his notebooks, we can see their correlation with interests derived from the artists's mid-nineteenth-century background:

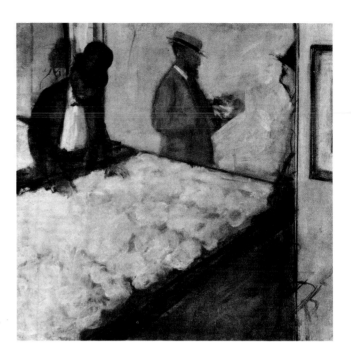

No one has ever done monuments or houses from below, from beneath, up close as one sees them going by in the streets.

On smoke, smoke of smokers, pipes, cigarettes, cigars, smoke of locomotives, of high chimneys, factories, steamboats, etc.

Series on instruments and instrumentalists, their shapes, twisting of the hands and arms and neck of the violinists, for example, puffing out and hollowing of the cheeks of bassoons, oboes, etc.[14]

Thus, as was the case with Manet, the appeal of the Japanese for Degas lay in their suggesting a means to render contemporary life more vividly than the painstaking realism of academic art permitted. Subject matter was again important. As many writers have pointed out, French salon art avoided the life of its own times, except when it represented military battles with patriotic appeal or sentimental pictures of sick children. In contrast, the innumerable Japanese theatrical prints showed the actors in their latest roles — we can actually date the prints from theatrical records, since the publishers rushed them at once into their shops. Degas' views of the stage, audience, orchestra, rehearsals, and examinations give a similar sense of contemporaneity. Where the Japanese depicted the teahouses of the Yoshiwara, Degas painted the cafes and concerts of the boulevards.

Since he believed in deliberately composing his work back in the studio rather than in faithfully reproducing what he saw on the spot, Degas was able to use the non-Western effects described above far more boldly than the other Impressionists. Paradoxically this was the result of his conservatism— he followed academic precepts governing the need to compose a painting that had been rejected by his friends.

In this connection it is important to realize that though Degas was the most obvious and frequent Japoniste, he came to appreciate Japanese art later than Manet and Monet. It was only in the seventies that Degas really accepted a Japanese approach, but then it became the basis of his compositions. He was less interested in landscapists than in artists who treated interiors, and by the seventies a large variety of prints was available, including many interior scenes. (Duret, critic and friend of the Impressionists, had gone, during the Franco-Prussian War, 1870–71, on a world tour that included China and Japan and had collected a number of Japanese prints.)

The oil sketch for the *Cotton Merchants*, 1873 Fogg Art Museum, Mass.; Fig. 34), is typical of many Degas works of the seventies. The composition moves up the painting from bottom to top rather than receding from front to back. A diagonal is used halfway up the work, reminding us particularly of Harunobu's prints. The figure of the man on the right is truncated. Altogether the sketch is a good illustration of Degas' experiments with Japanese ideas in the early seventies. The final version in the Pau Museum is more conventionally conceived, though it still contains Japanese elements and is a brilliant work.

Another type of composition used frequently by Degas was the view from the theater box in which the profile and fan of a spectator loom up in the corner, dwarfing the distant dancers on the stage. This technique does not seem to be borrowed from a particular Japanese prototype, but may reflect Degas' imaginative reworking of the Japanese use in some prints of a dramatically enlarged object in the foreground (the lantern in the Hiroshige snow scene [74] is a typical example of a device that Hiroshige often employed).

Degas is represented in the exhibition by one of his fan paintings [184] because it illustrates the Impressionists' use of the fan form as well as their in-

Figure 35. *The Boating Party*. Oil on canvas,
35-1/2 x 46-1/8 inches (90.2 x 117.1 cm.), 1893–94.
Mary Cassatt. Washington, National Gallery of Art,
Chester Dale Collection.

Below: Figure 36. *The Blue Dress*. Oil on panel,
12-9/16 x 10-1/4 inches (31.9 x 26 cm.), 1860's.
Alfred Stevens (Belgian). Williamstown, Mass.,
Sterling and Francine Clark Art Institute.

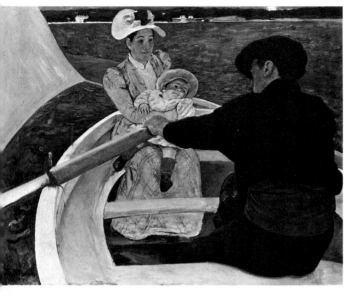

clusion of this form in paintings of interiors. We have mentioned in connection with Pissarro the challenge of the fan shape, and this was even more true for Degas, who conceived of a scene as viewed through a keyhole. His bird's-eye composition of stages lent themselves well to the fan format, as we see in this example. Another interesting aspect of this fan, painted late in the seventies, is the reduction of linear forms within the pastel to achieve a more amorphous, decorative play of color. Here we see a characteristic that could have been influenced by a variety of Japanese sources that are not prints: paintings (some of the works descended from Sotatsu, for example), glazes on ceramics, or the gorgeously colored abstract designs on papers used for mounting paintings or as end papers for books.

The women bathers who occupied an increasingly important place in Degas' art after 1880 are also associated with Japanese examples, though of course the female nude is far more common in Western than in Japanese art. But where the nude had been presented as a model of grace in the West, in Japanese art she appeared in the awkward poses favored by Degas. This can be attributed partly to the Japanese fondness for striking configurations, partly to their love of the humorous and the grotesque, and partly to their lack of skill in drawing the human figure, as life models were not used. Hokusai's sketches in the *Manga* have been compared to Degas' bathers. Also comparable are the public bathhouse scenes which provided Japanese artists with an excuse for creating many different contortions of the human figure. Kunichika is an example of a minor nineteenth-century printmaker imported in large quantity who did this kind of scene and certainly provided further stimulus for Degas. Weisberg's essay and his selection of Degas prints cover this aspect of the artist's work very well; Weisberg even points out (p. 12) that Degas had a Kiyonaga bathhouse scene in his bedroom.

Degas' friend, the American artist Mary Cassatt, who lived in Paris, shows less direct Japonisme in her work of the seventies (though she appears as the subject of a very Japanese composition by Degas [54]). She did, however, participate wholeheartedly in the second wave of Japonisme, when she renewed her art with an intensification of the surface compositional elements. In *The Boating Party,* 1894 (Fig. 35), she adopts the use of a large foreground figure sliced off by the picture frame, so

that the boatman appears more silhouetted than rounded and becomes part of a play of opposing curved, dark, and light forms.[15] Even more successful in their creation of a dynamically patterned surface deriving directly from Japanese prints are Cassatt's color etchings [116–119]. This concept is also beautifully represented in her painting of *The Bath,* circa 1892 (Art Institute of Chicago).

Conventional Painters of Japanese Objects

In this first phase of Japonisme, which continued until the mid-eighties, the number of painters borrowing Japanese ideas was quite small, though they represented the major young artists of the period. There was, in addition, a group of conventional painters who introduced Japanese objects into their pictures in order to give them an exotic and fashionable appeal. The result is a body of pictures which present a French interior with a screen or fan, or a *parisienne* dressed in a kimono, though the light is the familiar academic gloom, with none of the sparkle of Renoir's fan painting. This superficial approach to Japanese art is chiefly interesting for the evidence it provides of the fashion for Japan in Paris. An example is Alfred Stevens' *Blue Dress,* 1860's (Fig. 36). Stevens, born in 1828, was a friend of the Impressionists who, in his art, occupied a middle ground between the Impressionists and the Salon artists. He pioneered the presentation of the contemporary *parisienne* in art, a concern which led him to include Japanese objects in many paintings. Stevens, in his book *Impressions on Painting,* originally published in 1886, wrote that the "Japanese are the true Impressionists" and that "Japanese art is a powerful element of modernity."[16] Yet I have seen no painting of his that shows the stylistic effects of this conviction.[17] Perhaps, since he was one of the artists whose style was set before the Japanese works came to France, he found it impossible to adopt any of the qualities that he admired without giving up the basis of his style.

An artist similar to Stevens was James Tissot, a friend of Degas. He also included Japanese objects in pictures of contemporary life but was never able to adopt either the Impressionist or the Japanese vision with boldness.

Two older painters who took a positive interest in Japanese art were the Barbizon artists, Théodore Rousseau and Jean-François Millet. The latter introduced the high horizon line into several of his drawings, while Rousseau experimented with Japanese ideas in his paintings.[18] These experiments did not work out entirely satisfactorily and the Japanese elements are not obvious today. However, the fact that these Barbizon landscapists at the ends of their careers were so responsive to Japanese art shows both their calibre as artists and the sheer pervasiveness of Japonisme among all the best artists of the time.

Whistler

Whistler's painting *Purple and Rose: The Lange Lijzen of the Six Marks,* 1864 [185],[19] has been included in the exhibition, although it was painted in London, because of Whistler's importance as a popularizer of Japanese art in the early sixties. He lived in Paris during the late fifties and visited it regularly in the sixties and seventies. His *Symphony in White, No. 1* was a sensation at the *Salon des refusés* of 1863, and he was a personal friend of the Impressionists.

The Lange Lijzen includes both Chinese and Japanese objects, although its style is mainly European. It is one of the earliest of the pictures described above that depend chiefly on exotic appeal, but if Whistler encouraged this minor side of Japonisme the Oriental cartouche for the artist's signature in the upper right is evidence of his turn toward a more creative approach. As Whistler's passion for Oriental art developed, he tried, unlike the Impressionists, to immerse himself in the Oriental artist's tradition. This concern can be seen in another painting, begun in 1864—*Variations in Flesh Color and Green: The Balcony* (Freer Gallery of Art, Washington, D.C.).[20] The composition of this picture of Japanese women on a balcony overlooking a river is taken from two prints by Kiyonaga that Whistler owned. He also introduced cut-off sprays of flowers at the lower edges of this painting, as well as insects—Japanese motifs not found in the Kiyonagas. Moreover, the picture is not a simple pastiche; the background landscape (more prominent than in Kiyonaga) is a modern industrial Thames scene with factory chimneys. Whistler was trying to work through Japanese art toward an original vision that did not reject his Western heritage but gave it a new direction. The result was a series of paintings that were poetic reveries or fantasies on his subjects. This was especially true of the *Nocturnes.* These were inspired by actual London

or French scenes but so transformed that it seems quite natural for a cartouche with Whistler's butterfly signature to appear in the central lower edge of *Nocturne in Blue and Green: Chelsea*, 1871 (private collection).

While Whistler's friends used Japanese ideas to make a work that was an expression of European naturalism, Whistler sought an evocative art that was out of key with his times. He therefore found little appreciation. It was only in the later part of the century, when the Symbolist period had brought about dramatic changes of taste, that Whistler was widely understood and achieved his great reputation. His original peacocks of the mid-seventies for the Peacock Room became a cliché in other artists' work in the nineties.[21]

Whistler's use of a butterfly as a signature signifies his originality. Insects had never been deemed worthy as an artistic subject by themselves in Europe, and had been confined to an occasional, almost furtive, appearance on still-life bouquets. In Oriental art, however, they flourished as delightful, beautiful creatures (the Redon painting, *The White Butterfly* [193], was selected to illustrate this aspect of Japanese influence). Whistler evolved his butterfly monogram as a motif that not only demonstrated his identification with the Oriental artist but also made a satiric comment on Western art.

Whistler's creation in so many of his paintings of the seventies of an undefined space with mere hints of subjects floating in it shows his feeling for Japanese screens and paintings. As we have seen, his fellow painters preferred the "realism" of the prints.[22] Whistler's contribution to Japonisme, therefore, was highly individual and prepared the way for the broader use of Japanese art that characterized the second phase of Japonisme.[23]

The Second Phase of Japonisme

Post-Impressionism and Symbolism

The dramatic change in avant-garde art in the eighties, with the rejection of naturalism by so many young artists, created the circumstances for this new phase of Japonisme. As painters sought exaggerated forms and arbitrary color harmonies for symbolic or expressive purposes, a whole new range of possibilities was discovered in Japanese art. The new artists—the Pont-Aven group, the Pointillists, the *Nabis*, Van Gogh, Toulouse-Lautrec,

Redon, and others—had differing styles and ideals, but all were united by their passion for Japanese art.[24] The Impressionists themselves went through a crisis as they felt the necessity for a renewal of their work. In the case of Monet and Degas this led to a new phase of Japonisme particularly conspicuous in Monet's work. As a result of this ferment, specifically Japanese characteristics were now adopted by French artists. These new influences are more easily recognized and have been far more frequently discussed. Because more references are available, less need be said here concerning this phase of Japonisme; it is necessary merely to suggest its range and indicate the sources for more detailed study.

Gauguin and the Pont-Aven Artists

The meeting of Paul Gauguin and Emile Bernard in the Brittany village of Pont-Aven in 1888 gave birth to the Synthetist or Cloisonist style which inspired directly or indirectly so many of the brilliant young artists of the period. The picture in this exhibition by Gauguin, *Le pardon breton, près d'un tombeau*, 1889 [186], is a perfect example with its flat areas of color surrounded by a black outline, of cloisonisme (cloisons are the metal outlines which create the designs in medieval enamels).

Gauguin and Bernard admired the Bretons for their sincere and uncomplicated faith which seemed more profound than the cynicism of Paris or the intellectualism of the Gothic revival. Their art was an attempt to match this faith with simple, almost crude forms that were rendered profound by the use of line and color. As sophisticated Parisians and intelligent artists, they realized that they could not revive medieval art; instead, they found in the black outlines and flat color of Japanese prints a means of indirectly, and very personally, approaching their subject. Emile Bernard wrote, "The study of Japanese prints led us (with Anquetin) towards simplicity. We created cloisonnisme—1886."[25]

As a result, *Le pardon* is a picture that in its subject and mood reminds us of the age of faith, yet is the creation of a modern sensibility with which we can empathize. The pattern of straight tree trunks in the upper part of the painting (another Japanese feature which illustrates the rejection of Impressionism) was widely imitated by Gauguin's admirers.

124

Gauguin enthusiastically collected Japanese prints and used them to decorate his rooms both in France and in the Pacific. They appear in the backgrounds of his paintings (most notably in *Still Life with a Japanese Print,* 1889) as well as influencing his style. A frequently quoted example of the latter is the picture of Jacob and the Angel wrestling in *Vision after the Sermon,* 1888 (National Gallery of Scotland, Edinburgh). This angular group is derived from Hokusai's *Manga,* so often used as a source by French artists.

Gauguin also noted the suppression of shadow in Japanese prints and regarded it as an important method for eliminating naturalism in favor of expressive color. Like almost all the Pont-Aven artists, Gauguin painted the rocks and sea of the Brittany coast with the decorative curlicues of the waves and foam that are so familiar to us from innumerable reproductions of Hokusai's *Great Wave* [68]. (In the exhibition, Lacombe's *Grey Sea* [188] represents this type.)

The direct Japanese influence in Gauguin's work was at its height in the years 1888 and 1889. These were the years during which the artist assimilated what he needed from Japanese art. Later the influence became implicit in the individual style that he had forged; it was no longer explicit, as it had been in the exuberant formative years.

Bernard's *Fête de nuit,* 1888 [187], was chosen to complement the Gauguin because it, too, depicts a contemporary scene. The theme of fireworks is taken from Hiroshige. The *Fireworks at Ryogoku Bridge* [79] is one of several such scenes by Hiroshige.[26] The foreground close-up of heads is an obvious Japanese motif both in its placement and in its mixture of the decorative and the grotesque. Bernard, too, collected prints and exchanged them with Vincent van Gogh. The latter frequently mentions Japanese art in his letters to Bernard, and he stressed the Japanese qualities in Bernard's painting.

Various less important Pont-Aven painters also showed their admiration for Japanese art in wave paintings and in works like Meyer de Hahn's *Self-Portrait on a Background in Japanese style* (Altschul collection). The movement towards the decorative arts that was part of the shift in the avant-garde style also produced a number of screens, of which Seguin's *Delights of Life* (private collection, U.S.A.)[27] is a good example.

The Nabis

The story has often been told of the young Sérusier in 1888 meeting Gauguin in Brittany and being encouraged to paint with simplified, bold coloring. He bore the resulting small panel back to Paris where it had an electrifying effect on his group of friends. This connection between Pont-Aven and the *Nabis*[28] is reflected in their mutual admiration for Japanese art and in some very similar works that were produced as a result. We are fortunate to have Lacombe's *Grey Sea,* circa 1890 [188], as an example which typifies the popular Japoniste seascape of Brittany. Lacombe, who was independently wealthy, did not sell his works, and his paintings disappeared into obscurity. Only recently, with the renewed interest in the art of the 1890's, have they reappeared. Hiroshige's *Whirlpool at Naruto* [191a] is the kind of Japanese sea picture that inspired Lacombe, though there were many others even closer to Lacombe's work.[29]

A comparison of *Grey Sea* with Monet's similar composition, *Belle-Ile-en-Mer,* 1886 (Bridgestone Museum of Arts, Tokyo), illustrates both the changes in Monet's work during the 1880's and the difference between his new work and the abstract decorativeness of the younger generation of painters. Monet started from the same Japanese sources, with a sea-lashed rock in the middle of the picture; he uses the high Japanese horizon line, but his painting is a masterpiece of sensitive brushstroke and close observation of the actual Brittany scene. Lacombe, on the other hand, eliminates the sky altogether so that perspective is almost eliminated as well, as his spray and waves have outlines that freeze them in bubbly arabesques. It is a fine picture, but painted in the studio, not out-of-doors.

Like many of the very young artists prominent in the 1890's, Maurice Denis later could not adjust to the new concepts of art created by Cubism in the early twentieth century. His work deteriorated sharply in quality, and his name, like Lacombe's, is known only to specialists today. However, in the nineties he painted many brilliant canvases with subtle and fascinating color harmonies and intriguing compositions. *Procession Under the Trees,* 1892 [189], runs foreground elements from top to bottom of the canvas to create a two-dimensional pattern superimposed on the depth of the work—a Japanese conception that dominates the work of

the *Nabis*. The pattern of the shadow of the foliage (which bears no resemblance to real foliage) is very similar to Lacombe's representation of waves and is an excellent example of the new abstraction which makes the Japanese influence of the late eighties and the nineties so conspicuous.

The elegant and often superbly self-confident woman was one of the obsessions of the art of the nineties; she is represented here by Paul Ranson's *Woman Standing by a Balustrade with a Poodle,* circa 1895 [190]. The tall, thin format, the balustrade diagonally cutting the middle of the picture, the woman's head in profile with elaborate hair and hat, her exaggerated height, and the wiggly outline of the dog come straight from Japan. The Harunobu print [62] in the exhibition makes a good comparison but is such a common Japanese type that a hundred other prints would have done equally well. Ranson loved the undulating outlines of the Japanese women, and we find them in many of his paintings, tapestry designs, and prints. (See his equally dashing *Tiger* [137].)

In the nineties Bonnard and Vuillard became friends with Claude Monet, by then a successful artist on his way to becoming the patriarch of Giverny. They took up his themes of the 1870's (Paris streets and bridges, domestic interiors, mealtables, people enjoying their gardens, mothers and children), which he had abandoned for haystacks, poplars, and empty fields. But Bonnard and Vuillard transformed these scenes with flattened compositions, fantastic distortions of the figure, and richly colored patternings—all taken from the Japanese.

Bonnard (known as *le Nabi Japonard*) in these early years had a delightful sense of humor that found its ideal nourishment in Japanese art. Bonnard's genius lay in never imitating the Japanese but rather finding in the exaggerated height or fantastic outlines of kimono-clad geishas an inspiration for whimsically playing with the *parisienne* and the shape of her peignoir, overcoat, or splendid hat. The Impressionist influence just mentioned led Bonnard always to start with his subject, not with the Japanese idea, so the character of the original is never lost. Before they are Japanese his women are always unmistakably *parisiennes*.

Especially comical are the leaping, pouncing, sniffing dogs who often accompany Bonnard's women—like the Ranson poodle—and make fur-

ther mockery of the elegance the artist has parodied. The dogs are perfect pets for the lovably grotesque babies and children (derived from Utamaro's Kintaro)[30] who swarm through his paintings and drawings, often in small packs like the dogs themselves.

One result of the continued interest in Japanese art was the re-evaluation of both the color print and the book illustration as art forms. The Impressionists had produced very few prints in their earlier years, while illustrating books lay outside their interests entirely. The nineties, however, saw a reduction in the importance of oil painting; this occurred for a variety of reasons, but one was the new evaluation of the hierarchy of art prompted by the greatness of artists like Hokusai and Utamaro.

Bonnard reflected this trend; he produced outstanding prints and illustrations; he is represented in the exhibition by his prints, which repeat the themes of his paintings. His illustrations of Verlaine's *Parallèlement,* 1900, are both a climax and a finale to the glorious decade of the nineties. The intermingling of illustrations and text suggests the importance given to the calligraphy and poems in so much Japanese art. The erotic content reminds us, too, of the one class of Japanese print that we have not so far encountered—the *shunga* (overtly sexual pictures). While Bonnard and Verlaine do not match the Japanese in explicitness, Bonnard's illustrations do have the charm and elegance of the best Utamaro erotics.[31]

Vuillard's Japonisme is not carried into as many areas as Bonnard's and is integrated with his pictures so that it is not as obvious. Nevertheless it exists and is, indeed, quite original. Vuillard was fascinated by the large number of different kimono patternings that the Japanese dazzlingly arrayed in a single print. Though other painters, including Bonnard, responded to this effect, Vuillard went further and made it a compositional principle. In his paintings the contrasted patternings of clothes, wallpapers, and tablecloths create such a kaleidoscopic result that it is often difficult to decipher the subject, especially the small children who disappear into their shapeless clothes. Though Vuillard's colors are soft, the works that influenced him were probably those of the "decadents" who abandoned the refinement of earlier prints for spectacular effects. The Kunichika actor portrait [85] is an example.[32]

Figure 37. *The Bec du Hoc, Grandcamp.*
Oil on canvas, 26 x 32-1/2 inches (66 x 82.5 cm.), 1885.
Georges Seurat. London, The Tate Gallery.

Figure 38. *Hakone* from *Fifty-Three Stages of the Tokaido.*
Woodcut, 9 x 14 inches (22.9 x 35.6 cm.), ca. 1832.
Ando Hiroshige. New York Public Library.

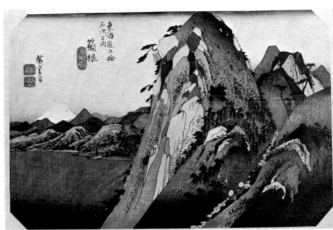

Seurat and the Pointillists

Seurat, in spite of his scientific approach to painting, did not escape the Japanese influence, as has been pointed out by Henri Dorra and Sheila Askin.[33] The compositions Seurat imposed on nature and the schematization of his forms drew on Japanese landscape prints. The dramatic rising form of *Le Bec du Hoc, Grandcamp,* 1885 (Fig. 37), is seen by Dorra and Askin as a response to the wave prints. They cite in particular one by Hokusai in which the wave in the middle of the picture takes on a solid quality. One might question whether the methodical Seurat would have used a wave as a source for a cliff, as there are comparable cliff prints, like Hiroshige's *Hakone* (Fig. 38) from the *Fifty-Three Stages of the Tokaido.* The scalloped edge of the cliff does, however, bear a resemblance to the Hokusai, and the comparison may be justified. In either case, Seurat's assimilation of the motif was aided by Claude's Monet's 1882 cliff pictures at Pourville and Varengeville, which marked a new stage of Japonisme in his work. Seurat's harbor scenes have also been related to prints, particularly to Hiroshige's *Wagon Wheel on a Beach* and *Beuten Temple*—both from the *One Hundred Views of Famous Places in Edo.*[34]

The numerous young followers of Seurat soon abandoned his semi-scientific doctrines in response to the subjective mood of their time, and by the early nineties we find in the work of Signac, Cross, and the Belgian pointillists many examples of Japanese effects. Signac, for example, collected Japanese prints, and in her book on the artist Françoise Cachin has reproduced two of them which relate directly to his paintings. The Japanese decorative play of winding branches inspired several Signac paintings of trees, notably *La place des Lices, St. Tropez,* 1893 (Carnegie Institute, Pittsburgh).[35] Particularly interesting is Signac's *Portrait of Félix Fénéon,* 1893 (Fig. 39), in which the abstract background comes from a kimono design (Fig. 40), another original use of Japanese forms.

Henri-Edmond Cross and other pointillists also emulated the decorative arabesques of Japanese trees or overall compositional concepts. Yet a further example of the response to Japan is the anonymous copy of Hiroshige's *Whirlpool at Naruto* [191, 191a]. This precise, enlarged copy done in pointillist style came from Emile Bernard's studio and was presumably given to him by a pointillist friend who had explored the secrets of Hiroshige by copying in the approved Academic tradition.

127

Figure 39. *Portrait of Félix Féneon.* 1890.
Paul Signac. New York, Private Collection.

Below: Figure 40. *Kimono Design.*
Anonymous print. Formerly in the collection of Signac.

Vincent Van Gogh

Van Gogh's exploration of Japanese art in the last
four years of his life was so intense that justice can-
not be done to it here. He amassed a collection of
over 200 prints, and there are numerous references
to Japan in his correspondence. A lengthy discus-
sion of some aspects of his Japonisme can be found
in Mark Roskill's book on Van Gogh and Gauguin.[36]

Van Gogh's copies after Hiroshige are well
known, as are his paintings of flowering fruit trees
derived from one of them, his portraits of Père
Tanguy with a background of Japanese prints, and
his boats on the beach at Saintes-Maries, not to
mention numerous other pictures of bridges, but-
terflies, and similar Japanese-inspired subjects. To
present a less familiar aspect of the artist's work,
the exhibition includes one of his reed pen draw-
ings, *Corner of a Park,* 1888 [192]. Van Gogh tried
to identify with Japanese artists; using the reed pen
was one means of doing so. The mixture of different
hatchings, curls, and dots goes back to Hokusai,
especially to the *Manga* [see especially 67a]. Van
Gogh thus drew on both great early nineteenth-
century landscapists. Significantly, as Meyer Scha-
piro has pointed out, although he reproduced Jap-
anese heads in the backgrounds of his portraits of
Père Tanguy, Van Gogh did not imitate them.[37] His
great concern for perceiving and recreating in-
dividual character was utterly different from the
Oriental indifference to specific personality.

Van Gogh's admiration for the life of the Jap-
anese artist was exceptional, and in his readings he
found support for his concept of a community of
artists mutually aiding each other. (This need for
psychological support, however, had disastrous re-
sults when he actually lived with Gauguin in Arles
in 1888.) Encouraging this ideal was Van Gogh's
continual desire to exchange works with other art-
ists, another practice he claimed was common in
Japan. His Japonisme was consequently more ex-
tensive and more complex than that of any other
artist of the period and deserves a lengthy study of
its own, one in which his writings would also play
an important part.

We have seen the role of Japonisme in the work
of three of the four great Post-Impressionist paint-
ers—Gauguin, Seurat, and Van Gogh. As earlier in-
dicated, the fourth, Cézanne, appears to have been
the only major painter who was unmarked by it.

Figure 41. *Flowers and Grasses of the Four Seasons* (detail). Gold and silver underpainting on paper,
13-1/4 x 30 feet 4-7/8 inches (33.7 x 924.1 cm.), early 17th century.
Sotatsu, Tawaraya, and Koetsu Hon'ami. Tokyo, Hatakeyama Kinenkan.

It is possible to imagine a case being made for the evidence of Japanese influence in the high horizon lines of his Mont Sainte-Victoire pictures and the bird's-eye views of the Bay of l'Estaque. We believe, however, that Cézanne's development was a European one, and that these similarities are coincidental.

Odilon Redon

Although he so completely expressed the Symbolist outlook, Redon always stood apart from the other artists of that school. This is true of his Japonisme as well. In his prints he used the horrifyingly grotesque that was an important element in Japanese work but had not appealed to other French graphic artists.

In his paintings Redon looked chiefly, though certainly not exclusively, to Japanese paintings rather than to prints. The beautiful, hazy color, the fluid space in which objects float, the veiled allusion rather than the direct statement, take us back to an artist like Sotatsu (Fig. 41). Redon must have seen works by the followers of men like Sotatsu, Koetsu, and Kenzan, if not the originals themselves. *The White Butterfly* [193] embodies all these aspects, though the human head and the color harmony are Redon's own personal note. The butterfly itself reminds us of Redon's paintings exclusively of butterflies, and here we can postulate an influ-

ence from prints like those of Shumman. Yet even in these paintings the complete effect of Redon oils is derived from Japanese painting. In this respect he follows Whistler's work of the seventies. The two artists, so different in personal character, resembled each other in never belonging to any of the artistic groups of the time, perhaps because each sought a poetry in his work that would not be encouraged by the theorizing and search for common stylistic elements that occurred in most of these groups.

Redon also thoroughly understood Japanese screen painting and was able to expand his delicate art to a large scale in works such as the panels of flowers and butterflies that he executed for Mme. Ernest Chausson, the widow of the composer. There were five panels in this set, each over eight feet high. His murals for the Abbey of Fontfroide are another example of Redon's decorative powers drawn from Japanese painting.

Toulouse-Lautrec

The Japanese qualities of Lautrec's paintings were even more brilliantly expressed in his prints, which have been chosen to represent him on a considerable scale in the exhibition. Just as Bonnard and Vuillard reworked Monet's subjects of the seventies, so Lautrec redid many Degas compositions of the same period with a dash of caricature that

Figure 42. *Antibes (Cap d'Antibes)*
Oil on canvas, 25-3/4 x 36-1/4 inches (65.4 x 92 cm.),
1888. Claude Monet.
Courtauld Institute Galleries, University of London.

Figure 43. View from *Fifty-Three Stages and Four Post Towns Along the Tokaido.* 19th century. Utagawa Kuniyoshi.

comes from both the French graphics tradition and from Japan. This process lies behind not only the delightful humor of Lautrec seen in so many of the posters but also the savage quality apparent in his paintings of prostitutes.

Claude Monet after 1880

Claude Monet's work changed steadily in the 1880's as he, too, entered the new phase of Japonisme. He became concerned with dramatic compositional elements and turned to obvious Japanese sources. We have already mentioned, in connection with other French artists, his silhouetted cliffs of 1882 and his Brittany paintings of 1886[38] which drew very directly on Japanese prints. This is true also of his views of pine trees at Cap d'Antibes, 1888 (Figs. 42 and 43), which reflect the common Japanese composition of foreground trees that are superimposed on the picture for a vivid effect.

In 1884 Monet painted some decorative panels of flowers and fruit for Durand-Ruel. The tall, thin shape of some of the panels betrays their Japanese inspiration, as does Monet's signature, written vertically up the panel—a reversal of Hokusai's habit of writing his signature in horizontal Western style![39] Unlike the Japanese influence on Monet in the sixties and seventies, this new stage has been widely recognized because it is so apparent.

Monet's love of things Japanese was carried over from the decoration of his dining room with prints into his garden at Giverny, where he built a Jap-

anese bridge that naturally figured in some of his paintings. The last, and climactic, phase of Monet's career in the first quarter of the twentieth century —the phase which saw his large paintings of water lilies and wisteria—is also infused with Japanese feeling. The confusions of perspective in the water lilies and the lack of ground or skyline closely resemble elements in Redon's pictures. The lilies themselves float in a sea of reflections, so that there is an ambiguous play of surface and depth. Monet's development has brought him from his early "snapshots" of contemporary life to an art of evocation and contemplation—the last, but one of the most profound, gifts of Japan to French painting.

1. Another swing in the pendulum of taste, as well as the production of excellent books by Japanese art publishers, is changing this situation at the present time.

2. For example, when they deal with the years of the Impressionist exhibitions, they cite Manet and Degas almost exclusively as showing Japanese influence. See note 3.

3. E. Scheyer, "Far Eastern Art and French Impressionism," *Art Quarterly*, VI (1943), 126. And F. Fosca, in *XIXth Century Painters* (New York, 1960), p. 117, observes, "I do not think that too much importance must be attached, as is usually done, to the role that Japanese prints played in forming the artists belonging to the Impressionist group. . . . But which members of the group were directly influenced by them? Only two, Manet and Degas. . . ."

4. W. C. Seitz, *Claude Monet* (New York, 1960), p. 25.

5. When Monet visited Pissarro in the winter of 1869–70, he painted a view of *The Road to Versailles at Louvciennes* with this perspective, which was repeated almost exactly by Pissarro. See illustrations in J. Rewald, *The History of Impressionism* (1961), pp. 212, 213. When Sisley in his turn visited Monet at Argenteuil in 1872, they painted identical views of a *Street in Argenteuil,* illustrated in Rewald, p. 288.

6. Both these perspective Hiroshige prints are from the *One Hundred Views of Famous Places in Edo.* [See also 73, 75.]

7. T. Duret, preface to *Works in Oil and Pastel by the Impressionists of Paris* (New York, 1886), p. 5.

8. Reproduced in color in Rewald, *History of Impressionism,* p. 270.

9. Galerie Durand-Ruel, *Receuil d'estampes gravées á l'eau-forte* (Paris, 1873), p. 23.

10. Apart from specifically erotic prints, the brothels are represented as centers of social life, conversation, and music-making, thus portraying a subject matter analogous to that of the Impressionists. E. Scheyer, pp. 118 and 119, stresses the correspondence between Impressionist and *ukiyo-e* subjects but fails to see the stylistic debts.

11. C. Pissarro, *Letters to his Son Lucien* (New York, 1943), p. 206.

12. For reproductions of Caillebotte's work, see M. Berhaut, *Caillebotte* (Paris, 1951).

13. Quoted in P. Schneider, *The World of Manet* (New York, 1970), p. 62.

14. Quoted in L. Nochlin, *Impressionism and Post-Impressionism* (Englewood Cliffs, New Jersey, 1966), p. 63.

15. There is a reminiscence also of Manet's Japanese-inspired painting *Boating,* 1874 (New York, Metropolitan Museum of Art).

16. A. Stevens, *Impressions on Painting* (New York, 1891).

17. Stevens is an intriguing painter who should be better known. The current interest in nineteenth-century academic painting should provoke a major exhibition of his works, which might reveal a more profound Japonisme.

18. I am grateful to Professor Robert Herbert of Yale University for pointing out to me that both these artists collected Japanese prints and were influenced by them. Herbert's catalog for the Millet show that he is organizing for the Louvre will discuss the Japanese influence in Millet's drawings. For Rousseau, see J. Bouret, *The Barbizon School* (Greenwich, Connecticut, 1973), p. 213, where one of Rousseau's Japoniste paintings is reproduced and discussed.

19. The *Lange Lijzen* is a Dutch expression referring to the figures on the Chinese vases, and the six marks are the artist's signature.

20. It is reproduced in color, together with the Kiyonaga prints, in T. Prideaux, *The World of Whistler* (New York, 1970), p. 94.

21. See the prints by Braquemond [20] for examples of Japanese bird pictures of the type that inspired Whistler.

22. While Whistler used a Hiroshige print as a starting point for the composition in his famous *Nocturne in Blue and Gold: Old Battersea Bridge,* 1872–75 (Tate Gallery), the final picture has a painterly mood quite unlike that of the print.

23. Redon's evocative *The White Butterfly* is a natural development of Whistler's approach.

24. The writings of the artists themselves, which are referred to below, testify to this passion.

25. Quoted in Y. Thirion (who provides much information on the role of the prints in the Pont-Aven group as a whole), "L'Influence de l'Estampe Japonaise dans l'Oeuvre de Gauguin," *Gazette des Beaux-Arts,* XLVII (January/April 1956), 95–114. C. F. Ives, *The Great Wave* (New York, 1974), gives a concise account of Gauguin's use of prints on his walls and references to Japanese art in his writings.

26. It was, of course, Whistler's famous "fireworks" painting, *Nocturne in Black and Gold,* 1875 (Detroit Institute of Arts), that caused his lawsuit with Ruskin. Bernard had probably heard of this, even if he had never seen the painting.

27. This work is illustrated in the Museum of Modern Art catalog, *Art Nouveau* (New York, 1959), p. 59. It is extremely close to Bonnard in style.

28. The artists in the *Nabi* group were Bonnard, Vuillard, Denis, Lacombe, Ranson, Sérusier, Roussel, Vallotton, and Verkade. They were linked more by friendship than by a common artistic or philosophic ideal.

29. *World Cultures and Modern Art* illustrates Japanese representations of a comparable rock with waves beating on it, done in two different media: a print by Harunobu, and a raised design on a writing paper box; another example is a painting on a Chinese bowl, p. 108. The Monet mentioned in the next paragraph is also reproduced in color, p. 109.

30. Kintaro was a legendary boy of great strength.

31. I have wondered if the cat with arched back in Shunsho's well-known erotic print from the album *The Cuckoo's Verse* (reproduced in P. Rawson, *Erotic Art of the East* [New York, 1968]), pl. XXIV), was not the source for the cat in Manet's *Olympia.*

32. See *World Cultures and Modern Art,* pp. 91–97, for a discussion of this aspect of Japonisme in a European context, as well as its significance for the development of abstract art. For other aspects of Vuillard's Japonisme, see the print section of this catalog. J. Russell illustrates an amusing series of watercolor sketches of the actor Coquelin *cadet,* 1892, inspired by Sharaku, [15–23], in his catalog, *Vuillard* (Greenwich, Connecticut, 1971).

33. H. Dorra and S. C. Askin, "Seurat's *japonisme*", *Gazette des Beaux-Arts,* LXXIII (February 1969), 81–91.

34. *World Cultures and Modern Art,* p. 119, and R. Herbert, *Neo-Impressionism* (New York, 1968), pp. 126–27.

35. Reproduced in F. Cachin, *Paul Signac* (Greenwich, Connecticut, 1971), pp. 63, 66.

36. Mark Roskill, *Van Gogh, Gauguin and the Impressionist Circle* (Greenwich, Connecticut, 1970). See also J. Rewald, *Post-Impressionism, from Van Gogh to Gauguin* (New York, 1962), which has numerous references and quotations.

37. Meyer Schapiro, *Van Gogh* (New York, 1952), p. 44.

38. See p. 125 and p. 127.

39. Reproduced in color in *World Cultures and Modern Art,* p. 145.

190 *Woman Standing Beside a Balustrade With a Poodle.*
by Paul Ranson.

Catalog

French Painters and Japonisme 1854–1910

Claude Monet, 1840–1926.

181a *Road Near Honfleur in the Snow.*

Oil on canvas, Winter 1866–67.
Mr. and Mrs. Alex M. Lewyt.

Monet adopts the exaggerated one-point perspective that the Japanese had developed from imported European prints in the eighteenth century. The great foreshortening funnels the spectator's eye rapidly to the back of the canvas so that an *impression* of the whole picture is gained immediately without any denial of the actual depth of the landscape. Monet was undoubtedly inspired by prints like the two Hiroshiges, *Asakusa Kinryuzan Temple* [74] and *Yabu-koji Street, Shiba District, in Winter* [75]. Both these prints and other comparable Hiroshiges were done after the opening up of Japan, and were widely known in France.

(This painting will be shown only in Cleveland.)

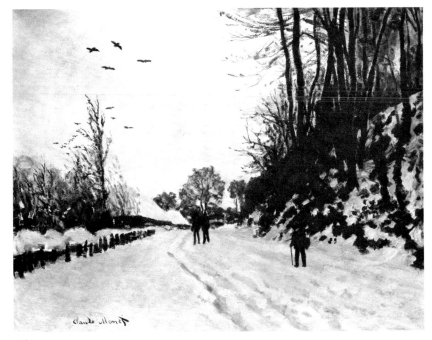

181a

Claude Monet.

181b *The Beach at Trouville (Hôtel des Roches noires).*

Oil on canvas, 1870.
21-1/2 x 23-1/4 inches (54.6 x 59 cm.).
Hartford, Connecticut, Wadsworth Atheneum, Ella Gallup Sumner and Mary Catlin Sumner Collection.

(This painting will be shown only in Baltimore.)

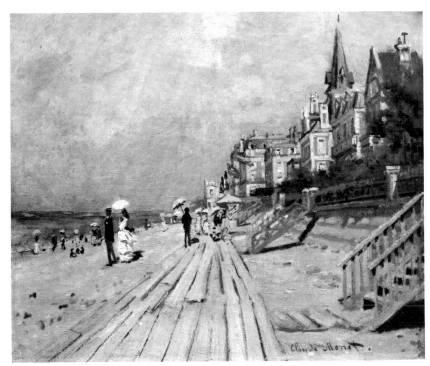

181b

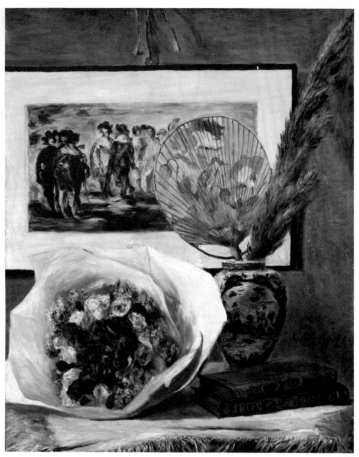

182

Auguste Renoir, 1841–1919.

182 *Still Life with Bouquet.*

Oil on canvas, 1871.
29-1/2 x 23-1/4 inches (74.9 x 59 cm.).
Houston, Museum of Fine Arts.

Renoir's painting illustrates not only the Impressionists' love of prints and fans, which they collected, but also the importance of the freshness and brightness of Japanese color in lightening their own palettes.

Gustave Caillebotte, 1848–1894.

183 *The Bridge of Europe (Le Pont de l'Europe).*

Oil on canvas, 1876.
25 x 31-1/2 inches (63.5 x 80 cm.).
Stephen Hahn Gallery.

In this oil sketch Caillebotte takes as a motif the modern girder bridge and gives it extraordinary prominence. While unusual in the painting of Caillebotte's time, this dominant diagonal structure was common in Japanese prints of bridges by Kiyonaga, Utamaro, and Hiroshige (see Hiroshige's *Ryogoku Bridge* [71].

183

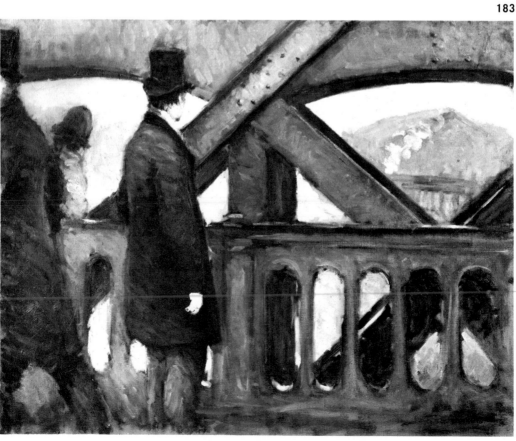

Edgar Degas, 1834–1917.

184 *Fan Design: Dancers.*

Gouache or distemper with gold and
 charcoal on linen, ca. 1879.
11 x 22 inches (28 x 56 cm.).
Baltimore Museum of Art, Fanny B.
 Thalheimer Memorial.

The popularity of Japanese fans led both
Degas and Pissarro (see Fig. 32) to design
them. Degas adopted his bird's-eye per-
spective from Japanese art and likewise
borrowed his almost abstract play of
color from Japanese paintings and end
papers. The Impressionist exhibition of
1879 included a roomful of fan paintings.

184

James Abbott McNeill Whistler,
 1834–1903.

185 *Purple and Rose: The Lange Lijzen
 of the Six Marks.*

Oil on canvas, 1864.
36-1/4 x 24-1/4 inches (92.1 x 61.6 cm.).
Philadelphia, John G. Johnson Collection.

This early work by Whistler shows his
enthusiasm for collecting all kinds of
Oriental objects, both Chinese and
Japanese. He played an important role in
spreading this enthusiasm among his
artist friends. *Lange Lijzen* is a Dutch
expression referring to the tall women
on the vase that the model is holding,
while the six marks are the potter's sig-
nature. The two cartouches in the upper
right-hand corner of the painting show
that Whistler wanted to develop a style
influenced by the Orient, rather than
merely to include exotic objects in a
European-style painting.

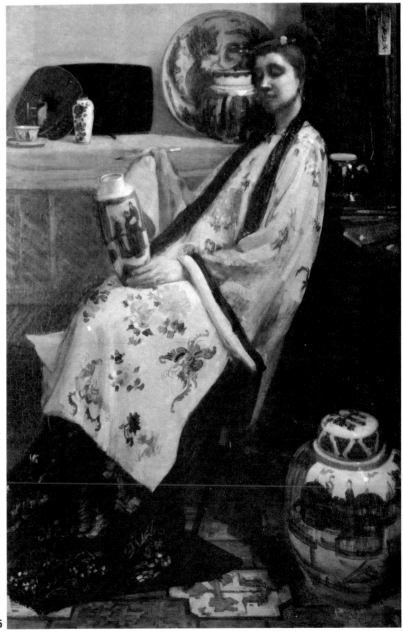

185

135

Paul Gauguin, 1848–1903.

186 *"Pardon Breton," Near a Tomb (Pardon breton, près d'un tombeau).*

Gouache on board, 1889.
11 x 12-3/4 inches (28 x 32.4 cm.).
Anonymous Loan.

A *pardon breton* is a kind of religious pilgrimage peculiar to Brittany. The black outlines and flat color were inspired in the works of Gauguin and Emile Bernard by Japanese prints. They appealed to the artists in part because they suggested medieval stained glass and enamels, which seemed appropriate to the almost medieval piety of the Breton peasants. The pattern of trees in the upper part of the painting also comes from Japanese art; see, for example, Hiroshige's *Five Pines Along the Konaki River* [73].

Emile Bernard, 1868–1941.

187 *Fireworks on the River.*

Oil on panel, 1888.
34-1/2 x 23-1/4 inches (87.6 x 59.1 cm.).
Yale University Art Gallery, Gift of Arthur G. Altschul, B.A. 1943.

At the age of twenty Bernard was a pioneer in the reaction against the naturalism of Impressionism. Like Gauguin, whom he influenced, Bernard collected Japanese prints. Both the heads in the foreground and the subject of fireworks are inspired by Japanese art; see as an example of the latter Hiroshige's *Fireworks at Ryogoku Bridge* [79].

Georges Lacombe, 1868–1916.

188 *The Grey Sea.*

Oil on canvas, 1890.
18-1/8 x 25-5/8 inches (46 x 65.1 cm.).
Utah Museum of Fine Arts, University of Utah.

Lacombe was a member of the *Nabi* group that also included Bonnard, Vuillard, Denis, and Ranson—all of whom are represented in this exhibition. This painting shows the influence of the Pont-Aven artists around Gauguin and Bernard, who often painted the rocky Brittany coast in this style. The motif of the rock in the middle of the picture occurs over and over again in Japanese art. The decorative play of the waves and foam is characteristic of these works and can be seen in Hiroshige's *Whirlpool at Naruto.*

186

187

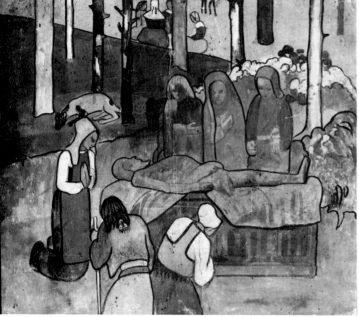

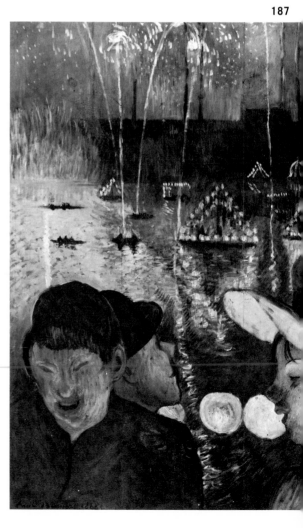

Maurice Denis, 1870–1943.

189 *Procession Under the Trees.*
Oil on canvas, 1892.
22 x 32 inches (55.9 x 81.3 cm.).
Arthur G. Altschul.

Denis, another of the *Nabis,* combined
an admiration for Puvis de Chavannes
with a similar respect for Japanese art.
The solemn mood comes from Puvis, but
the compositional use of the tree trunks
is Japanese, as is the abstract shadow of
the foliage which resembles the curlicues
of foam in the Lacombe painting.

188

189

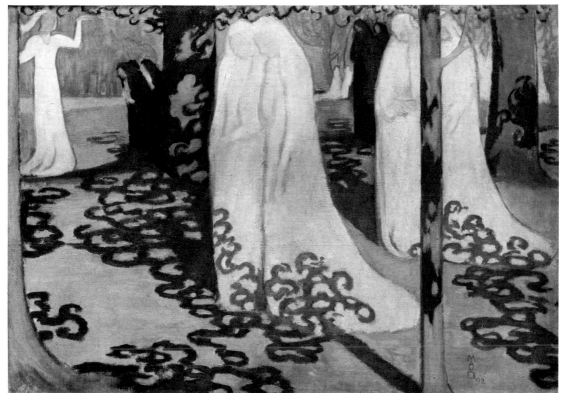

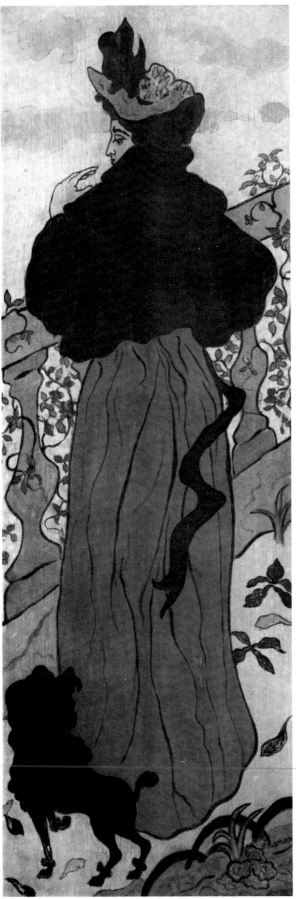

191a

191

Paul Ranson, 1864–1909.

190 *Woman Standing Beside a Balustrade with a Poodle.*

Oil on canvas, 1895.
35 x 12 inches (88.9 x 30.5 cm.).
Arthur G. Altschul.

The subject; the tall, thin format of the picture; the woman's head in profile with elaborate hair and hat; her exaggerated height; and the wiggly outline of the dog come straight from Japan. The Harunobu print [62] is but one example of the hundreds that exist.

Anonymous, French.

191 *The Whirlpool of Naruto in Awa* (copy after Hiroshige).

Oil on canvas, late 1880's or early 1890's.
32 x 21-1/2 inches (81.3 x 54.6 cm.).
Hirschl & Adler Galleries.

This pointillist painting comes from the studio effects of Emile Bernard and was presumably a gift from an artist friend. The care with which the copy is made [191a] shows the artist's admiration for Japanese works.

Vincent Van Gogh, Dutch, 1853–1890.

192 *Corner of a Park (Coin de Parc).*

Brown ink on paper, September 1888.
12-3/8 x 9-3/8 inches (31.5 x 23.8 cm.).
New York, Private Collection.

Van Gogh had a collection of over 200 Japanese prints; their influence can be seen in many of his paintings. He found support for his ideal of working in close collaboration with other artists and for exchanging works with them from his readings on Japan. The technique of this drawing, the choice of the reed pen, and the hatchings and dots come from Hokusai's drawings; see Hokusai's *Manga* [67a].

Odilon Redon, 1840–1916.

193 *The White Butterfly.*

Oil on canvas, ca. 1910 (?).
25 x 19-1/4 inches (63.5 x 48.9 cm.).
Ian Woodner Family Collection.

The prominence of the butterfly reminds us of Japanese prints devoted to butterflies (Redon did such paintings), while the style of the picture, with its mysterious floating quality, is derived from Japanese painting.

192 **193**

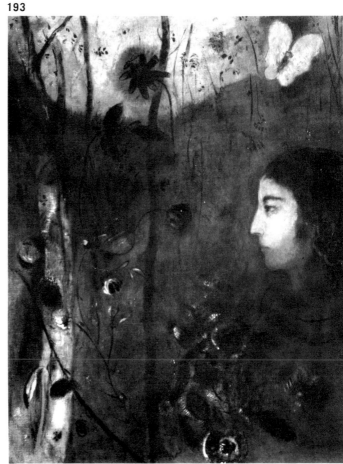

Three Japonisme Ceramics by Albert Dammouse
205 Cup and Saucer
206 Vase
265 Plaque

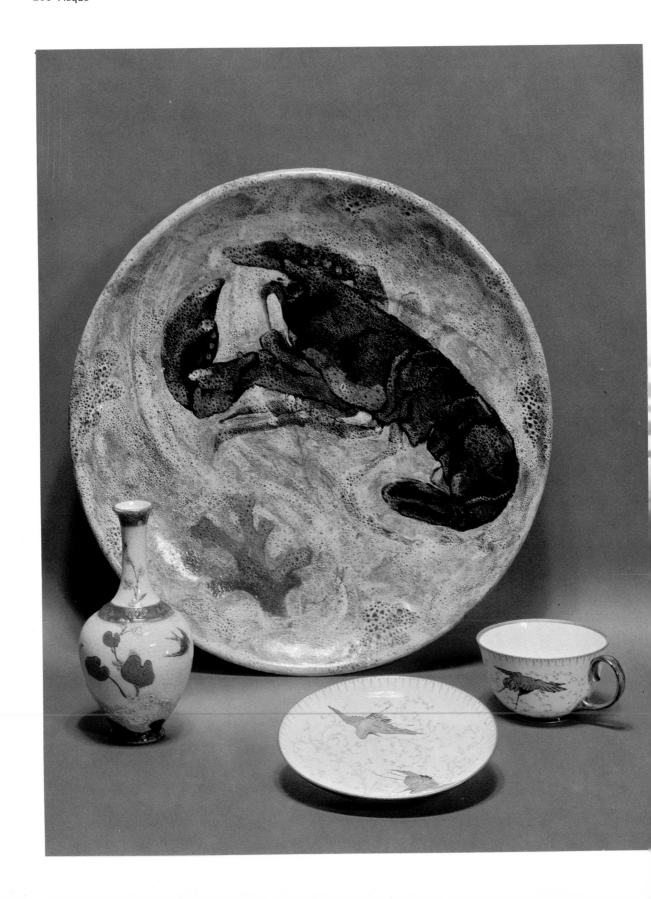

IV. Japonisme and French Decorative Arts
Martin Eidelberg and William R. Johnston

1854—1867

In February 1854 Commodore Matthew C. Perry sailed into Uraga Bay on his second visit to Japan and with a formidable display of naval strength intimidated the shogun into signing a treaty with the United States. Within four years, commercial ties were established between Japan and the principal Western powers, the repercussions of which were soon felt in Asia and Europe.

Previously Japan had appeared to Westerners as an enigmatic—though not entirely unknown—entity. In the mid-sixteenth century Portuguese merchants, followed by Jesuit missionaries, made contact with the Japanese, but throughout much of the seventeenth and eighteenth centuries Japan pursued xenophobic policies, restricting her intercourse with the West to trading with a Dutch enclave isolated on the islet of Deshima in Nagasaki Harbor.

In France, where distinctions between Far Eastern countries were generally blurred, Japanese goods inadvertently contributed to the *goût chinois*. The imports were usually altered to adapt them to their new environment; lacquer screens were dismembered and used to decorate furniture, while porcelains were set in ormulu mounts. Competing with the limited supply of Japanese products, French craftsmen sought to simulate them: among the more attractive "copies" were the pseudo-lacquers of the Martin brothers and the soft-paste porcelains of Chantilly decorated with Arita ware motifs. This fanciful, cavalier approach to Oriental art continued into the nineteenth century, encouraged particularly by the Second Empire's nostaligia for the eighteenth century. As Roger Marx observed, it was not merely coincidental that the early devotees of Japanese art should have included the Goncourt brothers, Frédéric Villot, and Philippe Burty, all of whom were proponents of the Rococo revival as well.[1]

To understand the evolution of Japonisme in French decorative art in the second half of the nineteenth century we must recall that France had been swept by a series of historic revival styles in the first half of the century. They ranged from the Greco-Roman of the first Empire and the neo-Gothic introduced at the coronation of Charles X to the Renaissance and Rococo revivals of Louis Philippe and Napoleon III. And throughout the century the authority of the Renaissance weighed heavily on everyone's shoulders. Of far more consequence, though, was France's fascination with the Near and Far East. Whether we choose to see this as a result of colonialism or as Romantic escapism, it cannot be denied that there was a persistent impulse to seek beyond the confines of the European continent.

Napoleon's Egyptian campaign had popularized the Egyptian style during the First Empire, and gradually this was expanded into a fascination with the world of Islam as a whole.[2] This was nourished by a sequence of developments including archaeological discoveries, the Greek War of Independence which aroused sympathy in the West, and the 1830 conquest of Algeria. Islamic themes were treated by most of the major painters of the century, beginning with Baron Gros' *Pest House at Jaffa* and extending through the harem scenes of Delacroix and Gérôme. The cult of the Near East was equally reflected in the applied arts. In the area of ceramics Théodore Deck was known for his imitations of Iznik and Hispano-Moresque pottery, while Léon Parvillée in association with Adalbert de Beaumont produced beautiful examples of Turkish tiles. Similar accuracy in the rendition of Islamic prototypes is encountered in the enameled glass vessels of Joseph Brocard, whose specialty was copies of Syrian mosque lamps. Likewise, in metalwork, it should be recalled that the early experiments in enamel, particularly those of Barbedienne, were conducted in an Islamic vein and that the technically unsurpassed *plique-à-jour* enamels of Fernand Thesmar were of similar inspiration. As we shall see, all these artists were closely allied with the cult of Japan as well.

China, though even more remote in geography and culture, also proved to be an unending source of inspiration to French designers. The tradition of eighteenth-century *chinoiseries* may have encouraged the emergence of this Chinese influence in the nineteenth century, but it soon took on a more archaeological character typical of this age of eclecticism. Examples of Chinese-inspired ceramics by the Sèvres Manufactory; furniture by Goudel et Cie., Léon Feuchères, and Alphonse-Gustave Giroux; and metalware by Morel show the popularity of this mode throughout the first half of the century.[3] Here, too, we find that interest in Chinese art helped prepare the way for Japon-

Figure 44. Plate 31 from Adalbert de Beaumont
and Eugène V. Collinot, *Receuil de dessins
pour l'art et l'industrie* (Paris, 1859).

Figure 45. *Studies of Birds* from *Manga,*
volume 1. Hokusai.

isme, and that many a designer and collector found it easy to bridge these two alliances.

The influence of Japan was felt in French applied art from the same moment in the late 1850's that it began to affect printmaking and painting; moreover, it took place within the same relatively restricted circle of people. By now we are familiar with Léonce Bénédite's account of how in 1856 Bracquemond went to his printer, Auguste Delâtre, and there, while chatting, chanced upon a volume of Hokusai's *Manga* that had been used as packing material in a crate sent from Japan.[4] The importance of this discovery for the development of French fine arts is apparent and has already been discussed at length in this catalogue (pp. 4–9). Its implications for the history of French decorative arts are equally important; these albums of *ukiyo-e* prints were of prime significance in providing a decorative vocabulary for French designers. All too easily overlooked in Bénédite's story is the fact that the primary contents of Delâtre's crate were not the Hokusai album but Japanese porcelains and that there evidently were Frenchmen already established in Japan who were sending examples of Japanese goods back to their mother country.

Significantly, one of the first instances of French interest in Japanese art appears in the context of the decorative arts, namely, eighteen plates etched by Adalbert de Beaumont and Eugène V. Collinot as part of their *Recueil de dessins pour l'art et l'industrie* (Fig. 44).[5] This large folio was printed in 1859 by none other than Delâtre himself and was conceived in the same tradition as Owen Jones' *Grammar of Ornament,* which had been published in London just some three years earlier. Both works are pictorial encyclopedias of historical styles, emphasizing the art of the Near and Far East rather than that of Western tradition. The images that De Beaumont and Collinot present of Japanese birds, flowers, insects, marine life, samurai, and landscapes are based for the most part on Hokusai prints—from the *Manga,* the *Ringa,* and the *Hundred Views of Mt. Fuji* (Fig. 45). This publication is an accurate gauge of the times. Its Japanese motifs, like those De Beaumont and Collinot copied from the decorative art of China, Persia, North Africa, India, and Russia, are intended for the use of Western designers—to copy, to adapt, to plagiarize. Not only was Japonisme, at least in its opening phase, yet another species of the historic revivalism so

prevalent in the middle of the century, but also its emphasis on flowers, birds, and marine life was indicative of a growing tendency in the nineteenth century to insist upon nature as the basic source of inspiration for the decorative arts.

Despite the recommendations of De Beaumont and Collinot that their Japanese designs could be used by Western artisans, it would seem that such advice was not heeded until almost a decade later. It was not until about 1866 when, fittingly enough, the so-called "discoverer" of Japanese prints, Bracquemond, created a dinner service for the firm of Eugène Rousseau [194, 195]. Bracquemond's designs are nothing more than motifs of flowers, insects, birds, and marine life which are copied directly from Japanese prints by Hokusai and other *ukiyo-e* artists. It is appropriate not only that this first expression of Japonisme came from Bracquemond but also that it was expressed in the form of ceramics, since this proved to be a medium which, perhaps more than any other, succumbed to Japanese influence. Although the major impact of Japonisme was not registered until the 1870's, we can find some initial stirrings in the mid-1860's, as in the work of Eléonore Escalier at the factory of Théodore Deck.[6]

It would appear that metalware may also have been affected by Japonisme at this early date, but the case is less clear because Japanese and Chinese influences (as well as those from the Near East) were all too freely blended at this point. The two major exponents were the famed Barbedienne foundry and the firm of Christofle led by Ernest Reiber, one of the most important early Japonistes. Their use of Oriental shapes, various techniques of inlaid metal, and the duplication of cloisonné enamels registers the influence of Japanese decorative arts, even though contemporary reports generally speak of this only in terms of "Chinese."[7] The confusion between the arts of China and Japan was still not uncommon at this time; as one of the first Japanophiles recalled, there was so little knowledge of "these curiosities coming from the Far East that one indistinctly confused them under the name of *chinoiserie*. . . ."[8]

Because of the inevitable interest one has in the first examples of any style or movement, we have perhaps overemphasized these early examples of Japonisme. In the larger view of things, however, we find that there are very few such examples prior to 1868. Moreover, relatively few Japanese objects had made their way to the West. There were still only a few Paris curio shops dealing in Oriental products, notably *La Porte Chinoise* at 36 rue Vivienne, the Desoyes' boutique at 220 rue de Rivoli, and some lesser known shops such as that of Mallinet at 25 quai Voltaire.[9] Of these, the first was a Chinese tea-importing firm established in 1826 which apparently sold Japanese objects as a mere sideline, and Mallinet was essentially a dealer in antiques. Only the Desoyes are known to have actually travelled to the Far East.

1868–1878

The situation changed radically after the 1867 World's Fair because the Japanese government sent an exhibit that constituted the first major display of Japanese art seen in France; according to one observer it was "the first complete revelation of Japanese art."[10] The highly influential *Revue des deux mondes* dismissed the Japanese prints because of their failure to meet Western standards of perspective and modelling but, on the other hand, lavished praise on the technical excellence of Japanese industrial arts.[11] The effect of this display on both the initiated and the uninitiated cannot be overemphasized. Certainly the sudden surge of Japonisme after 1868 attests to its importance. Moreover, as we shall see, the displays of Japoniste pieces by Rousseau and Christofle were themselves influential in popularizing this new mode in France. With the closing of the exhibition many Japanese wares, especially lacquers, screens, and cabinets, were dispersed in Paris, further encouraging interest in the field.

Following the internal upheavals of 1868, the Japanese government embarked upon a Westernizing course and made itself increasingly accessible to foreign visitors. Among the first to travel to Japan were the liberal economist Henri Cernuschi and the critic Théodore Duret who made their voyage in 1871–72. Philippe Sichel sailed there in 1873–74 and Samuel Bing, a naturalized Frenchman from Hamburg, went in 1875. Other visitors included the prominent industrialist and scholar Emile Guimet who, accompanied by the artist Félix Régamey, set out in 1876 to study Eastern religions. These trips paralleled the increased trade between the two countries and, concomitantly, the marked growth

in the number of Parisian stores dealing in Japanese *objets d'art*. In fact, of the above-mentioned travellers, Sichel had a shop at 11 rue Pigalle and Bing opened one in 1877 at 19 rue Chauchat (later expanded around the corner to 22 rue de Provence) which became a major emporium for Japanese goods.

There were also several major public exhibitions which helped fan the flame of Japonisme. In 1869 there was an important display of Oriental arts, including Japanese art objects, sponsored by the principal French organization for the decorative arts, the *Union centrale des Beaux-Arts appliqués à l'industrie*. Two years later an even more important exhibit of Japanese art was held at the Palais des Industries; it was organized by Cernuschi, who, we recall, had just returned from Japan with a rich collection of objects. Nor should we overlook the important Japanese exhibits held outside France, notably those in Vienna in 1873 and in Philadelphia in 1876.

After 1868 and throughout the seventies French decorative arts were inundated by the mania of Japonisme, and nowhere was this more evident than in the field of ceramics. Rousseau hired other artists to create new dinner services in this style [197], while Bracquemond's talents were utilized by the firm of Charles Haviland [198]. Collinot, who had published the 1859 *Recueil des dessins*, also controlled a ceramic factory which, symptomatic of the times, turned from the Islamic to the Japanese style. Likewise, Théodore Deck utilized the Japanese mode more frequently [217], as did the Nancy factory of Emile Gallé and a host of other potteries such as that of Hippolyte Boulenger. The Creil factory produced tea sets in imitation of Satsuma ware, while the firms of Huard of Longwy and Vieillard of Bordeaux imitated Japanese cloisonné designs and crackleware. Nor should we neglect independent ceramists such as Laurent Bouvier [196], Camille Moreau [207], Michel Cazin, and Albert Dammouse [205]. Our list of these factories and individuals could be extended, but even without the weight of additional names it is quite apparent how many designers were following a Japanese mode. Moreover, since it is a commercial necessity that factories produce only what is economically rewarding, we can presume that there was a substantial buying public for goods in the Japanese style.

Surprisingly, French glassware responded very slowly to the Japanese taste in the 1870's. Only a few names figure prominently: the first is the well-established house of Baccarat [208], while the others—Eugène Rousseau [209], Emile Gallé, and André Jean—were relative newcomers to the medium.

Metalwork reflected the emergence of Japonisme as a major trend in the 1870's. As before, the firms of Barbedienne and Christofle continued to be dominant leaders in the field [210, 211, 214], although other artists and smaller firms soon followed suit. Falize, for example, extended the use of the cloisonné technique to jewelry.[12] In addition to small items—cigarette boxes, small vases, and the like—there were also elaborate pieces on a large scale, such as cloisonné enamel cabinets by Barbedienne and monumental ironwood and ebony furniture by Christofle, embellished with encrustations of blackened and gilt bronze as well as gold and silver. Throughout this period the French proved to be as inventive as always; for example, under the direction of Henri Bouilhet, Christofle produced objects with encrusted and damascened decoration in imitation of Japanese *shakudo* ware, but instead of using the laborious manual technique of the East the French firm developed a simpler, less costly process of combining silver plate with inlays of metal achieved through electro-deposit.[13] The dominance of Japonisme in Christofle's work can well be seen in their display at the 1878 World's Fair (Fig. 46), although it should also be recalled that, to the surprise of all Europe, it was the American firm of Tiffany and Company that won top honors at this exposition for its imitations of Japanese metal techniques.[14]

The art of the printed book in France was not immediately receptive to Japanese influence due to the inherent differences in format of Western and Eastern books. Yet as early as 1876 Mallarmé's poem *An Afternoon of a Faun*, with Manet illustrations inspired by Hokusai's *Manga* [5], was placed in a binding described as "somewhat Oriental with its Japanese felt, title in gold, and tie knots of black and Chinese pink."[15] There was also a play by Ernest d'Hervilly, *La belle Saïnara*, which in accordance with its Oriental theme was printed, Japanese style, from right to left and bound in a yellow cover supposedly designed by Bracquemond, Marc L. E. Solon, or Félix Régamey.[16]

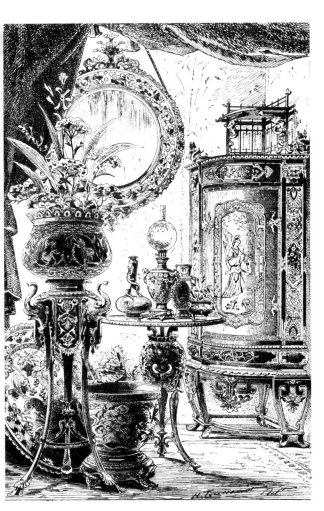

Figure 46. View of the display of Christofle et Compagnie at the 1878 World's Fair, Paris. (Photo: *Gazette des Beaux-Arts.*)

of Eastern or Western origin, are inevitably symmetrical, and we cannot help but notice how frequently the French designer sought out the more novel and picturesque of Japanese shapes, such as open fans, origami objects, and shafts of bamboo.

Much of the imagery that we see in these French works is plagiarized directly or adapted with slight modifications from Japanese prints. We are told that each time the ceramist Laurent Bouvier [196] sold one of his paintings "quickly he ran to the rue de Rivoli to Madame Desoye, and he came back from there loaded down with albums and kakemonos in glowing colors."[17] Falize, in his account, writes, "I copied the leaves of the albums with pen and brush. I, too, traced these models."[18] That the literal copying of Japanese prints was not uncommon is suggested by the existence of such tracings at the Haviland factory in Limoges and at the Sèvres Manufactory.[19]

Even if we do not have such tracings from most of the Japoniste artists, still, their works attest to such activities. As has been shown in this catalog and elsewhere, there are frequent one-to-one correspondences between Japanese prints (particularly the *Manga* and other *ukiyo-e* prints of Hokusai and Hiroshige) and the early works of Bracquemond, Dammouse, Moreau, Gallé, and others. The problem in tracing these prototypes is complicated not only by the modifications introduced by the French artists but also by the fact that there was such a vast repertoire of images available to these artists from the very beginning. Occasionally, as in the case of Camille Moreau, the albums have stayed intact in the family's possession [6–11], or, as in the case of Charles Haviland, a catalog was prepared before their dispersal. But most often, alas, we no longer have any accurate gauge of exactly what prints were amassed. Moreover, it would be wrong to limit our consideration to prints, since the images found on Japanese fans, pottery, lacquer, enamels, and other decorative objects had equal appeal to French artists.

Quite often we find that our artists were influenced not only by Japanese art but also by each other. For example, Falize was stimulated by Christofle's use of enamels, and Dammouse and Moreau [205, 207] were evidently influenced by Bracquemond's earlier dinner service. Often there were concrete links between the different generations of Japonistes: Bracquemond's position at Haviland

The emergence in the late 1870's of Japonisme in the more traditional aspect of French bookbinding coincided with the appearance of what Henri Béraldi termed the *"reliure emblématique."* In place of the standard scrolls and foliate motifs derived from renaissance traditions, the design on the cover was to reveal the nature of the book's content. Given the increased number of books dealing with Oriental themes, one can well understand the emergence of fine French bookbindings with Japanese motifs. One of the innovative binders who worked in this style was Amand, and it is significant that among his patrons were such well-known bibliophiles and Japanophiles as Philippe Burty and Octave Uzanne.

Despite the intrinsic differences between the various media and between the individual artists, a certain unity can be discerned. For the most part, the Japoniste objects of this period bear the unmistakable mark of the Second Empire in their preference for the most complicated and decorated of Japanese prototypes and in their insistence upon gilding, elaborate borders, and overly rich background patterns. The forms which are used, be they

fell to Chaplet, and Chaplet in turn sold the studio
to Delaherche; Deck employed Lachenal in his
factory, and when Lachenal in his turn became in-
dependent he employed Decoeur. Moreover, even
though we have considered each medium sepa-
rately, we should realize that these boundaries were
often crossed. For example, Falize evidently knew
Rousseau and borrowed Japanese prints from
him;[20] Reiber designed ceramics for the Deck fac-
tory at the same time that he worked for Christo-
fle;[21] Christofle was one of Bouvier's patrons, and
Madame Christofle owned the Moreau vase in this
exhibition. In short, there was a great deal of inter-
communication within this artistic community.
Thus, even if most Japoniste artists worked rela-
tively independently and never joined in any formal
society, Japonisme can still, in essence, be seen as
a group movement.

We should also recognize that there was some
relationship between the decorative and the fine
arts. An early testimony of this is Fantin-Latour's
painting *A Studio in the Batignolles Quarter,* 1870
(Fig. 47), where Manet is surrounded by, among
others, Renoir, Astruc, Bazille, and Monet (orig-
inally Duranty and Degas were to have been in-

cluded as well). The interest of this Impressionist
circle in Japanese art has already been expounded
upon, so we might almost take for granted the
Oriental-looking vase at the far left with its dragon
decoration, save that the vase is actually French
and was made by one of the first Japonistes, Laurent
Bouvier.[22] Indeed, Bouvier, Cazin, Moreau, and, of
course, Bracquemond were trained first as painters,
and they long retained the friendships first made in
art school and the cafes. Likewise, the Haviland
studio at Auteuil was a center where ceramists and
avant-garde painters like Gauguin and Degas came
into contact with each other.[23]

While we have been emphasizing Japonisme in
a positive way, we should also realize that it was
but another species of historic revivalism. Indeed,
most of the early Japonistes worked simultaneously
in other period styles as well. Moreau often turned
to the Medieval past and Rousseau used Medieval
and Renaissance modes while Bouvier preferred the
Persian style. Falize's most celebrated work at the
1878 Exposition was not his Japanese-style cloi-
sonné enamels but rather a neo-Renaissance-style
clock with figures by Carrier-Belleuse. Sometimes
these various styles were used in hybrid combina-

tions; Gallé, for example, made faience candle-sticks in an eighteenth-century faience tradition using the form of rampant, Medieval lions but decorating the bases with Japanese motifs. Although we now can see how Japonisme proved to be a beneficial force, we can also understand why so many critics of that era were worried about the deadening effect that it and all historicism would have on the decorative arts.

From the very outset these dangers had been recognized. When Ernest Chesneau delivered his discourse on Japanese art to the *Union centrale* in 1869 he announced that its basic principles (such as asymmetry and the transformation of nature into a decorative system) were equally applicable to the West. He also warned that French art should not merely submit to and imitate Japanese art but, rather, its charming conceptions should be studied so that "you will know how to apply them, extend them, perfect them, appropriate them to our usages, for the greatest glory and well-being of our industry in the markets of the world."[24]

Nonetheless, as we have seen, Japonisme remained essentially a matter of imitation; consequently, throughout the seventies critics bemoaned the influence of the Orient on French industry. The 1878 World's Fair made the problem even more apparent. De Liesville was provoked to write about the French pottery on display:

In short, ceramics which are very brilliant, greatly varied, but above all imitative; there is French ceramics! Japan, Persia and Muslim art give it its most beautiful accents. But as to decoration, we have not found anything French, anything European, anything decisive since the eighteenth century. The formula of a European decor corresponding to our needs, to our habits, to the normal objects of our existence, remains still to be discovered.[25]

Similarly, Victor de Luynes wrote in his tardy but official report after the same 1878 Exposition:

Japonisme! Attraction of the age, disordinate rage, which has invaded everything, taken command of everything, disorganized everything in our art, our customs, our taste, even our reason.[26]

Such criticism helped bring the first phase of Japonisme in the decorative arts to an end.

1878—1900

At the same time, the Japanese vogue in France was stimulated once again by renewed contacts with that country at the 1878 World's Fair. Japan's entries, a pavilion for the display of industrial arts on the rue des Nations and a farmer's habitation near the Trocadero, were unmitigated successes. *Le Japon à l'exposition de 1878*, published by the Imperial Commission as a proselytizing endeavor, proved invaluable as one of the earliest modern accounts written in French of the history of Japan and its industries. Further displays of that country's arts selected from private French collections were organized in the Trocadero under the direction of the Japanese commissioner to the exposition, M. Wakai, and his assistant, Tadamasa Hayashi.

At times the 1880's saw a flagging of interest in Japan on the part of the public. Symptomatic was Gustave Thierry's report on the Amsterdam International Exhibition of 1883, in which he deplored the invasion of Japanese goods into France as well as their pernicious influence on French industrial arts.[27] Such criticism was unquestionably warranted, for the Japanese in their haste to modernize had resorted to various unfortunate devices including the importation of French plain porcelain which they then decorated and resold in the West.[28]

Parallel with this there was increasing discernment on the part of serious collectors. The growing connoisseurship was manifested in a retrospective exhibition organized in 1883 by the Japanophile director of the *Gazette des Beaux-Arts,* Louis Gonse, in the gallery of Georges Petit. Included were over 3,000 objects borrowed from diverse sources; Gonse himself supplied 1,123; Samuel Bing, 666; Philippe Burty, 306; and Georges Petit, 132. Other collectors represented were the industrialists Charles Haviland and Henri Bouilhet; the counts Abraham, Isaac, and Nissim Camondo of the wealthy banking family; Sarah Bernhardt the actress; the artists Georges Vibert, Alphonse Hirsch, and Giuseppe de Nittis; and the writers Charles Ephrussi, J. M. de Hérédia, and Antonio Proust. In conjunction with his 1883 exhibition Gonse published *L'Art Japonais,* a systematic, two-volume history of a subject in which the French had previously lagged behind English scholars [178].

Five years later Samuel Bing initiated *Le Japon artistique* [179, 180], a journal comprised of short

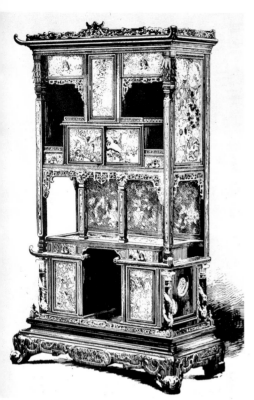

Figure 48. *Japanesque Cabinet.*
Wood, inlaid with bronze, silver, and cloisonné enamels, 1880.
Alphonse Giroux. (Photo: *The Art Amateur,* 1880)

Figure 49. *Oriental Smoking Room, ca. 1885.*
J. Justin Storck. (Photo: Union Centrale des Arts Décoratifs)

essays and lavish illustrations that appeared monthly in French, English, and German editions from 1888 to 1891. Contributors to this venture included most of the French Japanophiles—P. Burty, T. Duret, L. Falize, E. de Goncourt, L. Gonse, and Roger Marx, to name a few—as well as some of the English experts in the field. To commemorate the launching of the journal, Bing organized an important exhibition of Japanese art at his rue de Provence shop.

By the time of the 1889 World's Fair, Japan as a country had lost something of its exotic novelty. This is particularly understandable when we realize that the official display in that country's pavilion emphasized the modernization of its society and technology. On the other hand, Japanese art still held a position of esteem; an exhibition illustrating the history of Japanese ceramics and textiles organized by Bing and Gonse in the Palais des arts liberaux was regarded by contemporary observers as more interesting than the official Japanese one.

When we turn to French decorative arts made after the 1878 World's Fair we find that Japonisme still continued to be a major force. Despite the railings of critics against the dominance of the Oriental mode, an outright imitation of Japanese models predominated through the 1880's and only gradually waned in the following decade. Many of the major ceramic and glass factories including those of Deck, Carriès, Haviland, Vieillard, Rous-

seau, and Baccarat continued to produce *objets d'art* with the standard repertoire of Japanese motifs such as bamboo, cranes, water lilies, wisteria, and carp. Likewise, Parisian jewelers began to utilize these same motifs, translating the frogs, snails, dragonflies, wisteria blossoms, and Japanese fans into gold and diamond fancies.

French furniture, although always dominated by pastiches of the eighteenth century, still allowed itself to be swayed at times by the Japanese style. Deluxe enameled furniture with encrustations of metal continued to be made by Christofle and Barbedienne. Other firms such as Viardot, Giroux, and Majorelle made equally elaborate furniture [254], often with inlays of wood marquetry, ivory, and lacquer (Fig. 48). There are also some interesting anonymous examples done presumably in the nineties in which Japanese metal mounts were applied to French cabinetry. While it is true that the type of carved decoration that the French preferred has a basis in Japanese export furniture, still, it is noteworthy that they never adapted the more austere quality of most Japanese construction; for the same reasons they remained unaffected by Godwin's Anglo-Japanese furniture even though they saw it exhibited first hand at the 1878 Fair.[29]

Although the French could have become acquainted with the principles of Japanese interior design through exposition pavilions,[30] travelers' descriptions, and depictions in prints, here, too,

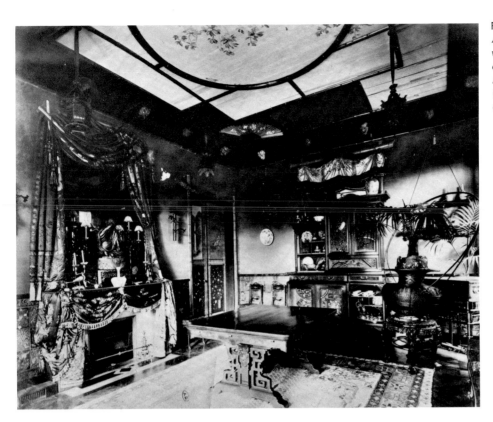

Figure 50.
A French Salon Fitted with Japanese Furniture,
ca. 1880–90.
Anonymous Photographer.
(Photo: Union Centrale des Arts Décoratifs)

they made little attempt to emulate such principles. The French Japanophile's chamber with its overwhelming amount of paraphernalia was as far removed from that of an Eastern aesthetic as had been rococo *chinoiserie interiors* (Figs. 49, 50). The starkness of the Japanese dwelling and its flexible, flowing spaces were quite alien to the French designer, who sought instead to create, through the display of a mélange of bibelots, a setting evocative of a romantic, exotic East. Characteristic components of the Japoniste room were fans applied to the wall in asymmetrical patterns, parasols, screens, a profusion of Oriental porcelain, imported bamboo furniture, hanging paper lanterns, and the ubiquitous palm tree. Often there was a frieze of noh masks, a device known to have been employed by the painter Gérôme before 1883.[31]

Japonisme was essentially a matter of highly transitory decor which was generally reserved for smaller rooms such as smoking dens, collectors' cabinets, and libraries, but not for formal salons or receiving rooms. Unfortunately, none of these rooms have survived intact. Typical of the frivolous attitude toward the Japanese style was the decision of the Duchesse de Biasaccia who, to prepare her Paris hotel for a charity ball in 1883, transformed it into a "Japanese palace" and clad her hostesses in kimonos.[32]

That the disposition of these Japoniste rooms had little to do with the real East was not unnoticed at the time. In 1887 Pierre Loti, whose naval service had taken him to Nagasaki for six months, decried these efforts of Parisian enthusiasts, contrasting them to actual Japanese dwellings in one of the most popular novels with a Japanese theme, *Madame Chrysanthemum*.[33] Yet he himself maintained a *pagode japonais* in his home which, with its rows of wooden pillars and brackets, hanging paper lanterns, and Buddhist statues set in niches, suffered from the same fault of clutter.[34] Moreover, this was but one room in a remarkably eclectic residence whose other rooms included a Turkish mosque and salon; Arabian, Chinese, and Gothic chambers; and a Louis XI dining room.

Bookbindings quite frequently reflected the Japanese mode. This can be seen in the works of Henri Marius Michel [257] and is even more pronounced in the works of his apprentice, Charles Meunier [258]. Meunier specialized in mosaic bindings which sometimes contained mounted Japanese metal or ceramic plaques. Certain masters were particularly fascinated with the possibilities of using richly decorated Japanese leather paper *(kamikawa)* for the covers and Japanese silks in place of the traditional marbleized end papers and separations between chapters.[35] Not to be overlooked were parallel developments in the field of commercial publishers' bindings. Naturally they were appropriate for books dealing with Japanese subjects, as in the case of the luxurious printed silk

Figure 51. *Silk Sample, pre-1885.*
Anonymous French Manufacturer.
Paris, Musée des Arts Décoratifs, Brunier Collection.

binding by Engel for Gonse's *L'art japonais,* 1883. That the Japanese influence was at times of questionable value is apparent in Henri Béraldi's censure of the "hystero-japonais" bric-a-brac manifest at the exhibition of bindings organized in 1893 by the *Union centrale des arts décoratifs.*[36]

The French textile industry was certainly affected by Japonisme in the late 1870's and the 1880's. Indeed, textiles may have been among the first of Japan's industrial products to have been appreciated in the West. Some were shown in London at the 1862 World's Fair, and gold and silk brocades from the private looms of the former shogun were exhibited in Paris five years later and subsequently dispersed. The 1878 World's Fair, with the first truly comprehensive exhibition of Japanese textiles in France, must also have spurred this phenomenon.[37] Of equal importance was the growth of private collections of Oriental fabrics, such as those of Giuseppe de Nittis, said to have been unequalled in its *fusakas* (elaborately embroidered panels of silk used for wrapping gifts), and of Samuel Bing, who succeeded in assembling a representative collection of fabrics from court robes dating as early as the fourteenth century.[38] Lyons, the undisputed center of the French textile industry, may even have had contact with Japan before the middle of the century. It has recently been shown that one of that city's silk manufacturers, Raoul du Seigneur,

owned some Japanese prints as early as the mid-1840's.[39] Certainly Lyons was well aware of Japanese art by the late 1870's, for between 1878 and 1888 the important collection of its native son, Emile Guimet, was housed there in his Musée National des Religions.

Some idea of the actual effect of Japonisme on the French textile industry can be gauged by the samples in the Brunier collection, gathered between 1870 and 1885 and now in the library of the Musée des Arts Décoratifs, Paris (Figs. 51, 52). Almost predictably, the silk manufacturers appear to have been more readily swayed by the Far East, and one often encounters in the Brunier collection silk samples showing Japanese fans, stylized flowers, or cloud or scale patterns that were evidently inspired by—if not directly copied from—Japanese silks. The heavier wools and velours intended for furniture covering seem to have succumbed less readily, but one occasionally finds fabrics printed with elaborate geometric and flower patterns or even with kimono-clad women.

Wallpaper is a field in which one might have anticipated early manifestations of Japonisme in view of the prominence of Oriental and *chinoiserie* papers in the eighteenth-century *goût chinois.* Also, Japanese papers suitable for wall coverings were exhibited at the Paris Exposition of 1878.[40] However, the French wallpaper industry in the third quarter of the nineteenth century was marked by a technological perfection unaccompanied by any dramatic stylistic innovations. As late as 1882 Charles Blanc recommended to French manufacturers that they take the apparently novel step of turning for inspiration to Oriental albums and fabrics.[41] Yet the response appears to have been slow, although we were able to find some late nineteenth-century examples with obvious Japanese motifs [260, 294–298].

Had Japonisme remained solely a whimsical fascination with various exotic motifs it might merit the derogatory appellation of *japonaiserie.* However, such was not the case. During the course of the 1880's new attitudes toward Japanese art were adopted which gave fresh life to the movement and a new vitality to French decorative arts in general.

One aspect of this new way of seeing Japanese art was well expressed by Lucien Falize in an article he wrote about 1882.[42] He not only admitted that he traced and copied Japanese prints (an admission

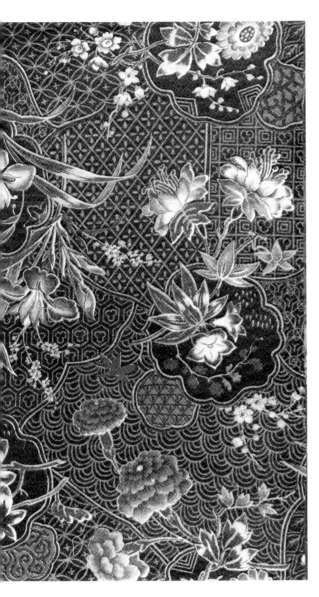

Figure 52. *Printed Upholstery Fabric* (detail).
Before 1885. Kochlin, Baumgartner (?).
Paris, Musée des Arts Décoratifs, Brunier Collection.

to which we have already referred); he also recognized that he copied these images without fully understanding their significance for the Japanese who created them:

> Do you know what made the artisan of Kyoto give his vase the shape of a gourd or a bulbous root? Have you penetrated the symbol of the white deer? To what end do you copy these peach flowers or these quince branches? You write this language drawn by the Japanese as you have copied all the religious symbols of all people—without understanding them. . . . And us, what are we to do? To copy still? No, but to be inspired by this art and likewise return to a healthy doctrine, to simple means, to the study of Nature.

The idea of learning from Japanese art to return to nature goes to the crux of the matter. This new understanding meant an increased vocabulary of motifs. As Ary Renan wrote in *Artistic Japan* in 1889:

> The *Man-gwa* is addressed beyond all to the handworking artisans who maintain our industries. Why do they leave the country, the streams, the fields, the sea? Why do they not surround themselves with models from nature brightly coloured and lovely? Why do they not add seaweed, butterflies, a branch of clematis, to their limited designs?[43]

French artists found in Europe the very same plants and birds and insects that they had been so assiduously copying from the Japanese. Their new vocabulary included, as Renan suggested, seaweed, butterflies, a great profusion of fish and crustacea, frogs, dragonflies, bats, mice, roosters, wisteria, iris, and pine branches.

Beyond this expansion of the French decorative vocabulary, there was a new appreciation of nature; one might say that the artists of the 1880's and 1890's learned to see it with Japanese eyes. Japonisme entailed not only a verisimilitude of action and gesture, but also a feeling of intimacy and grace. Above all, there arose a perceptive awareness of the poetic quality of nature, and it is in this light that we should view much of the later work of Gallé, Falize, Dammouse [265], and the other early Japonistes. And, of course, this new sense of nature was registered in all media—ceramics, glass, jewelry and metalware, furniture, textiles, wallpapers, and bookbindings.

Figure 53. *Stoneware Vase, ca. 1886–87*. Ernest Chaplet. (Photo: Paris, Musée des Arts Décoratifs)

A new sensibility to materials and color also became evident about this time and can be traced in large measure to Japonisme. French ceramists turned away from highly decorated wares to simple, strong forms enriched only by flowing, colored glazes. About 1880 Deck experimented with porcelains with flambé glazes, though one might be hard pressed to decide if they were more Chinese or Japanese in inspiration. About 1884, Bracquemond, that gray eminence who hovers behind so much of the history of Japonisme, suggested to Chaplet [261] that he imitate Eastern glazes.[44] One of the earliest examples of Chaplet's work in this vein is a simple stoneware vase now in the Musée des Arts Décoratifs, Paris (Fig. 53). This change in aesthetics was clearly registered a few years later in Bing's *Artistic Japan* in a discussion of a Seto saké bottle:

> It is strength which imparts the chief merit to the specimen before us. . . . There is strength in the composition of the paste [the clay body], in the lines of the shape, and in the rich colour of the enamel. . . . Our subject has no other decoration beyond the brightness of the lustre of its enamel, which is allowed to run freely over the sides. If decoration, added by a clever hand, gives the beauty which, according to the very general idea is the chief object to be obtained in pottery, ornamentation based on richness of tones of enamel produced in the firing arouses none the less admiration from an artistic eye. . . .[45]

Although Chaplet's subsequent experiments turned more toward Chinese prototypes, Delaherche quickly assumed leadership among French ceramists influenced by Japonisme, and his beautifully glazed flambé stoneware was acknowledged as a standard of excellence. At the same time, Jean Carriès [222, 223] became involved with ceramics and, even more than Delaherche, closely aped Japanese models in form and glaze. The freedom with which the glaze runs, the emphasis on the throwing and tool marks, and the essential "natural" quality of the work mark a dramatic change. The works of Carriès' followers at Saint-Amand such as Hoentschel [267] and Jeanneney [268], as well as those of other artists such as Bigot, Dalpayrat [230–232], and Doat show a similar concern for purity of form and softness of mat glaze in the Eastern manner, and these works dominated much of the Paris Salons at the end of the century.

A comparable phenomenon can be observed in the medium of jewelry, where under the leadership of Lalique [277] French craftsmen gave up the ostentatious tradition of diamond *joaillerie* for *bijouterie*. They now became concerned with semi-precious stones, with horn and enamels, and with the establishment of a harmony of color between the different elements. Not only were some of the materials and techniques borrowed from Japanese art, but the whole tendency to forsake the traditional Western emphasis on the preciosity of materials and to substitute in its stead a concern for craftsmanship on a small scale shows the sort of principles which French artisans were now able to adapt from Japanese *inro* and *netsukes*.

The 1890's also saw the emergence of the Art Nouveau style in France. While we would prefer to use this categorization only for those artists—like Guimard or Colonna—who strove for a consistent rhythmic stylization (thus omitting others—like Gallé and Dammouse—who, in essence, maintained a more specifically Japoniste point of view), we should recognize that even Art Nouveau was deeply affected by the cult of Japan. The curving line that is one of its chief characteristics was often likened to Japanese designs. As Marcel Bing wrote:

> Thus some artists have believed that they could find a new source of ornamentation or even the lost principles of modern style in various types of linear combinations. These attempts appear to have been somewhat inspired by the graceful, wavy movement of Japanese lines which has happily influenced linear ornament. Without a doubt, drawing in the decorative arts has experienced an enrichment through new types of linear coils and plays of meandering lines and has formed a manner in which something of the charming softness and sound decorative understanding of Oriental motives of this kind can be found again.[46]

Moreover, many of the floral and animal motifs and the way that they are stylized was also justified in terms of Japanese precedents; foremost designers like Grasset and Verneuil insistently turned to the East as a model.[47]

The growing rapprochement between modern French decorative arts and a Japanese aesthetic made it easy for Bing, who was disdainful of the lowered quality of goods coming out of the East, to switch the emphasis of his business from orientalia

to objects reflecting the modern style (which, inadvertently, he baptized "L'art nouveau"). When he officially opened his new galleries at the end of December, 1895, Japanese prints and paintings were juxtaposed with the works of Gallé, Lalique, Delaherche, and Dalpayrat. They were not in opposition, however; there was an essential harmony between East and West.

Thus by the end of the 1890's not only could the effects of Japonisme in its many forms be seen everywhere in the French decorative arts, but also the decorative arts had become a major form of expression. Their entry into the Paris salons on an equal footing with the "fine arts" suggests something of their growing importance.[48] While we might see this as an outgrowth of the English Arts and Crafts movement and the efforts of the *Union centrale,* we should also remember how contemporary writers like Henri Vever often championed the cause of the decorative arts by pointing to the example of Japan and the omnipresence of the decorative arts in the daily lives of its people.

1900—1910

Japan still continued to exert its influence after 1900. With the passage of time, French scholars had achieved a more secure position from which they could chart the development of Japanese art and grasp its full significance. The posthumous sales of Burty's collection in 1891 and that of De Goncourt in 1897 had memorialized the achievements of the first generation of collectors and at the same time revealed their weakness, namely, their inadequate historical perspective. The World's Fair of 1900 showed for the first time in Europe a comprehensive selection of materials illustrating the full scope of Japan's artistic achievements. Confrontation with Japan's early Buddhist sculpture and temple treasures borrowed by Hayashi, the commissioner for the event, must have proven a humbling experience for collectors who had known only eighteenth- and nineteenth-century *bibelots.* The more earnest approach adopted at this time is borne out by the establishment in 1900 of the Société Franco-Japonaise de Paris, which issued a monthly scholarly bulletin and had its offices strategically located in the Marsan pavilion of the Louvre, in other words, adjacent to the center for French decorative arts. The membership of this society, which sought to promote cultural exchanges between the two countries, included many of the foremost collectors and scholars of Japanese art.

The fortune of French decorative arts after 1900 was complicated. On the one hand there was increased recognition of the importance of the decorative arts, registered not only in the publicity accorded them at the 1900 World's Fair but also in the fact that two years later, at Turin, there took place the first international exhibition devoted solely to such arts. On the other hand, there was a noticeable lack of resolution when it came to determining what would be "the modern style" for France. The triumph of the Art Nouveau style was short-lived and was already declining by 1904. It left in its wake a vacuum which for some meant a return to classicism but for many more meant a return to the sanctioned traditions of Japanese art. Symptomatic of this state of affairs was the fact that Bing and his son Marcel, because of bankruptcy, gave up dealing in modern decorative arts in about 1903–04 and turned once again to the more secure field of Oriental *objets d'art.*[49]

It is fascinating to see how certain artists made a similar turnabout. The ceramist Emile Decoeur [273, 274], after having been seduced by the linear complexities of the Art Nouveau style while working for Lachenal, now renounced these works and produced vases either with simple bleeding glazes or with imagery that was specifically Japanese.

In a sense Tokyo replaced Rome as the artistic capital of the West, and it was to Japanese art that one turned to find the authority with which one could create a modern style. A curious resurgence in pointedly Japanese designs was apparent in all media after the turn of the century, not only in the work of students at the various schools of decorative art but also in the professional entries exhibited at the annual salons. Those, like Verneuil and Mehuet, who believed that nature was the essential basis of a modern style (this still remained a basic premise for the majority of designers) also believed that Japanese art contained the secret of how to translate these natural forms into a decorative system. Mehuet felt obliged actually to travel to Japan to experience it all first hand.

Those designers who sought an answer in terms of more geometric expression could also turn to Japanese art. The similar rendition of a floral pat-

Figure 54. *Salon, 1904.* Théodore Lambert.
(Photo: Paris, Union Centrale des Arts Décoratifs)

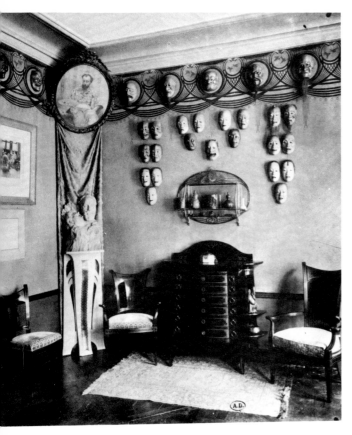

tern in terms of overlapping discs that we find on both a Lyons silk and a Sèvres vase of 1905 [272] can only be understood in such terms. Japanese sword guards and textile stencils were studied with new perception, as can be seen in the works of Théodore Lambert, a creator of jewelry and metal furniture at the turn of the century noted for the pure geometry of his designs. Although occasionally specific Japanese motifs appear in his work, as in an interior of about 1904 where a stenciled fillet design is intertwined with noh masks and medallions of flying ducks (Fig. 54), we are interested only in the basic linear patterns themselves and in the fact that five years later the artist published a book of design taken from Japanese stencils.[50]

One can also see the pervasive influence of Japanese techniques in Parisian ateliers. The *tabletiers* (makers of small, fancy objects for the table) increasingly participated in the annual salons, and the carved wood and leather boxes of Madame de Felice and Hairon [282], the inlaid mother-of-pearl objects by George Bastard, and the carved ivory of Mademoiselle O'Kin reflect an increased reliance

upon Japanese precedents. Mademoiselle O'Kin was actually only half-French and had been born in Yokohama, where apparently she learned her craft. Indeed, there was an increasing amount of firsthand contact with Japanese artisans as well as with their objects. Eugène Gaillard even imported Japanese workmen in 1900—something which Tiffany had done before him and which Lucien Falize had hoped to do.[51] With these men at hand, Gaillard was able to create sophisticated bronze patinas and to explore new media—for example, lacquer and its combination with other materials such as horn and mother-of-pearl. Not surprisingly, he often used straightforward Japanese designs as well—a practice which did not escape certain critics' ire. We might also note that Eileen Gray began to study the technique of Oriental lacquers in 1907 with Sougawara, and that five years later Jean Dunand studied with the same master.[52]

With these names—Decoeur, Bastard, O'Kin, Dunand—we have left the *fin de siècle* and are rapidly approaching the art of the teens and the twenties. As we see, Japonisme was not limited as we might have thought to a short period in the mid or late nineteenth century but was to extend throughout the entire history of modern French decorative arts. Japonisme became a basic element in the substructure of Western culture. Japanese art proved to be sufficiently diversified and adaptable that its interpretation could change with the decades and provide a constant source of authority and inspiration.

1. Roger Marx, "On the Role and Influence of the Arts of the Far East and of Japan," *Artistic Japan*, VI (1891), 462.

2. See *World Cultures and Modern Art* (Munich, Haus der Kunst, 1972), pp. 12–79; also Pierre Kjellberg, "L'orientalisme," *Connaissance des arts*, no. 258 (August 1973), pp. 59–67.

3. See, for example, A. Brongniart and D. Riocreux, *Description méthodique du musée de la manufacture royale de porcelaine de Sèvres* (Paris, 1845), p. 416, pl. P. IV; p. 417, pl. P. XV; p. 421, pl. P. IV; Denise Ledoux-Lebard, *Les ébénistes parisiens du XIXe siècle* (Paris, 1965), pp. 204, 210; Henri Bouilhet, *L'orfèvrerie française au XVIIIe et XIXe siècles*, 3 vols. (Paris, 1908–1912), II, 224.

4. L. Bénédite, "Félix Bracquemond, l'animalier," *Art et décoration*, XVII (1905), 39–40.

5. For a fuller discussion of this book and its Japanese images see M. Eidelberg, "Bracquemond, Delâtre and the Discovery of Japanese Prints" (forthcoming).

6. See her 1867 plaque in the Musée des arts décoratifs, Paris (R. Charleston, ed., World Ceramics [New York, 1968], fig. 906) and the closely related one in the Victoria and Albert Museum, London.

7. Alfred Darcel, "L'émaillerie moderne," Gazette des Beaux-Arts, s. 1, XXIV (1868), 74–84.

8. Ernest Chesneau, "Le japon à Paris," Gazette des Beaux-Arts, s. 2, XVIII (1878), 386.

9. G. Allemand, "Le rôle du Japon dans l'évolution de l'habitation et de son décor en France dans la seconde moitié du XIXe siècle et au début du XXe siècle" (Ph. D. thesis, Ecole du Louvre, 1964), pp. 80–87.

10. James L. Bowes, Japanese Enamels (Liverpool, 1884), p. 18.

11. P. Dechesne de Bellecour, "La Chine et le Japon à l'Exposition universelle," Revue des Deux Mondes, XXXVII (July 1867), 730.

12. Apparently Bracquemond also tried his hand at making enamels; see Philippe Burty, "Félix Bracquemond," L'Art, XII (1878), 296.

13. This technique of electro-deposit appears to have been in use before 1867; see Alfred Darcel, "Bronze et fonte modernes," Gazette des Beaux-Arts, s. 1, XXIII (1867), 430.

14. L. Falize (writing under the pseudonym of M. Josse), "L'art japonais," Revue des arts décoratifs, III (1882–83), 359. Tiffany had the benefit of employing skilled Japanese workmen. Falize was envious and wanted to do the same but his family would not let him make the trip to the Orient to do the hiring. See Henri Vever, La bijouterie française au XIXe siècle, III, Paris, 1908), 761.

15. Colta Feller Ives, The Great Wave (New York, 1974), p. 31, and G. Michaud, Mallarmé, trans. M. Collins and B. Humez (New York, 1965), 89.

16. Chesneau, p. 388.

17. E. Moreau-Nélaton, "Un précurseur: Laurent Bouvier," Art et décoration, IX (1901), 169.

18. Falize, p. 330. P. Burty, in Les émaux cloisonnés anciens et modernes (Paris, 1868), p. 57, is even more specific about the Japanese sources: "Il [Alexis Falize] s'est procuré la série complète des albums de croquis du grand artiste japonais Ou-Kou-Say [Hokusai], des feuilles imprimées de Toyo-Kouni, de son élève Kouni-Yossi, de Yossi-Toni, etc."

19. There is a clipping in a scrapbook in the library of the Musée des arts décoratifs, Paris (XXXVIII, no 28), which shows the Haviland atelier at Auteuil, and the walls of the studio are covered with what appear to be Japanese paintings.

20. Falize, p. 333.

21. For an example of Reiber's work for Deck see the statuette illustrated in L'Art, VII (1876), opp. 35.

22. This is pointed out by Moreau-Nélaton, p. 167.

23. Degas, circa 1879, made at least one lithograph at Auteuil; Gauguin lived in the home of P. Aubé, one of the chief Haviland decorators, and his celebrated pottery was done in collaboration with Chaplet. See J. and L. d'Albis, "La céramique impressionniste," L'oeil, no. 223, (February 1974), pp. 46–51. Gauguin wrote a review of the ceramics at the 1889 World's Fair and singled out Chaplet and Delaherche but, predictably, reproached them for their use of traditional forms; see Merette Bodelsen, Gauguin Ceramics in Danish Collections (Copenhagen, 1960), n. 10.

24. Ernest Chesneau, L'art japonais. Conférence faite à l'Union centrale des Beaux-Arts appliqués à l'industrie le vendredi 19 février 1869 (Paris, 1869), p. 28.

25. A. R. de Liesville, La céramique et la verrerie au Champ-de-Mars (Paris, 1879), pp. 40–41.

26. Victor de Luynes, Rapport du jury international. Classe 20. Rapport sur la céramique (Paris, 1882).

27. Gustave Thierry, "La céramique," Rapport du Jury International, Exposition universelle internationale de 1883 à Amsterdam (Paris, 1884), p. 23.

28. Thierry, p. 106.

29. Illus. R. Schmutzler, Art Nouveau (New York, 1964), fig. 295. One element of the ensemble has recently appeared; see Apollo, LXLVIII (October 1973), 27.

30. P. Burty, "Le mobilier moderne," Gazette des Beaux-Arts, s. 1, XXIV (1868), 27–28.

31. Louis Gonse, L'art japonais, II (Paris, 1883), 79–80.

32. Magali, "La vie mondaine," La vie moderne, April 21, 1883, p. 255.

33. Pierre Loti, Madame Chrysanthème (Paris, 1887), p. 23.

34. See François Le Targat, "Un voyageur privilégié, Pierre Loti," Touring, no. 861, (July-August 1974), pp. 10–15.

35. See Octave Uzanne, La reliure moderne (Paris, 1887), pp. 208–11, 206–61. Uzanne illustrates particularly interesting examples by Amand.

36. Henri Béraldi, La Reliure du XIX siècle, IV (Paris, 1896), 135–36.

37. Henry d'Hennezal, introduction to Decorations and Designs of Silken Masterpieces, Ancient and Modern (New York, 1930). There was a reciprocal influence as well. As part of its Westernizing program the Meiji government established spinning mills at Tomioko modeled after those of Lyons; see Le Japon à l'exposition universelle de 1878 (Paris, 1878), pp. 150–51.

38. Louis Gonse, L'art japonnais, II (Paris, 1883), 224–37.

39. Michel Melot, ed., L'estampe impressionniste (Paris, Bibliothèque Nationale, 1974), p. 8.

40. Le Japon à l'Exposition de 1878, II, 82–84.

41. Charles Blanc, Grammaire des arts décoratifs (Paris, 1882), p. 73.

42. Falize, pp. 330–31.

43. Ary Renan, "Hokusai's Man-gwa," Artistic Japan, II (1889), 103.

44. Bodelsen, p. 12.

45. S. Bing, Artistic Japan, II (1889), 76.

46. M. Bing, "Japan," in Die Krisis im Kunstgewerbe, ed. R. Graul (Leipzig, 1901), p. 87.

47. See E. Grassets' introduction to M. P. Verneuil, L'Animal dans la décoration (Paris, 1897), p. iii.

48. Salon of the Société nationale des Beaux-Arts, 1891; Salon of the Société des artistes français, 1895.

49. See Bulletin de la vie artistique, I. November 15, 1920, 670.

50. Théodore Lambert, Motifs décoratifs tirés de pochoirs japonais (Paris, 1909).

51. See note 14 above.

52. Yvonne Brunhammer, Jean Dunand, Jean Goulden (Paris, Galerie du Luxembourg, 1973), pp. 38–40.

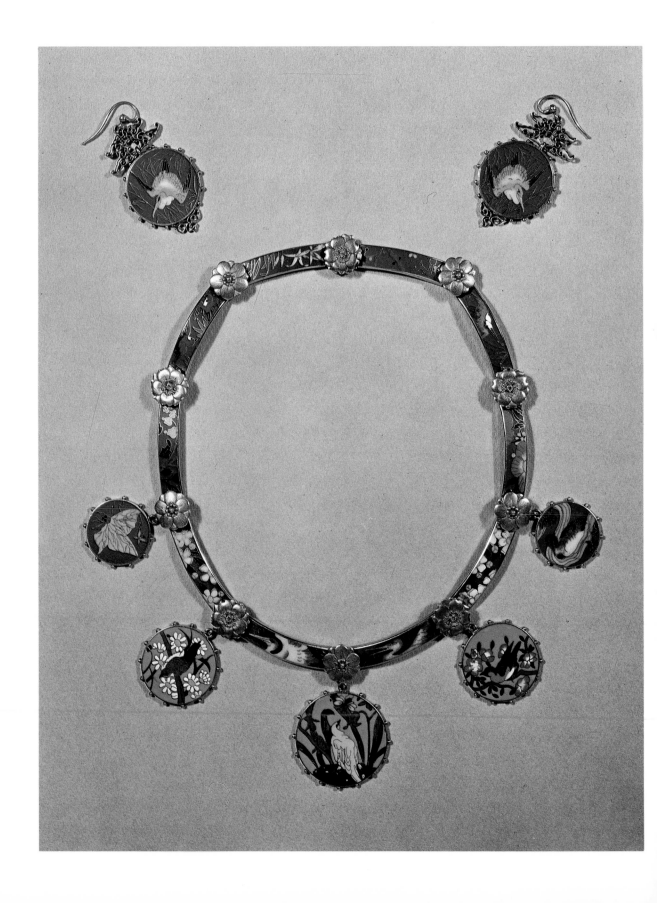

Catalog

Producer: Eugène Rousseau, 1827–1891, Paris.
Manufacturer: Lebeuf-Milet, Creil.
Designer: Félix Bracquemond, 1833–1914.

194 *Serving Dish.*
Faience with transfer printed design, ca. 1867.
H. 3 inches (7.6 cm.), Diam. 8-1/2 inches (21.6 cm.).
Stamped in black: CREIL / L M & Cie MONTEREAU / MODELE / E ROUSSEAU / A / PARIS.
Cleveland, Dr. and Mrs. Gabriel P. Weisberg.

The dinner service which Eugène Rousseau commissioned Bracquemond to decorate is justly famous as the first known example of Japonisme in the decorative arts. As has already been demonstrated, for the motifs that decorate this service, Bracquemond literally copied images of birds, flowers, and marine life from Japanese print albums by Hokusai, Hiroshige, and Isai.[1] The poppy seen on this dish, for example, is taken from a page in the *Kwacho Gaden* by Hokusen [194a]. The artist made etchings of the disparate motifs which were then cut up by the factory workmen and applied, piece by piece, to the ceramic blanks. As is customary in such commercial transfer printing, during the course of firing the paper burnt away, leaving behind only the printed image which was hand colored before glazing.

Traditionally, our interest has focused upon Bracquemond and his contribution, and while there is certainly justification for this, we should note that Bracquemond's interest in working with ceramics was supposedly sparked by another of the leading Japonistes, Théodore Deck. Even more important, we should not slight the role played by Rousseau. He was the owner of a long-established, fashionable store in Paris which dealt in fine china and glassware. The goods he sold at mid-century, whether Greek or Renaissance in style, are marked by their conservative nature and their high quality. One of his major artists was Marc Louis Emmanuel Solon, who, because of contractual agreements with the Sèvres factory, worked for him under the pseudonym of Milès. Solon

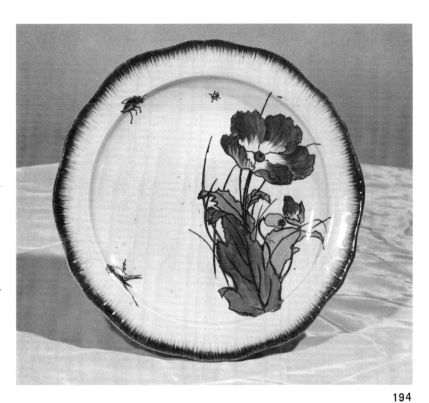

194

was an original member of the Jing-lar Society and a close friend of Bracquemond; one might wonder if it were perhaps through Solon that Bracquemond came to Rousseau's attention. Although Rousseau was not a member of the Jing-lar, nonetheless he seems to have been one of the early admirers of Japanese art. While Bracquemond already owned some of the Japanese albums which he copied for this service—specifically, a volume of the *Manga* that he carried with him as a "breviary"—we should not overlook the fact that the artist borrowed albums from Rousseau as well. We know nothing about Rousseau's Japanese collection, but he evidently had an abiding interest in the Far East, as his later pottery and glass show.

While one is fascinated by the Japonisme represented by this Bracquemond-Rousseau service, one must realize that it reveals an equally strong element of Rococo revival as well, due presumably to Rousseau's other designers. This is evident in the forms of the pieces—particularly the more complex, covered dishes—and in the type of "rayed" border which is used. Even the random scattering of the flowers and insects has little to do with Japanese principles of

194a

design, and can be more readily understood in terms of traditional eighteenth-century French porcelains. The marriage of these two quite separate historical styles is in keeping with a French mid-nineteenth-century sensibility and is still discernible in Gallé's furniture of a half century later.

This blending of conservative French traditions with the novelty of the Japanese decor may, in part, explain the great popularity the service enjoyed initially at the 1867 World's Fair and again in 1878. Rousseau was encouraged to commission other Japanese-style services from other artists, while his successor, Léveillé, continued to produce the Bracquemond service at least into the 1890's.[2] The *Escalier de Cristal,* another fashionable store in Paris, created a Japanese-style dinner service with cranes and carp that, remarkably enough, is still being offered for sale today by Rouard. In Bordeaux the firm of Viellard decorated a dinner service with images of Japanese birds and even Japanese calligraphy. Something of the popularity of Bracquemond's service can also be gauged by the imitations it provoked outside of France. In England, for example, the firm of Worcester created one such rival, and in the United States the fledgling Rookwood Pottery tried its hand. ME

1. See Weisberg [20–27].
2. *Les industries d'art à l'Exposition Universelle de 1889,* p. 188.

Producer: Eugène Rousseau, Paris.
Manufacturer: Lebeuf-Milet, Creil.
Designer: Félix Bracquemond.

195 *Plate.*
Faience with transfer printed design, ca. 1867.
Diam. 9-7/8 inches (25.1 cm.).
Stamped in black: CREIL / LM & Cie / MONTEREAU / MODÈLE / E ROUSSEAU / A / PARIS
Baltimore, The Walters Art Gallery, Gift of Mrs. Maurice Stern.

The designs on this plate from the Bracquemond-Rousseau service raise an interesting question. The study of branches and the small butterfly have parallels in Japanese albums like the *Manga,* and it might seem equally plausible that the flying duck could be derived from a Japanese print. This is put in doubt because the same duck can be seen at the right side of Bracquemond's etching of 1862, *Vanneaux et Sarcelles* [31]. If the duck is not copied from a Japanese image we must then wonder how Bracquemond came to include it in a series in which almost all the other images are Japanese-inspired. If, on the other hand, the duck is indeed borrowed from a Japanese source, then we should consider whether the artist's other etchings of seemingly naturalistic scenes also incorporate such borrowings. Whatever the answer, it reminds us that Bracquemond was a noted *animalier* before he came upon the *Manga,* and it was just

this background that caused him to admire the spirited way in which Hokusai had caught the lively, natural gestures of animals. ME

1868–1877

Joseph Laurent Bouvier, 1840–1901, Paris or Saint-Marcellin (Dauphiné).

196 *Plaque.*
White clay with red and black slips, clear glaze, ca. 1868–69.
Diam. 12-1/2 inches (31.7 cm.).
London, The Bethnal Green Museum.

Laurent Bouvier originally trained as a painter and achieved his first major triumph in 1868 when the French government bought from that year's Salon one of his paintings, *La Céramique.*[1] One wonders whether it was the subject of this painting which prompted him that summer, while vacationing in his native Dauphiné, to try his hand at pottery. Working with a local Saint-Marcellin potter, he produced his first pieces, which remained hidden until at the urging of Bracquemond he submitted them to the 1869 exhibition of the *Union centrale.* Thus this plaque, which was purchased in 1869, must be counted among his first creations.

Bouvier's interest in Japanese prints can be linked to his relationship with the early Impressionists, many of whom he had first met at art school. He maintained these acquaintanceships through meet-

195

196

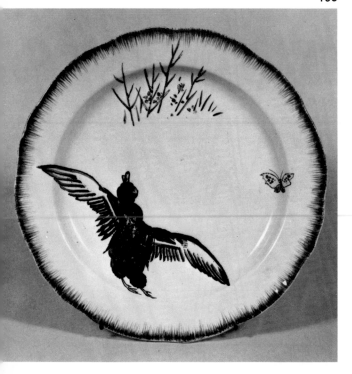
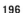
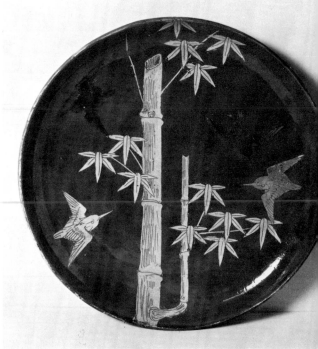

ings at the *Café Guerbois,* one of the rallying points for this group. As we have noted before, one of Bouvier's vases is included in Fantin-Latour's painting of Manet, Monet, Renoir, Astruc, etc. We know that Bouvier had hanging from the walls of his atelier his own collection of Japanese prints bought from Madame Desoye. Quite apropos of this plaque, with its pure Japanese design of swallows among bamboo, is Etienne Moreau-Nélaton's comment that Bouvier was inspired by the imagery of his *ukiyo-e* prints: "How to divert the flight of these swallows or wild cranes and prevent them from stopping an instant in the frame of the plate which, without doubt, has been prepared to receive them?" Bouvier was one of the first independent ceramists to use Japanese decoration, but, indicative of the general Orientalizing trend of the 1860's and 1870's, he was equally influenced by the art of Persia. His reputation, although quickly established, was nonetheless annulled by his removal to the Dauphiné and by an illness which brought his creative productivity to an end, forcing him to spend the latter part of his life as an invalid. ME

1. See E. Moreau-Nélaton, "Un précurseur: Laurent Bouvier," *Art et décoration,* IX (1901), 166–72; see also *Keramic Studio, III* (1901), 104–5.

Producer: Eugène Rousseau, Paris.
Manufacturer: Lebeuf-Milet, Creil.
Designer: Henri Lucien Lambert, ca. 1836–1909.

197 *Plate.*

Faience with painted decoration, ca. 1870–79.
Diam. 10 inches (25.4 cm.).
Printed in black: CREIL / L M & Cie / MONTEREAU / DEPOSE / E ROUSSEAU / A / PARIS.
Limoges, Musée National Adrien-Dubouché.

In the 1870's Rousseau's firm produced vases and dinnerware which featured Japanese decoration. Among the artists Rousseau commissioned was Henri Lucien Lambert, who, like Solon, was also formally employed by the Sèvres Manufactory at the same time. We know all too little about Lambert, but he evidently was an enthusiastic Japoniste; in fact, he is caricatured dressed in Japanese costume in an album of humorous portraits of the Sèvres artists which is preserved in the Manufactory's archives. At this point we cannot say if Lambert's interest in Japanese art was stimulated by Rousseau's ventures or by a meeting of two like temperaments, but, whatever the case, it cannot be denied that this plate and the others in the set in the museum at Limoges are striking examples of early Japonisme. The ceramic blank is sadly uninspired and its molded design is unrelated to its decoration. Only the

latter concerns us, however. As is often true of early examples of Japonisme, this witty and sophisticatedly cropped scene is not the invention of the French artist, but is taken directly from a Japanese model—a fan. We do not have the fan itself, but one with an almost identical design is depicted on the wall in the background of Monet's famous *La Japonaise, 1876* (see below). Once again, a close parallel can be drawn between the fine and applied arts. Unlike the Bracquemond services for Rousseau, which were printed, Lambert's is hand-painted and, interestingly, the bold strokes reveal a study of Japanese brush technique. Like the decoration, however, the technique reflects a literal copying of an Eastern idea and not the assimilation or adaptation of a principle. ME

197

197a

Manufacturer: Haviland and Company, Limoges.
Designer: Félix Bracquemond.

198 *Plate.*

Porcelain with designs produced by chromolithography and retouched with enamels, 1875.
Diam. 9 inches (22.9 cm.).
Printed on front: B. Printed on reverse in a circle in blue: Haviland & Co. / Limoges. Printed in green: H & C°.
New York, The Metropolitan Museum of Art, Gift of George Haviland.

In 1872 Bracquemond began to work for the firm of Charles and Théodore Haviland. Their company was based in Limoges, but an atelier had been established in the Auteuil section of Paris to attract artists who would have been reluctant to leave Paris for the provincial center. Charles Haviland and Bracquemond had become acquainted while the latter served as a director at the Sèvres Manufactory in 1870, a position he abandoned after six months because of the uncongenial artistic climate. The Haviland post proved to be more suitable, particularly since the factory was anxious to experiment with new printing techniques.

While working for Haviland, Bracquemond produced a number of dinner sets which exemplified his penchant for Japanese designs. One of the most celebrated was his so-called "Service parisien," which, despite its name, featured only Japanese imagery. The plate in the Metropolitan Museum is typical of the series, showing clouds and a bolt of lightning, bamboo bending in the wind, and swallows flying about at the advent of the oncoming storm. The other designs also show animals and plants set within contexts of temporal conditions—seasons, times of day, changes in weather. One is given an intimate glimpse of nature and a sense of constantly shifting patterns in an ephemeral world; in other words, one sees the very heart and core of what the *ukiyo-e* prints represent. This is not, of course, mere coincidence, since the prints were quite clearly the source of Bracquemond's imagery.[1] When this service was exhibited at the 1876 exhibition of the *Union centrale*, Adrien Dubouché commented: "The jewel of this service . . . is a dozen plates where Bracquemond has represented with some fine lines and some delicate tones subjects of a rare poetry: mist, snow, rain, the setting sun, etc.; it is an unexpected delight."[2] In addition to imitating prints, the plates may reflect a conscious attempt to imitate Far Eastern porcelains as well. Although they were printed by a chromolithographic process (one of the earliest examples of its use for this material), they were then retouched by hand with enamels, thus giving a semblance of Oriental hand-enameled decoration. ME

1. The type of pattern formed by the lightning and the clouds can be seen, for example, in one of Hokusai's *Views of Mt. Fuji,* vol. 2
2. A. Dubouché, "La céramique contemporaine à l'exposition de l'Union centrale des Beaux-Arts," *L'Art,* VII (1876), 56. There were evidently two slightly different editions of this service. A plate of this design owned by the Haviland Company (illus. G. Weisberg, "Félix Bracquemond and Japanese Influence in Ceramic Decoration," *Art Bulletin,* LI [1969], fig. 11) shows variations in the arrangement of the sparrows and in the shape of its border.

198

199

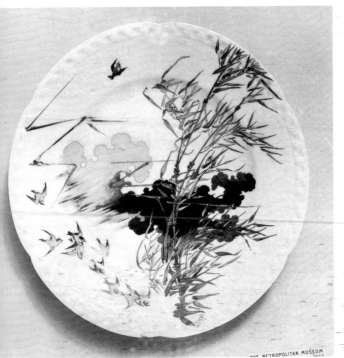

Manufacturer: Haviland and Company, Limoges.
Designer: Félix Bracquemond.

199 *Plate.*

Porcelain with impressed design, grayish glaze, ca. 1875.
Diam. 8-3/4 inches (22.2 cm.).
Printed on front: B. Printed on reverse in green: H & C⁰ / L.
New York, The Metropolitan Museum of Art, Gift of George Haviland.

In the mid-1870's Bracquemond created another set of designs for Haviland called "The Bestiary."[1] It was a large set of thirty designs showing the typical sort of floral and faunal iconography one might expect from a Japoniste: storks, roosters, carp, deer, rabbits—often accompanied by flowering branches, waves, a glimpse of the moon, or patterns of falling rain. The form of the ceramic blank, fittingly enough, is derived from the pad of a water lily plant.[2] As before, Bracquemond's image of the two running horses is closely dependent upon Japanese models. The short-necked, muscular animals (called *umas*) belong to species peculiar to Japan. Moreover, the way they are depicted with an economy of line follows Japanese practice (Hokusai was celebrated for having been able to portray a horse in just eight strokes). This, too, is in accord with what we know of Bracquemond's penchant for literal copying. For some versions of this service Bracquemond's etchings were used in the normal process of transfer printing; the resulting designs were then colored. As in this case, a die was cast from the original etching plate and was then impressed in the clay.[3] Sometimes the impressed designs were gilt; in other cases, including that of the present plate, the glaze was allowed to well up in the crevices. The pale gray and celadon glazes that were used are obviously the result of Bracquemond's study of Eastern pottery, and it should be remembered that it was he who, a few years later, encouraged Chaplet to emulate the glazes of Japanese ceramics. ME

1. Béraldi, nos. 642–72. It would seem to have been issued by 1876; see A. Dubouché, "La céramique contemporaine à l'exposition de l'Union centrale des Beaux-Arts," *L'Art, VIII* (1876), 56.
2. The designation of the form as "Nenuphar" is marked on some of the sample plates in the Metropolitan Museum, nos. 23.31.15 and 19.
3. The explanation of these technical matters was provided by Charles Haviland at the time of his bequest in 1923. This service was reissued by Goupy during World War II; see *Notre Province,* Jan.–Feb. 1942, no. 1.

Manufacturer: Haviland and Company, Limoges.
Designer: Félix Bracquemond.

200 *Plate.*

Porcelain with an impressed design, partially colored in varying shades of gold, ca. 1872–80.
Diam. 9-1/2 inches (24.1 cm.).
Printed in blue in a circle: HAVILAND & C⁰ / LIMOGES. Printed in green: H&C. Painted in red: 3769 Tarif. Ruban Gravé G^d feu / Vt 15^f la Douzaine.
New York, The Metropolitan Museum of Art, Gift of George Haviland.

In its literal dependence upon Japanese prototypes and its bright—if not garish—gilding, this plate is typical of early French Japonisme. However, the use of geometric rather than naturalistic Japanese motifs was at this early period more common in British than in French interpretations of the Oriental style. The preference in France for images of birds and flowers says much about the nature of French taste. ME

200

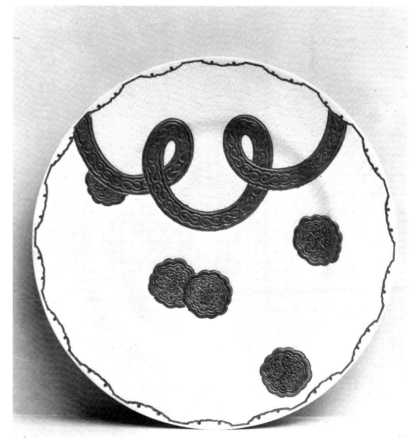

201

202

Manufacturer: Haviland and Company,
 Limoges.
Designer: Félix Bracquemond.

201 *Plate.*

Porcelain with impressed design, ca.
 1872–80.
Diam. 7-3/8 inches (18.7 cm.).
Printed in green: H & C° / L.
New York, The Metropolitan Museum of
 Art, Gift of Charles Haviland.

Were it not for Charles Haviland's testi-
mony that this plate was designed by
Bracquemond, we would be hard
pressed to name the artist, since there is
so little about it that is specifically
Western. Its overall design and its im-
pressed geometric motifs—an imitation
basket weave, stylized flowers, and a
diaper pattern—closely reflect a Japan-
ese aesthetic. ME

Haviland and Company, Paris (Auteuil).

202 *Vase.*

Stoneware with incised decoration,
 white and brown slips, heightened
 with gold, 1882–85.
H. 19 inches (48.2 cm.).
New York, The Metropolitan Museum of
 Art, Gift of George Haviland.

Chaplet, Bracquemond's successor as
artistic director of the Haviland Auteuil
studio, became interested in stoneware
while recuperating from an illness in
Normandy in 1881.[1] He subsequently
moved the studio to rue Blomet in the
Vaugirard section of Paris, where higher-
firing kilns were installed, capable of
producing this reddish-brown stoneware.
Production began in 1882 and met with
success at the *Union centrale* exhibition
of 1884 but was abruptly terminated the
following year when a financial crisis
forced Haviland to divest itself of the
studio. Albert Dammouse joined the
Haviland staff in 1882, and it has been
suggested that he was closely connected
with this line of production, presumably
because of his expertise with the use of
colored enamels. Several examples of
this ware bear his signature, including
the very first piece made at the factory—
one which was dedicated to Charles
Haviland's wife. The decoration on the
Metropolitan Museum's vase is what one
would expect from Dammouse. The prin-
cipal motifs—the dragonfly resting on
the arrowroot plant, the iris, the water
lily, and the fish humorously trying to
catch a fly—are the sort of designs bor-
rowed from Japanese prints that Dam-
mouse had employed on his porcelains.
The decorative borders, the bands of

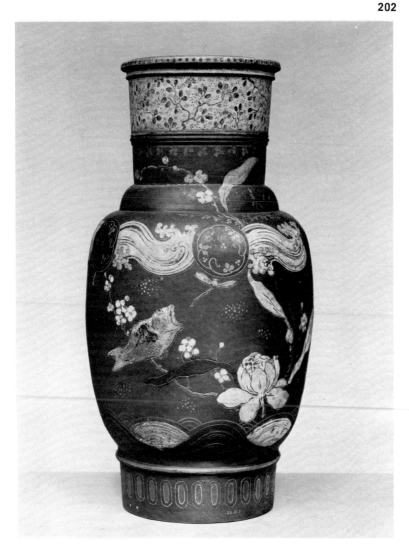

discs and waves, are equally Japanese-inspired. However, this vase is without any mark whatsoever, making it difficult to attribute the work of a specific hand. Another Haviland artist as partial as Dammouse to Japanese imagery was Albert Kalt, whose vase in the Copenhagen Kunstindustrimuseet exhibits Japanese stylized waves.² Even in those Haviland pieces in which the main motifs are decidedly non-Oriental—be they *putti*, farmers, or circus performers—the border decorations of flowering branches and stylized discs of flowers are of Japanese inspiration. ME

1. See *Französische Keramik zwichen 1850 and 1910* (Cologne, Kunstgewerbemuseum, 1974), pp. 112–19, especially nos. 46–47.
2. See *Weltkulturen und moderne Kunst* (Munich, Haus der Kunst, 1972), nos. 861, 866–69.

Manufacture Nationale de Porcelaine, Sèvres.

203 *Bowl.*

Porcelain inset with *plique-à-jour* enamel, 1872.
H. 2-15/16 inches (7.5 cm.), Diam. 7 inches (17.8 cm.).
Printed in green horizontal lozenge: S. 72. Printed in orange circle: cipher of letters RF / DECORE A SÈVRES / 72.
Limoges, Musée National Adrien-Dubouché.

The role of the Sèvres Manufactory in the history of Japonisme remains enigmatic. Because of its nationalistic, bureaucratic nature, it was inevitably a bastion of conservatism basking in glory borrowed from the eighteenth century and in its role as the promulgator of publicly acceptable taste. Nonetheless, Japonisme left its mark at Sèvres at an early date. One might have expected Marc Emmanuel Solon, the leading decorator at Sèvres, to have played an influential role in this regard. He was, after all, an original member of the Jing-lar Society, which held its monthly meetings at Sèvres. However, no traces of Japonisme can be discerned in any of Solon's oeuvre, including his work at the Minton Factory in England dating from after the outbreak of the Franco-Prussian War. Yet some decorators at Sèvres, most notably Paul Avisse, worked in the Japoniste style. Preserved in the Manufactory's archives are designs by Avisse of roosters

and hens clearly derived from Japanese prints. One also might wonder what was produced by Henri Lambert, who, while employed as a decorator at the Sèvres Manufactory, produced some important early Japoniste designs for Rousseau [see 197].

The shape of this bowl, its decorative motifs, and its *plique-à-jour* enameling are characteristic of the decorative Japonisme of the seventies. The significance of the combination of pine, bamboo, and plum branches—termed the *Sho-chiku-bai* and denoting good fortune—may have eluded the Sèvres designer, but his dependence on a Japanese prototype is readily apparent.¹ The identities of the designer and of the artisan who duplicated these difficult techniques remain unknown. Moreover, it has not been possible to locate many similar examples of Sèvres, a fact suggesting how limited they were from the outset. ME

1. See J. L. Bowes, *Japanese Pottery* (Liverpool, 1890), pp. 507–9.

203

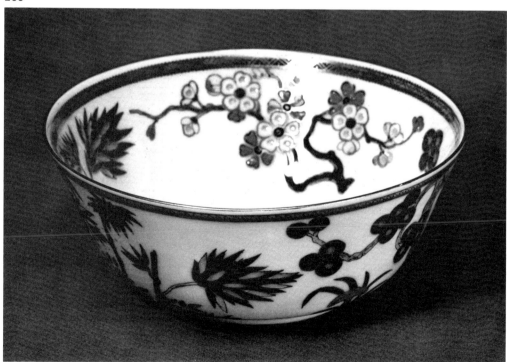

Jean Charles Cazin, 1841–1901, Fulham (London), England.

204 *Plaque.*

Stoneware with white, blue, and brown
 salt glazes, 1872.
Diam. 13-3/8 inches (34 cm.).
Incised on front side in vertical
 cartouche: CAZIN.
Sèvres, Musée National de Céramique.

Cazin was one of those French ceramists whose fame, at least until recently, was dominated by his reputation as a landscape painter. However, ceramics played an equally important part in his life.[1] He learned the art of decorating porcelain at the Sèvres Manufactory and studied at the *Ecole des arts décoratifs*. Among his friends at this time were the sculptor Dalou and the painters Legros and Fantin-Latour. Subsequently, he moved from the French capital to Tours, where he became the head of the *Ecole des Beaux-Arts* and then curator at the Museum. With the outbreak of the Franco-Prussian War he, like so many of his compatriots, fled to the safety of England. There, between 1872 and 1874, he found employment with the Fulham pottery of C. J. C. Bailey & Co., producing utilitarian and decorative stoneware. Thus it happened that some of Cazin's earliest and most important ceramics in the Japanese style, such as this plaque, were produced abroad. In 1875 the artist returned to France, settling in Equihen near Boulogne-sur-Mer. Later he and his son Michel removed to Paris, though they continued to fire their wares in the Equihen kilns during the summer months.

The Japanese character of this early design is readily apparent. Depicted are branches of a chestnut tree whose flowers are so abstracted as to render them closer to the Japanese *kiku* or chrysanthemum badge than to the botanical species they are intended to represent.[2] It is curious that though his canvases continued the gentle, relatively naturalistic tradition of Barbizon landscape painting, Cazin's ceramics are marked by a much bolder style.[3] The patterned background and the stylized clouds can be compared with the Japonisme exemplified by Falize's cloisonné pendants. Nor should one overlook the signature enclosed in a cartouche which figures so prominently in the overall design; it is clearly derived from the Japanese print tradition. ME

1. See *L'art de la poterie en France de Rodin à Dufy* (Sèvres, Musée National de Céramique, 1971), pp. 19–20; *Französische Keramik zwischen 1850 and 1910* (Cologne, Kunstgewerbemuseum, 1974), p. 206.

2. A bookbinding in tooled leather by Seguy (illus. *Art et décoration*, VII [1900], 175) would appear to be based upon this Cazin plate, but the stylization is perhaps even more thoroughly geometric; as we have suggested elsewhere, it is only after the turn of the century that this type of pattern-making really took hold in France.

3. For a painting by Cazin of these same flowers and leaves, but rendered naturalistically, see L. Bénédite, "Jean-Charles Cazin," *Art et décoration*, I (1897), opp. 172.

204

205

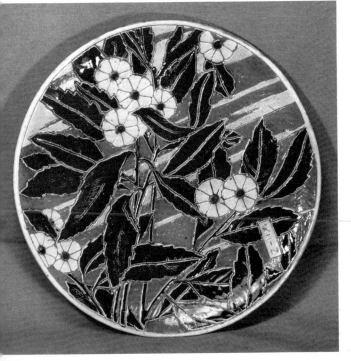

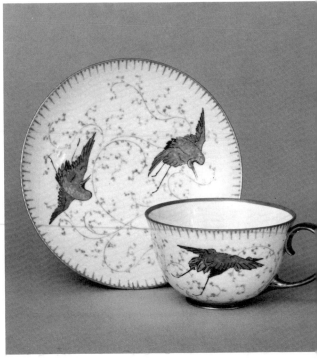

Albert-Louis Dammouse, 1848–1926, Sèvres.

205 *Cup and Saucer.*

Porcelain with green *pâte-sur-pâte* decoration and gray, black, and gold overglaze decoration, ca. 1878.

Diam. of saucer, 6-7/8 inches (17.5 cm.); Diam. of cup (without handle) 4-3/8 inches (11.1 cm.); H. 2-1/2 inches (6.3 cm.).

Painted in green: a monogram formed of the letters "AD" Sèvres and a star-shaped device.

New York, Private Collection.

Following the precedent of his father, who had trained under Barye as a sculptor before seeking employment at the Royal Manufactory at Sèvres, Dammouse began as a sculptor and then turned to porcelain. Previously he had won at the 1869 exhibition of the *Union centrale* a grand prize for decorative composition and had worked on the decorative sculpture of the Pavillon de Flore of the Louvre. Under Solon at Sèvres he studied the technique of *pâte-sur-pâte,* but with the outbreak of the Franco-Prussian War his master departed for England. Beginning in 1871 Dammouse worked independently in porcelain at Sèvres, encountering grave difficulties; not being attached to the Manufactory, he could not avail himself of its services and was obliged to import from Limoges some of his materials, which he decorated and then returned to Limoges for firing. He participated in the *Union centrale* exhibitions of 1874 and 1876, winning gold medals and a *prix d'honneur.*

Dammouse's reputation was firmly established by his display at the 1878 World's Fair and by his work for the Limoges firm of Pouyat et Dubreuil. Though beaux-arts renaissance decoration is encountered in Dammouse's earliest porcelains, the Japanese elements predominate.[1] Like many of his contemporaries, he exploited the animal and plant motifs found in the Hokusai and Hiroshige print albums; certainly the witty and angularly contorted cranes of this cup and saucer betray their Japanese origin. It was this fresh vision of the lively gestures of wildlife that the early Japonistes appreciated in Far Eastern art. Parallels in the art of Japan can also be found for the rinceau pattern of the background delicately rendered in *pâte-sur-pâte.*[2] A coffee service of similar, though not identical, form and decoration was exhibited by Dammouse at the 1874 *Union centrale*[3]. ME

1. For a resumé of Dammouse's early career, see E. Garnier, "Albert Dammouse," *Art et décoration,* VI (1899), 97–105; see also *Französische Keramik zwischen 1850 und 1910* (Cologne, Kunstgewerbemuseum, 1974), pp. 166–68.

2. T. W. Cutler, *A Grammar of Japanese Ornament and Design* (London, 1880), pp. 49, 58.

3. A photograph of his 1874 work is in the library of the Musée des Arts Décoratifs, Paris (illus. G. Weisberg, "Japonisme in French Ceramic Decoration," *Connoisseur,* CLXXXIV [1973], 128); many of Dammouse's original drawings are in the same library.

Albert Louis Dammouse, Sèvres.

206 *Vase.*

Porcelain with *pâte-sur-pâte* and overglaze decoration, primarily white, green, brown, and gold, ca. 1875–80.

H. 7-1/4 inches (18.4 cm.).

Impressed: A.D. Incised: Sèvres and device of a star.

New York, Private Collection.

Here, too, Japanese influence is apparent not only in the plants, flying swallows, and decoratively breaking waves but also in the geometric patterns at the bottom and top and the chrysanthemum designs encircling the middle of the piece. Although Dammouse is known to have copied Japanese prints, it would appear that he imitated Japanese ceramics as well. For example, the cresting wave whose spray is delicately rendered in *pâte-sur-pâte* can be compared with Oriental prototypes.[1] The juxtaposition of the large, tranquil plants with the diminutive ocean waves may appear arbitrary, but similar associations appear in Japanese pottery. ME

1. See, for example, George A. Audsley and James L. Bowes, *Keramic Art of Japan* (Liverpool and London, 1875), pl. XLVII, 1 and 4.

206

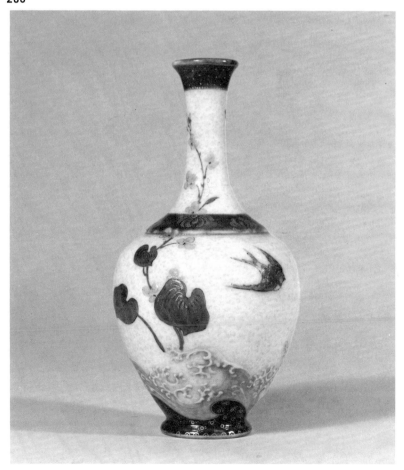

Camille Moreau, 1840–1897, Paris and
Bourg-la-Reine.

207 *Plate.*
Faience with decoration in barbotine,
1876.
Diam. 17-3/8 inches (44 cm.).
Painted in black on reverse: C^lle Moreau
— 1876 — ; on obverse: C^lle M 76.
Germany, Marxen am Berge, Maria and
Hans-Jorgen Heuser.

Camille Moreau, like many nineteenth-
century decorative artists, trained initially
as a painter[1] and was essentially an ani-
malier. So fascinated was she by the
Bracquemond-Rousseau service exhibited
at the 1867 Exposition that she was in-
spired to create her own dinner service,
a task accomplished over the next dec-
ade. In preparation, she bought porcelain
blanks and Japanese print albums con-
taining images which she directly ap-
propriated. She further advanced her
technical knowledge by studying with
the minor potters Bouquet and Edièvre
and then with the prominent Japonistes
Théodore Deck and Laurent Bouvier. Of
these, the last had probably the most pro-
found influence upon her work. In fact,
her husband purchased the first ceramic
that Bouvier ever sold, which, ironically,
was in the Persian rather than the Japan-
ese style.[2] Bouvier provided her with
technical advice and artistic stimulation,
as is evident in the similarities of some
of their decorative motifs such as the
dotted background patterns. She worked
at home and never established her own
kiln, using instead the Laurins' factory at
Bourg-la-Reine. The boldly painted de-
sign of flowers and squashes on this plate
could have been inspired by one of the
many *ukiyo-e* prints in her possession;
for example, it could be compared to a
print by Sadahide in the *Bansho Shashin
Zufu,* a two-volume album issued the
previous decade which she owned
[207a]. Though much of her work was
in the Japanese style, one must not over-
look the frequent references to Chinese
and Medieval art in her oeuvre as well.
ME

1. For the artist's biography and cata-
logue raisonné, see Etienne Moreau-
Nélaton (her son), *Camille Moreau,
peintre et céramiste, 1840–1897,* 2 vols.
(Paris, 1899); this plate appears on pl. XX,
no. E. See also G. Weisberg, "Japonisme
in French Ceramic Decoration, II," *The
Connoisseur,* CLXXXIV (1973), 125–27.

2. E. Moreau-Nélaton, "Un précurseur:
Laurent Bouvier," *Art et décoration,* IX
(1901), 171. The artist's family still pos-
sesses a number of major Bouvier ce-
ramics in the Japanese mode.

207a

208a

207

208

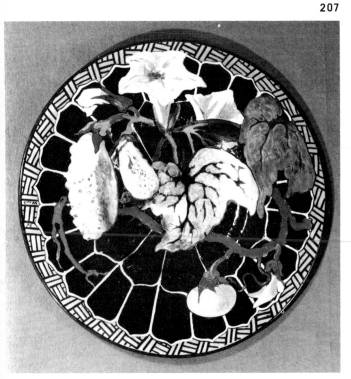

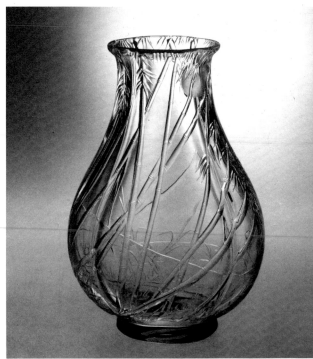

La Manufacture de Baccarat.

208 *Vase.*

Engraved crystal, ca. 1870–78.
H. 11-7/16 inches (29 cm.).
Acid-etched stencil (added later):
 Baccarat France in a circle enclosing
 emblems of a stemmed glass, a carafe,
 and a tumbler.
Paris, Cie. des Cristalleries de Baccarat,
 and New York, Baccarat, Inc.

The celebrated name of Baccarat seldom
appears in considerations of French glass
of the last third of the nineteenth cen-
tury. Yet in the period being examined,
the 1870's, when Japonisme first affected
glass and when Rousseau and Gallé had
barely begun their ventures in this me-
dium, Baccarat already held a position of
preeminence comparable to that of
Christofle in metalware and Deck in
ceramics. Unfortunately, all too little is
known of the Baccarat atelier and of the
designers responsible for the introduc-
tion of Japonisme. By the 1878 Exposi-
tion, however, it was a fully developed
phenomenon, as is evidenced in this
model exhibited at the time.[1] Readily
apparent is the manner in which the
company adapted its high standard of
crystal engraving to the new mania for
things Japanese. Nothing could be more
Japanese than this scene of Mt. Fujiyama
viewed through a bamboo grove with a
pair of storks looking at the moon over-
head. The imagery, rather than being a
generalized statement of orientalia, is
taken quite literally from a Hokusai *Hun-
dred Views of Mount Fuji* [208a] except
for the storks, which are apparently bor-
rowed from another print.[2] Baccarat also
produced a considerable amount of
glassware enameled with Japanese motifs
such as long-tailed turtles, cranes, and
carp which are borrowed from the
Manga. It should also be noted that the
forms of the vessels and their ormolu
mounts reveal an awareness of Japanese
objets d'art, though the taste governing
their production shows a tendency to-
wards elaborateness that might be ex-
pected of the time. ME

1. See, for example, A. R. de Liesville,
"La verrerie au champs du Mars," *Ga-
zette des Beaux-Arts,* s.2, XVIII (1878),
696–98, 701. The company's museum in
Paris has a series of photographic albums
which record the strong impact that
Japonisme had on this firm's work. There
were at least three closely related ver-
sions of this model, and it is not certain
which was at the World's Fair. In addi-
tion to this vase, there is one in the Bac-
carat Museum in Paris which has small
handles at either side; a third with an

ormolu mounting is recorded in a photo-
graph in the company's albums, vol. VI,
no. 5848.

2. The storks appear by themselves on
another of the 1878 World's Fair vases;
see De Liesville, p. 701. Similarly, posed
birds appear in other Hokusai prints,
especially one in the *Manga* (vol. 4).

Producer: Eugène Rousseau, Paris.
Manufacturer: Appert Frères, Clichy.

209 *Vase.*

Glass, blue and topaz, engraved and
 enameled, ca. 1875–80.
H. 6-3/4 inches (17.1 cm.).
Etched: E Rousseau / Paris.
New York, Lillian Nassau, Ltd.

Rousseau apparently became interested
in glass about the time of the 1867
World's Fair, but at first he made only
designs for glass models—perhaps for
drinking glasses.[1] At some time in the
1870's, he entered into a "close partner-
ship" with Appert Frères at Clichy and
began production of glass on a more
consistent and direct basis. The vases he
exhibited at the 1878 World's Fair are the
first recorded examples we have from his

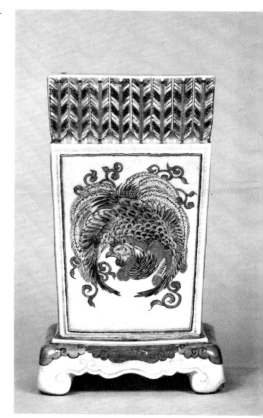

209a

209

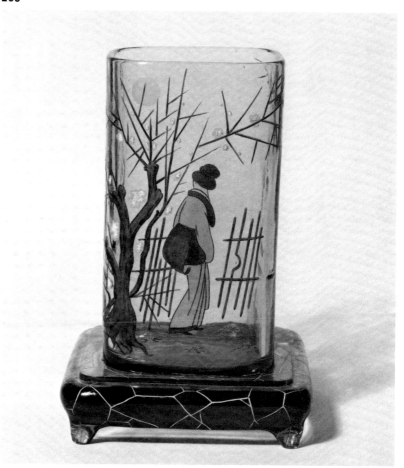

firm; like our vase, they are both enameled and engraved, and their decor is totally Japanese.[2] The imagery on our vase of a kimono-clad woman standing under a flowering plum tree must have appealed to the readers of *Madame Chrysanthemum*. The geometric shapes of the rectangular vessel and the squat base must have seemed equally exotic to French eyes. Although Rousseau has joined the two parts together, there is precedence for this in Japanese art, as is shown by a Satsuma vase in the collection of the Walters Art Gallery which is not only similarly shaped, but has been fabricated as a single piece [209a]. ME

1. See A. Polak, *Modern Glass* (New York, 1962), pp. 21–23; *Glassammlung Hentrich, Jugendstil und 20er Jahre*, ed. H. Hilschenz (Düsseldorf, Kunstmuseum, 1973), pp. 342–44.

2. One vase with bamboo decoration is in the Musée des Arts Décoratifs, Paris (illus. Polak, fig. 3), and others with fish are in the Bethnal Green Museum (inv. nos. 673. and 674.1878) and the Victoria and Albert Museum, London.

Orfèvrerie de Christofle, Saint-Denis. Designer: Emile A. Reiber, 1829–1893.

210 *Gaming Jeton.*
Cloisonné enamel on both surfaces, 1868.
13/16 x 2-3/8 inches (2 x 6 cm.).
The letter "C" for Christofle is incorporated into the design on the reverse of the *jeton*.
Saint-Denis, Orfèvrerie Christofle Bouilhet & Cie.

Under the direction of Henri Bouilhet, nephew of Charles Christofle (the founder of the firm), Orfèvrerie de Christofle pioneered in the exploration of Japonisme in French metalwork. Even before the World's Fair of 1867 they had begun to experiment with cloisonné enamel—a technique which had fallen into disuse in Europe save for occasional liturgical objects made in imitation of medieval work. Credit for its reintroduction must be given to Emile A. Reiber, the firm's chief designer, and to the technician Tard. That they were inspired by Near and Far Eastern examples is evident not only in the execution but also in the equally imitative designs on the pieces they made.[1] Their first works were hybrid in style, though Reiber's became more explicitly Japanese after the revela-

tion of the Japanese display at the 1867 Exposition, which included twenty examples of cloisonné enamel. This *jeton* and others with equally Japanese imagery of plum branches and ducks belong to a series that is regarded as containing some of the earliest examples in the genre. Preserved in the Musée Bouilhet-Christofle is a drawing for the box that contained these *Jetons*. The drawing is signed by Reiber and dated January 25, 1868. WRJ

1. Examples were purchased by the South Kensington Museum and are now at the Bethnal Green Museum; particularly relevant is a covered bowl, inv. no. 725-1869.

210

211

210a

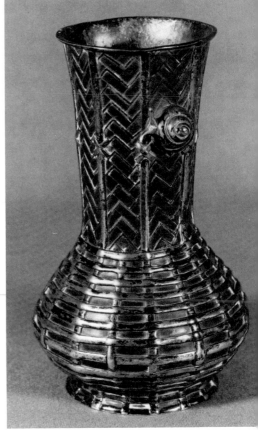

Orfèvrerie de Christofle, Saint-Denis.

211 *Vase.*

Silver-plated with gold and oxidized
 ornamentation, 1875–80.
H. 6-1/2 inches (16.5 cm.).
Marked on base: 918 415.
Saint-Denis, Orfèvrerie Christofle
 Bouilhet & Cie.

The Japanese craftsman's microcosmic
interpretation of nature was readily ad-
mired and adopted in France. Likewise,
the drollery of interpreting one medium
in another was appreciated and easily
copied. Under the direction of Henri
Bouilhet in the 1870's Christofle pro-
duced metalwares based directly on
Japanese formulas, such as this vase with
its snails encircling a wicker vessel, all
rendered in silver-plate. Not only are
such imitation wicker-work vases with
animals common among Japanese
bronzes [300], but also we should recall
what was perhaps the most celebrated
artifact in Louis Gonse's collection, a
seventeenth-century Japanese bouquet
holder in bronze simulating wicker,
adorned with a crab in red lacquer.[1]
WRJ

1. Louis Gonse, *L'art japonais*, I (Paris,
1883), frontispiece.

Alexis Falize, 1811–1898.

212 *Necklace and a Pair of Earring
 Pendants.*

Cloisonné enamels set in gold, 1867–68.
Diam. of necklace band, 6-3/8 inches, or
 16.2 cm. (external), 4-1/8 inches, or
 10.5 cm. (internal); Diam. of largest
 pendant of necklace, 1-1/4 inches (3.1
 cm.); Diam. of earring pendants, 1
 inch (2.5 cm.).
Marked A F within a diamond lozenge.
 Stamped: Eagle's head gold warranty
 mark.
Oxford, Visitors of the Ashmolean
 Museum.

The prominent jeweler Alexis Falize and
his son Lucien (1839–1897) have the dis-
tinction of being the first to employ the
Japanese technique of cloisonné enamels
in jewelry.[1] They became enthusiasts of
Japanese art after seeing Sir Rutherford
Alcock's collection in London in 1862,
and their admiration was sparked again
by Christofle's enamels at the Paris Ex-
position. In fact, their experiments in this
genre were undertaken in collaboration
with Tard, an enameler who worked for
Christofle. The Falizes' first works were
naturally fraught with difficulties, particu-
larly since they exchanged the traditional
copper cloisons for those of gold and had
to manipulate them into very fine pat-

terns, but success was quickly achieved,
as can be seen in the Falize jewelry illus-
trated in Philippe Burty's *Les émaux
cloisonnés anciens et modernes* (Paris,
1868).[2] In fact, these exquisite earrings
and necklace probably date from that
very time. According to Miss M. D.
Legge, sister of the donatrix, they were
bought in Paris in 1867 [*sic*] from Alexis
Falize by Henry F. Makin for his wife
(daughter of a well-known London jew-
eler).[3] Contradicting Miss Legge's testi-
mony is Lucien Falize's own history,
written closer to the time in question and
indicating that the artist did not begin to
make cloisonné jewelry until 1868; re-
gardless of this discrepancy these pieces
must have been among Falize's earliest
work of this nature.[4] The individual
medallions are imitative of Japanese art
in both design and technique. Lucien
Falize admitted to having freely copied
and traced images found in the Japanese
print albums that he either borrowed
from E. Rousseau and P. Burty or bought
from Mme. Desoye. As a result the West-
ern origin is barely discernible in his
jewelry. ME

1. Henri Vever, in *La bijouterie française
au XIXe siècle*, III (Paris), 492, attributed
the introduction of Japonisme into the
firm's production to the son, Lucien,
rather than to the father. Lucien worked
for his father until 1871. See also Lucien
Falize, "L'art japonais," *Revue des arts
décoratifs*, III (1882–83), 329–38, 353–63.

2. The black and white decorative motifs
based on Japanese prints interspersed in
this book are by Félix Regamey, the son
of the illustrator. Included is an adver-
tisement for the jewelry store of M.
Martz, who was also the distributor of
the book.

3. Letter from Miss Legge to the Mu-
seum. Mrs. Makin was the daughter of
John Hunt of Hunt and Roskell, the firm
that made a cloisonné bracelet to accom-
pany the earrings and necklace.

4. See D. J. Janson, *From Slave to Siren*
(Durham, N. C., 1971), no. 76.

212

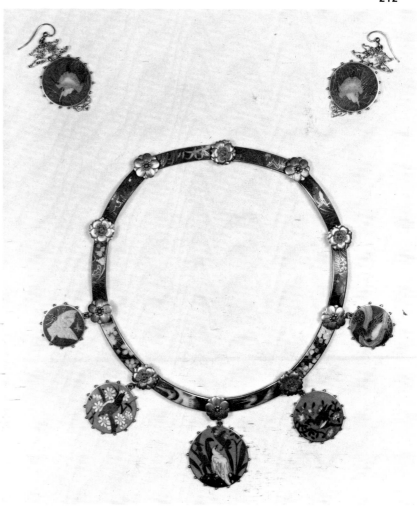

Barbedienne et Cie., Paris.

213 *Covered Vessel.*

Ostrich egg in bronze mounts, parcel gilt, applied lacquer and ivory, before 1872.

H. 8-7/8 inches (22.7 cm.), Diam. 6-1/8 inches (15.5 cm.).

Signed: F. BARBEDIENNE.

London, The Bethnal Green Museum.

Barbedienne et Cie., founded by Ferdinand Barbedienne and Achille Collas in 1839, originally specialized in bronze replicas of antique and, later, renaissance and modern statuary. About 1867 the firm established a laboratory to study the adaptation of Oriental processes to Western production.[1]

Ostrich eggs such as this one, decorated with lacquers and other encrustations, were occasionally exported by Japan in the nineteenth century (a lacquered ostrich egg mounted in silver is preserved in the Walters Art Gallery, Baltimore). This egg was purchased at the International Exhibition, South Kensington, London, 1872. The mounts, including the elephant-head handles and the feet based on cloud motifs, are more closely related to Chinese than to Japanese prototypes and suggest the less than precise understanding of Oriental styles that typifies early Japonisme. WRJ

1. Theodore Child, "Ferdinand Barbedienne," *Harper's New Monthly Magazine,* September, 1886, p. 503.

Manufacturer: Barbedienne et Cie., Paris.
Designer: Fernand Thesmar, 1843–1912.

214 *Tray.*

Cloisonné enamel and gilt bronze, ca. 1875.

Diam. including handles, 17-1/4 inches (43.8 cm.).

Signed in enamel: "Paris" and intertwined Barbedienne and Thesmar monograms.

Baltimore, The Walters Art Gallery.

The laboratory of Barbedienne et Cie. experimented with the production of enamel vases decorated with Islamic and Far Eastern motifs. Among its developments was *cloisonné sur fonte,* a process involving the casting in place rather than the application of the cloisons; this method was usually reserved for large works.

Fernand Thesmar was a painter of flowers before being employed at Barbedienne et Cie., where he succeeded Tard as head of the enamel division. The Thesmar-Barbedienne products usually reflected an interest in the techniques and general scheme of decoration of Japanese enamel. However, Oriental design was seldom directly copied, at least not according to contemporary critics.[1] In this instance the plants—liles, rhododendron, and buttercups—might seem to be of European origin, but similar floral species and insects appear throughout the *Manga* and other *ukiyo*-e prints.

Likewise, the seemingly classical gilt-bronze mounting so characteristic of Barbedienne has a Japanese variant on the universal meander pattern.[2] Thesmar was criticized by L. Falize for suppressing the cloisons and for his failure to exploit the distinctive features of the enamel medium.[3] WRJ

1. Theodore Child, "Ferdinand Barbedienne," *Harper's New Monthly Magazine,* September, 1886, p. 503.

2. For a differentiation between Eastern and Western types, see G. Audsley and J. Bowes, *Keramic Art of Japan,* 2 vols. (London and Liverpool, 1875), I, v.

3. L. Falize, "Les bronzes au Champs de Mars," *Gazette des Beaux-Arts,* September, 1878, p. 618.

213

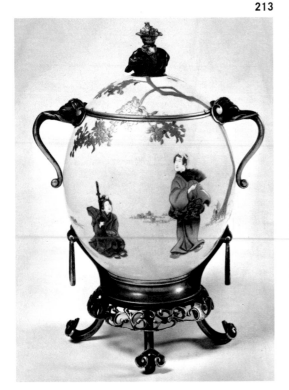

214

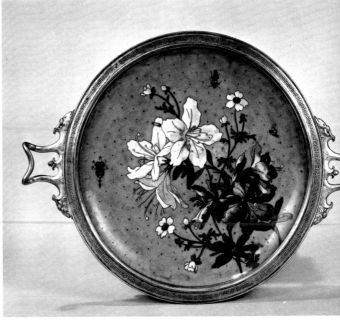

Alphonse Giroux, Paris.

215 *Clock.*

Polished steel, ivory, mixed woods, and metals, 1870's.

H. 13-5/8 inches (34.6 cm.).

Incised on ivory marquetry of base a cipher of the letters "DF," B^té [Breveté].

Paris, Collection Comoglio.

This clock belongs to a *garniture de cheminée* that includes a pair of candelabra shaped like roosters holding in their beaks scrolls supporting candleholders. One of the candelabra bears the identifying stamp: "ALPH GIROUX PARIS." The clock itself is in the form of a rooster carrying on its back a drum containing the clock movement and standing on a platform supported by four turtles. As a mélange of Oriental motifs combined without regard for their symbolic significance, the clock is characteristic of the early Japonisme of the 1870's. The *coq* and temple drum are a common subject in Japanese art, though invariably the bird is shown standing on the drum as in Hokusai's *Ehon Tei-kun Orai* or—even more apropos—the silver version in the Walters Art Gallery [299]. This motif is an allusion to an ancient Chinese legend in which the drum, used in an emergency to summon warriors, is forgotten and allowed to fall from its position on the palace portal to the ground, where it becomes a perch for the nearby birds.[1]

The firm of Alphonse Giroux et Cie. was founded by François-Simon-Alphonse Giroux at 7, rue du Coq-Saint-Honoré, during the consulate and remained active under the direction of two sons, Alphonse-Gustave and André, until the end of the Second Empire ME WRJ

1. V. W. Weber, *Ko-Ji Hoh-Ten*, I (Paris, 1925), 126.

Ernest Gaillard, 1836—retired 1892.

216 *Pair of Bud Vases.*

Silverplate, 1870's.

H. 3-3/4 inches (9.5 cm.).

Impressed: E GAILLARD FILS / indecipherable hallmark / Paris.

New York, Private Collection.

In 1860 Ernest Gaillard assumed control of the famous jewelry house established by his grandfather, Auguste Gaillard, and abandoned the manufacture of copper-gilt jewelry for work in silver. Henri Vever alluded to the phials, candy dishes, cardholders, cigarette holders, etc., produced by the firm in the Japanese style in the 1870's.[1]

These vases reveal, on the one hand, an undercurrent of naturalism in the 1870's and, on the other, the contemporary emergence of Japonisme in French silversmithing. The vase in the form of a bamboo shoot repeats a familiar Japanese motif;[2] its companion, in the form of a tree trunk and bearing a lizard stalking a fly, is equally in keeping with the Japanese microcosmic approach to nature, although its motifs are also to be found on a beer stein, quite Western in character, made by the progressive silversmiths Fannière Frères for Napoleon III.[3] WRJ

1. Henri Vever, *La bijouterie française*, III (Paris, 1908), 628.

2. Illustrated, for example, in Louis Gonse, *L'art japonais*, I (Paris, 1883), 110, 127.

3. Henri Bouilhet, "L'Orfèvrerie française, III (Paris, 1912), 67.

215

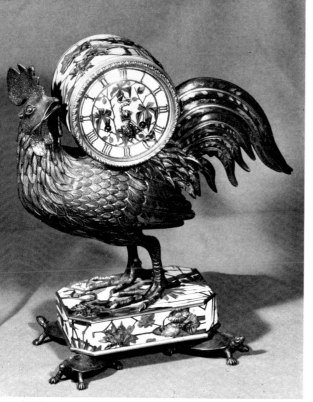

216

Joseph-Théodore Deck, 1823–1891,
Paris.

217 *Plaque.*

Glazed faience, primarily purple, green,
brown, and blue, ca. 1875–85.
Diam. 16-1/4 inches (41.3 cm.).
Impressed: TH (conjoined) DECK.
New York, Private Collection.

The figure of Théodore Deck looms as
one of the most important in the ceramic
art of France between 1850 and 1880.[1]
He was born in Alsace and thus spent
much of his youth wandering and study-
ing in Germanic lands. He arrived in Paris
by 1847 and, after a brief interruption
caused by the Revolution, established his
own kilns in the French capital. From the
beginning Deck was concerned with the
production of artistic pottery and a-
dopted the mid-nineteenth-century
conception of having professional artists
(i.e., painters) and ceramists work to-
gether in his studio. Thus, among the
characteristic products of the factory are
the large plaques painted by "visiting"
artists. Deck also produced a great variety
of vases and plaques couched in historic
revival styles—especially the Islamic,
Chinese, and Japanese modes which
predominated in the 1860's and 1870's.

E. A. Reiber, one of the first Japonistes,
is known to have designed for Deck as
well as for Christofle. This plaque typi-
fies Deck's Orientalism. Although the
background pattern and the celadon and
turquoise glazes seem Chinese, the
rooster and hen are clearly Japanese in
origin. Similar images of a rooster with
head turned and a hen bending down
to feed can be found in Japanese *ukiyo-e*
prints and paintings.[2] Such birds, for
example, appear side by side on a page
in the fourth volume of Hokusai's
Manga. As is the case in his use of other
historical styles, Deck's Oriental work
often has a solid basis in specific sources.
One need only recall that Burty remem-
bered seeing Deck examining some of
the designs Adalbert de Beaumont had
brought back from his travels to the
Orient.[3] ME

1. See *Französische Keramik zwischen
1850 und 1910* (Cologne, Kunstgewerbe-
museum, 1974), pp. 68–87.
2. See also the Hokusai prints illus.
Weltkulturen und moderne Kunst
(Munich, Haus der Kunst, 1972), p. 188,
and *Artistic Japan,* IV (1889–90), 268.
3. P. Burty, "Félix Bracquemond," *L'Art,*
XII, 1878, 296.

Joseph-Théodore Deck, Paris.

218 *Tile Panel.*

Painted faience.
10 x 15 inches (25.4 x 38.1 cm.).
Painted on face: TH. (conjoined) DECK.
Philadelphia Museum of Art, Gift of
Lillian Nassau.

This tile panel shows the almost predict-
able repertoire of motifs used by Japon-
istes—gracefully drooping wisteria
branches laden with blossoms (the wiste-
ria had just recently been introduced
from Japan into Europe), arrowroot
plants, water lilies, ducks, and butterflies
—in short, those images that were so
eagerly culled by Europeans from Japan-
ese prints. A pendant set of tiles in the
Philadelphia Museum reflects a similar
bias—water lilies, iris, flowering cherry
blossoms, and a swimming duck. In our
panel, specific Japanese iconography is
evident in the two mandarin ducks; they
represent marital bliss and in Japanese
art are inevitably shown together as a pair.[1]
Deck's designer may have been aware of
this significance and thus amplified it by
pairing the butterflies as well. ME

1. See, for example, J. L. Bowes, *Japanese
Pottery* (Liverpool, 1890), p. 506.

218

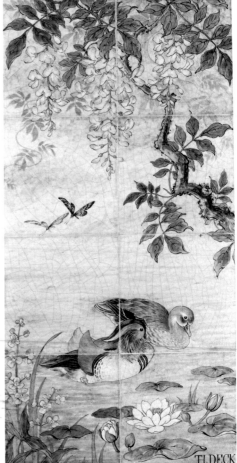

217

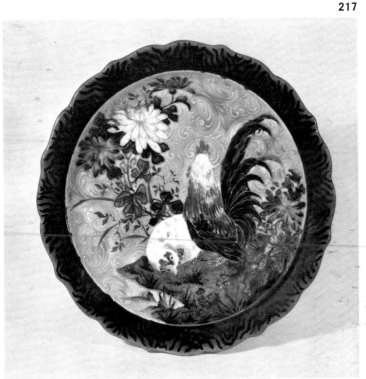

Emile Gallé, 1846–1904, Nancy.

219 *Vase.*

Faience with painted decoration primarily in blue, black, orange, and white with gilt overglaze, ca. 1875–85.
H. 15-3/4 inches (40 cm.).
Painted in black: E, device of cross of Lorraine, G / déposé / 3.
New York, Carol Ferranti Antiques, Ltd.

Whereas Gallé's name is inevitably associated with glass, it should be remembered that he was, particularly in his early career, concerned even more with ceramics.[1] The young Gallé's studies took him to Weimar, Meisenthal, London, and Paris. We know that he was designing faience for his father's firm by 1870 and that by 1874 he had opened his own workshop in Nancy, together with his father and some of the workers from the senior Gallé's factory. By the time of the 1878 World's Fair, when he first exhibited under his own name, he had already begun to establish a reputation. As was the case with most artists of his generation, Gallé's earliest work was rooted in historical styles. The Rococo predominated not only because Nancy had been an artistic center in the eighteenth century but also because this was a vogue in Paris and throughout the whole of the country. Gallé also favored medieval and renaissance styles. To these must be added his interest in Japanese art; some critics have attributed this interest to Gallé's meeting with a Japanese horticultural student in Nancy in 1885, but it

is certain that Gallé knew and was interested in Japanese art much earlier. He had represented his father's firm at the London World's Fair of 1862 when Alcock's collection of Japanese art was shown and, of course, he was very much aware of what was occurring in Paris. He evidently had access to Japanese print albums at an early date, since one of the glass vases he exhibited at the World's Fair of 1878 is based directly upon a print in the *Manga.* Despite our current notions about the sobriety of Japanese ceramic arts, the complex and highly decorative nature of Gallé's vase is in accord with the general European sense in the 1870's of what Japanese pottery represented; it should be compared, for example, with the illustrations in Audsley's and Bowes' *Keramic Art of Japan,* 1875. The sections of changing geometric patterns; the preference for combinations of strong colors such as orange, black, and silver; and the abundant gilding are indicative of how Japonisme emerged out of and in accord with mid-nineteenth-century aesthetic values.
ME

1. For a discussion of Gallé's ceramics, see Helga Hofmann, ''Gallé avant Gallé,'' *Festchrift Luitpold Dussler* (Munich, 1972), pp. 433–56.

Emile Gallé, Nancy.

220 *Vase.*

Painted faience, ca. 1875–85.
H. 11-1/2 inches (29.2 cm.).
Printed: E. Gallé / Nancy / E, device of cross of Lorraine, G / déposé.
Paris, Private Collection.

Using today's aesthetic standards, we might be tempted to dismiss Japoniste objects such as this vase shaped like a folding fan as mere *Japonaiserie,* that is, as a product of a superficial fascination with Japan. Certainly we must grant that the shape and elaborate decoration of this object is in keeping with late Second Empire aesthetics, but we must not think of it as lacking a basis in Japanese art. Many of the Japanese ceramics which came to Europe at this time were as elaborate and as fancifully shaped as this fan.[1] In fact, the style of the central medallion with its scene of fowl and flowers is clearly an imitation of the style of decoration found on Eastern enameled porcelain rather than in *ukiyo-e* prints and suggests the firsthand knowledge that Gallé and his workers must have had of such Japanese objects. The geometric designs and the way in which they overlap are equally Japanese. There are certain Western elements as well. In the central scene a hen on a trellis waits while two cocks below fight for her; above and to the right is written, ''Une poule survint . . . voilà la guerre allumée'' (a hen suddenly arrives . . . thus war is ignited). Gallé may be alluding to

219

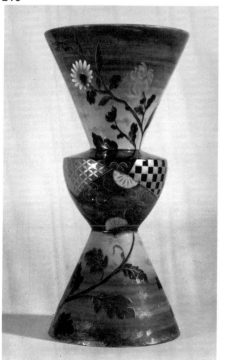

220

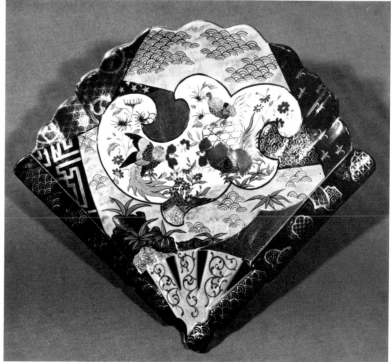

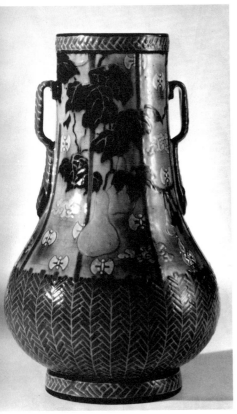

the eternal battle of two men over a woman; however, the presence of the fleur-de-lys in the upper-right corner also suggests a reference to the recent Franco-Prussian War, which resulted in the loss of France's eastern territories—a disaster sorely felt in all of France, but especially in Lorraine.[2] ME

1. See G. Audsley and J. Bowes, *Keramic Art of Japan,* 2 vols. (London and Liverpool, 1875), I, LIV, 30, 31; II, pl. XVII-3c.

2. For example, pins were made with the upper right corner missing to symbolize the loss of eastern territory; see H. Vever, *La bijouterie française au XIX siècle,* III (Paris, 1908) 346–49, and especially the pin illustrated on p. 346 which shows the upper-right corner of France symbolically broken off.

Camille Moreau, Paris and Bourg-la-Reine.

221 *Vase.*

Faience with barbotine decoration, 1883.
H. 12-7/8 inches (32.7 cm.).
Painted in black on reverse: "C^lle. Moreau 1883". Painted under handle: monogram "CMC 83."
221 Germany, Marxen am Berge, Maria and Hans-Jörgen Heuser.

222 The pendant gourds and the imitation of woven straw are motifs which appear throughout Japanese art. Unlike Moreau's previously discussed plaque which is essentially a neutral surface for a painting, this type of footed vase with ringed handles is of a form occurring in Japanese ceramics and metalwork, thus serving as a reminder that the artist was influenced by Oriental artifacts as well as prints. Similar forms and decoration occur in Christofle's production exhibited at the 1878 World's Fair.[1] Interestingly, this Moreau vase was originally owned by Mme. Christofle, thus raising the question of the complicated interactions between the French Japonistes.[2] ME

1. "L'orfèvrerie et la bijouterie au Champs de Mars," *Gazette des Beaux-Arts,* s.2, XVIII (1878), 229–30.

2. It has recently been noted that Mme. Christofle painted a still life picturing a similarly shaped vase of enameled glass set in a bronze mounting which, like Moreau's vase, imitates straw *(Französische Keramic zwischen 1850 und 1910* [Cologne, Kunstgewerbemuseum, 1974], p. 91, no. 28). Since it is unlikely that the vase was Japanese, one wonders whether the combined vase and mount were not another example of French Japoniste fabrication.

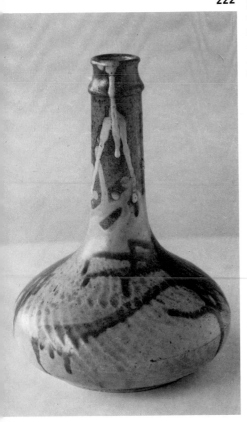

Jean-Joseph-Marie Carriès, 1855–1894, St. Amand-en-Puisaye or Château Montriveau.

222 *Vase.*

Stoneware with mat glazes, ca. 1889–94.
H. 8-1/2 inches (21.6 cm.).
Incised: Jean Carriès.
Paris, Alain Lesieutre.

Jean Carriès played a crucial role in the evolution of Japoniste ceramics, although the greater part of his career was spent as a sculptor rather than as a ceramist.[1] At nineteen he left his native Lyons for Paris, where he worked initially in bronze, exploring the coloristic potentials of its patination. In 1888, during an important exhibition of his work, he considered the possibilities offered by richly glazed ceramic sculpture. Above all, he recalled the soft mat glazes that he had seen a decade earlier on the Japanese pottery exhibited at the 1878 World's Fair. He thereupon went to Nièvre, where there was a long-standing local tradition of stoneware, and settled first in Cosne, then in Saint-Amand-en-Puisaye, and finally in Château Montriveau. Enamored of his new materials, he created vases whose shapes and glazes reveal his indebtedness to Japan more clearly than does his sculpture. His exhibitions at the 1889 World's Fair and the 1892 Salon des Beaux-Arts revealed what he had achieved in so short a time. Many years later, in 1921, the famous critic Arsène Alexandre wrote some reminiscences about Carriès which are quite apropos to our study: "I see again the artistic 'hive' on the Arago Boulevard where Jean Carriès pursued his first pottery experiments and became so excited at the sight of a little, grayish tea pot from Seto, a marvel of discretion and harmony, [and] that a little time afterward he in his turn created an art which was entirely different and nonetheless fraternal; and we other Frenchmen have the right to say equally, perhaps even more forcefully, an art which at the same time is refined and robust, sober and sumptuous."[2] Alexandre then relates how Carriès was continually inspired by the collection of Japanese pottery owned by his friend and disciple, Paul Jeanneney: "Carriès loved to come to his house [Jeanneney's] to examine with his eye and his hand the magnificent collections of Far Eastern ceramics. He was proud to see on the shelves his works rival those with the most fatty celadon glazes."[3].

Despite Alexandre's references to flambé and celadon glazes, Carriès was evidently more attracted to the handier aspects of Japanese stoneware. The var-

ious glazes on this vase are typical. They have been freely and vigorously applied but with a certain amount of control, so that their running creates a striking set of colored configurations that parallel the vigor and "natural" quality of Japanese prototypes. We see here how in just a few years Carriès surpassed Chaplet's first essays in this genre. Through his many disciples at Saint-Amand, Carriès established this type of Oriental pottery as one of the basic mainstays of modern French ceramics. This particular vase belonged to his close friend and disciple, Georges Hoentschel. ME

1. For Carriès and his school, see St. Amand en Puisaye, *400 ans de poterie en Puisaye* (1969), nos. 125–62; this vase appears as no. 126. See also *L'art de la poterie en France de Rodin à Dufy* (Sèvres, Musée national de céramique, 1971), pp. 17–18.

2. Sale, Paris, Hôtel Drouot, June 28–29, 1921, Collection Paul Jeanneny, p. 6.

3. *Ibid*, p. 8.

Jean-Joseph-Marie Carriès, St. Amand-en-Puisaye or Château Montriveau.

223 *Vase.*

Stoneware with mat glazes, ca. 1889–94.
H. 7-7/8 inches (20 cm.).
Paris, Alain Lesieutre.

Carriès was an early admirer of the [302] bolder qualities of Japanese pottery and proceeded to emulate them in his own work. His glazes pulled irregularly to create deep fissures which he sometimes heightened with gold. Carriès' forms were generally gourd shapes or long-necked vases, though he occasionally created vessels such as this one with its slightly distended walls and pronounced throwing marks, suggesting analogies to Japanese water containers. Apart from their significance in Carriès' oeuvre, these developments were significant for twentieth-century pottery in general. However, it was not until after World War II, when the West once more turned to the East for inspiration, that such robust forms were again so willingly embraced. ME

Auguste Delaherche, 1857–1931, Paris.

224 *Vase.*

Stoneware with mustard-green glossy glazes and blue, pink, and ochre mat glazes, 1887–94.
H. 17-1/4 inches (43.8 cm.).
Impressed in circular cachet: AUGUSTE DELAHERCHE 3914.
New York, Private Collection.

Between 1883 and 1886 Delaherche operated a pottery in his native Beauvais, producing salt-glazed ware in the local tradition.[1] After the failure of this venture he removed to Paris where he worked for a year at Christofle's, first as a designer and then as head of an atelier. One can only speculate as to the influence on his development of the Reiber-Christofle legacy of Japonisme. Seeking a kiln to fire in stoneware some designs that he made while at Christofle's, he was directed to Chaplet; after his second visit the elder ceramist agreed to sell the rue Blomet studio, its contents, and all the glaze formulas except for that of his famed copper oxide. One year later at the 1887 *Union centrale* exhibition, Delaherche scored an outstanding success, overshadowing Chaplet and receiving a gold medal. He was praised for his particularly fine mat glazes and for his control over their coloration, which fluctuated much in the manner of the Japanese ceramics which he so greatly admired. The glaze on this vase 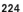 flows down the sides giving an illusion of spontaneity similar to that found in Oriental models, but it should be noted that Delaherche carefully controlled his work, refusing to keep any piece he could not duplicate. Another copy of this model is seen on a mantelpiece in a photograph of the painter Aman-Jean.[2] ME

1. See Gabriel Mourey, "The Potter's Art; with Especial Reference to the Work of Auguste Delaherche," *The Studio*, XII (1898), 112–18; Roger Marx, "Auguste Delaherche," *Art et décoration*, XIX (1906), 52–63; Hélène Demoriane, "A la recherche de Delaherche," *Connaissance des arts*, July, 1970, pp. 74–79, 100; *Französische Keramik zwischen 1850 und 1910* (Cologne, Kunstgewerbemuseum, 1974), pp. 175–92.

2. Illus. *The Studio*, VIII (1896), 197.

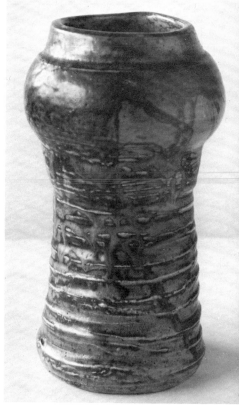

223

224

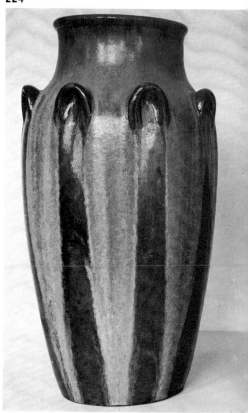

Auguste Delaherche, Armentières.

225 *Plaque.*

Stoneware with semi-mat blue-green, ochre, and brown crystalline (adventurine) glazes, ca. 1894–1904.
Diam. 12-1/2 inches (31.7 cm.).
Impressed horizontal mark: Auguste / Delaherche / 4214.
New York, Private Collection.

Delaherche apparently was easily attracted away from Paris and urban life. During the summers he worked at Héricourt, using local clays and kilns, and in 1894 he settled permanently in the commune of La Chapelle-aux-Pots at Armentières. Though the clays and glazes remained much the same as before, a change occurred in pieces with applied decoration such as this plaque. The stronger sense of form and bolder composition dependent on Japanese design differ from the somewhat linear, spindly decoration of Delaherche's earlier wares produced at rue Blomet. The striking similarity in design, color, and thematic motif between this plaque and the contemporary bookbinding by Marius Michel [257] can be attributed to their common reliance upon Japanese ideas. ME

Edmond Lachenal, 1855–ca. 1930, Châtillon-sous-Bagneaux.

226 *Vase.*

Stoneware with blue and green mat glazes, 1895.
H. 12-5/8 inches (32 cm.).
Painted in black: original E Lachenal 1895. Incised: no. 6.
Sèvres, Musée National de Céramique.

Lachenal's career in pottery was well founded. From 1870, when he was only fifteen years old, until 1880 he worked in the factory of Théodore Deck.[1] Using the various historical revival styles practiced there, especially the neo-Renaissance and Japanese modes, he quickly achieved a position of prominence. Some of his pieces were exhibited at the 1873 Vienna World's Fair and were singled out with an award; as a result, Deck placed him in charge of the painting studio. In 1880 Lachenal set up his own pottery firm in Malakoff on the outskirts of Paris, where he continued the Deck tradition of painted faience. By 1887 he moved to Châtillon-sous-Bagneaux, but it was not until the early 1890's that he became interested in stoneware and flambé glazes.

As this vase with its design of bamboo and waves shows. Lachenal was one of those who continued to adhere to an obvious form of Japonisme into the last decade of the nineteenth century; other vases from this period show crawling lizards and bamboo laden with snow.[2] Presumably this retention of straightforward Japanese motifs stemmed from the artist's early training, although there are certain new elements in this vase distinguishing it from a work of the 1870's or 1880's, most notably its soft color and texture. Caught up in admiration of Japanese mat glazes, Lachenal induced an analogous effect artifically by exposing his glazed surfaces to fumes of hydrofluoric acid. His style was to change before the end of the decade, however, and he became one of the first ceramists to devote himself wholeheartedly to the Art Nouveau style. ME

1. Fritz Minkus, "Edmond Lachenal," *Kunst und Kunsthandwerk,* IV (1901), 390–98; *L'art de la poterie en France de Rodin à Dufy* (Sèvres, Musée National de Céramique, 1971), p. 40; *Französische Keramik zwischen 1850 und 1910* (Cologne, Kunstgewerbemuseum, 1974), p. 79, no. 15, and pp. 92–96.
2. *L'art de la poterie,* nos. 168, 171, 175. Apparently some of the vases continued in production for some time; for example, one popular model with bamboo (illus. M. Battersby, *Art Nouveau* [Feltham, 1969], fig. 27) would seem, judging from its bright coloration, to be a later repetition of a model already established in 1893 (illus. *Der moderne Stil,* I [1899], pl. 113, no. 2).

225

226

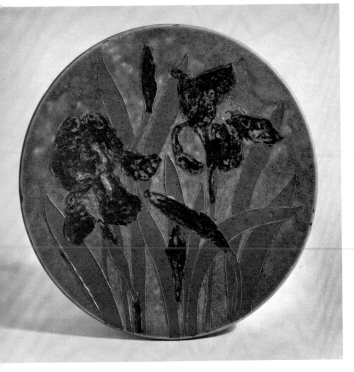

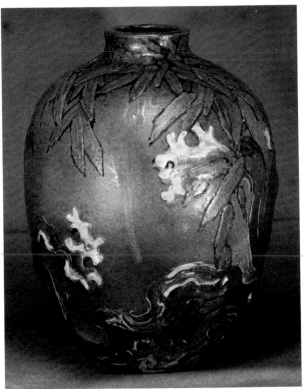

Lerosey, Paris.

227 *Vase.*

Soft-paste porcelain with translucent enamels, ca. 1900.
H. 6-7/8 inches (17.5 cm.).
Painted in gold: the monogram "LES" and an indecipherable mark beneath the glaze.
Baltimore, The Walters Art Gallery.

Emile Molinier alluded to the technique of cloisonné enamels in soft-paste porcelain introduced at Sèvres by Fernand Thesmar and later adopted by the relatively little-known Parisian artist, Lerosey.[1] A similar vase by Lerosey, decorated with narcissus, was illustrated in the same review. Both the design composed of flowers and insects and the technique (enameling on porcelain) exemplify the continuation of Japonisme, albeit of a more relaxed strain, at the turn of the century. ME WRJ

1. Emile Molinier, "Quelques mots sur l'Exposition de Céramique," *Art et décoration,* II (1897), 8.

Manufacturer: A. Bigot et Cie., Mer (Loire et Cher). Bigot, 1862–1927; firm closed 1914.
Designer: Henri Nocq, b. 1868.

228 *Inkwell.*

Stoneware with brown, ochre, blue, and green glossy and crystalline glazes, ca. 1899–1905.
H. 3-3/4 inches (9.5 cm.). L. 14-1/2 inches (36.8 cm.).
Incised: 3 / NOCQ / A BIGOT.
New York, Private Collection.

Alexandre Bigot originally studied chemistry, but after viewing the Japanese and other Far Eastern pottery at the 1889 World's Fair he decided to become a ceramist.[1] He established kilns in his native Mer, not far from Orleans, and by 1894 had sufficiently mastered his new art to exhibit at the *Société nationale des Beaux-Arts.* His chemistry background stood him in good stead, enabling him to create flambé and crystalline glazes whose rich effects won him critical acclaim from the very beginning. His indebtedness to Japan is clearly seen on his simpler pieces in which the form of the vessel and the bleeding glazes stand forth by themselves; in this regard, his aesthetic is comparable to that of Delaherche and Dalpayrat. He also produced plaques with frogs and lizards that reveal in their imagery his debt to Japanese pottery.

This particular inkwell was designed by the Parisian jeweler Henry Nocq, but the same principles are in effect.[2] The crab, the seaweed, and the tidal pools sparkling with crystalline glazes are the ultimate development of the marine imagery that three decades earlier Bracquemond and other Japonistes had borrowed from *ukiyo-e* prints. By the late 1880's they had discovered the same elements at the French seashore and, stimulated by Japanese representations, they were able to capture a similar sense of intimacy and poetry. As Ary Renan had promised in *Artistic Japan* when he urged French artists to be inspired by the *Manga* and return to Nature, "If they loved their models as the author of the *Man-gwa* loved his, they would pass from the ranks of artisans to that of artists."[3] Nocq and Bigot did just that. ME

1. *L'art de la poterie en France de Rodin a Dufy* (Sèvres, Musée National de Céramique, 1971), p. 15; *Französische Keramik zwischen 1850 und 1910* (Cologne, Kunstgewerbemuseum, 1974), pp. 198–205.

2. Nocq designed another model of an inkwell in which the crab was set with jewel stones: illus. *L'art décoratif,* I (1898–99), 196.

3. *Artistic Japan,* II (1889), 103.

227

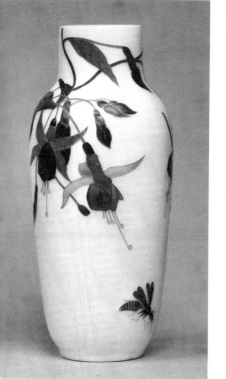

228

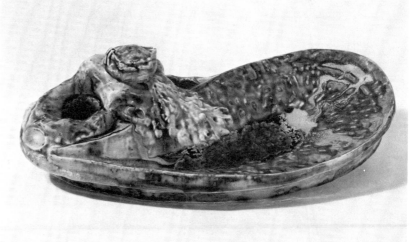

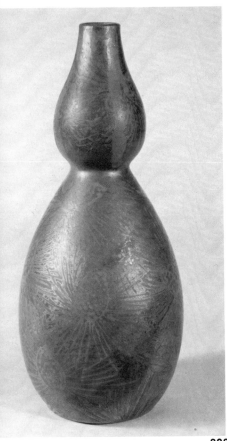

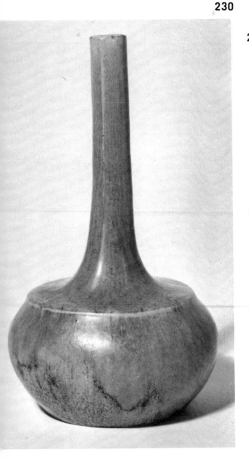

229

230

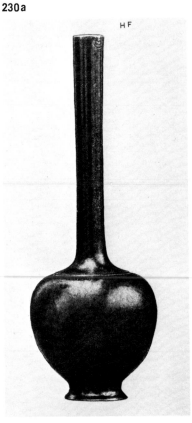

230a

Clément Massier, ca. 1845–1917,
 Vallauris (Alpes Maritimes).

229 *Vase.*
Faience with copper reduction glaze,
 ca. 1900.
H. 10 inches (25.4 cm.).
Painted: Clément / Massier / Golfe Juan /
AM. Incised: MCM / Golfe Juan.
New York, Private Collection.

Clément Massier was descended from a
family of ceramists in Vallauris, though
it is not clear how the members were
related.[1] By 1883 he had established his
own pottery in Golfe Juan. Little is
known about his production at this
time, but it was apparently still in the
historic revival styles. Although there
were some pieces with Japanese ico-
nography,[2] Massier's specialty was the
imitation of Hispano-Moresque lustered
ware. This situation change in 1889 when
an iridescent glaze achieved through
reduction was perfected, and by the
early 1890's Massier's name was synony-
mous with the painted iridescent ware
of this vase.

 Although there is a tendency to asso-
ciate Massier's pottery with Art Nouveau,
the overriding stylistic element is really
late Japonisme. The elegant double
gourd, like so many of Massier's other

forms, was a shape common in Japanese
pottery. Likewise, the motif of pine
needles was introduced into French art
through Japonisme (see the Rousseau
vase [233] and the Sèvres bowl [203]).
Of course, the Japanese stylized repre-
sentation of the motif was soon aban-
doned, and like so much of the new
iconography in late nineteenth-century
French decorative art, it was "domesti-
cated" and applied in such diverse media
as the silverware of Christofle and the
jewelry of Lalique, as well as in ceramics.
ME

1. *L'art de la poterie de Rodin à Dufy*
(Sèvres, Musée National de Céramique,
1971), pp. 44–45; *Französische Keramik
zwichen 1850 und 1910* (Cologne, Kunst-
gewerbemuseum, 1974), pp. 161–65. For
his early work, see C. Monkhouse,
"Vallaureis and its Allies," *Magazine of
Art*, VI (1883), 30–36.
2. One vase from this period showing
the Japanese idea of a rabbit in the moon
was on the New York market.

Pierre Adrien Dalpayrat, 1844–1910,
 Bourg-la-Reine.

230 *Vase.*
Stoneware, blue-green flambé glaze
 tinged with red, ca. 1892–1910.
H. 8 inches (20.3 cm.).
Impressed device of a pomegranate;
 incised cross.
New York, Private Collection.

Dalpayrat's early career as a ceramist
took him to Bordeaux (1867), Toulouse,
and Monte Carlo, where he directed a
large ceramic factory from 1876 to 1888.[1]
He was also employed briefly in Limoges,
possibly as an enameler.[2] Dalpayrat's
fame, however, rests on the pottery that
he began to produce at Bourg-la-Reine
in 1889. He was initially associated with
the sculptor Alphonse Voisin-Delacroix,
but following the latter's death in 1893
he took as his partner Adèle Lesbros.
After 1904 he appears to have controlled
the factory himself. The ceramic output
of Bourg-la-Reine ranged from delicate,
Rococo-like bathing women to symbolist
imagery of crouching panthers and tor-
mented sleeping figures Rodinesque in
style; these designs presumably were the
work of his partners or other sculptors
working at the factory.

 Throughout this period, from at least
1892 onward, the one unifying element
in the factory's output was the type of
glaze that Dalpayrat perfected: a reddish-
blue flambé which was often compared
to jasper. This type of bleeding glaze can
be linked to his admiration of Japanese
pottery, though of course a transmuta-

tion glaze of this sort is more common in Chinese ceramics.[3] Certainly Japonisme was a major factor in Dalpayrat's development, and, while it is less apparent in the elaborate sculpted vases that public exhibitions demanded, his indebtedness can be seen in the simpler vases he made which actually constitute a large percentage of his output. The form of this vase, for example, was probably adapted from a Japanese prototype—a bronze vase illustrated in *Artistic Japan*, 1889 [230a].[4] Although Dalpayrat has broadened the lower portion of the vase, the essential idea of the shape still remains, as do smaller details such as the horizontal break between the two sections (a demarcation which is meaningful for metalware but not for ceramics) and the slight vertical channels in the neck. Similarly, another Dalpayrat vase in the form of a squared bottle is a direct imitation of a Bizen ceramic vase illustrated in another 1889 issue of *Artistic Japan*.[5] ME

1. *Französische Keramik zwischen 1850 und 1910* (Cologne, Kunstgewerbemuseum, 1974), pp. 150–61.

2. See *Art Amateur,* VI (1882), 84.

3. For a Japanese example of this sort of glaze, see Henri Rivière, *La céramique dans l'art d'Extrême-Orient,* 2 vols. (Paris, 1923), II, pl. 88.

4. See *Artistic Japan,* II (1889), pl. HF.

5. The Dalpayrat vase, which has wrongly been tied to Art Nouveau, is illustrated in *Um 1900* (Zurich, Kunstgewerbemuseum, 1952), pl. 17, and again in Robert Schmutzler, *Art Nouveau* (New York, 1964), fig. 324; Schmutzler's interpretation of the vase on p. 207 is a misreading of Dalpayrat's aesthetic. The Japanese prototype is illustrated in *Artistic Japan,* III (1889), pl. AFI.

Pierre Adrien Dalpayrat, Bourg-la-Reine.

231 *Vase.*
Stoneware with essentially red and blue flambé glaze, ca. 1892–1910.
H. 7-3/4 inches (19.7 cm.).
Impressed device of a pomegranate.
New York, Private Collection.

This vase, which is formed like a shaft of bamboo, is clearly meant to suggest the Far East, but it differs markedly in quality from earlier interpretations of the motif such as those by Rousseau or Gaillard [234]. It is far more sober and omits the decorative overlay which characterized those earlier Japoniste objects. It is tempting here, as in the case of the pre-

vious Dalpayrat vase, to turn again to *Artistic Japan* and to a Seto sake bottle whose surface is similarly covered with irregularly flowing glazes and whose ringed shape is suggestive of bamboo.[1] We are not concerned with a specific correspondence of form, however, but with a general aesthetic approach. Bing's text to the illustration, which we have quoted at length in our opening essay, discusses the Japanese concern for material, form, and color, and it de-emphasizes applied decoration. It is this new understanding of Japanese pottery which links Dalpayrat with other French potters like Carriès and Delaherche; despite their very different preferences of color and texture, their general approach to the medium is similar. ME

1. *Artistic Japan,* II (1889), 96–97 and plate ID.

Pierre Adrien Dalpayrat, Bourg-la-Reine.

232 *Vase.*
Porcelain with green flambé glaze, traces of red; wooden cap; ca. 1892–1910.
H. 7-1/4 inches (18.4 cm.).
Impressed device of a pomegranate.
New York, Private Collection.

Japanese prototypes were responsible for the introduction into French Art of such motifs as gourds and squashes. Initially the Japonistes restricted themselves to two-dimensional representations of these vegetables, but towards the end of the century they began to create three-dimensional examples displaying all the surface irregularities inherent in the natural vegetable forms. In addition to the Dalpayrat vases, there are examples of these forms in porcelain by Taxile Doat, in metal by Jean Dunand, and in glass by Daum Frères. Besides the Japonisme displayed in the glaze and form of this piece, one should mention the small wooden stopper that resembles the ivory and wooden stoppers traditionally employed with Japanese pottery. Only towards the end of the century were they adopted in France as in the case of the Hoentschel vase [267]. ME

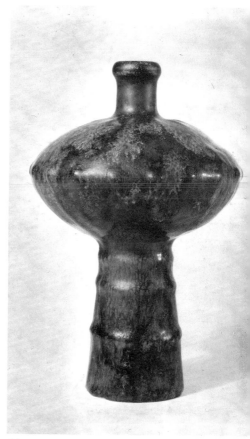

231
232

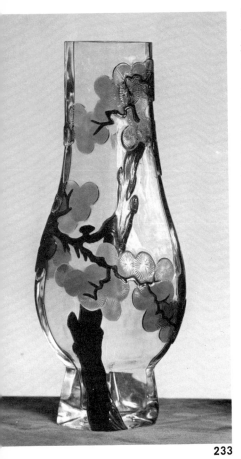

233

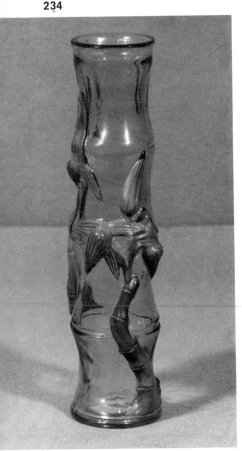

234

Producer: Eugène Rousseau, Paris.
Manufacturer: Appert Frères, Clichy.

233 *Vase.*

Glass, clear and green, engraved and
 enameled, ca. 1878–85.
H. 10-3/4 inches (27.3 cm.).
Etched: E Rousseau / Paris.
Baltimore, The Walters Art Gallery.

Sometime between the 1878 World's
Fair and the 1884 exhibition of the *Union
centrale,* Rousseau began to produce
"cameo glass," that is, glass of two or
more cased layers in which the design is
created by cutting away selected parts of
the upper color to reveal the under layer.
Although all the vases Rousseau made
in this manner have Japanese decors,
the origin of the technique is actually
Chinese and is known as "Peking glass."
The technique of cameo glass was even-
tually to dominate all French glassmaking
until World War I. Of course, we must
remember that at this time—the 1870's
and 1880's—the distinctions between
Chinese and Japanese sources were not
always that firm, and very often the two
came together in French applied arts.
The striking pattern of the gnarled
branches and the stylization of the pine
needles as discs with radial patterns
show us how literally the French—and
all Europeans, for that matter—first
imitated Japanese designs. ME

Producer: Eugène Rousseau, Paris.
Manufacturer: Appert Frères, Clichy.

234 *Vase.*

Glass, clear and red, molded and en-
 graved, ca. 1878–85.
H. 7-1/2 inches (19 cm.).
Paris, Félix Marcilhac.

Bamboo was inevitably one of the prin-
cipal motifs to be seized upon by the
early Japonistes. The concept of using a
ringed shaft of bamboo as the form of
the vessel and then having additional
branches and leaves of the plant embel-
lish the surface, while in accord with
European taste for elaborate decoration,
nonetheless had its origin in Japanese
art.[1] Examples in varying materials such
as bamboo, horn, and silver suggest the
sort of Japanese object which Rousseau
must have known and emulated. On the
other hand, the Chinese origin of Rous-
seau's cameo technique is quite appar-
ent in this vase, especially in the sharp
contrast of the red glass against the clear
ground—a color combination which is
often seen in Peking glass. In fact, a
Rousseau vase of this same model was
recently sold with an erroneous attribu-
tion to China.[2] ME

1. For example, see Gonse, *L'art japonais,*
2 vols. (Paris, 1883), I, pl. IX, 110, 127; II,
102, 103.

2. Collection of M. S. and others (Paris,
Hôtel Drouot, February 9–10, 1970),
no. 46.

Producer: Eugène Rousseau, Paris.
Manufacturer: Appert Frères, Clichy.

235 *Vase.*

Glass, butterscotch and cloudy gray with
 purplish-red striations, engraved
 design, ca. 1878–85.
H. 7 inches (17.8 cm.).
Etched: E Rousseau Paris
 E Rousseau / Paris.
Baltimore, The Walters Art Gallery.

More than any other artist of the 1880's
Rousseau was susceptible to the softly
undulant forms found in Japanese pot-
tery. Abandoning the traditional Euro-
pean stricture of symmetry, he trans-
ferred the irregular profiles of Oriental
ceramics to his glass vessels. A further
allusion to pottery can be seen in the
way in which the glass is overlaid at the
top to suggest the irregular flow of a
ceramic glaze, an aspect that coinciden-
tally began to interest French ceramists
of the 1880's. The image of the carp mov-
ing through swirling waters comes from
another Japanese tradition, the *ukiyo-e*
print. In this case, the source is a two-
page print in the *Manga* showing the
goddess of Fortune on a carp [235a];
this was evidently a popular print, since
it was illustrated by Gonse and had been
employed by Gallé on an enameled vase
of 1878.[1] The reverse side of the Rous-
seau vase shows a school of small fish
and waves that are also taken from Hoku-
sai. Despite this analysis of the separate
elements of the vase, it is not marked by
any feeling of disparateness; on the con-
trary, it imparts a wonderful sense of
unity which, together with the craft dis-
played in its manufacture and the allure
of its color, explains the high esteem in
which Rousseau was held. ME

1. L. Gonse, "L'art japonais," *Gazette des
Beaux-Arts,* s.2, XXVI (1882), 123. See
also M. Eidelberg, "Japonisme, Nature,
and French Decorative Arts of the Nine-
teenth Century," *The Connoisseur,* July,
1975 (forthcoming).

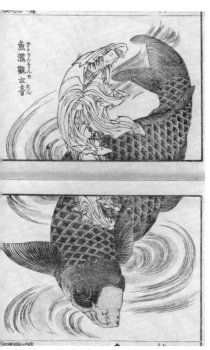

Producer: Eugène Rousseau, Paris.
Manufacturer: Appert Frères, Clichy.

236 *Vase.*

Glass, clear green and red with gilding, engraved, ca. 1878.

H. 9-7/8 inches (25.1 cm.).

Etched: E ROUSSEAU / E ROUSSEAU / PARIS.

Baltimore, The Walters Art Gallery.

Though the imagery of this vase is pronouncedly Oriental, the sources of its individual elements are difficult to identify. Even the shape itself, with its bold contrast of a square vessel and curving lip, though seemingly non-Western, is not necessarily derived from an Eastern source.[1] The morning-glory pattern of the background, which is comparable to a design used by Bracquemond for Haviland,[2] may be traced to the school of Korin, though the specific source is unknown. Likewise, the robed figure poses a problem of identity. The manner in which the back of the figure is carved on the vase's reverse in clear glass suggests a possible three-dimensional prototype such as a rock crystal figurine. In any event, it is unlikely that the French designer was concerned with any potential religious significance that the figure might originally have possessed; undoubtedly he appropriated it merely as a curiosity. ME

1. Another Rousseau vase of the same shape, but decorated with a Bacchic mask, is illus. *Art verrier 1865–1925* (Brussels, Musées royaux d'art et d'histoire, 1965), no. 47.

2. See, for example, New York, Metropolitan Museum of Art, inv. no. 23.31.17.

235a

5

236

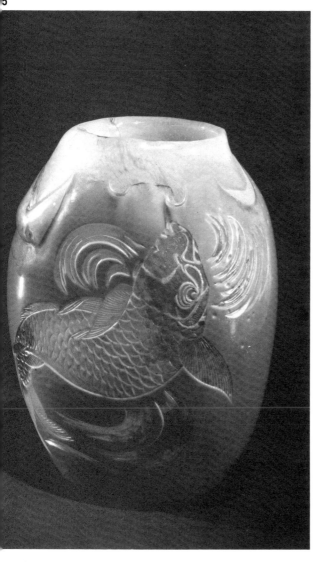

Producer: Eugène Rousseau, Paris.
Manufacturer: Appert Frères, Clichy.

237 *Vase.*
Glass, red and cream-colored, 1884.
H. 3-5/8 inches (9.2 cm.).
Etched: *E. Rousseau Paris.* Acid-etched
stencil: *E. Rousseau Paris 1884.*
Corning, New York, Corning Museum
of Glass.

Although another vase of this model in
the Musée des Arts Décoratifs, Paris, has
been touted by Nicolas Pevsner as one
of the most novel examples of early Art
Nouveau design, it seems more sensible
to place this design wholly within the
context of Japonisme.[1] The type of curv-
ing form and the stone which is imitated
(carnelian in this instance, and jade in
the case of the Paris example) follow a
Japanese tradition of carved semi-
precious stonework.[2] The way the stone
is imitated by boldly irregular bands of
color, which, to a degree, are not con-
trollable in their molten state, created
the sort of effect praised by the critic
Roger Marx, who noted that Rousseau
profited by these "accidents of nature"
as did the artists of Japan.[3] At the same
time, Rousseau used other combinations
of colored and stressed glasses to dupli-
cate the effect of Medieval and Renais-
sance rock crystal vessels, reminding us
again of the context of historicism with-
in which the artist worked.[4] ME

1. N. Pevsner, *The Sources of Modern
Architecture and Design* (New York,
1968), pp. 50–51. For a more correct as-
sociation, see *Welkulturen und Moderne
Kunst* (Munich, Haus der Kunst, 1972),
no. 1195.

2. A third exemplar of this model in a
more evenly colored light jade green,
made at the turn of the century by
Léveillé, Rousseau's successor, is in the
Kunstindustrimuseum of Copenhagen;
illus. A. Polak, *Modern Glass* (New York,
1962), fig. 7A. Polak (p. 23) wrongly be-
lieved the design was due to Léveillé.

3. R. Marx, *La décoration et l'art à
l'Exposition Universelle de 1889* (Paris,
1890). Although the glass to which Marx
is referring was officially presented by
Léveillé, it nonetheless was exactly the
type of glass Rousseau had shown in
1884.

4. See, for example, the decanter illus.
M. Rheims, *L'objet 1900* (Paris, 1964),
fig. 25.

Emile Gallé, Nancy.

238 *Vase and Stand.*
Glass with enameled decoration, ca.
1880.
H. 12 inches (30.5 cm.).
Enameled on base: E. Gallé, à / Nancy.
Paris, Cazalis-Sorel Collection.

Although much of his early experience
was in ceramics and he did not begin to
establish his reputation in glass until the
late 1870's, Gallé's acquaintance with
the latter medium extended as far back as
the sixties.[1] Between 1867 and 1868,
when he was only twenty, he studied
glassmaking at the Meisenthal firm of
Burgun et Schverer and subsequently
established a laboratory in the same city
for his own experiments. After Meisen-
thal was lost to Germany as a result of
the Franco-Prussian War, he set up a
small glass studio in Nancy, and by the
1878 Exposition he had begun to es-
tablish a reputation.

The essential element in Gallé's ear-
liest glass was its enameled decoration.
Evidently Joseph Brocard's imitations of
enameled Islamic glass, so popular in the
seventies, had served as a source of in-
spiration. In fact, some of Gallé's early
glass was in the Islamic style or was
based on Persian metalwork designs. But,
like Rousseau, Gallé was seduced by
Japanese art and, as already noted, one
of his vases at the 1878 Exposition was
decorated with a swimming carp taken
from Hokusai's *Manga.* Certainly the

237

238

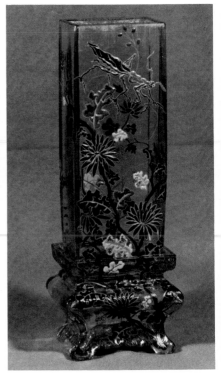

influence of Japanese art on this vase cannot be disputed. It is evident in the rectangular form of the vase and in its decoration. Moreover, the asymmetrical and stylized branch of chrysanthemums and the witty characterization of the praying mantis with its alert eyes betray Gallé's close adherence to Japanese formulas, which he could have found either on imported Japanese artifacts or in *ukiyo-e* prints. There is a pendant vase in the Cazalis-Sorel collection which, though identical in form, is of amber glass and is decorated with fish, nets, and marine plants—another aspect of the Japonistes' rediscovery of nature. ME

1. *Glassamlung Hentrich, Jugendstil und 20er Jahre,* ed. H. Hilschenz (Düsseldorf, Kunstmuseum, 1973), pp. 232–309.

Emile Gallé, Nancy.

239 *Vase.*

Glass, 1882.
H. 9 inches (22.9 cm.).
Etched: *Cristallerie / d'Emile Gallé / à Nancy / 1882.*
Paris, Private Collection.

During the 1880's Gallé's star slowly ascended. In the 1884 exhibition of the *Union centrale* he received as much attention as Rousseau; in fact, one commentator found Gallé's display to be "the revelation and main event."[1] Like

Rousseau, Gallé turned to carving the glass; this vase must be counted as one of the earliest examples of this technique. The principal motif (dragonflies) and the small stellate flowers scattered across the surface are of course Japanese in origin. Indeed, much of Gallé's iconography was so inspired and was rightly described at the time in a poetic way: a combat of octopi in the depths of the sea, amorous butterflies and warring insects amidst plants, and—quite apropos—a dragonfly gliding across the surface of a lake.[2] Not only does the dark coloration of this vase appear to imitate a richly patined bronze surface, but the shape seems to be derived from a metal form. This transference from one medium to another is quite common; it reminds us of the wide range of objects Japonistes knew and studied and, of course, it makes it all the more difficult to determine the exact sources the artist used. ME

1. *Revue des arts décoratifs,* V (1884–85), 193.
2. *Ibid.,* 259.

Emile Gallé, Nancy.

240 *Vase.*

Translucent glass, light green and pink, engraved, ca. 1880–90.
H. 3-1/4 inches (8.2 cm.)., Diam. 5-5/8 inches (14.3 cm.).
Printed oval paper label: EMILE GALLE / NANCY • PARIS . Handwritten: 51163.
New York, Macklowe Gallery.

This bowl was evidently made to imitate Japanese carved semi-precious stone. The gently scalloped form—suggestive perhaps of a lotus blossom—the simple Eastern foot, and, most striking of all, the imitation of "mutton fat" jade in the coloration of the glass body contribute to the impression that this object was made far beyond France's eastern border. The way in which the marks of the small polishing wheels have been left on the surface emphasizes the handmade nature of this object. The insistence upon the integrity of the individual craftsman in the face of industrialization was, of course, a basic tenet of the European arts and crafts movement. Not infrequently one finds expressions of admiration for Japanese workmen who, working with the simplest of tools, created objects of art with patience and love. At times they are even referred to as the ultimate descendants of the Medieval craftsmen. ME

239

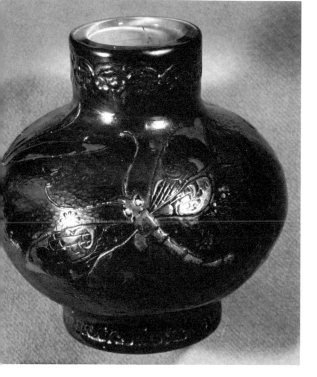

240

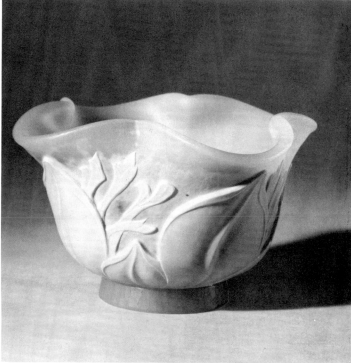

Emile Gallé, Nancy.

241 *Vase.*

Case and engraved glass, 1891.
H. 6-1/4 inches (15.9 cm.).
Etched: *Nanceiis comp et fecit Emile
 Gallé Epreuve définitive 1891.*
E G device of Cross of Lorraine.
Boston, Museum of Fine Arts, Gift of
 Miss Mildred Kennedy.

Gallé's success in the 1880's and Rousseau's retirement in 1885 impelled the Nancy artist to a summit of achievement that was marked by his impressive display at the 1889 World's Fair, set under a dramatic canopy likened to a druidic tent. From then until his death in 1904 he was the unrivaled champion of French glass and a leading spokesman for the decorative arts in general. During the course of the 1880's his style had assumed a clear direction. The Renaissance and Near Eastern elements had diminished in importance as, more and more, Gallé concentrated on a vision of nature tempered by his experience with Japanese art. In works such as this vase one can see the dual aspects of Japonisme and nature complementing each other. Certainly the concept of a frog attentively watching a dragonfly is Eastern in origin; likewise, a residue of Japanese style is still apparent in the portrayal of the dragonfly. Nonetheless, this vase is marked by a growing assimilation of Japanese principles rather than by a mere copying of outward form. In 1885 Gallé made the acquaintance of Takasima, a Japanese

student at the horticultural school of Nancy, but this did not represent the introduction of Japonisme to Nancy as has been claimed by some modern critics; it was, rather, a reaffirmation of an artistic choice that Gallé (and France) had already made.[1] Nevertheless, one can well imagine that Takasima helped Gallé to see the gardens and countryside of Lorraine with Eastern eyes.

One of the most intriguing aspects of Gallé's art was his inclusion of poetic phrases; this vase bears a phrase from the Parnassian poet Leconte de Lisle: "Echappez-vous des ombres immobiles" (Escape from motionless shadows).[2] Gallé's inscriptions do not provide a literary motif, nor do they merely continue the decor. As the critic Roger Marx noted, Gallé's aim was to go beyond visual pleasure to a second and higher plane: "He solicits the interest of the spirit, the awakening of the spirit, by a symbol."[3] The phrases are selected from a wide range of authors, from Villon and the *Pleiade* to Baudelaire and Victor Hugo, but they are so closely bound to French literary tradition that we almost fail to notice how Oriental it is to juxtapose image and poetry. Unlike the sentimental and humorous inscriptions on English pottery and furniture which, in rhymed couplets, proclaim the object's use or a moral, Gallé's selections are merely brief phrases whose terseness, like a haiku, is meant to be emotionally evocative. ME

1. For example, S. T. Madsen, *Art Nouveau* (New York and Toronto, 1967), p. 59.
2. A vase of almost identical form and decoration which was included in his display at the 1889 World's Fair is in the Musée de l'Ecole de Nancy; it has a different phrase: "Nul souci de plaire."
3. R. Marx, *La décoration et l'art industriel à l'Exposition Universelle de 1889* (Paris, 1890), p. 24.

Emile Gallé, Nancy.

242 *Vase.*

Glass with molded and enameled
 decoration, ca. 1890–1900.
H. 12 inches (30.5 cm.).
Boston, Museum of Fine Arts, Gift of
 Arthur B. Nichols in memory of
 Dorothy Nichols.

Beyond the evident Orientalism inherent in the shape of the vase, we see here as well a major aspect of Japonisme as it evolved in France after 1880—the concept of returning to nature.[1] Gallé's flowering branches of honeysuckle appear to be taken from nature, but nature as seen through Japanese eyes. The delicacy with which the flowers and leaves are rendered and the charmingly asymmetric way the branches grow show an Eastern technique of recording nature and at the same time turning it into a suitable decorative pattern. The treatment of the trellis offers a good case in

241

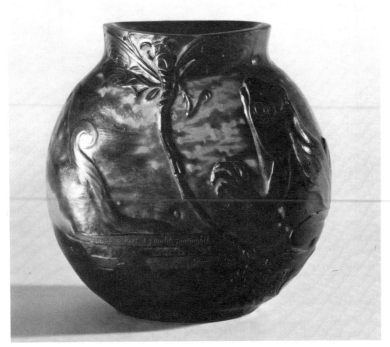

242

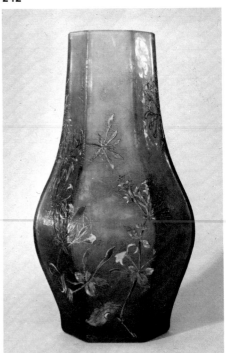

point. Its linear pattern and the way it sporadically fades from sight as though hidden by atmosphere are based wholly on Japanese decorative principles which Gallé knew and had copied quite literally earlier in his career, as can be seen in the scale pattern he used on the ceramic vase in the shape of a fan [220]. ME

1. For the dating of this vase, see the copy of an 1892 vase from this series in the Hentrich collection, *Glassammlung Hentrich, Jugendstil und 20er Jahre* (Düsseldorf, Kunstmuseum, 1973), no. 217.

Emile Gallé, Nancy.

243 *Vase.*

Glass, essentially white, yellow, and rust colored, ca. 1897–1904.
H. 4-5/8 inches (11.7 cm.).
Incised lower right corner of front face: Gallé.
Paris, Félix Marcilhac.

Although by the nineties he had ceased to imitate Japanese decoration, Gallé continued to borrow that country's forms. The rectangular shape of this vase is based upon Japanese metal brush containers.[1] By the turn of the century Gallé also adopted the traditional shapes of the Japanese tea bowl and bronze flower vases.[2] In addition to these specific borrowings, Galle's repertoire of shapes was marked by a more generalized infiltration of simple Oriental forms as he

sought to break with the West's traditional formulas. The strikingly beautiful coloration of the glass in this instance imitates richly veined, striated stone and reflects the new, Japanese-inspired appreciation for semi-precious stones and their bold, irregular markings that developed during the 1880's. Like Rousseau, Gallé began during that decade to experiment with combinations of salts and oxides to create endless effects of color which he likened to such stones as sapphire, agate, quartz, jade, and amber;[3] the listing reads like the enumeration of beautiful stones in Huysman's *Au rebours*. While much of Gallé's energy was necessarily spent as a chemical engineer, it was his poetic nature which governed such undertakings. ME

1. Vases with the same form but with decoration in a marquetry technique (hence, dating after 1897) were sold in Paris, Hôtel Drouot, May 21, 1974, nos. 103, 125.
2. See, for example, *Miscellanea,* IV (Hamburg, Dr. Heuser & Co., 1971), no. 4; sale catalogue (Versailles, Hôtel Rameau, December 13, 1970), no. 63.
3. R. Marx, *La décoration et l'art industriel à l'Exposition Universelle de 1889* (Paris, 1890).

Emile Gallé, Nancy.

244 *Vase.*

Inlaid and carved glass, primarily translucent, in tones of ochre, purple, brown, and green, ca. 1897–1904.
H. 4-1/8 inches (10.5 cm.).
Etched on front side: GALLÉ. Original paper label printed: EMILE GALLÉ / NANCY — PARIS / No. Handwritten: 37679 (the second line of numerals indecipherable).
Paris, Cazalis-Sorel Collection.

In many ways this piece by Gallé is closely related to Rousseau's vases of the early 1880's. Gallé has imitated an Oriental carved onyx vessel with variegated coloring and undulant walls similar to Rousseau's carnelian vase in Corning [237]. Their common denominator is, of course, a mutual dependence upon Japanese art. Gallé has even included a glass base resembling dark jade, making it impossible to overlook the Japanese precedent. As suggested in our previous example, Japonisme was still a vital force in Gallé's art at the turn of the century.[1] This vase bears not only Gallé's name arranged vertically in a Japanese fashion, but also the inscription *Pervincio,* or periwinkle. An almost poetic aura pervades the vase; the floral motif is not treated in a literal way but is only vaguely and quickly suggested as in a *sumi* painting. In a contemporary poem "Le bouquet sacré," dedicated to "the master of all flowers, Emile Gallé," the Nancy writer Emile Hinzelin speaks of the periwinkle as an "image of discreet happi-

243

244

ness."[2] Not the least interesting aspect of this vase is that it once belonged to the discerning critic—and one of Gallé's major champions—Roger Marx, the author of an essay on the influence of Japanese art in France which appeared in *Artistic Japan*.[3] ME

1. The dating of this vase to the last part of Gallé's career is based not only upon the richness of coloration and material, but more specifically upon the fact that the technique of *marquetrie-de-verre* which is used here (the literal laying in of glass sections to create a design just as in wood marquetry) is one which Gallé did not introduce publicly until 1897.

2. "Et toi, parmi la mousse, ô ma pauvre *pervenche*. Image du bonheur discret!" *La Lorraine*, XXI (January 15, 1903), 17.

3. Collection Roger Marx, sale catalogue (Paris, Galerie Manzi, Joyant, May 13, 1914), no. 87, illus.

Jules Wièse, 1818–1890, or Louis Wièse, b. 1852.

245 *Brooch.*

Gold and opals, ca. 1880.
1-1/16 x 1-3/4 inches (2.7 x 4.4 cm.).
Stamped on reverse in neo-Gothic letters: WIÈSE. Marks on clasp: French guaranty and maker's mark, WIÈSE, with one star above and three below.
New York, Private Collection.

The brooch, in the shape of a coiled, three-clawed dragon, resembles in size and composition a Japanese *manju netsuke*, a type of design which is often encountered in prints and metalware, as it is on the rooster and the drum from the Walters Art Gallery [299].

Henri Vever referred to the father, Jules Wièse, as a skillful *ciseleur* and *bijoutier* who entered the studio of F. D. Froment-Meurice in 1839 and established his own studio six years later.[1] In the 1850's and 1860's he received many

awards for his jewelry, which was generally in the Renaissance revival style. His son Louis succeeded him as head of the firm in 1880 and continued to produce work resembling that of his father. WRJ

1. Henri Vever, *La bijouterie française au XIXe siècle*, II (Paris, 1908), 208–11.

Anonymous.

246 *Pin.*

Gold, enamels, rose diamonds, ca. 1890.
H. 1-9/16 inches (4 cm.), L. 1-3/4 inches (4.4 cm.).
French guaranty mark and unidentified mark A...G.
New York, Private Collection.

The pin is in the shape of a Japanese open (*uchiwa*) fan. Its decoration consists of a swallow in translucent enamels, an engraved shoot of bamboo with enamel

245

246

247

248

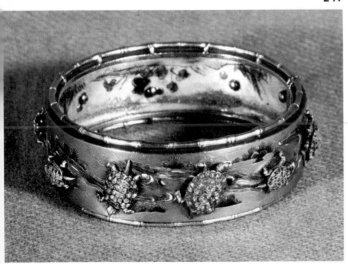

leaves, and some floral motifs set with diamonds. Although such Japanese whimsies were introduced into French jewelry in the late 1870's and were popular throughout the following decade, the use of rose diamonds on this piece suggests a still later dating. WRJ

Anonymous.

247 *Bracelet.*
Gold, enamel, and silver set with rose
 diamonds.
Diam. 2-1/2 inches (6.3 cm.), W. 7/8
 inches (2.2 cm.).
Marked on tongue: French gold warranty
 and unidentified mark with "B...1."
New York, Private Collection.

On the face of the bracelet ten turtles with shells of rose diamonds swim or crawl through a swamp suggested by patterns of flowing water and plants in enamel and by engraved rippling designs. The counter-enamel is decorated with water-plant motifs. Circumscribing the rims of the bracelet are bands of bamboo. The Japanese motif of turtles swimming in patterns of rippling water was familiar to French Japanophiles. It occurred, for example, on the base of an early nineteenth-century bronze statue belonging to Henri Cernuschi.[1] It appears throughout Japanese prints and paintings and was used as marginal decoration in Gonse's *L'art japonais*[2] and in Bing's *Artistic Japan*.[3] WRJ

1. Louis Gonse, *L'art japonais*, II (Paris, 1883), 73.

2. *Ibid.*, p. 191.

3. William Anderson, "Hiroshige," *Artistic Japan*, III (1888), 200.

Bapst et Falize, Paris.

248 *Cream Pitcher.*
Silver, before 1889.
H. 3-3/8 inches (8.5 cm.), L. 4-1/8
 inches (10.4 cm.).
Impressed: — BAPST ET FALIZE — ORF.
Paris, Musée des Arts Décoratifs.

In 1879 Germain Bapst, son of the noted jeweler Alfred Bapst, suggested to Lucien Falize that they combine their family firms in an enterprise; it proved successful until the former's retirement in 1891. This cream pitcher is part of a service in which all the utensils are shaped in the forms of flora and fauna. Unlike much metalwork of the 1880's which reflects the influence of a neo-Rococo style that was all-pervasive, this pitcher also illustrates in the careful delineation of the shell and supporting algae an acute per-

ception of natural phenomena which had in part been inspired by Japanese precedents. In this connection, one is reminded of Ary Renan's admiration for the Japanese rendering of marine life.[1] WRJ

1. Ary Renan, "Animals in Japanese Art," *Artistic Japan,* IV (1890), 266.

Albert Bartholomé, 1848–1928.

249 *Portrait of Tadamasa Hayashi.*
Bronze, ca. 1894.
H. 10 inches (25.4 cm.).
Signature in casting: A. Bartholomé.
Paris, Private Collection.

From his arrival in Paris in 1878 until his retirement in 1902, Hayashi's expertise was a significant factor in the formation of collections of Japanese art.[1] Originally he was sent to Paris by the commissioner Wakai to act as agent and interpreter at the Exposition Universelle of 1878. Hayashi remained in France to dispose of the unsold stock and subsequently settled there, selling goods sent to him by

Wakai. Eventually he became an independent agent and traveled between Paris and Tokyo to obtain further stock. In this pursuit he was aided by two brothers. Hayashi acted as translator for both S. Bing and L. Gonse in their publications on Japanese art and also assisted many other prominent collectors in the late nineteenth century. In 1900 he was appointed *Commissaire Général* for Japan at the Exposition Universelle. He died six years later. His portrait, made in the form of a noh mask and cast in Japan, was first exhibited at the Société Nationale des Beaux-Arts in 1894. Eleven years later Paul Vitry recalled "the strange and penetrating mask of M. Hayashi where the artist was amused to give the appearance of those Japanese masks so powerfully summarized in their expression, so alive in their apparent regular smoothness."[2] WRJ

1. See S. Bing's introduction to *Objets d'art du japon et de la Chine réunis par T. Hayashi* (Paris, Galeries de MM Durand-Ruel, January 1902).

2. In "Bartholomé," *Art et décoration,* XVII (1905), 146.

249

René Lalique, 1860–1945.

250 *Barrette.*

Gold, horn, and enamel, ca. 1898.
L. 7/16 inches (1.4 cm.), H. 3-5/8 inches (9.2 cm.).
Signed on hinge-end: LALIQUE.
New York, Private Collection.

The composition consists of an umbelliferous flower in blue cloisonné enamel with stems of tinted horn applied against a light, transparent horn ground. In its size, oblong shape, raised decoration, and horizontal composition, this barrette may have been inspired by a traditional Japanese *kodzuka,* a hilt for a little knife.

An apparent disregard for the intrinsic value of materials was a trait of Lalique and some of his contemporaries. In the 1896 salon of the Société des artistes français, Lalique exhibited a bracelet made of horn with silver applications. It was his earliest use of horn, a substance which had been neglected in the West since the seventeenth century. In the Orient, horn (particularly that of the rhinoceros) was esteemed as a material for drinking vessels and *netsukes* because of its alleged magical properties. The exploitation of horn's translucency in jewelry was a contribution of Lalique, who may have been endeavoring to emulate the properties of Japanese lacquer.[1] WRJ

1. Dora Jane Janson, *From Slave to Siren* (Durham, N. C., 1971), p. 33.

René Lalique.

251 *Hair Comb.*

Horn, 1898.
H. 5-7/8 inches (14.9 cm.).
Paris, Musée des Arts Décoratifs.

French collectors grew to appreciate the role of the hair comb in the daily life of Japan at the same time as an emergence of higher hair styles in their own country dictated the use of similar implements.[1] The aesthetic possibilities of the comb were explored by a number of French Art Nouveau designers including Lalique, who exhibited a vitrine of combs in horn and ivory at the salon of the Société des artistes français in 1897.[2] The incised design of this comb, one of two acquired by the City of Paris at the salon in 1898, is based on the same umbelliferous flower as that in the barrette and on the Gallé cabinet [256]. On this comb the flowers and their stems resemble in form the ornamental Oriental hairpins that the Japonophiles included in their comb collections. A more abstracted version of the flower appears on a slightly later comb by Lalique.[3] WRJ

1. See "The Ornamental Hair Comb and European Art Around the Year 1900," *World Cultures and Modern Art* (Munich, 1972), pp. 159–63.

2. Henri Vever, *La bijouterie française au XIXᵉ siècle,* III (1908), 727–28.

3. Illus. "Recent Examples of the Jeweler's Art in France," *The Studio,* XXIII (1901), 27.

René Lalique.

252 *Man's Watch.*

Gold and enamel set with eleven moonstones, before 1900.
2-7/8 x 2 inches (7.3 x 5.1 cm.).
Signed on rim: LALIQUE. Stem bears French "owl" mark indicating the movement was foreign.
New York, Private Collection.

250

251

252a

252b

The face of the watch is decorated with butterflies in blue and white enamel, and the case with bats in mottled mauve and gray enamel protected by eleven protruding moonstones. A ring in the form of a coiled snake is attached to the stem. In a review of the 1900 Exposition, Raymond Bouyer commented on the ingenuity and imagination displayed by the designer of this watch.[1] He also illustrated two other watches exhibiting decoration of obvious Japanese inspiration, one with pine needles and cones in the Musée des Arts Décoratifs, Paris, and another bearing three snails. The overall combination of Japanese inspiration and French sentiment in Lalique's display at the Exposition was noted by Henri Vever.[2] WRJ

1. Raymond Bouyer, "La décoration des montres," *Art et décoration,* IX (1901), 36–37.

2. Henri Vever, *la bijouterie française,* III (Paris, 1908), 738.

Fernand Thesmar, Neuilly.

253 *Pendant.*
Enamel on silver with gold cloisons, ca. 1895–1900.
3-3/8 x 2-1/8 inches (8.6 x 5.4 cm.).
Signed on counter-enamel with monogram.
Philadelphia, Dr. and Mrs. Joseph Sataloff.
Not illustrated.

Although Thesmar's name is generally associated with *plique-à-jour* enamel cups and enameled porcelains, he also executed some jewelry.[1] The realistic treatment of the insects and the leaf are among his characteristics. A ladybird beetle, such as that in the upper corner of the leaf, frequently occurs in conjunction with his monogram on the bases of his cups. Designs composed of insects and leaves are relatively common in Japanese art.[2] However, translucent enamels such as those utilized by Thesmar were not employed by the Japanese until after 1868. WRJ

1. Gabriel Mourey, "Fernand Thesmar," *Les Arts,* September, 1912, pp. 19–22.

2. Louis Gonse illustrated a shallow iron box in the form of a leaf incrusted with insects, *L'Art japonais,* II (Paris, 1883), 177.

Louis Majorelle, 1859–1926, Nancy.

254 *Table.*
Wood with lacquer, inlays of bronze and mother-of-pearl, ca. 1885.
H. 32 inches (81.3 cm.), L. 32 inches (81.3 cm.), W. 22 inches (55.9 cm.).
Two oval paper labels printed with a device of an artist's palette and FABRIQUE A NANCY / 3, RUE GIRARDET / LOUIS MAJORELLE / DEPOT / 56, RUE DE PARADIS / PARIS.
Chappaqua, New York, Marjorie Messer Freeman.

Although ultimately overshadowed by the activities of his children, Auguste Majorelle, like Gallé's father, is a major but forgotten personage behind the so-called "School of Nancy." His firm produced fashionable domestic wares in the 1870's and 1880's, some of which were in the Japanese taste. We know that in the early 1880's they were producing pottery imitating Japanese lacquer,[1] and also furniture like this table. The repertoire of fans, flying swallows, and flowers is typical of the motifs favored by the early Japonistes, and the elaborate mixture of lacquer with inlays of bronze and carved mother-of-pearl [301] also bespeaks something of the aesthetic which then governed France and its appreciation of certain aspects of Japanese art. Although the actual designs and the skillfully wrought lacquer and inlays might pass for Japanese exportations, the form of the table, particularly its legs, is noticeably dependent upon Rococo formulas. ME

1. *Art Amateur,* V (1881), 79. It has not been possible to locate any examples of this pottery, but some idea of its appearance can perhaps be gauged by the contemporary glass productions of the Val Saint-Lambert factory; see *Art verrier 1865–1925* (Brussels, Musées royaux d'art et d'histoire, 1965), no. 21.

253

254

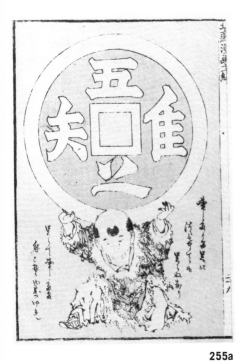

H. Catelin after a design
 by Marie-François-Firmin Girard,
 1838–1921. Gilding probably
 by Bibollet.

255 *Framed Plaque.*
Painted pseudo-lacquer wooden frame
 and painted porcelain panel, 1886.
 30 x 20 inches (76.2 x 50.8 cm.).
Plaque signed: H. Catelin. peint.
 d'après firmin Girard / Bibollet.
 dècor. / 1886.
Paris, Private Collection.

The panel shows what purports to be a
Japanese girl holding a parasol, painted
in pastel colors and set against a back-
ground of flowering trees and birds exe-
cuted in gold. Much more convincingly
Eastern, however, is the frame painted to
imitate lacquer. Its images are taken from
the Japonistes' favorite source, Hokusai's
Manga. The droll caryatid figure which
appears to support the panel comes from
a similarly used figure on the final plate
of volume 11 [255a]. The rooster and
cat and the three workmen cleaning an
elephant's gigantic leg at the left side are
from the same volume. The man in the
upper-left corner is from Hokusai's tenth
volume and the crane at the right is from

the seventh. The fish at the right, but not
the fisherman, comes from the second
volume, and it is probably the same fish,
but in reverse, that appears on the Havi-
land vase [202]. Sources for the coquet-
tish woman with a fan and the frog next
to her are to be found on separate pages
in the twelfth volume. Curiously, save for
a few Japonistes likes Guérard, the hu-
morous aspects of Japanese art had little
appeal, and so one wonders even more
about the identity of the unknown
French artisan who chose these
drolleries. ME

Emile Gallé, Nancy.

256 *Cabinet.*
Wood inlaid with marquetry, after 1893.
64 x 34 inches (162.5 x 86.3 cm.).
Inlaid in the marquetry: Gallé.
New York, Macklowe Gallery.

Gallé became interested in furniture in
the late 1880's, having been attracted by
the color and grain of woods he found
in a lumber yard where he had gone to
obtain wood for the base of a glass vase.
It was the coloristic qualities of wood
and the pictorial possibilities of mar-

255a

255

256

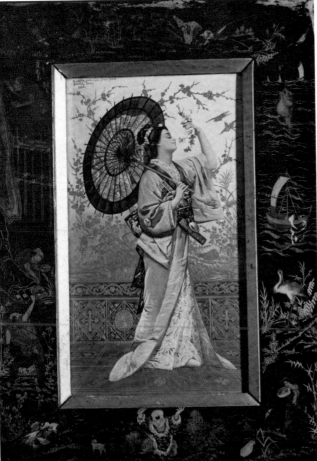

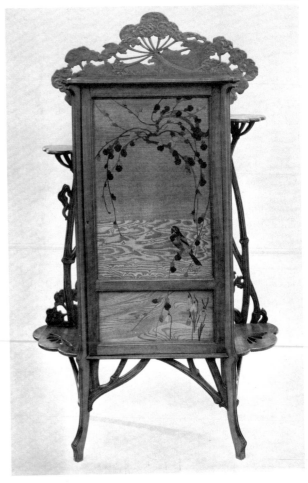

quetry rather than the architectural and functional aspects of structure that intrigued him. His first furniture, shown at the 1889 World's Fair, already bore the marks of his love for nature though it still contained references to various historical styles. It was not until a few years later that Gallé more successfully united structure and vegetal decoration, as in this "ombelliflore" cabinet.[1] The effect of Japonisme is apparent in the asymmetrical design of the marquetry with its very Oriental-looking picture of a bird sitting on a gracefully bending branch; the shelves at the sides are placed at unequal heights to further the asymmetry. One can understand how it came to pass that Comte Robert de Montesquieu, a noted aesthete of his time, used both Gallé furniture and furniture imported from Japan.[2] ME

1. For other pieces in this suite, see E. Mannoni, *Meubles et ensembles, Style 1900* (Paris, 1968), p. 8.
2. See the clippings in a scrapbook in the library of the Musée des Arts Décoratifs, vol. 236, no. 42.

Henri-François-Victor Michel, known as Marius Michel, 1846–1925, Paris.

257 Bookbinding for Gabriel-Urban Fauré's manuscript *Pavane avec choeur,* op. 50, ca. 1890.
13-3/4 x 10-1/2 inches (34.9 x 26.7 cm.).
Incised on face: H M (conjoined) M.
Stamped in gold on turn-in: MARIUS MICHEL.
New York, The Pierpont Morgan Library.

This deep brown binding with crushed morocco borders is ornamented with incised irises, a butterfly, and a trilobal motif enclosing the letter *E* (for the recipient's first name) and two Japanese maple leaves. The doublures are of Oriental yellow watered silk decorated with cranes. Marius Michel, the most innovative binder of his period, was responsible for the reintroduction of incised decoration, not employed since the Renaissance. Though rendered naturally, the flora and fauna, in their selection and asymmetrical disposition on the cover, are obviously of Japanese inspiration.

Fauré's manuscript is dedicated to the Comtesse Greffulhe (née Elizabeth de Chimay), a luminary of the Faubourg Saint-Germain who served as a model for Marcel Proust's Duchesse de Guermantes. WRJ

Charles Meunier, 1866–1940.

258 Bookbinding for *Balades dans Paris.* After 1894.
10-1/16 x 8-1/16 inches (25.5 x 20.5 cm.).
Stamped in gold on turn-in: CH. MEUNIER.
Baltimore, The Walters Art Gallery.

The front cover of this crushed morocco binding includes a mélange of Japanese and *fin-de-siècle* motifs including paper lanterns, bats, ribbons, a windmill, and a cat, whereas the back contains an inlaid circular design incorporating a mask, chestnut leaves, flowers, and brushes. The spine is decorated with gold-tooled swallows. Purple and black Japanese silk is employed for the doublures.

Meunier as a youth studied with Gustave Bénard, Dumont, and Maillard before entering the studio of Marius Michel. At the age of twenty he founded his own studio at 75 boulevard Malesherbes. Following the tradition of Marius Michel he specialized in *reliures emblématiques* utilizing mosaic and chiseled decoration. Until his retirement in 1920 he was one of the most active binders in France. WRJ

257

258

Manufacturer: Aubusson
Designer: Antoine M. Jorrand.

259 *Tapestry.*
Woven wool, ca. 1895.
118 x 35-1/2 inches (297.7 x 90.2 cm.).
Signed: A. J. in weave.
Paris, Galerie de Luxembourg.

259

A very similar poppy design said to have been based on a Japanese print appears in a tapestry mounted in a screen illustrated by M. P. Verneuil in 1897.[1] The Oriental poppy with its vibrant color and sinuous stems appears frequently in Japanese designs.[2]

Antoine M. Jorrand of Aubusson (Creuse) worked in Paris in the salons of the Société des artistes français after 1891. WRJ

1. M. P. Verneuil, "La décoration intérieure et les travaux féminins," *Art et décoration,* I (1897), 73, 79.

2. See, for example, Collection Ch. Gillot, *Objets d'art* (Paris, 1904), no. 310.

Joseph Petitjean, Paris.

260 *Wallpaper Sample.*
Printed paper, 1896.
15-9/16 x 18-15/16 inches (39.5 x 48.1 cm.).
Paris, Bibliothèque Forney.

This wallpaper is adorned with a multitude of Oriental motifs including a vase decorated with prunus blossoms, a framed panel enclosing a fantastic bird perched on a rock, and various floral and geometric patterns. The firm was founded by Joseph Petitjean in 1873 and operated under his direction until 1903 when a son assumed control. Located on the rue Fabre d'Eglantine the firm continued production until 1911. It won a silver medal at the 1889 exposition and was *hors concours* in 1900 when Joseph Petitjean served on the jury.[1] WRJ

1. H. Clouzot and C. Follot, *Histoire du papier peint en France* (Paris, 1935), pp. 203–4.

1900–1910

Ernest Chaplet, 1835–1909, Choisy-le-Roi.

261 *Vase.*
Porcelain with brown, red, and blue glazes, ca. 1895–1904.
H. 7-13/16 inches (19.8 cm.).
Impressed device of a rosary.
Germany, Marxen am Berge, Maria and Hans-Jörgen Heuser.

Ernest Chaplet, though born in Paris, spent his youth in Sèvres, where he was already associated with the Manufactory.[1] He then trained in Paris with Emile Lessore, and when his teacher moved to Sèvres, Chaplet followed him there. Between the late 1850's and 1874 Chaplet worked with Laurin at Bourg-la-Reine, where he invented barbotine painting. In 1875 he introduced this technique into Charles Haviland's Auteuil studio where he had been summoned by Bracquemond. Chaplet succeeded Bracquemond as artistic director of the Haviland atelier, which he moved from Auteuil to rue Blomet in the Vaugirard section of Paris. Here he produced stoneware. In 1884, at the instigation of Bracquemond, Chaplet experimented with simple, unadorned vessels covered with Oriental types of flowing glazes. The following year, after acquiring Haviland's Vaugirard property, he began his independent career, producing stoneware with dripping glazes of decidedly Japanese inspiration [303]. In 1887 Chaplet sold his studio to Delaherche and built new kilns at Choisy-le-Roi, where he experimented in porcelains decorated with copper flambé glazes based on Chinese prototypes. In his work of the late nineties, one discerns a concern for complicated colorations in the glazes and a preference for simpler shapes of less specific historical inspiration. The combinations of different colored glazes, their bubbling and pulling, and the revelation of underlying glazes through fissures are all suggestive of Japanese precedents. This vase and three others in the Heuser collection were—fittingly enough—once in Bracquemond's own collection. Indeed, before blindness ended his career in 1904, Chaplet's last project, the decoration of the villa of the Baron Vitta, was undertaken in conjunction with his life-long friend Bracquemond. ME

1. See *Französische Keramik zwischen 1850 und 1910* (Cologne, Kunstgewerbemuseum, 1974), pp. 143–49; see also *L'art de la poterie en France de Rodin à Dufy* (Sèvres, Musée National de Céramique, 1971), pp. 21–22.

Auguste Delaherche, Armentières.

262 *Bowl.*

Porcelain with ochre, gray-green, bluish, and clear glazes, ca. 1903.

H. 3-15/16 inches (10 cm.), Diam. 7 inches (17.8 cm.).

Painted in green: a two-branched floral device terminating in trefoils and A D / 873 / 13. Painted in red: FRANCE.

New York, Private Collection.

Delaherche turned to the use of porcelain before the end of the century; he exhibited a few pieces in 1897 and again in 1902, but it was not until 1903 that he began to produce it in earnest. His treatment of porcelain, however, differs very little from that of his previous stoneware. More of the body is allowed to show through the glaze, probably because of its greater fineness. The type of signature and the work number suggest a date of about 1903, though in essence the "pure" expression founded on Eastern principles exhibited by this piece is relatively timeless, having been utilized for the past eight decades.[1] ME

1. For similar examples, see the two vases acquired by the Musée Adrien Dubouché, Limoges, inv. nos. 6640, 6641 (*Art et décoration,* XIX [1906], opposite 40) and one in the Heuser collection (*Französische Keramik zwischen 1850 und 1910* [Cologne, Kunstgewerbemuseum, 1974], no. 138, with further references).

260

261

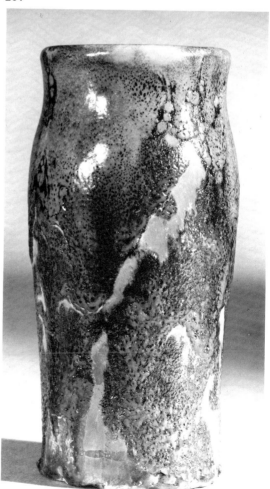

262

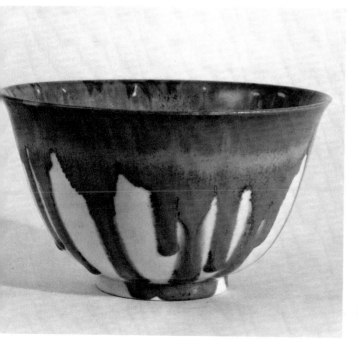

Keller et Guerin, Lunéville.

263 *Vase.*

Stoneware, iridescent glaze in tones of purplish gray and yellow; interior in purplish red with iridescent glaze. The decoration on the surface is achieved through acid etching. Ca. 1900.
H. 4-3/8 inches (11.1 cm.).
Impressed: LUNEVILLE and a device resembling a semicircle. Painted in yellow: K. G / Lunéville / R.
New York, Private Collection.

Located less than two miles to the southeast of Nancy, it was inevitable that Keller and Guerin should have produced work reflecting the influence of that school. The technique of acid etching in the glaze[1] and the floral imagery of this vase offer analogies with the contemporary glass of Gallé, which is also marked by the dual emphasis on Japanese art and nature. The bending of the flowers and the folding-over of the leaves were certainly inspired by the type of imagery readily accessible in Japanese *ukiyo-e* prints. Equally Japanese is the shape of the vase with its distended oval form, its low proportions, and the impressions of finger marks in the clay near the base, all features found in Japanese tea bowls. ME

1. Keller and Guerin may not have been the first firm to use this technique, which was also practiced by Gebleux at the Sèvres Manufactory.

Manufacturer: Keller et Guerin, Lunéville.
Designer: Ernest Bussière, d. 1937.

264 *Vase.*

Stoneware with blue and white crystalline glazes, ca. 1900–1905.
H. 5-1/2 inches (14 cm.).
Painted in blue: Lunéville / Bussière / K.G. Impressed device resembling a circle between the two arms of a right angle.
New York, Private Collection.

Bussière, a Nancy sculptor, began his association with Keller and Guerin in 1896 with *Chaos d'Automne*, a gigantic pitcher showing despondent females languishing under the broken bough of a chestnut tree. From this arch-Romantic point of view, he turned to a smaller, more practical scale, and—like the rest of the Nancy school—he fell under the sway of Gallé and his doctrine of a return to nature. Bussière's oeuvre hovered between forms that were stylized in an Art Nouveau manner and those more suggestive of a Japanese mode, as in this vase with its playful lizards. Whereas in the 1870's and 1880's it was almost *de rigueur* for Japonistes like Deck, Bouvier, and Christofle to imitate the dragons that encircled Far Eastern vases,[1] artists of the latter part of the century, including Bussière and Lachenal, were more attracted to equally Japanese but more naturalistic motifs such as these lizards.

The squatness of this vase and its small, lipless neck are also suggestive of Japanese pottery, characteristics often reflected in Bussière's work. An example of this model was shown in 1903 at the major exhibition devoted to the art of Lorraine.[2] ME

1. For example, see *Weltkulturen und Moderne Kunst* (Munich Haus der Kunst, 1972), pp. 337, 341.
2. *L'École de Nancy au Pavillon de Marsan*, II (1903), pl. 26, bottom row.

Albert-Louis Dammouse, Sèvres.

265 *Plaque.*

Stoneware with white, green, and orange-brown mat glazes, ca. 1900–1905.
Diam. 16-7/8 inches (42.8 cm.).
Painted: A D/S.
New York, Private Collection.

Dammouse's early concern with porcelain [205] was diverted in 1882 when, on the advice of Bracquemond, Charles Haviland invited the artist to work at his company's Auteuil studio. (Dammouse's brother Edouard Alexandre had already been working there for a number of years.) It may have been Dammouse who was charged with the production of reddish-brown stoneware decorated with engobes. In spite of the move to Auteuil he maintained his own studio at Sèvres where, in addition to porcelain,

263

264

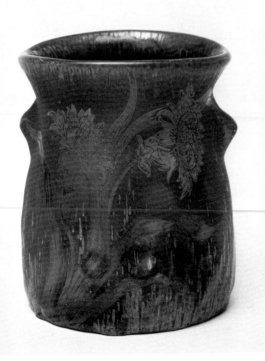

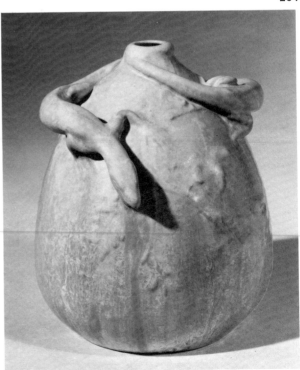

he began to make the more durable stoneware. In 1892 he built special kilns for faience and stoneware, enabling him to continue his experiments and, coincidentally, to assist Camille Moreau, whom he had befriended.

Dammouse's imagery in the 1890's was quite different from that of his earlier work. Although he retained such motifs as chrysanthemums and swimming fish, his references to Japanese art were noticeably less direct. Unlike the lobster in Bracquemond's Rousseau service, taken directly from a Hiroshige print [22], this lobster was studied from nature. The artist's absorption of Japanese principles is also apparent in the asymmetrical apposition of the crustacea and the seaweed. A date after 1900 for the plaque seems probable on the basis of compositional and thematic similarities with Dammouse's documented pieces;[1] the bold use of the bubbly glaze to suggest the frothiness of the sea is indicative of a late date, as are the irregularities and texture of the glaze, suggesting parallels with the work of other late Japonistes including Vallombreuse [270]. ME

1. Cf. the plate with fish and seaweed illus. *Der Moderne Stil,* V (1903), pl. 42, no. 3.

André Metthey, 1871–1920, Paris.

266 *Vase.*

Stoneware with grayish green mat glaze, ca. 1903.
H. 11-1/8 inches (28.2 cm.).
Incised: 2458 / A Metthey / Y (?) 11.
Paris, Félix Marcilhac.

Metthey was another ceramist who began his career as a sculptor.[1] After studying—supposedly with little success—at the École des Beaux-Arts in Dijon, he worked with a stonemason in his native Laignes (Côte d'Or). When his family moved to Paris, Metthey apprenticed with a sculptor of ornamental plaster. Other unrewarding experiences of this nature were followed by obligatory military service. While a soldier in Auxerre he took night courses in drawing and won as a prize in a regional contest Garnier's *Traité de Céramique.* It was this book that stimulated his interest in pottery. Upon his return to Paris Metthey built a kiln, but by 1892 he was still unsuccessful. At this time he began to work for the famous company of Pleyel, doing decorative carving for their pianos and harps, and for a while he desisted in his attempts to make pottery. However, across the street from Pleyel was a factory that made ceramic retorts. Metthey became friendly with the owner who allowed him access to these kilns, thus encouraging him to try his hand once again. In 1901 he exhibited his ceramics at the Salon des Indépendants and met with critical success. In essence, his career began at this

moment. Although Metthey is well known today for his enameled pottery, often made in association with the Fauve painters, his earlier works such as this vase were quite different in character. They are made of heavy stoneware and are covered with mat glazes of a type which derives from Japanese pottery but which, as we have already seen, had been popularized in France by Carriès and his followers. Metthey's simple forms, such as this long-necked flask with its flattened back side, can also be traced to the Far East, as can his decorative vocabulary. This vase with its jumping frogs, some on top of each other, is pendant to another vase which has the equally Japanese motif of snails crawling across its surface. These two models were exhibited in the 1903 Salon des artistes français. M. P. Verneuil, a major designer who championed a Japanese sense of stylization and the exploitation of animal forms, found these works somewhat rustic but amusing; in short, he admired them for just those Japanese qualities which he employed in his own art.[2] ME

1. H. Clouzot, *André Metthey—décorateur et céramiste* (Paris, 1922), esp. pl. 1; *Französische Keramik zwichen 1850 und 1910* (Cologne, Kunstgewerbemuseum, 1974), pp. 208–12. Other examples of this model are illus. *Französische Keramik,* no. 155, and M. Rheims, *L'objet 1900* (Paris, 1964), fig. 16.

2. M. P. Verneuil, "Les objets d'art à la Société des artistes français," *Art et décoration,* XIV (1903), 229.

265

266

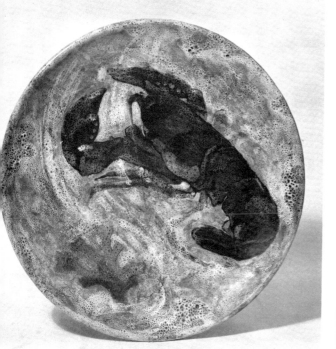

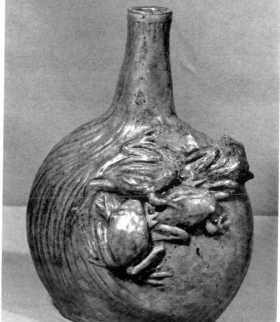

Georges Hoentschel, 1855–1915,
Château Montriveau.

267 *Covered Pot.*

Stoneware with brown, blue-green, and
white glazes and gilding, after 1900.
H. 5-3/4 inches (14.6 cm.).
Impressed monogram of "GH". Incised:
"F 143".
Paris, Alain Lesieutre.

As was the case with the Goncourts and
so many of their contemporaries,
Georges Hoentschel's interests were di-
vided between the arts of Japan and
those of eighteenth-century France.[1]
Little is known about his early career
other than that his initial orientation may
have been toward architecture or interior
decoration.[2] He was commissioned to
create the *boiseries* for the *Union cen-
trale* exhibition at the 1900 World's Fair
and was known to have designed some
furniture as well. However, Hoentschel
is primarily remembered as a ceramist.
As a close friend of Carriès, he bought
the Château Montriveau after the latter's
death and continued the production of
pottery aided by Emil Grittel, another
Carriès disciple. In later years Grittel's
kilns at Clichy gradually supplanted the
Château Montriveau establishment.

This vessel with its small handles and
ivory cover is a literal imitation of the
Japanese tea caddy, a form long familiar
to Westerners but one which was over-
shadowed by the more elaborately dec-
orated forms that initially intrigued Euro-
peans.[3] It was not until the end of the
century that such simple, sober ceramics
were admired and imitated, and even
then such work was for the most part
restricted to the members of Carriès'
circle, namely, Jeanneny and Hoentschel.
ME

1. *L'art de la poterie en France de Rodin
à Dufy* (Sèvres, Musée National de Cé-
ramique, 1971), p. 38, illus. no. 154;
*Französische Keramik zwichen 1850 und
1910* (Cologne, Kunstgewerbemuseum,
1974), pp. 131–32. See also *Weltkulturen
und moderne Kunst* (Munich, Haus der
Kunst, 1972), nos. 1523, 1522.

2. His collection of Rococo *boiseries*
and mounts constitutes the basis of the
Metropolitan Museum of Art's holdings
in these fields.

3. For example, only one is illustrated in
G. Audsley and J. Bowes, *Keramic Art of
Japan* (London and Liverpool, 1875), pl.
XXV, E.

Paul Jeanneney, 1861–1920, Saint-
Amand-en-Puisaye.

268 *Vase.*

Stoneware with brown "curdled" and
gray-ochre glazes, after 1900.
H. 10 inches (25.4 cm.).
Incised: Jeanneney and device resem-
bling a "T" with right angles under
each arm.
New York, Private Collection.

Little is known about Jeanneney's back-
ground, save that he was an enthusiastic
collector of Japanese pottery and that it
was his collection which inspired Car-
riès.[1] In turn, Carriès' work supposedly
inspired Jeanneney to try his own hand
at making ceramics. While certain bio-
graphical and chronological matters—
such as when Jeanneney came to Saint-
Amand—remain unresolved, the points
of departure for the artist's oeuvre are
clearly established as having been Car-
riès' ceramics and Japanese pottery. For
the most part, Jeanneney's glazes are a
continuation of Carriès' formulas, al-
though he emphasized particular effects
such as the brown "curdled" glaze on
this vase and the contrast between its
richness and the thin transparent glazes

267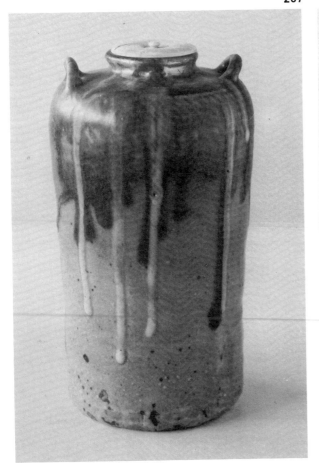

268

below. Jeanneney's forms were more varied than those of his master; still, they often constituted obvious references to Japanese shapes. It is interesting to see how in this vase Jeanneney first threw what must have been a symmetrical gourd shape and then, while the clay was still wet, gently nudged and struck it into a more irregular form—a practice in accord with the Japanese principle of exploiting the happenstance. ME

1. *Französische Keramik zwischen 1850 und 1910* (Cologne, Kunstgewerbemuseum, 1974), pp. 133–37; see also [22].

Manufacturer: Abbé Pierre Pacton, 1856–1938.
Designer: André Minil.

269 *Covered Box.*
Stoneware with green and brown mat glazes, after 1895.
H. 4-1/2 inches (11.4 cm.).
Incised monogram of PACTON. Incised: AM.
New York, Private Collection.

Abbé Pacton of Arquian learned the craft of pottery at Saint-Amand under the influence of Carriès.[1] The sculptor of the box was André Minil, a local carpenter who sometimes collaborated with the abbé. Although amateurs and only indirectly artistic descendants of Carriès, Abbé Pacton and Minil exhibited in their work a general infiltration of Japanese ideas at a secondary level. Beyond the matter of glazes already discussed in relation to other Saint-Amand potters, Eastern traditions also lie behind the concept of the lidded box and its vegetable form.[2] The interest in the lower members of the animal kingdom, such as the lizard posed on the top, was one of the lasting contributions of Japonisme to French art. ME

1. *L'art de poterie en France de Rodin à Dufy* (Sèvres, Musée, National de Céramique, 1971), p. 50.

2. See *Weltkulturen und moderne Kunst* (Munich, Haus der Kunst, 1971), nos. 1283–5.

Henri de Vallombreuse, 1856–1919, Saint-Amand-en-Puisaye.

270 *Vase.*
Stoneware with brown and white mat glazes, ca. 1905–10.
H. 3-3/4 inches (9.5 cm.).
Incised: Vallombreuse.
New York, Private Collection.

Vallombreuse was a rich Creole who, like so many of the artists associated with Saint-Amand, had a collection of Japanese pottery and an intense admiration for the work of Carriès.[1] He was associated with William Lee and Eugène Lion, and much of his pottery was accordingly indistinguishable from that of his fellow potters. Also, like so many of the later members of the Saint-Amand school, he was inspired by the rougher aspects of Japanese stoneware. The vase is hand-built and thus slightly asymmetrical; its bulky form and proportion and the intentionally irregular, frothy glaze were possible in France only after the turn of the century. ME

1. *L'art de la poterie en France de Rodin à Dufy* (Sèvres, Musée National de Céramique, 1971), p. 64.

269

270

197

Jean Pointu, 1843–1925, Saint-Amand-en-Puisaye.

271 *Vase.*

Stoneware with brown engobe and brown, white, and blue glazes, after 1900.
H. 4-5/8 inches (11.7 cm.).
Painted in blue: .U. Incised: 75.
New York, Private Collection.

Little has been forthcoming about the career of Jean Pointu prior to his arrival at Saint-Amand.[1] It is thought that his family had a factory at Fontainebleau and that he worked at various places before going to Saint-Amand. Pointu was one of the few potters at that center whose work remained relatively independent of Carriès', although he was allied with his fellow potters of that school through their common admiration for Japanese pottery. Most often, as in this vase, he covered the ceramic body with a dark brown or black engobe over which variously colored glazes blended and ran down as if at random. His sense of somber coloring is similar to that of such potters as Vallombreuse. Again, it must be noted that although the French were long familiar with Japanese pottery enameled with dark, satiny glazes, they did not endeavor to assimilate such a sober aesthetic in their own work until after the turn of the century. ME

1. *Französische Keramik zwischen 1850 und 1910* (Cologne, Kunstgewerbe-museum, 1974), p. 138.

Manufacturer: Manufacture Nationale de Porcelaine, Sèvres.
Designer: Henri Gillet.

272 *Vase.*

Porcelain with ormolu mountings, 1905.
H. 9-1/2 inches (24.1 cm.).
Marked: "Décoré à Sèvres 1905."
London, Mrs. Joan Collins.

The stylized chrysanthemum design seen on this vase has its origin in Japanese art.[1] Such decorative patterns, created by overlapping discs and other geometric formations, were used by early Japonistes: Christofle used them on some of his bronzes, and Gallé, Deck, and Cazin used them on pottery.[2] Essentially, though, these examples are a straightforward imitation of Japanese prototypes and show little attempt to assimilate any underlying principles. Moreover, in the hiatus between 1880 and the turn of the century there was little interest in this aspect of Japanese art. This situation altered around 1900 when French designers began to look at the principles of Japanese pattern-making, a change clearly registered in Grasset's books on design. It is only then that we find the re-emergence of such Japanese geometric designs. In addition to this Sèvres vase, one might look at one of the Lyons silk fabrics in the Metropolitan Museum [290], Manuel Orazzi's 1900 poster for Loie Fuller, and the work of Théodore Lambert.[3] Of course, one should turn to Vienna and the work of Klimt and

Moser to find a more consistent usage of such pattern-making ideas. Seen in this vase is the seed of the new style of the 1920's, a reminder that Japonisme did not end with World War I but was a phenomenon that has continued in varying guises to the present day. ME

1. This vase is illustrated in R. Bouyer, "Les vases de Sèvres décorés par Henri Gillet," *L'art décoratif,* XXVI (Paris, 1911), 27.

2. For such Christofle pieces, see especially *Gazette des Beaux-Arts,* s.2, XVIII (1878), 231. The Cazin vase is in the Sèvres Museum, inv. no. 219.

3. Quite evident Japanese references in the Orazzi poster are the crane and the three-leaved patterns which are basic elements in Japanese heraldry. Moreover, the bleeding bands of horizontal colors that constitute the background are a clear allusion to the standard tradition of Japanese printmaking.

272

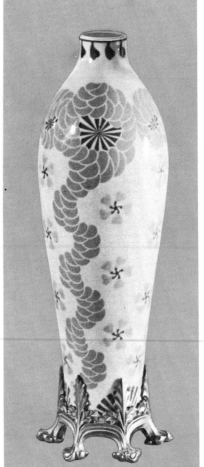

271

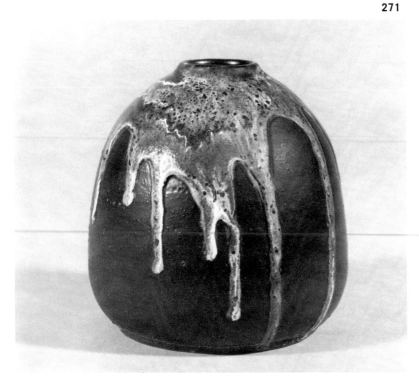

Emile Decoeur, 1876–1953, Paris.

273 *Vase.*

Stoneware with brown and gray mat
glazes, ca. 1905–10.
H. 13-1/2 inches (34.3 cm.).
Incised: E D (conjoined) ecoeur.
Painted: 19.
Paris, Félix Marcilhac.

Emile Decoeur was apprenticed at the
age of fourteen to Edmond Lachenal.[1]
His talent was soon recognized and he
was placed in charge of the atelier. By
the late 1890's Lachenal was working in
a high Art Nouveau style characterized
by abstract designs with whiplash curves
and highly stylized floral motifs. Many of
the finest pieces from this period bear
both Lachenal's mark and Decoeur's
cipher. Indeed, although he was not in-
dependent, Decoeur's work was always
clearly marked with his name appearing
alongside that of Lachenal's; at the 1900
World's Fair he received a separate
bronze medal. About 1903 Decoeur left
Lachenal and established his studio in the
Auteuil section of Paris where he worked
together with Rumèbe. This association
lasted less than four years, and by 1907

Decoeur, now totally independent, had
moved to Fontenay-aux-Roses.

Decoeur's interest in Far Eastern pot-
tery is evident even in his most obviously
Art Nouveau vases produced during his
stay with Lachenal, for, despite the com-
plicated interlaces, one can see that De-
coeur was equally concerned with richly
colored flambé glazes. His departure in
1903 coincided with the declining popu-
larity of Art Nouveau; while he produced
some vases whose sculpted forms re-
tained suggestions of that dying style,
many of his works had no decoration
whatsoever, their pure shapes enhanced
only by bleeding glazes. Also, like other
artists of the first decade of this century,
when he did try his hand at decoration,
he turned to patterns that were quite
explicitly Japanese, as we can see in the
formalized pattern of rippling water on
this vase.[2] Moreover, the soft mat quality
of glaze and the refined harmony of gray
and brown were in accord with the
"modern" sense of Japonisme being ex-
pressed at the same time by the potters
of Saint-Amand. ME

1. *Französische Keramik zwischen 1850
und 1910* (Cologne, Kunstgewerbe-
museum, 1974), pp. 215–19.

2. That this formalized pattern represents
water rather than, for example, clouds, is
demonstrated in an original photograph
(signed by the artist) in a scrapbook in
the library of the Musée des Arts Dé-
coratifs, Paris (CXXXVIII, no. 24), which
shows a Decoeur vase with a similar rip-
pling pattern with seaweed below, mak-
ing it clear that the decoration is marine
in nature.

E. Decoeur, Paris.

274 *Vase.*

Stoneware with brown and grayish white
mat glazes, ca. 1905–10.
H. 13-1/4 inches (33.6 cm.).
Incised: E D (conjoined) ecoeur.
Numbered in red paint: 19.
New York, Private Collection.

As in the case of the previous Decoeur
vase, here too the decoration is una-
bashedly Japanese. For some viewers the
bamboo may be too Japanese. It is in-
teresting that such a frank return to

273

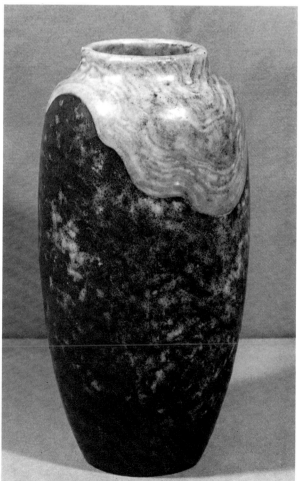

274

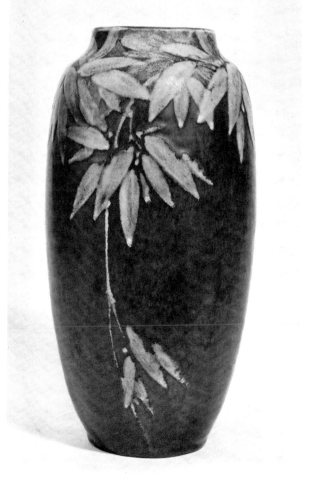

Japanese art came at a moment of retrenchment. With the decline of the Art Nouveau style, critics and artists alike appeared to have fallen back with relief upon a "safer" style; in the 1870's the safer style would have lain somewhere in the Greco-Roman/Renaissance tradition, but by 1900 Japanese art had assumed this role for the *modern* designer. Decoeur showed a vase with similar decoration of bamboo, although of different form, in 1907; he exhibited an almost identical vase in 1911 and, in 1918, a third, also similar to ours. This suggests that the period between 1905 and 1920 represented a lull between two peak moments of artistic creativity.[1] Japonisme was a basic subcurrent which connected them and, in a period of lessened creativity, it rose more clearly to the surface. ME

1. Illus. *L'art décoratif*, XVII (1907), 48; *Art et décoration*, XXIX (1911), 95; *La renaissance de l'art français et des industries de luxe*, I (1918), 177.

Fernand Rumèbe, 1875–1952, Paris.

275 *Plaque.*

Stoneware with green, beige, brown, and white mat glazes, ca. 1904–10.
Diam. 9-3/8 inches (23.8 cm.).
Incised: F. Rumèbe. Impressed: 128.
New York, Private Collection.

Fernand Rumèbe's early career is shrouded in obscurity.[1] His background appears to have been provincial, and we cannot trace his whereabouts until 1904, when he shared with Decoeur a studio in the Auteuil section of Paris. In 1907 the two ceramists went their separate ways, and again we have little knowledge about Rumèbe's activities, except that sometime between then and 1911 he traveled to Turkey. This trip to the Near East was symptomatic of Rumèbe's extra-European outlook, and ultimately the artist traveled to French Indo-China as well.

This plaque would seem to be from the early part of his career. In terms of material and glaze it is comparable to Decoeur's work, and it appears to precede the point at which he was seduced by the glazed wares of the Near East and their overall patterns. The highly stylized and asymmetric arrangement of eucalyptus leaves and flowers is typical of the sharper, more geometric type of Japanese design favored in France at the end of the first decade of this century. ME

1. *Französische Keramik zwischen 1850 und 1910* (Cologne, Kunstgewerbemuseum, 1974), pp. 213–14.

Manufacturer: Georges Despret, 1862–1952, Jeumont.
Designer: Yvonne Serruys, 1874–after 1931.

276 *Vase.*

Molded *pâte-de-verre* glass, ca. 1900–1910.
H. 10 inches (25.4 cm.).
Etched: Despret.
Corning, New York, Corning Museum of Glass.

A major innovation in late nineteenth-century glassmaking was the invention of *pâte-de-verre*, that is, a paste of powdered colored glass formed and fired almost like a ceramic.[1] Its discovery can be attributed to Henri Cros, whose early work in encaustic painting and sculpture in the antique manner led him to speculate about what Pliny referred to as "long-grained" glass. Although Cros had successfully fabricated *pâte-de-verre* by 1884, he did not exhibit it until the 1889 World's Fair. By the late 1890's this material began to attract a number of artists

275

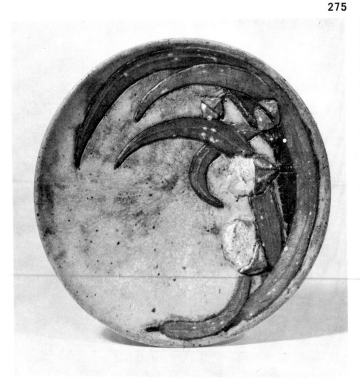

276

such as Albert Dammouse, Emile De-corchemont, and Georges Despret, the director of the Glacerie de Jeumont. The new material did not per se demand any particular style. Cros, for example, worked in the Greco-Roman vein as be-fitted his archaeological leanings; Dam-mouse relied upon a Japanese-tempered sense of nature as did Decorchemont, although the latter also created striking Art Nouveau designs constructed on the basis of a whiplash curve. Despret's work also hovered between the poles of Japonisme and Art Nouveau. Although some critics have been tempted to as-sociate the form of this Despret vase with the Art Nouveau style, it should more accurately be seen as yet another mani-festation of Japonisme. As a symbol of courage, the leaping carp is a form fre-quently used in Japanese vases of all media. Despret's example may be styl-ized in a less specifically Japanese fash-ion than is a Rousseau model of two decades earlier, since it represents the type of assimilation of Japanese concepts encountered in 1900.[2] ME

1. *Glassammlung Hentrich, Jugendstil und 20er Jahre* (Düsseldorf, Kunst-museum, 1973), pp. 224–29. Another ex-ample of this model, but with a base, is discussed as no. 167.
2. *Revue des arts décoratifs,* V (1884–85), opp. 194.

René Lalique, Paris.

277 *Comb.*
Carved horn, 1905.
4-1/2 x 4 inches (11.4 x 10.2 cm.).
Incised: LALIQUE 1905.
New York, Lillian Nassau, Ltd.

The chrysanthemum is the national flow-er of Japan and as such is seen frequently in the art of that country. Quite predict-ably it became popular in France as well, not only as a decorative motif but also as a cultivated flower (Gallé presented a horticultural treatise on the flower). Lalique's use of the flower on this comb, particularly in this marked asymmetrical composition, and his use of horn are clearly undisguised references to Japan-ese art and are typical of how French artisans—even major practitioners of the Art Nouveau style like Lalique—often fell back on Japonisme as an alternative mode. WRJ ME

Lucien Gaillard, b. 1861, Paris.

278 *Comb.*
Carved blond and tinted horn, after 1900.
5-5/8 x 3-7/8 inches (14.3 x 9.8 cm.).
Engraved: L. Gaillard.
New York, Private Collection.

One of the most enthusiastic Japan-ophiles was unquestionably Lucien Gail-lard, son of Ernest Gaillard, the noted silversmith. In 1878, the year he joined his father's firm, Lucien was exposed to Japanese metalwork at the Exposition. Three years later he began investigations of Japanese industrial arts that culmi-nated in 1900 with the introduction of Tokyo craftsmen into his new manu-factory on rue La Böetie in Paris.[1] As an admirer of Lalique, he turned to the pro-duction of *objets de fantaisie,* including combs which he exhibited at the Salon of 1902. The swallow motif in this piece is quite naturalistic but its appearance in conjunction with the bough of prunus blossoms bespeaks its Oriental source of inspiration. WRJ

1. H. Vever, *La bijouterie française,* III (Paris, 1908), 636–43.

277

278

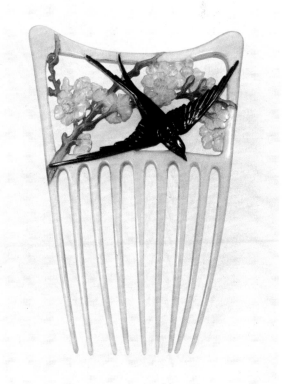

Lucien Gaillard, Paris.

279 *Covered Box.*

Wood with beetle in bronze, ca. 1905–10.

H. 3-1/8 inches (7.9 cm.), W. 4-1/2 inches (11.4 cm.), D. 3-3/8 inches (8.5 cm.).

Incised on left front side of lid: L. GAILLARD.

New York, Lillian Nassau, Ltd.

The exploitation of the graining of wood for decorative purposes was a practice originating in Japan. Audsley, discussing a Japanese screen in 1880, remarked that the wood was "so treated, by some grinding or rubbing process, that the hard portions of the grain stand in slight relief. By this process, the details of which we are ignorant, a beautiful texture is imparted to the surface of the wood, and one which the Japanese workman is particularly fond of."[1] Like so many Oriental techniques which seemed mysterious at first and then were quickly imitated by Western artists, this too was mastered. In the first decade of this century Gaillard and his contemporaries were exploring a range of techniques involving semi-precious materials, lacquer, and encrusted woods. Of course Gaillard was greatly aided in his experiments by the Japanese workmen whom he brought over to work in his atelier. This box was probably produced about 1907, the year that Gaillard ex-

hibited another box of similarly treated wood (described, alas, as *bois de Chine*), and adorned with a bronze cobra head rather than a beetle.[2] The insect, both in terms of its motif and its material (a richly patinated bronze), is obviously of Japanese inspiration. In fact, more than one reviewer rebuked Gaillard for aping Japanese patinas and designs. ME

1. G. Audsley, *Ornamental Arts of Japan* (London, 1884), sec. V, pl. VII.

2. *Art et décoration*, XXI (1907), 216. For similar bronze scarabs by Gaillard see *ibid.*, XVI (1904), 168; XIX (1906), 188.

Designer: Henri Husson, 1852–1914.
Foundry: A. Hébrard, Paris.

280 *Vase.*

Martelé copper with silver incrustations, ca. 1900–1910.

H. 6-7/16 inches (16.4 cm.).

Incised: h husson. Impressed: A. Hébrard, Paris. Painted: No 290.

New York, Lillian Nassau, Ltd.

Husson was born in Grau (Vosges) and came to Paris, where he was employed by furniture restorers and dealers as a locksmith. While practicing this craft he learned the early techniques of metalwork that he later put to good use as a *ciseleur* and silversmith. He left Paris for Nantes and later settled in Vétheuil, though he continued to exhibit at the

Paris Salons from 1900 until his death in 1914. In 1909 the founder Hébrard, who had discovered him thirty years earlier, organized an exhibition of his metalwork. Husson's work represented the assimilation of Japonisme into a highly personal naturalistic style. Although denying the influence upon his metalwork of the traditional French styles, Thieme and Becker admitted that Japanese art had played a role in his development,[1] a fact apparent not only in his interpretation of fauna but in his treatment of the surfaces of his medium. WRJ

1. Ulrich Thieme and Felix Becker, eds., *Allgemeines Lexikon der Bildenden Kunstler*, XVIII (Leipzig, 1925), 183.

Pierre Jules Augustin Lenormand, fl. 1889–1913, Paris.

281 *Bowl.*

Bronze with green and red patinas, ormolu, about 1900.

Diam. 10 inches (25.4 cm.).

Incised: A. Lenormand.

New York, Carol Ferranti, Ltd.

Christopher Dresser in his discussion of Japanese metalwork, which he regarded as the most perfect ever produced, cited its extraordinary color harmonies that were said to have been unequaled in the West.[1] This piece in its combination of patinas and use of gilding as well as in

279 **280**

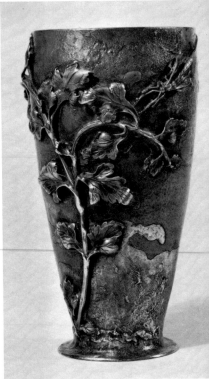

its vegetative form strongly bespeaks an Oriental source. In a Japanese bronze cup belonging to the celebrated Japanophile, Alphonse Hirsch,[2] leaves are also used to form the bowl and a stem of a flower is likewise used for the handle. WRJ

1. Christopher Dresser, *Japan: Its Architecture, Art and Art Manufactures* (London, 1882), 428.

2. Louis Gonse, *L'art japonais*, II (Paris, 1883), 48.

Charles Hairon, Paris.

282 *Covered Box.*

Light and dark woods with gold appliqué, ca. 1909.

Diam. 2-1/2 inches (6.3 cm.).

Incised inside of lid: C. HAIRON, PARIS. Paper label: 7 juillet 1909 / Achat fait à / Mr. C. Hairon.

Paris, Musée des Arts Décoratifs.

Applied to this round wooden box is a fish of dark wood with grain simulating scales. Gold is used for the fins and for the plant forms.

In reviewing the sixth Salon of the Societé des Artistes Décorateurs Charles Saunier cited the sculpted and encrusted boxes of Hairon as examples of how French craftsmen had put into practice certain Japanese principles including the rejection of size merely for itself and the emphasis on perfection of execution rather than on concern for the preciousness of materials.[1]

Charles Hairon exhibited at the Salons of the Société Nationale des Artistes Français from 1904 to 1911, and participated in the Salons of the Société des Artistes Décorateurs from 1904 to 1912, and again from 1920 to 1931. ME WRJ

1. *Art et décoration*, XXIX (1911), 87.

Paul Vié, Paris.

283 Binding for *Petites Fêtes* by Henri Lavedan.

Ca. 1900.

7-1/2 x 5 inches (19 x 12.7 cm.).

Printed on flyleaf: PAUL VIE.

New York, Lucien Goldschmidt.

Japanese leather paper *(kami-kawa)* ornamented with raised floral and arabesque motifs has been employed by the publisher for the covers. Octave Uzanne cites several examples of the use of this material by the binder Amand prior to 1882,[1] but this example is undoubtedly later, since Vié is listed as having been active between 1900 and 1910.[2] WRJ

1. Octave Uzanne, *La reliure moderne* (Paris, 1887), pls. 22, 25.

2. Roger Devauchelle, *La reliure en France*, III (Paris, 1961), 279.

283

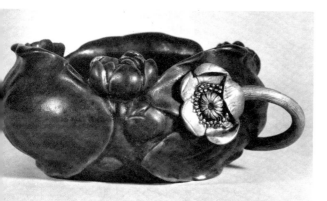

281

282

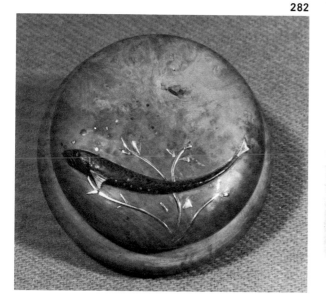

284

285

Charles Meunier, Paris.

284 Bookbinding for *A Catalogue of Blue and White Nankin Porcelain Forming the Collection of Sir Henry Thompson.*
1902.
10-1/4 x 8-1/4 inches (26 x 21 cm.).
Stamped in gold on turn-in:
 CH. MEUNIER, 1902.
Baltimore, The Walters Art Gallery.

The blue and cream marbled calfskin binding is decorated with prunus blossoms in mosaic and blind-tooled butterflies resembling Whistler's familiar signature. Circular Chinese plaques of blue and white porcelain are set into the front and back covers. Oriental silk of blue and gold woven with phoenix motifs is used for the doublures and *gardes,* while Japanese paper bearing hawthorne designs serves for the inner *gardes.* Meunier was noted for his marbled-calfskin bindings.[1] His earliest recorded *reliure-céramique* was for the 1887 publication of Deck's *Histoire de la faïence.*[2] This book, published in London in 1878 in a limited edition of 220 copies, contains twenty-six illustrations printed after drawings by J. M. Whistler and Sir Henry Thompson. WRJ

1. Roger Devauchelle, *La reliure en France,* III (Paris, 1961), 100, n. 1.
2. Henri Béraldi, *La reliure du XIXe siècle,* IV (Paris, 1896), 142.

Charles Meunier, Paris.

285 Bookbinding for *L'Effort* by Edmond Haroucourt.
1909.
11-1/4 x 9 inches (28.6 x 22.9 cm.).
Stamped in gold on turn-in:
 CH. MEUNIER, 1909.
Edward R. Schaible.

L'Effort, a deluxe book published in 1894 by Les Bibliophiles contemporains and illustrated by A. Lunois, E. Courbon, Carlos Schwabe, and A. Séon, is often encountered in an equally deluxe binding. The morocco leather covers are inlaid with patterns composed of irises and foliate interlace. Lily motifs are employed on the spine. Hokusai's and Hiroshige's representations of these flowers popularized them in the West, and they were subsequently incorporated into the vocabulary of Art Nouveau.[1] WRJ

1. *World Cultures and Modern Art* (Munich, 1972), pp. 110–11.

Charles Meunier, Paris.

286 a-b Bookbinding for *La vie des abeilles* by Maurice Maeterlinck.

About 1908–11.
9-5/8 x 7-1/2 inches (24.4 x 19 cm.).
Stamped in gold on doublure:
 CH. MEUNIER, 1911.
Edward R. Schaible.

This lavishly bound book, printed by the Société des Amis du Livre Moderne in 1908 for the Swiss bibliophile Marc Peter, exhibits a number of features conveying an Oriental character. The crushed morocco binding is decorated with bees tooled in gold. Carlos Schwabe's sixty-eight colored woodcut illustrations are protected with tissue plates laid with Japanese motifs. The full doublures are inlaid with floral and bee motifs and the *gardes* are of blue and gold Japanese silk. WRJ

286a

286b

Anonymous, Lyons.

287 *Fabric Sample.*

Silk, warp twill with areas
of plain weave and satin, patterned
in various combinations of weft
threads, ca. 1897–1905.

11-1/2 x 7-1/2 inches (29.2 x 19 cm.);
matted, 19 x 14 inches (48.2 x 35.6
cm.).

New York, The Metropolitan Museum
of Art, Rogers Fund, 1908.

This sample incorporates orange-,
green-, and gold-colored bird, flower,
fan, and diaper motifs against a blue
ground. Its unusually rich design, sug-
gesting a Japanese *obi* (sash) worn by
women, offers close parallels with Japan-
ese silks such as one in a set of Japanese
examples assembled by S. Bing and now
also in the Metropolitan Museum [304].
This French fabric and the following
seven are believed to have been assem-
bled by the firm of J. Claude Frères et
Cie. of 10 rue d'Uzes, Paris, between
1897 and 1905. Though they are pre-
sumed to have been woven in Lyons,
their actual manufacturer has not been
identified. WRJ

287

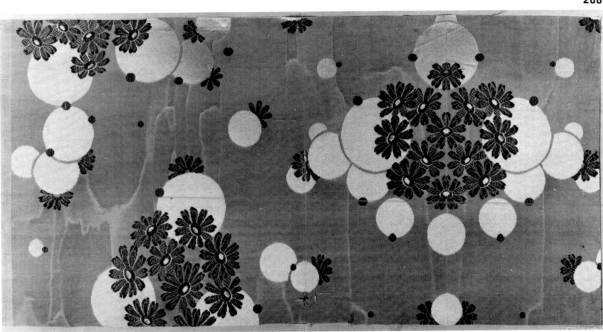

Anonymous, Lyons.

288 *Fabric Sample.*

Silk, warp-surfaced plain weave moiré
with details in satin weave and
weft floats, ca. 1897–1905.
7-1/2 x 15-1/2 inches (19 x 39.3 cm.).
New York, The Metropolitan Museum
of Art, Rogers Fund.

Irregular patterns of pink and ivory
asters and circles against a moiré gray
constitute the design of this sample
which is of apparent Japanese inspira-
tion. WRJ

Anonymous, Lyons.

289 *Fabric Sample.*

Silk, warp-surfaced plain weave
with satin flower in flushing warp,
ca. 1897–1905.
8-3/4 x 9-1/4 inches (22.2 x 23.5 cm.).
New York, The Metropolitan Museum
of Art, Rogers Fund.

Set against a background of pink, yellow,
and greenish-gray stripes is an ochre
flower—perhaps a morning glory—that
in its abstraction recalls the *mon,* or
family crests, found on Japanese pen-
nants. WRJ

Anonymous, Lyons.

290 *Fabric Sample.*

Silk, satin damask with details
in weft floats, ca. 1897–1905.
5-1/2 x 8-1/2 inches (14 x 21.6 cm.).
New York, The Metropolitan Museum
of Art, Rogers Fund.

This design, composed of irregularly
shaped elements connected by delicate
web-like filaments, appears to have been
inspired by the mulberry-paper stencil
patterns used by the Japanese for dyeing
silk and cotton fabrics. WRJ

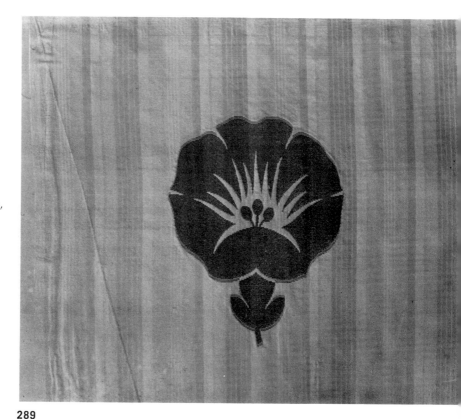

289

290

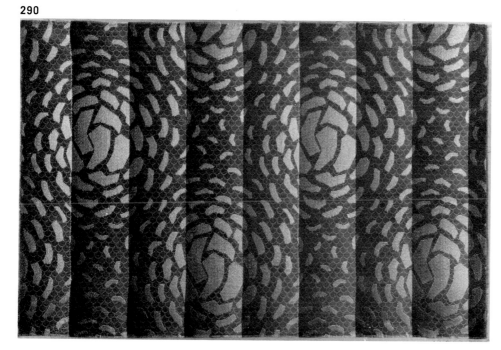

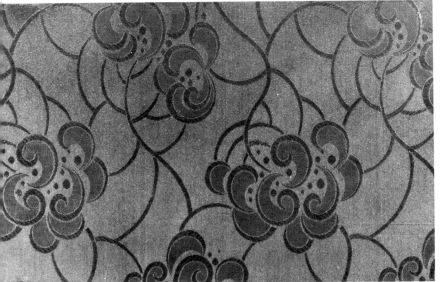

Anonymous, Lyons.

291 *Fabric Sample.*

Silk, satin damask with details in weft
 floats, ca. 1897–1905.
6 x 9-1/2 inches (15.2 x 24.1 cm.).
New York, The Metropolitan Museum of
 of Art, Rogers Fund.

Like the previous example, this abstract
floral design rendered in purple on
brown, is reminiscent of the patterns
employed in Japanese stencils. WRJ

Anonymous, Lyons.

292 *Fabric Sample.*

Silk, satin damask with details
 in weft floats, ca. 1897–1905.
8 x 9-1/4 inches (20.3 x 23.5 cm.).
New York, The Metropolitan Museum
 of Art, Rogers Fund, 1908.

This geometric design of red and green
discs and stripes resembles the type of
plaid design associated with robes worn
in the Japanese *Kyōgen* comedies. WRJ

Anonymous, Lyons.

293 *Fabric Sample.*

Silk, plain weave with pattern
 dyed in warps *(chiné),* ca. 1897–1905.
8 x 9-1/2 inches (20.3 x 24.1 cm.).
New York, The Metropolitan Museum
 of Art, Rogers Fund, 1908.

Although this design of blue circles con-
nected by wavy bands of orange lines
cannot be related to a specific Oriental
archetype, its two decorative compo-
nents are derived from Japanese designs.
WRJ

291

292

293

208

Anonymous.

294–298 *Wallpaper Samples.*

Ca. 1900–1910.

12-5/8 x 18-15/16 inches (32 x 48.1 cm.).
Paris, Bibliothèque Forney.

These five examples of Japonisme are
from an album of 444 leaves by an uni-
dentified French manufacturer. The vi-
brant colors of many of the samples sug-
gest a relatively late date of manufacture.
Included in the albums are samples dec-
orated with such motifs as kimono-clad
ladies, rickshas, fans with Japanese calli-
graphy, and branches of cherry blossoms,
as well as various abstract motifs. Occa-
sionally, as in the case of a pattern with
stylized flowers [297], there are interest-
ing parallels with Japanese prototypes
such as fabric designs. WRJ

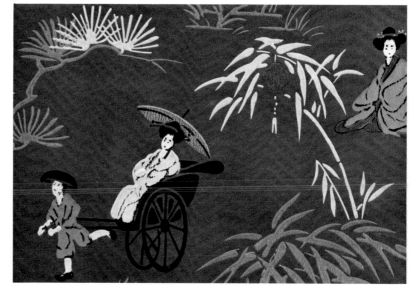

294

295

296

297

298

299 *Cock on Temple Drum.*
Silver and gilt.
Japan, 19th century.
H. 15-11/16 inches (39.9 cm.).
Baltimore, The Walters Art Gallery.

300 *Basket-Weave Vase.*
Bronze.
Japan, 19th century.
H. 7-7/8 inches (20 cm.).
Baltimore, The Walters Art Gallery.

301 *Snuff-Bottle in Form of Withered
 Peach with a Bat.*
Mother-of-pearl with a green
 glass stopper.
Japan, 19th century.
H. 2-7/16 inches (6.2 cm.).
Baltimore, The Walters Art Gallery.

302 *Tea Bowl.*
Stoneware with reddish black glazes.
Japan, 19th century.
H. 3-13/16 inches (9.7 cm.).
Baltimore, The Walters Art Gallery.

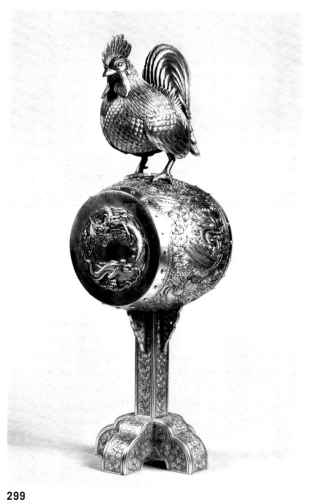

299

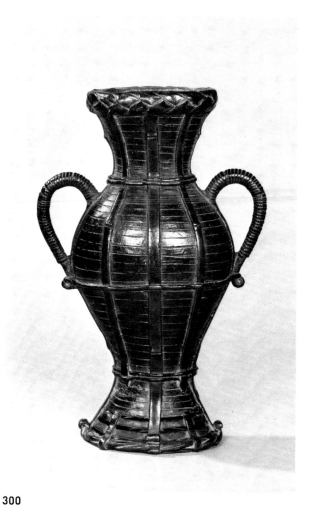

300

301

302

303 *Vase.*
Stoneware, partially glazed.
Japan, 19th century.
H. 11-3/8 inches (28.9 cm.).
Baltimore, The Walters Art Gallery.

304 *Mounted Japanese Textile Samples.*
Silk textiles and embroideries.
Japan, 17th to 19th centuries.
Collector's mark: 4.2.145.
New York, The Metropolitan Museum of
 Art, Gift of Mr. and Mrs. H. O.
 Havemeyer, 1896.

These six textiles, exhibiting various
Japanese techniques and patterns, were
assembled and mounted by Samuel Bing
in the late nineteenth century.

303

304

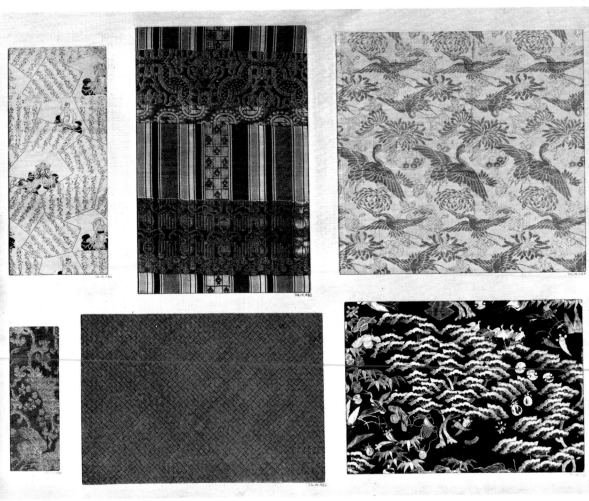

V. Photographic Documentation: Japan as Known to Early Japonistes

A strong interest in photography during the 1860's increased the value of the work of Felice Beato who took a series of images in Japan between 1862 and 1868. While the exact number of photographs he took is difficult to ascertain (186 albumen prints are now in the Victoria and Albert Museum, London), they do provide an exacting impression of contemporary Japan—then being opened to Western contact.

Beato was a Venetian, later a British subject, who travelled in the Near East and India recording the architectural monuments of Egypt as well as contemporary events. He was often involved in violent episodes such as the Crimean War (1855–56), the Indian Mutiny (1859), and possibly the Japanese Civil War (1868). Essentially, Beato combined accurate reporting with a sensitivity to people and places. His views of Japan capture a country untouched by Western influence [305 and 306] although a number of photographs show the European settlement in Yokohama.

Beato's photographs of peasants, ordinary family life, and governmental officials were augmented by scenes of the countryside and architecture. Engravings of some Beato photographs were used by Aimé Humbert in his *Le Japon Illustré* (Paris, 1870) [307 and 308]. This volume was known to all French Japonistes and provided them with a current view of Japan. Undoubtedly Beato's prints were also collected independently in France.

A collection of Beato's photographs was published in Japan as Signor F. Beato, *Photographic Views of Japan, with historical and descriptive notes compiled from authentic sources and from personal observation during a residence of several years by James William Murray, Esq., Assistant Commissary General, Yokohama* (Yokohama, 1868; printed by the *Japan Gazette* office).

G.P.W.

Felice Beato (English, born in Italy).

305 *The Tokaido, Between Yokohama and Fujisawa* from the album, *Photographic Views of Japan* (Yokohama, 1868).
Albumen print, 9-1/4 x 11-1/4 inches (23.5 x 28.5 cm.).
Rochester,
George Eastman House Collection.

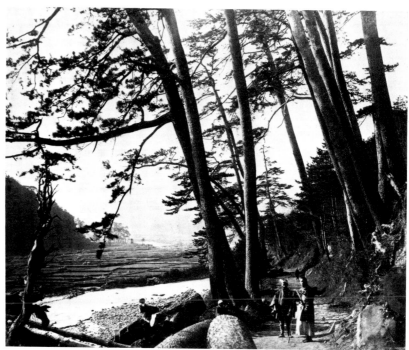

305

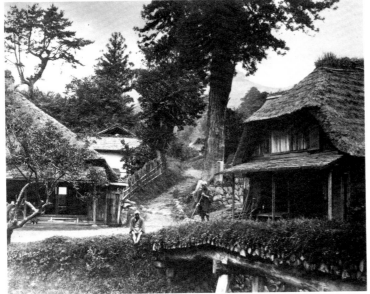

306

Felice Beato.

306 *View at Eiyama* from the album, *Photographic Views of Japan.*

Albumen print, 9 x 11-3/8 inches (22.9 x 28 cm.).

Rochester, George Eastman House Collection.

Felice Beato.

307 *Curio Shop* from the album, *Photographic Views of Japan.*

Albumen print, 7-1/2 x 10 inches (10 x 25.4 cm.).

Rochester, George Eastman House Collection.

Anonymous.

308 Engraving after Felice Beato from Aimé Humbert, *Le Japon Illustré* (Paris, 1870).

Boston, Museum of Fine Arts Library.

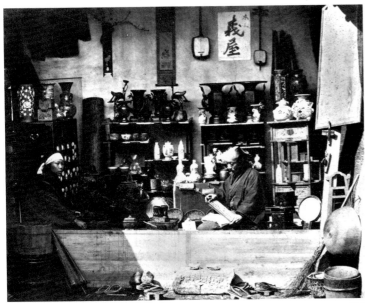

307

308

Bibliography

Selected Print Bibliography

Adhémar, Jean. *Toulouse-Lautrec: His Complete Lithographs and Drypoints.* New York, 1965.

Alcock, Rutherford. *Catalogue of Works of Industry and Art Sent from Japan, International Exhibition.* London, 1862.

Alexandre, Arsène. "George Auriol." *Art et Décoration,* 5 (June 1899), 161–70.

Allemand, Geneviève. "Le Rôle du Japon dans l'évolution de l'habitation et de son décor en France dans la seconde moitié du XIXè siècle et au début du XXè siècle." M. A. thesis, Ecole du Louvre, 1964.

André, Edouard. *Alexandre Lunois.* Paris, 1914.

Astruc, Zacharie. "Beaux-Arts, l'Empire du Soleil Levant." *l'Etendard,* February 27 and March 23, 1867.

———. "Le Japon chez nous." *l'Etendard,* May 26, 1868.

Azechi, Umetaro. *Japanese Woodblock Prints, Their Technique and Appreciation.* Tokyo, 1963.

Bailly-Herzberg, Janine. *L'Eau-forte de peintre au dix-neuvième siècle: La Société des Aquafortistes (1862–67).* Paris, 1972.

Bénédite, Léonce. "Félix Bracquemond l'Animalier." *Art et Décoration,* 17 (February 1905), 35–47.

———. "Whistler." *Gazette des Beaux-Arts,* 34 (1905), 142–58.

Béraldi, Henri. *Les Graveurs du dix-neuvième siècle.* Paris, 1885–92.

Bing, S. *Le Japon Artistique.* Paris, 1888–91.

———. *Exposition de la gravure japonaise à l'Ecole Nationale des Beaux-Arts.* Paris, 1890.

———. "La Gravure japonaise." *l'Estampe et l'Affiche,* 1 (April 1897), 38–44.

Boller, Willy. *Masterpieces of the Japanese Colour Woodcut.* London, 1957.

Bouillon, Jean-Paul. "La Correspondance de Félix Bracquemond, une source inédite pour l'histoire de l'art français dans la seconde moitié du XIXè siècle." *Gazette des Beaux-Arts,* 82 (December 1973), 351–86.

———. *Catalogue de l'exposition, hommage à Félix Bracquemond.* Paris: Bibliothèque Nationale, 1974.

———. *Catalogue de l'exposition Félix et Marie Bracquemond.* Mortagne and Chartres, 1972.

Bourcard, Gustave. *Félix Buhot.* Paris, 1899.

Félix Bracquemond and the Etching Process, An Exhibition of Prints and Drawings from the John Taylor Arms Collection. Organized by Robert H. Getscher. Cleveland: John Carroll University, 1974.

Breeskin, Adelyn. *The Graphic Work of Mary Cassatt.* New York, 1948.

Burty, Philippe. *Les Emaux cloisonnés anciens et modernes.* Paris, 1868.

———. "Le Musée oriental à l'Union centrale." *Le Rappel,* October 25 and November 2, 1869.

———. "Exposition Universelle de 1878, Le Japon ancien et le Japon moderne." *L'Art,* 15 (1878), 241ff.

———. Series in *La Renaissance littéraire et artistique,* 1: "Japonisme I" (May 1872), 25–26; "Japonisme II" (June 1872), 59–60; "Japonisme III" (July 1872), 83–84; "Japonisme IV" (July 1872), 106–7; "Japonisme V" (August 1872), 122–23; vol. 2, "Japonisme VI" (February 1873), 3–5.

———. *Grave Imprudence.* Paris, 1882.

———. "Félix Buhot, Painter and Etcher." *Harpers New Monthly Magazine,* 76 (February 1888), 329–35.

Cailler, Pierre. *Catalogue raisonné de l'oeuvre gravé et lithographié de Maurice Denis.* Geneva, 1968.

Caso, Jacques de. "1861: Hokusai rue Jacob." *The Burlington Magazine,* 111 (September 1969), 562–63.

Catalogue de l'exposition rétrospective de l'art japonais. Paris, 1883.

Champfleury. "La Mode des Japoniaiseries." *La Vie Parisienne,* November 21, 1868, pp. 862–63.

———. *Les Chats.* Paris, 1869.

———. *Le Réalisme* (Textes choisis et présentés par Geneviève et Jean Lacambre). Paris, 1973.

Charlevoix, Père de. *Histoire et description générale du Japon.* Paris, 1736.

Chesneau, Ernest. *L'Art Japonais.* Paris, 1869.

———. "Beaux-Arts, l'Art japonais." *Le Constitutionnel,* January 14, January 22, and February 11, 1868.

———. "Le Japon à Paris." *Gazette des Beaux-Arts,* 18 (1878), 385–97.

Collection Ph. Burty. *Catalogue de peintures et d'estampes japonaises, de kakemonos, de miniatures indo-persanes et de livres relatifs à l'orient et au Japon.* Introduction by Ernest Leroux. Paris, 1891.

Collection Charles Gillot, estampes japonaises et livres illustrés. Paris, 1904.

Collection Henri Vever: Part I. Sale catalog, Sotheby and Company, London, March 26, 1974.

Crauzat, E. de. *l'Oeuvre gravé et lithographié de Steinlen.* Paris, 1913.

Cutler, Thomas W. *A Grammar of Japanese Ornament and Design.* London, 1879.

de Goncourt, Edmond. *Outamaro, Le Peintre des Maisons Vertes.* Paris, 1891.

———. *Hokousai.* Paris, 1896.

Delteil, Loys. *Edgar Degas, Le Peintre-Graveur Illustré.* Paris, 1919.

Duranty, Edmond. "L'Extrême Orient à l'Exposition universelle." *Gazette des Beaux-Arts,* séries 2, 18 (December 1878), 1011–48.

———. "Japonisme." *La Vie Moderne,* June 26, 1879, pp. 178–80.

Duret, Théodore. "L'Art japonais." *Gazette des Beaux-Arts,* séries 2, 26 (August 1882), 113–33.

———. *Livres et albums illustrés du Japon réunis et catalogués.* Paris, 1900.

Eaux-fortes, manière noire, pointes sèches, J. J. Tissot. Paris, 1886.

L'Estampe Impressionniste. Catalog by Michel Melot, Conservateur au Cabinet des Estampes. Paris, 1974.

L'Exposition de 1874 chez Nadar (rétrospective documentaire). Catalog by Hélène Adhémar and Sylvie Gache. Paris, 1974.

Fontaine, André. "Félix Buhot: sa vie et son oeuvre." Manuscript, Cabinet des Estampes, Bibliothèque Nationale, 1930.

Forgotten Printmakers of the 19th Century. Catalog of the Kovler Gallery; preface by Marjorie B. Kovler. Chicago, 1967.

Goldschmidt, Lucien, and Schimmel, Herbert, eds. *Unpublished Correspondence of Henri de Toulouse-Lautrec.* London, 1969.

Gonse, Louis. *L'Art Japonais,* 2 vols. Paris, 1883.

———. "L'Art Japonais et son influence sur le goût européen." *Revue des arts décoratifs,* 18 (April 1898), 97–116.

Guérin, Marcel. *L'Oeuvre gravé de Gauguin.* Paris, 1927.

Guide to the National Museum of Ethnology. Leiden, 1962.

Hahn, Ethel. "The Influence of the Art of the Far East on Nineteenth Century French Painters." M.A. thesis, University of Chicago, 1928.

Hanson, Anne Coffin. Review of "The Drawings of Edouard Manet." *The Art Bulletin,* 53 (December 1971), 542–47.

Harris, Jean C. *Edouard Manet, Graphic Works: A Definitive Catalogue Raisonné.* New York, 1970.

Haus der Kunst. *World Cultures and Modern Art: The Encounter of 19th and 20th-Century European Art and Music with Asia, Africa, Oceania, Afro and Indo-America.* Organized by Siegfried Wichmann. Munich, 1972.

Honour, Hugh. *Chinoiserie, the Vision of Cathay.* London, 1961.

Ikegami, Chuji. "Le Japonisme de Félix Bracquemond en 1866." *The Kenkyu.* Kobe: Kobe University, 1969. Pp. 30–62.

Ives, Colta Feller. *The Great Wave: The Influence of Japanese Woodcuts on French Prints.* New York, 1974.

Le Japon à l'Exposition Universelle de 1878. Paris, 1878.

Joyant, Maurice. *Henri de Toulouse-Lautrec, 1864–1901, Dessins, Estampes, Affiches.* Edited by H. Floury. Paris, 1927.

———. *Henri de Toulouse-Lautrec, 1864–1901, Peintre.* Edited by H. Floury. Paris, 1926.

Julien, Edouard. *The Posters of Toulouse-Lautrec.* Translated by Daphne Woodward. Monte Carlo, 1966.

Karsham, Donald H., and Stein, Donna M. *L'Estampe Originale: A Catalogue Raisonné.* New York, 1970.

Kobayashi, Taichiro. "Hokusai et Degas sur la peinture Franco-Japonaise en France et au Japon," in *International Symposium on History of Eastern and Western Cultural Contacts.* Compiled by the Japanese National Commission for UNESCO, November 1959. Pp. 69–75.

Kloner, Jay Martin. "The Influence of Japanese Prints on Edouard Manet and Paul Gauguin." Ph.D. dissertation, Columbia University, 1968.

Leipnik, F. L. *A History of French Etching.* New York, 1924.

Lemoisne, P. A. *Degas et son oeuvre.* Paris, 1946.

Leymarie, Jean. *The Graphic Works of the Impressionists.* Translated by Jane Brenton. London, 1971.

L'Image: revue littéraire et artistique, ornée de figures sur bois. Paris, December 1896–November 1897.

Lotz-Brissonneau, A. *l'Oeuvre gravé de Auguste Lepère.* Paris, 1905.

Mantz, Paul. "Exposition rétrospective de l'art japonais." *Gazette des Beaux-Arts,* séries 2, 27 (May 1883) 400–10.

Mellerio, André. *La Lithographie en couleurs.* Paris, 1898.

Michener, James A. *The Hokusai Sketch-Books.* Tokyo, 1958.

Morin, Louis. *French Illustrators.* New York, 1893.

Mourey, Gabriel. "French Wood Engraver: Auguste Lepère." *The Studio,* 12 (1898), 143–55.

Novotny, Fritz. *Toulouse-Lautrec.* Translated by Michael Glenney. New York, 1969.

van Rappard-Boon, Charlotte. "Japonism, the First Years, 1856–1876." *Liber Amicorum, Karel G. Boon.* Amsterdam, 1974. Pp. 110–17.

Reff, Theodore. "Manet's Portrait of Zola." *The Burlington Magazine,* 117 (January 1975), 34–44.

Reidemeister, Leopold. *Der Japonismus in der Malerei und Graphik des 19 Jahrunderts.* Berlin, 1965.

Renan, Ernest. "Hokusai's Mangwa." *Le Japon Artistique,* 9 (1889), 99ff.

Rencontres Franco-Japonaises (Catalogue de la collection historique réunie sur les rapports de la France et du Japon du XVIIème au XXème siècle). Paris-Osaka, 1970.

Rewald, John. *The History of Impressionism.* New York, 1973.

Roger-Marx, Claude. *Bonnard Lithographié.* Monte Carlo, 1952.

———. *Graphic Art, the Nineteenth Century.* New York, 1962.

———. *l'Oeuvre gravé de Vuillard.* Monte Carlo, 1948.

Roskill, Mark. *Van Gogh, Gauguin, and the Impressionist Circle.* New York, 1970.

Rosny, Léon de. "Botanique du Nippon, aperçu de quelques ouvrages japonais relatifs à l'étude des plantes." *Mémoires de l'Athénée Oriental.* Paris, 1871–72. Pp. 123–32.

Russell, John. *Edouard Vuillard, 1868–1940.* London, 1971.

Sandberg, John. "Japonisme and Whistler." *The Burlington Magazine,* 106 (November 1964), 500–07.

———. "The discovery of Japanese prints in the nineteenth century before 1867." *Gazette des Beaux-Arts,* 71 (June 1968), 295–302.

Sandblad, Nils Gosta. *Manet, Three Studies in Artistic Conception.* Lund, 1954.

Saunier, Charles. *A. Lepère, 1849–1918.* Paris, 1931.

Scheyer, Ernst. "Far Eastern Art and French Impressionism." *Art Quarterly,* 6 (1943), 116–43.

Schwartz, William Leonard. "The Priority of the Goncourts' Discovery of Japanese Art." *Publications of the Modern Language Association of America,* 42 (September 1927), 798–806.

Shapiro, Barbara S. *Camille Pissarro: The Impressionist Printmaker.* Boston: Museum of Fine Arts, 1973.

———. *Edgar Degas: The Reluctant Impressionist.* Boston: Museum of Fine Arts, 1974.

Spencer, Charles R. *The Aesthetic Movement, 1869–1890.* London, 1973.

Steinlen, Théophile Alexandre. *Des Chats, Dessins sans Paroles.* Paris, n.d.

Stern, Harold P. *Master Prints of Japan.* New York, 1969.

Strange, Edward F. *The Colour-Prints of Hiroshige.* London, 1925.

Sullivan, Michael. *The Meeting of Eastern and Western Art from the Sixteenth Century to the Present Day.* Greenwich, Connecticut, 1973.

Takahashi, Seiichiro. *Traditional Woodblock Prints of Japan.* Translated by Richard Stanley-Baker. New York, 1972.

The Avant-Garde in Theatre and Art: French Playbills of the 1890's. Catalog for traveling exhibition circulated by the Smithsonian Institution; essay by Daryl R. Rubenstein. Washington, 1973.

Thirion, Yvonne. "Le Japonisme en France dans la seconde moitié du XIXᵉ siècle, à la faveur de la diffusion de l'estampe Japonaise." *Cahiers de l'association internationale des études françaises,* 13 (1961), 117–30.

Tinchant, Albert. *Sérénités.* Illustrated by George Auriol, Fau, Poitevin, Henri Rivière, Henry Somm, Steinlen. Paris, 1885.

James Jacques Joseph Tissot. Catalog by Henri Zerner, David S. Brooke, and Michael Wentworth. Providence: Rhode Island School of Design, 1968.

Toda, Kenji. *The Ryerson Collection of Japanese and Chinese Illustrated Books.* Chicago: The Art Institute of Chicago, 1930.

Toudouze, Georges. *Henri Rivière.* Paris, 1907.

Uzanne, Octave. *Félix Buhot, dessinateur et aquafortiste.* Extract from *Livre.* Paris, 1888.

Vallotton, Maxime, and Goerg, Charles. *Félix Vallotton, catalogue raisonné of the printed graphic work.* Geneva, 1972.

Weisberg, Gabriel P. "Félix Bracquemond and Japonisme." *Art Quarterly,* 32 (Spring 1969), 56–68.

————. "Félix Bracquemond and Japanese Influence in Ceramic Decoration." *The Art Bulletin,* 51 (September 1969), 277–80.

————. "Samuel Bing: Patron of Art Nouveau." "Part I: The Appreciation of Japanese Art." *The Connoisseur,* 172 (October 1969), 119–25; "Part II: The Salons of Art Nouveau," 172 (December 1969), 294–99; "Part III: The House of Art Nouveau Bing," 173 (January 1970), 61–68.

————. *The Etching Renaissance in France, 1850–1880.* Salt Lake City: Utah Museum of Fine Arts, 1971.

————. "Japonisme in French Ceramic Decoration. Part I: The Pieces for E. Rousseau, Paris." *The Connoisseur,* 183 (July 1973), 210–13.

————. "Japonisme in French Ceramic Decoration. Part II: The Pieces by Camille Moreau and Albert Dammouse." *The Connoisseur,* 184 (October 1973), 125–31.

————. "Aspects of Japonisme." *The Bulletin of The Cleveland Museum of Art,* 42 (April 1975), 120–30.

————. "Les Albums Ukiyo-e de Camille Moreau: Sources nouvelles pour le 'Japonisme.'" *Nouvelles de l'estampe.* Paris, 1975 (in press).

Selected Painting Bibliography

Berhaut, Marie. *Caillebotte.* Paris, 1951.

Bouret, Jean. *The Barbizon School.* Greenwich, Connecticut, 1973.

Cachin, Françoise. *Paul Signac.* Greenwich, Connecticut, 1971.

Dorra, H., and Askin, S. C. "Seurat's japonisme." *Gazette des Beaux-Arts,* 73 (February 1969), 81–91.

Dorra, Henri. "Seurat's dot and the Japanese stippling technique." *Art Quarterly,* 33 (Summer 1970), 108–13.

Duret, Théodore. *Preface to Works in Oil and Pastel by the Impressionists of Paris.* New York, 1886.

Fosca, François. *XIXth Century Painters.* New York, 1960.

Galerie Durand-Ruel. *Receuil d'estampes gravées à l'eau forte.* Paris, 1873.

Herbert, Robert. *Neo-Impressionism.* New York, 1968.

Museum of Modern Art. *Art Nouveau.* New York, 1959.

Nochlin, Linda. *Impressionism and Post-Impressionism, 1874–1904.* Englewood Cliffs, New Jersey, 1966.

Pissarro, Camille. *Letters to His Son Lucien.* New York, 1943.

Prideaux, Tom. *The World of Whistler.* New York, 1970.

Rawson, Philip. *Erotic Art of the East.* New York, 1968.

Rewald, John. *The History of Impressionism.* New York, 1961.

————. *Post-Impressionism, from Van Gogh to Gauguin.* New York, 1962.

Roskill, Mark. *Van Gogh, Gauguin, and the Impressionist Circle.* Greenwich, Connecticut, 1970.

Schapiro, Meyer. *Van Gogh.* New York, 1950.

Scheyer, Ernst. "Far Eastern Art and French Impressionism." *Art Quarterly,* 6 (1943), 116–43.

Schneider, Pierre. *The World of Manet.* New York, 1968.

Seitz, William C. *Claude Monet.* New York, 1960.

Stevens, Alfred. *Impressions on Painting.* New York, 1891.

Thirion, Yvonne. "L'influence de l'estampe Japonaise dans l'oeuvre de Gauguin." *Gazette des Beaux-Arts,* 47 (January–April 1956), 95–114.

Selected Decorative Arts Bibliography

(Note: Not included in this listing are the many monographic articles and reviews of salons which appeared in major French periodicals such as *Revue des arts décoratifs, Gazette des Beaux-Arts, Art et décoration,* and *L'art décoratif.*)

Alcock, Rutherford. *Art and Art Industries in Japan.* London, 1878.

Allemand, Geneviève (Lacambre). "Le rôle du Japon dans l'évolution de l'habitation et de son décor en France dans la seconde moitié du XIXe siècle et au debout du XXe siècle." M.A. thesis submitted to the Ecole du Louvre, Paris, 1964.

L'Art de la poterie en France de Rodin à Dufy. Sèvres: Musée Nationale de Céramique, 1971.

Aslin, Elizabeth. *The Aesthetic Movement.* New York, 1969.

Audsley, George A. *Descriptive Catalogue of Art Works in Japanese Lacquer, Forming the Third Division of the Japanese Collection in the Possession of James L. Bowes.* London, 1875.

————. *Ornamental Arts of Japan.* London, 1884.

Audsley, George A., and Bowes, James L. *Keramic Art of Japan.* Liverpool and London, 1875.

de Beaumont, Adalbert, and Collinot, Eugène V. *Receuil de dessins pour l'art et l'industrie.* Paris, 1859.

de Bellecour, P. Duchesne. "La Chine et le Japon à l'Exposition universelle." *Revue des deux monds,* 37 (July 1867), 710–32.

Béraldi, Henri. *La reliure du XIXe siècle.* 4 vols. Paris, 1896.

Bing, S. "L'art japonais et l'industrie." *Revue des arts décoratifs,* 8 (1887/8), 351–52.

————. *Le Japon Artistique.* Paris, 1888–91.

Borrman, Richard. *Moderne Keramik.* Leipzig, 1902.

Bouilhet, Henri. *L'orfèvrerie française aux XVIIIe et XIXe siècles.* 3 vols. Paris, 1908–12.

Bousquet, Georges. "L'Art japonais." *Revue des deux mondes* (May 1877), 288–329.

Bowes, James L. *Descriptive Catalogue of Japanese Enamels and Other Works of Art Exhibited to the Members of the British Association.* Liverpool, 1870.

————. *Japanese Enamels,* Liverpool, 1890.

————. *Japanese Pottery.* Liverpool, 1890.

Brüning, Adolf. "Der Einfluss Chinas und Japans auf die europäische Kunst." *Velhagen & Klasings Monatshefte,* 15 (1900–01), 281–96.

Burty, Philippe. *Les emaux cloisonnés anciens et modernes.* Paris, 1868.

Catalogue de l'exposition retrospective de l'art japonais organisée par M. Louis Gonse. Paris, 1883.

Catalogue des tableaux, pastels et dessins par feu Félix Régamey. Paris: Hôtel Drouot, June 18, 1907.

Céramique impressionniste, l'atelier Haviland de Paris-Auteuil, 1873–1882. Paris: Bibliothèque Forney, 1974–75.

Chesneau, Ernest. "Le Japon à Paris," *Gazette des Beaux-Arts.* séries 2, 18 (1878), 385ff., 841ff.

Cluzot, H., and Follot, Ch. *Histoire du papier peint en France.* Paris, 1935.

Collection Charles Gillot. Paris, 1904.

Cutler, T. W. *A Grammar of Japanese Ornament and Design.* London, 1880.

Devauchelle, Roger. *La reliure en France.* Paris, 1961.

Dolmetsch, H. *Japanische Vorbilder.* Stuttgart, 1886.

Dresser, Christopher. *Japan: Its Architecture, Art and Art Manufactures.* London, 1882.

Four Hundred Years of Pottery in Puisaye. St. Amand en Puisaye, 1969.

Französische Keramik zwischen 1850 und 1910. Cologne: Kunstgewerbemuseum, 1974.

Glassammlung Hentrich, Jugenstil und 20er Jahre. Dusseldorf: Kunstmuseum, 1973.

de Goncourt, Edmond. *La maison d'un artiste.* Paris, 1881.

Gonse, Louis. *L'Art japonais.* 2 vols. Paris, 1883.

_____. "L'Art japonais et son influence sur le goût européen." *Revue des arts décoratifs,* 18 (April 1898), 97–116.

Havard, Henry. *Dictionnaire de l'ameublement de la décoration depuis le XIIIe siècle à nos jours.* Paris, 1887/90.

d'Hennezal, Henry. *Decorations and Designs of Silken Masterpieces Ancient and Modern.* New York, 1930.

Hofmann, Helga. "Gallé avant Gallé." *Festschrift Luitpold Dussler.* Munich, 1972. Pp. 433–56.

Huish, Marcus B. *Japan and Its Art.* London, 1889.

Ives, Colta Feller. *The Great Wave: The Influence of Japanese Woodcuts on French Prints.* New York, 1974.

Janson, Dora Jane. *From Slave to Siren: The Victorian Woman and Her Jewelry from Neo-Classic to Art Nouveau.* Durham, North Carolina, 1971.

Le Japon à l'exposition universelle de 1878. Paris: Imperial Commission, 1878.

Lambert, Théodore. *Motifs décoratifs tirés des pochoirs japonais.* Paris, n.d.

Lancaster, Clay. "Oriental Contributions to Art Nouveau." *The Art Bulletin,* 34 (1952), 297–310.

Ledoux-Lebard, Denise. *Les ébénistes Parisiens.* Paris, 1965.

Loti, Pierre. *Madame Chrysanthèmes.* Paris, 1887.

Madsen, Stephan Tschudi. *Sources of Art Nouveau.* New York, 1956.

Marx, Roger. *La décoration et l'art industriel à l'exposition universelle de 1889.* Paris, 1890.

_____. "Sur le rôle et l'influence des arts de l'Extrême Orient et du Japon." *Le Japon artistique,* 3 (1891), 141–48.

Morse, Edward S. *Japanese Homes and Their Surroundings.* Boston, 1886.

Moser, D. H. *Book of Japanese Ornamentation.* London, 1880.

Notice sur l'Empire du Japon et sur la participation à l'Exposition Universelle. Yokohama, 1873.

Objets d'art du Japon et de la Chine réunis par T. Hayashi. Paris, 1902.

Polak, Ada. *Modern Glass.* New York, 1962.

Rheims, Maurice. *The Flowering of Art Nouveau.* New York, 1966.

_____. *L'objet 1900.* Paris, 1964.

Rosenthal, Léon. *La verrerie française depuis cinquantes ans.* Paris, 1927.

Schmutzler, Robert. *Art Nouveau.* New York, 1964.

Schwartz, William Leonard. "The Priority of the Goncourts' Discovery of Japanese Art." *Publications of the Modern Language Association of America,* 42 (September 1927), 798–806.

Tokunosuke. *Céramique japonaise.* Paris, 1895.

Uzanne, Octave. *La reliure moderne.* Paris, 1887.

Valotaire, Marcel. *La Céramique Française Moderne.* Paris, 1930.

Verneuil, Maurice P. *Etoffes japonaises.* Paris, 1910.

Vever, Henri. *La bijouterie française au XIX siècle.* 3 vols. Paris, 1908.

_____. "L'influence de l'art japonais sur l'art décoratif moderne." *Bulletin de la société franco-japonaise de Paris,* 22 (June 1911), 109–19.

Weisberg, Gabriel P. "Félix Bracquemond and Japanese Influence in Ceramic Decoration." *The Art Bulletin,* 51 (1969), 277–80.

_____. "Félix Bracquemond and Japonisme." *Art Quarterly,* 32 (1969), 57–58.

_____. "Japonisme in French Ceramic Decoration." *The Connoisseur,* 184 (1973), 125–31, 210–13.

World Cultures and Modern Art. A revised edition of *Weltkulturen und moderne Kunst.* Munich: Haus der Kunst, 1972.

Lenders to the Exhibition

Arthur G. Altschul
Musée des Arts Décoratifs, Paris
Ashmolean Museum, Oxford, England
Associated American Artists, New York
Cie. des Cristalleries de Baccarat, Paris,
 and Baccarat, Inc., New York
The Baltimore Museum of Art
The Bethnal Green Museum, London
Bibliothèque Nationale, Cabinet des Estampes,
 Paris
Bogart Gallery, New York
The Museum of Fine Arts, Boston
Boston Public Library
Mr. and Mrs. Peter H. Brandt, Riverdale, N.Y.
The Booklyn Museum
Brooks Memorial Art Gallery
Mr. and Mrs. Phillip Harding Cate
Cazalis-Sorel Collection
The Art Institute of Chicago
Orfèvrerie Christofle, Bouilhet et Cie., Saint-Denis
Sterling and Francine Clark Art Institute
The Cleveland Museum of Art
Cleveland Public Library
Mrs. Joan Collins, London
Corning Museum of Glass, Corning, N.Y.
Detroit Public Library
Musée National Adrien-Dubouché, Limoges
Carol Ferranti Antiques Ltd., New York
Bibliothèque Forney, Paris
Mr. and Mrs. Charles Freeman, New York
Lucien Goldschmidt, Inc.
Mr. and Mrs. Edwin Grabhorn, San Francisco
Stephen Hahn Gallery
Harvard College Library
Maria and Hans-Jörgen Heuser, Marxen Am Berge,
 Germany
Hirschl and Adler Galleries, New York
The Museum of Fine Arts, Houston
Indiana University, The Lilly Library
Jacques Lejeune
Alain Lesieutre, Paris
Mr. and Mrs. Alex M. Lewyt
Library of Congress
Galerie des Luxembourg, Paris
Macklowe Gallery, New York
Félix Marcilhac, Paris

Maryland Institute College of Art
The Metropolitan Museum of Art
The Museum of Modern Art
Descendants of Camille Moreau, France
Lillian Nassau, Ltd.
National Gallery of Art
Office of Naval Records & Literature
The William Rockhill Nelson Gallery-Atkins
 Museum of Fine Arts, Kansas City
New York Public Library
The Newark Museum
Newark Public Library
The Philadelphia Museum of Art
The Pierpont Morgan Library
Princeton University Library
Rutgers University Art Library
Rutgers University Fine Arts Collection
Dr. and Mrs. Joseph Sataloff, Philadelphia
Edward R. Schaible
Mr. and Mrs. Herbert Schimmel
Musée National de Céramique, Sèvres
Robert Tschoudoujney, Paris
David Tunick, Inc.
Utah Museum of Fine Arts, University of Utah
The Wadsworth Atheneum
The Walters Art Gallery
Dr. and Mrs. Gabriel P. Weisberg
Ian Woodner Family Collection
The College of Wooster
Yale University Art Gallery

Photographic Credits

Martin Linsey
5a-g, 6,7,8,9a-b, 10, 11, 12, 13, a-d, 14a-c, 20, 21, 22,
23, 24, 25, 26, 27, 28, 32, 33, 34, 35, 37a-b, 178, 179,
180, 194, 203, 204, 210, 211, 215, 220, 226, 234, 238,
239, 243, 244, 246, 247, 248, 249, 250, 251, 252, 254,
255, 260, 266, 273, 282, 294-297

Taylor & Dull, New York
205, 206, 224, 225, 228, 229, 230, 231, 232, 263, 264,
265, 268, 269, 270, 271, 274, 275

Yvonne M. L. Weisberg
89, 90, 91, 92, 93

COLOR TRANSPARENCIES

Nickolas C. Hlobeczy
Cover, Frontispiece (also p. 42), back cover
(also p. 52)

Nathan Rabin
p. 132